W9-BAV-376

HOW TO READ A PAINTING

PATRICK DE RYNCK

HOW TO READ A PAINTING

Decoding, Understanding and
Enjoying the Old Masters

Thames & Hudson

Contents

Preface

These days, many museum-goers are no longer sufficiently familiar with the Christian and Classical pictorial traditions on which European painters drew so heavily and for so many centuries. What precisely were the Old Masters trying to say in their paintings; and how did they seek to express it? The aim of this book is to make a modest and reader-friendly contribution towards answering those questions.

Most of the panels, frescos and canvases brought together here are universally acknowledged as absolute masterpieces of painting. A number of other works have been included primarily to illustrate specific themes or features. The final selection of about 180 paintings offers a concise yet representative survey of five centuries of Western art. The book begins around 1300, as a profound revolution in painting was unfolding in Tuscany, and concludes shortly after 1800, as artists began to shrug off the iconographic traditions with which we are concerned here. The works are basically presented in chronological order, except where paintings by the same artist are kept together: the Van Eycks, Titians, Rembrandts and Poussins, for instance, all appear in succession, even when they would ordinarily have been interspersed with works by other artists.

Each entry takes up a double-page spread in which the fully illustrated picture is accompanied by a brief introduction and the discussion of some relevant details. Where a painting is based on a literary, mythological or Biblical source, the original story is quoted or summarized. The many eye-catching details make this a book to browse in as well as one to consult more systematically.

The sizeable index, finally, is intended to help readers explore the material from different angles: by name (Venus, Michelangelo, St Joseph, Jerusalem) or alternatively by theme, motif or concept (Annunciation, satyr, arrow, self-portrait, perspective).

PDR
Leuven, 8 July 2004

DUCCIO DI BUONINSEGNA *Maestà*

1308–11
Panel, 214 x 412 cm
Museo dell'Opera del Duomo, Siena

Duccio's greatest work was a multi-panelled altarpiece for the cathedral of his home town, Siena. This, the main panel of that work, presents us with a theme much loved by Sienese and Florentine patrons: the *Maestà* (literally 'majesty') or enthroned Madonna, surrounded by a 'court' of angels and saints. Twenty-six panels on the back of the work recount the story of Christ's life, while other smaller panels arranged around the main panel narrated episodes from his ministry, as well as his Resurrection, and the Death of the Virgin. Many of the original forty-five panels that made up the complete work are now spread across a number of museums or are lost. Contemporary chroniclers recorded that the work was carried in procession on 9 June 1311 from Duccio's workshop to the cathedral, illustrating the civic importance attached to the work.

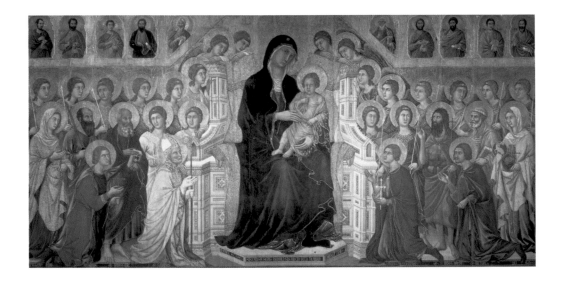

● Ten of Christ's twelve **apostles** appear along the top of the main panel, including (left) James and Thomas; the remaining two may originally have appeared in the panels directly above.

● **Four saints** kneel in the foremost row of the group, their names shown on the steps beneath them: Ansanus (see p. 15) and Savinus (right, above), Crescentius and Victor. Being the patron saints of Siena, their prominence reinforces the local, civic character of the work: here they are presented as if they are contemporary ambassadors come for an audience with the Virgin, to pray for the well-being of their city.

● The twenty angels that flank the Virgin and Child – sixteen in the back row, and four more in the middle row, at the sides of the throne – display a great variety of robes, poses and even hairstyles. The **six saints** (right) in the second row are identified by 'attributes' specific to them. From the left they are Catherine of Alexandria (holding a martyr's palm), Paul (with the sword of his execution) and John the Evangelist; John the Baptist, Peter and Agnes (holding the Lamb of God, or *Agnus Dei*).

THE CULT OF THE VIRGIN

Devotion to the Virgin Mary, as the Mother of God, dated back to early Christianity; by the late Middle Ages, however, it had grown so strong that she seemed to equal her Son in importance. Mary's popularity as an intercessor between man and God is obvious in paintings such as the Maestà, *although her rich iconography drew more on apocryphal stories than the Bible.*

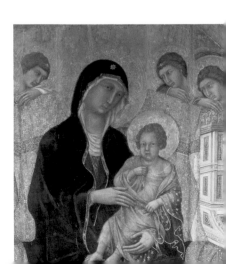

● The civic tone is continued in the **marble throne**, which has the appearance of a miniature version of Siena Cathedral. Christ looks at the viewer and seems to point to himself. The Madonna follows the Byzantine model, with her oval face, long nose, small mouth, traditional pose and elongated body. Since she is the most important figure, she is also depicted larger than the others.

about 1267–1337

GIOTTO *Ognissanti Madonna*

about 1310
Panel, 325 x 204 cm
Galleria degli Uffizi, Florence

Like Duccio's *Maestà*, this large altarpiece by contemporary Florentine artist Giotto focuses on the Virgin and Child, surrounded by a host of saints and angels (it was painted, appropriately enough, for the Ognissanti – All Saints – church in Florence). As in Duccio's masterpiece, the Virgin is placed on an imposing architectural throne, which elevates her above, and separates her from, the worshippers. The composition is rigorously symmetrical, making the image yet more awe-inspiring.

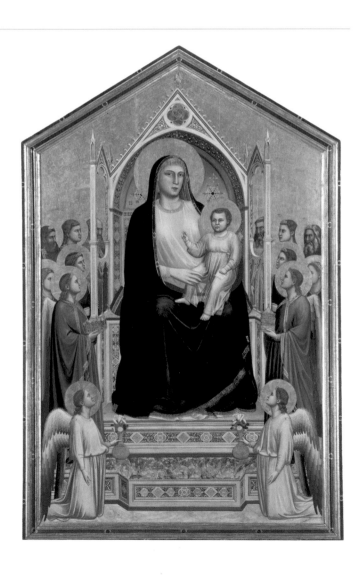

● Giotto has rendered the **Virgin Mary's face** without the austere Byzantine stiffness evident in the work of Duccio. It is a more human Mother of God that looks out at us, her body having volume, her head held upright. As in Duccio's *Maestà*, the Virgin is out of scale to the other figures, again expressing the hierarchical relationship. The golden ground, meanwhile, represents divinity, and is typical of Italian painting of this period. The infant Christ raises his hand in the customary blessing.

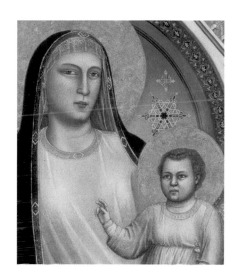

● Two **bearded prophets** can be seen through the open sides of the throne, while two more Old Testament prophets stand at the edges of the work. As prophets of the Virgin and of Christ, their presence visually links the Old Covenant with the New. They are shown in three-quarter view, whereas the angels in the foreground appear in profile.

● Two **angels** with colourful wings kneel before the dais on which the throne stands; each holds a vase of white lilies, symbols of the Virgin's purity. They are at the viewer's level and thus serve to draw us into the scene.

● This **standing angel** holds the crown that will be offered to the Queen of Heaven. The coronation of the Virgin as a motif first became popular in the 12th century.

about 1267–1337

GIOTTO *The Adoration of the Magi*

about 1310
Panel, 45.1 x 43.8 cm
The Metropolitan Museum of Art,
New York. John Stewart Kennedy Fund,
1911 (11.126.1)

This little panel was the first in a sequence of seven that are now spread across different collections. Each illustrates an episode from the Life of Christ, although in this one two events are commemorated at the same time – an unusual approach in Giotto's Florence. The Three Wise Men from the East worship the infant Christ in the foreground, while angels announce the Messiah's birth to the shepherds in the background.

The panels formed part of an altarpiece that Giotto painted for a church belonging to the Franciscan order of monks. The innovative nature of his work is apparent even in this small and sober panel: there is a clear sense of space, while the figures are imbued with individual personalities. Giotto was much in demand and headed a large workshop; an assistant probably helped with this panel.

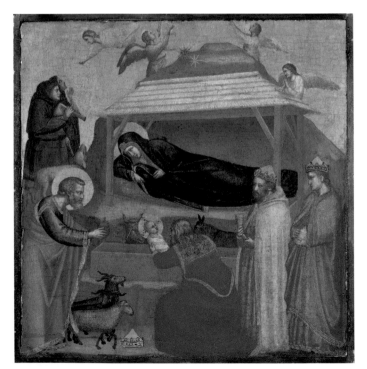

● Shepherds in the dress of **Franciscan friars**, accompanied by a dog, receive the angel's glad tidings on a plateau located higher up.

EPIPHANY

The Christmas story is one of many examples in which a brief mention in the Gospels (in this case only in Matthew and Luke) was elaborated on and expanded in the Middle Ages to include many additional details. The Three Wise Men – who from around AD 200 were known as 'Kings' – were granted large royal retinues, while the ox and the ass were added and the shepherds brought gifts. The kneeling Mary, worshipping her own child, is another medieval embellishment. Here, Giotto offers a simple, no-frills version of the story, in the spirit of moderation preached by the Franciscans. His Adoration for the Arena Chapel in Padua was a private commission and is much more exuberant.

● **Two of the Kings** wait their turn, clutching gifts. They are of different ages, something typical in images of the Magi.

● The **oldest King** has removed his crown as a token of humility, a gesture typical of Giotto's innovative approach. He kneels and raises the newborn, swaddled infant from its wooden crib, which stands on a piece of raised ground with the ox and the ass beyond it. Franciscans were especially keen to present Christ's life in as realistic as possible a manner to worshippers.

● This **shooting star** was added long after Giotto's time; traces of the original painted star – which guided the Kings to the infant Christ – can still be made out above it and to the left.

about 1280/85–1344

SIMONE MARTINI

St Louis of Toulouse Crowning Robert of Anjou King of Naples

about 1317
Panel, 250 x 188 cm and 56 x 205 cm
(predella)
Museo di Capodimonte, Naples

Simone Martini of Siena painted this altarpiece for Robert of Anjou, King of Naples (r. 1309–43), around 1317. It was in that year that the latter's older brother, Archbishop Louis of Toulouse (d. 1297) was canonized, thanks in part to lobbying by Robert himself, who is the small, kneeling figure in this panel. Louis had handed over rule of Naples to his brother, which is the event we are witnessing here; however, the image is symbolic, as Louis never actually crowned his brother. Canonization was a religious move with a political motive: to justify continued Angevin rule. The richness of this family monument would have been unlikely to find favour with Louis, who was a proponent of sober living.

BYZANTINE INFLUENCE?

The way Louis is portrayed is solemn and ceremonious. His pose harks back to Byzantine art, as do the princely gold and the precious stones used to decorate the picture's surface. Yet the painting is un-Byzantine in presenting an illusion of reality: in the rendering of the textiles, in the three-dimensionality that is heightened by the carpet on the floor, and in the sense of perspectival space in the predella scenes.

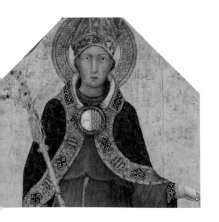

● **Louis** joined the Franciscan order, founded a century earlier by Francis of Assisi, which set great store by sobriety and poverty. However, this painting shows him wearing richly embroidered bishop's robes over his brown habit. Two angels hold a royal crown above his mitre, while Louis himself lowers a smaller but identical crown onto his brother's head.

● The numerous **fleurs-de-lis** (the heraldic emblem of the French monarchy) in the frame confirm the dual meaning of this altarpiece: religious and political, divine and worldly.

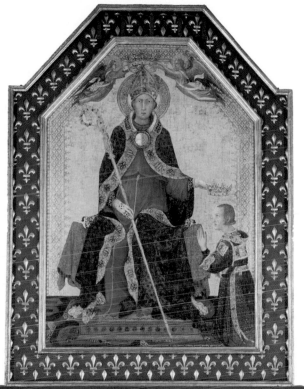

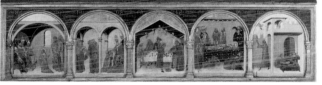

● The face of the praying **Robert** is slightly individualized, meaning that it goes beyond a basic representation of a human face to become a specific person. This was a novelty at the time, and a fitting touch for such a monument of courtly art.

● The **predella** is the narrow connective strip between the main scene and the altar. Four episodes from Louis' life are represented here, as well as the miracle he performed after his death. In the fragment to the left Louis is crowned bishop and joins the Franciscan order. His cope resembles the one he wears in the principal scene. On the right we see an entire story in a single scene. Louis restores a dead child to life, upon which, as a sign of their gratitude, the parents offer a wax effigy of the saint.

SIMONE MARTINI
& LIPPO MEMMI

The Annunciation

1333
Panel, 184 x 114 cm and 105 x 48 (x 2) cm
Galleria degli Uffizi, Florence

This Annunciation scene was once displayed on one of the altars in Siena Cathedral, each of which featured an episode from the life of the Virgin Mary, to whom the building was dedicated. This particular altar was devoted to the local patron saint Ansanus. There are three key participants in every presentation of this theme – Gabriel (the Angel of the Annunciation), the Virgin Mary and a descending dove symbolizing the Holy Spirit. The Annunciation marks the moment of Christ's conception and incarnation as a human being.

● **Gabriel** speaks the words of his greeting as recorded by Luke: *"Ave Maria, gratia plena, dominus tecum."* Further lines are inscribed in the hem of his robe. Gabriel usually holds a lily, but here it has been replaced by an olive branch, the lily being the emblem of Siena's arch-enemy Florence.

● Most Annunciation scenes show **Mary** kneeling at her prie-dieu, reading the Bible. St Bernard of Clairvaux even narrowed it down to the exact passage, a prophecy of Isaiah: "Behold, a virgin shall conceive, and bear him a son, and shall call his name Immanuel." This Mary is perplexed, as Luke tells us (see opposite).

● While Gabriel might hold an olive branch, the **lily** does still make an appearance as the traditional symbol of purity and virginity (see also p. 9).

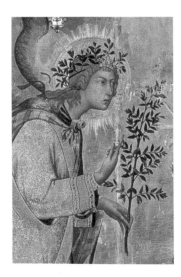

"[The Angel Gabriel] *came in unto her, and said, 'Hail, thou that art highly favoured, the Lord is with thee: blessed art thou among women.' And when she saw him, she was troubled at his saying, and cast in her mind what manner of salutation this should be. And the angel said unto her, 'Fear not, Mary: for thou hast found favour with God. And, behold, thou shalt conceive in thy womb, and bring forth a son, and shalt call his name Jesus'.... Then said Mary unto the angel, 'How shall this be, seeing I know not a man?' And the angel answered and said unto her, 'The Holy Ghost shall come upon thee, and the power of the Highest shall overshadow thee: therefore also that holy thing which shall be born of thee shall be called the Son of God.'"*

Luke 1 : 28–31 and 34–35

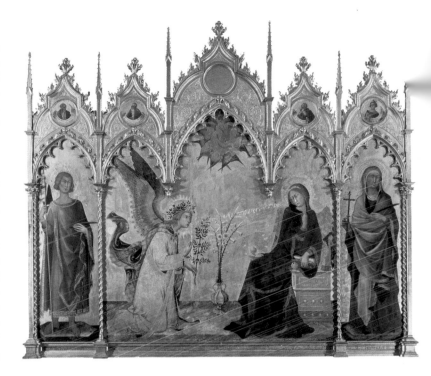

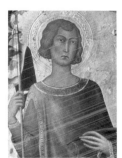

● The medallions show four Old Testament prophets unfurling scrolls. From left to right they are Jeremiah, Ezekiel, **Isaiah** (his scroll displaying the prophecy discussed opposite) and Daniel.

● The **Holy Spirit**, in its typical dove form, is surrounded by winged angel heads. God the Father would most likely have been depicted in a medallion above it. The Annunciation marks the completion of the Holy Trinity, comprising the Holy Spirit, God the Father and the newly conceived Christ.

● **St Ansanus** – a Sienese nobleman of the 4th century – converted to Christianity when he was twelve years old, preached his new faith and was executed when he was twenty. He later became the patron saint of Siena and is often shown with the martyr's palm and the 'banner of the Resurrection', the symbol of victory over death (see also pp. 6–7).

Richard II Presented to the Virgin and Child by his Patron Saints ('The Wilton Diptych')

about 1395
Hinged panels, 53 x 37 cm (x 2)
National Gallery, London

A crowned dignitary kneels in the company of saints. All eyes are fixed on Mary and the infant Christ, to whom the saints present the royal figure. Mary in turn looks at the supplicant and the Child strains towards him. The supplicant, supported by his patron saints, one of whom offers a reassuring arm, is praying to the Virgin, asking her to intercede for his soul's future salvation. His prayer seems to be heard.

We do not know who painted this portable altarpiece, despite its very high quality, nor do we know if it was created to mark a specific event. The dignitary, who must have been the patron, presumably took the painting with him wherever he went, ensuring his own personal salvation was always at hand.

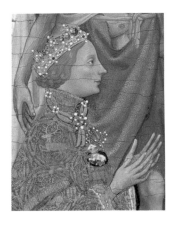

● The Virgin and Child stand in a **paradisaical meadow** of flowers, in the company of eleven beatific angels who kneel, bow or stand upright. They, too, are focused on the figures in the left wing. All of them wear the king's emblem: a white hart with golden antlers. And they are all dressed in ultramarine blue robes.

● We do know who the kneeling man is: **King Richard II of England**, husband of Anne of Bohemia, who reigned 1377–99. The painted figure has Richard's physical features and is wearing a brooch with the hart device that he adopted in 1390.

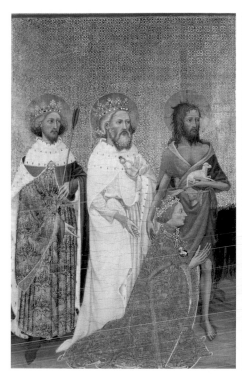
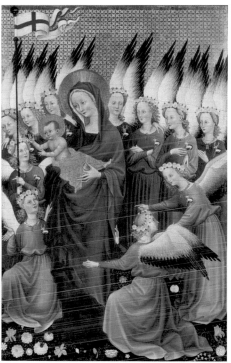

● We can also identify the **three saints**: the one on the right is the king's patron saint, John the Baptist. He lived as a hermit in the wilderness and is usually depicted in ragged clothes with a lamb close by. The man in the middle is the pious Edward the Confessor (1003–1066), former King of England, who holds a ring associated with one of his legends. The saint on the left is Edmund, like Edward a former Anglo-Saxon king (9th century) who was subsequently canonized. He displays the arrow that killed him. Edmund was *de facto* patron saint of England before being displaced by Edward, who gave way in turn to St George (whose flag we see in the right-hand panel).

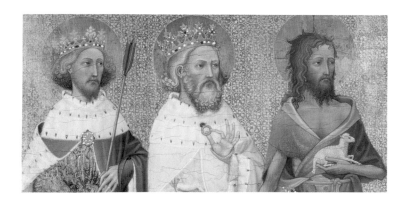

about 1370–1427

GENTILE DA FABRIANO *The Adoration of the Magi*

1423
Panel, 303 x 282 cm
Galleria degli Uffizi, Florence

This magnificent altarpiece, still in its original frame, shows the Holy Family (including two servant girls in the bottom left corner), accepting the offerings – gold, frankincense and myrrh – of the Three Magi or Kings (whose large retinue appears on the right). The narrative panel literally sparkles like some tremendous jewel. Gentile, who came from Fabriano in the Marche region of Italy, was the most sought-after painter of his generation in that country.

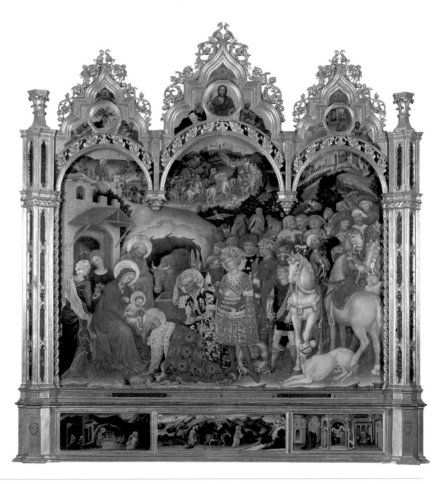

● Three long, horizontal panels form the **predella** of the altarpiece. They illustrate Christ's childhood: on the left the Adoration, on the right the Presentation in the Temple (the dedication of the Christ Child to God), and in the centre the Flight into Egypt (see opposite). Mary and Joseph flee with the baby Jesus through a hilly, Italianate landscape, with extensive views to the left and right. The many spires of the city on the right reflect the wealth of its citizens.

18

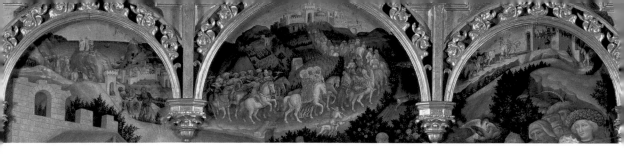

● In the **background** Gentile has painted the journey of the Kings and their grandiose train with great attention to the naturalistic detail of the landscape. High on the left they see the star that tells of Christ's arrival and shows them the way to Bethlehem. The centre shows them reaching Herod's palace in Jerusalem, while on the right they arrive in Bethlehem.

● The painting was commissioned for the chapel of the Strozzi family in Santa Trinità, Florence. This is the donor, **Palla Strozzi**, an immensely wealthy banker and humanist, with his son **Lorenzo**. The fact that he has had himself included in the scene, close to the main characters, illustrates the degree of his self-confidence.

● The painting features numerous **animals** and a rich variety of **plants**. In addition to the traditional ox and ass, the landscape and the Magi's retinue are filled with horses, camels, monkeys, a deer, a leopard, and various birds. These might be interpreted symbolically, yet here they appear simply to represent nature at its most exuberant, while simultaneously allowing the artist to show off his observational skills.

● Gentile's refined **Kings** are dressed in sumptuous courtly attire. As in Giotto's *Adoration* (see pp. 10–11), they represent the three stages of human life: the oldest kneels and honours the infant Christ, while the second, who is middle-aged, bows. The youngest of the three is shown standing and holding his gift at the ready.

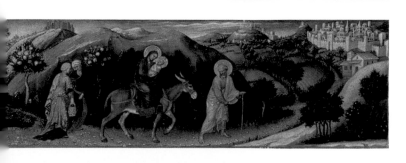

MASACCIO *The Holy Trinity*

about 1425
Fresco, 667 x 317 cm
Santa Maria Novella, Florence

This is the first painting known to employ a correctly constructed one-point perspective, a technique introduced to Florence by the famous architect Filippo Brunelleschi (who was also responsible for the dome on Florence Cathedral). The effect of this device is dramatic: we seem to be looking into a real chapel, as if through a hole in the wall. Masaccio combines two motifs in this fresco: the Holy Trinity (Christ on the Cross, God the Father towering above him, and the Holy Spirit, in the form of a dove, hovering between the two) and the intercession of the Virgin Mary as both Mother of Christ and human being. At the very front of the fictive space are the two donors, who are unidentified. They are kept out of the holy space by a step. The whole scene is enclosed in a triumphal arch inspired by Classical Rome – a reference, perhaps, to Christ's triumph over death through his Crucifixion and Resurrection. Beneath the main scene is another fresco of a skeleton lying on a tomb (see opposite, below).

● A **praying man and woman** kneel on a platform, looking towards one another. They are positioned in front of the pilasters so that they do not occupy the same space as the Crucifixion. These are the donors of the fresco and are depicted on the same scale as the divine figures in the chapel. The man appears to be a prominent city official.

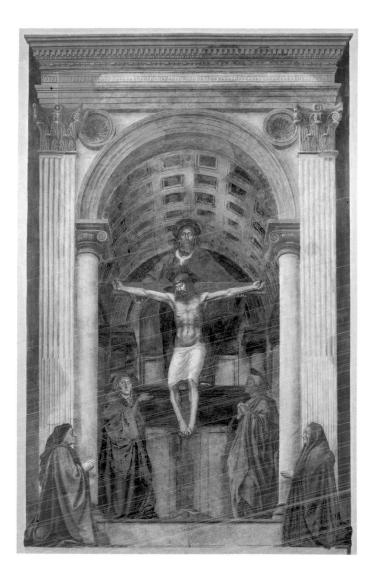

● **The Virgin** and **John the Evangelist** stand on either side of the cross, inside the arch. Mary looks out of the painting, drawing the viewer's attention to the central image: her crucified son. The gesture of her hand is the only movement in this giant work. The Virgin is the link between our transient world and the divine.

● "I was once that which you are and that which I am you will also be." This **memento mori** is written above the **skeleton** in the fresco beneath the Trinity image. It has been suggested that the latter – laid on a sarcophagus and below an altar – is Adam, who was supposedly buried at Golgotha, where the crucifixion of Christ took place. This part of the work, which seems built into the wall of the church, heightens the greater message: during our earthly lives, which are destined to end in death, we achieve salvation only by praying to God and seeking the intercession of the Virgin and the saints.

MASACCIO *The Tribute Money*

1426–7
Fresco, 255 × 598 cm
Santa Maria del Carmine, Florence

Masaccio was only twenty-seven when he died. One of the masterpieces of his short career was a large cycle of frescos in the Brancacci chapel in Santa Maria del Carmine, Florence, featuring scenes from the life of the Apostle Peter. This fragment epitomizes the cycle's approach: flesh-and-blood people are shown in a realistic landscape featuring a lake surrounded by bare mountains, with the odd patch of snow. Christ stands in the centre, surrounded by his Twelve Apostles. The man seen from behind is a tax collector, who has come to ask if Jesus has paid his temple tax. The fresco presents three moments from the story, which is recounted in St Matthew's Gospel.

"They that received tribute money came to Peter, and said, 'Doth not your master pay tribute?' He saith, 'Yes'. And when he was come into the house, Jesus prevented him, saying, 'What thinkest thou Simon? of whom do the kings of the earth take custom or tribute? of their own children, or of strangers?' Peter saith unto him, 'Of strangers.' Jesus saith unto him, 'Then are the children free. Notwithstanding, lest we should offend them, go thou to the sea, and cast an hook, and take up the fish that first cometh up; and when thou hast opened his mouth, thou shalt find a piece of money: that take, and give unto them for me and thee.'"

Matthew 17:24–7

● On the shore of Galilee, **Peter** takes the coin that Jesus told him would be in the mouth of the gaping fish. He then hands over the money to the tax collector outside his house.

● **Jesus and his Apostles** are rather static figures, yet the eye contact between them results in intensive interaction within the group. Jesus and Peter point to the scene on the left, which acts out what Christ is here prophesying. The figures are barefoot and are dressed in clothes that look both ancient Greek and Roman: tunics beneath togas that cover their left shoulders.

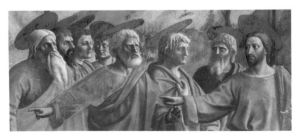

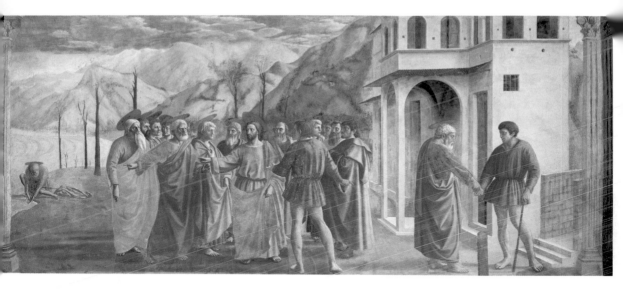

A TRIBUTE TO REFORM?

It is tempting to read the subject of the work as relating to current affairs. The Florentine tax system was reformed in 1427 with the introduction of an official register, allowing the fairer collection of taxes.

● The **individualized faces** suggest that Masaccio used those around him, perhaps friends or studio assistants, as models.

● Masaccio's figures are given a greater solidity by his use of light and shade. The **shadows** clearly indicate that the source of light in this fresco is on the right.

about 1375–1445

ROBERT CAMPIN
and assistant

The Annunciation Triptych ('Merode Triptych')

about 1425–30
Panel, 64.1 x 63.2 cm
and 64.5 x 27.3 cm (x 2)
The Metropolitan Museum of Art,
New York. The Cloisters Collection,
1956 (56.70)

Gabriel announces Mary's pregnancy in a typical northern European bourgeois interior of the 1420s. The Archangel has appeared silently, without distracting the Virgin from her pious reading. She sits humbly next to a bench placed across the fireplace. In the right-hand panel Joseph is at work in his workshop, while kneeling donors observe the central scene from the panel on the left; a messenger employed by the city of Mechelen (Malines) is standing behind them.

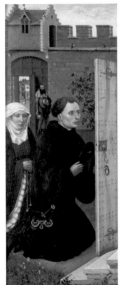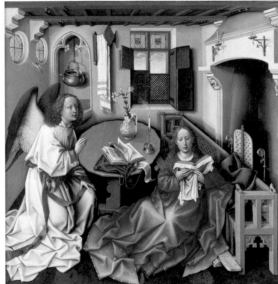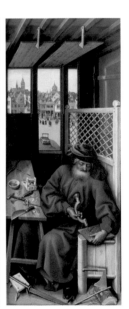

REVEALING NAMES?

The triptych was commissioned by Pieter Engelbrecht, who married Gretgin Schrinmechers in the 1420s; husband and wife both hailed from wealthy families. Joseph's carpentry may be intended as a reference to the wife's surname, which translates as 'Carpenter', while the Annunciation may allude to the Engelbrecht family name, which – in Dutch – can be read as 'the angel brought'.

● Several realistically rendered objects allude to Mary's purity: the **lilies** in the Florentine maiolica vase; the **white cloth** in her hands; and even the **kettle** hanging in the alcove at the back. The coming of Christ will cleanse the world of sin. The candle on the table – and the one on the mantelpiece – has just been extinguished. Instead, the room is now filled with divine light. Some of the objects in the interior are decorative rather than metaphorical in intent.

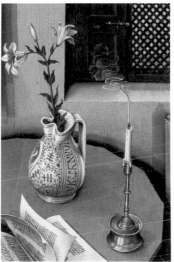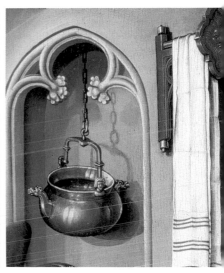

"The Lord immediately became a complete human being, perfect in soul and body; that body was already possessed of all its essential features, yet was so small as to be barely visible to human eyes."
Ludolf of Saxony, d. 1378

● A tiny child carrying a wooden cross descends on a **beam of light**, referring both to Mary's virgin pregnancy and to Christ's subsequent death on the cross.

● **Joseph** is hard at work in his carpenter's workshop, drilling holes in a piece of wood. He is unaware of the miracle unfolding in the adjoining room. The mousetraps on the workbench and the counter by the window allude to St Augustine, one of the Fathers of the Church, who wrote: "The cross of the Lord was the Devil's mousetrap; the bait by which he was caught was the Lord's death." In other words, the death of Christ meant the end of the Devil. Joseph was a crucial figure in deceiving Satan; Mary's husband was a lowly man and a mortal, which helped conceal from the Devil that Jesus was actually the Son of God.

JAN VAN EYCK *The Adoration of the Mystic Lamb*

about 1425–33
Central panel of the Ghent Altarpiece,
137.7 x 242.2 cm
Cathedral of St Bavo, Ghent

This is the central panel of the *Ghent Altarpiece*, which in its totality is made up of twenty panels. It hung in a chapel where the donors Judocus Vijd and Elisabeth Borluut wished a daily Mass to be celebrated perpetually after their death 'to the glory of God, his Holy Mother and all the saints'. Van Eyck wove the couple's desire into an all-encompassing statement of Christian doctrine. This panel shows the focus of that doctrine: a populous Kingdom of Heaven, with all the saints, worshipping the Eucharistic Lamb of God. The polyptych as a whole took years to complete.

PAINTED TEXTS

The Ghent Altarpiece *incorporates numerous Latin texts from a variety of religious sources. Van Eyck was a learned artist and this painting sets out a complex theological programme that by no means will have been immediately comprehensible to every churchgoer. The Latin inscription on the altarfront reads: "Behold the Lamb of God who taketh away the Sins of the World."*

● **Four groups** converge on the heavenly meadow – a new, flower-strewn Garden of Eden. The two groups approaching from the back are of holy bishops and cardinals (with their distinctive flat red hats), and, from the right, Holy Virgins. In both groups there are a number of palms, denoting martyrdom. The left-hand group in the foreground, meanwhile, is made up of representatives of the Old Testament – including patriarchs and prophets, each individualized – and a number of prominent pagans, including

the Roman poet Virgil (dressed in white with a laurel crown), who foretold the coming of "a child".

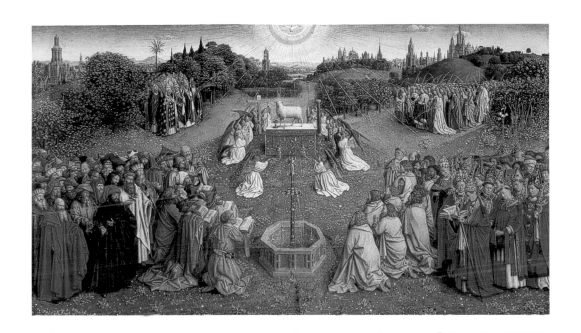

On the altar that stood below this scene, bread and wine were believed to be transformed into the body and blood of Christ during the daily **celebration of the Eucharist**. The *painted* altar, meanwhile, shows the Lamb of God, which was sacrificed on humanity's behalf to redeem us from Adam and Eve's Original Sin. Its blood spurts into the chalice. Angels stand around the altar, four holding the Instruments of the Passion: the column on which Christ was flogged, the cross and

nails of the crucifixion, the lance that pierced his side, and the sponge used to quench his thirst when on the cross. Two other angels swing censers, as occurs during Mass. The Holy Ghost in the shape of a dove spreads the light of its mercy across the entire meadow and the Heavenly Jerusalem beyond. The Fountain of Life below the altar, whose basin echoes the shape of a baptismal font, symbolizes immortality.

The fourth and final group represents the **Church**. The Twelve Apostles – ordinary men, dressed in grey habits – are shown at the front, followed by the prelates who were their successors: popes, bishops, deacons and martyrs. Above them we see the female saints, accompanied by their traditional attributes.

JAN VAN EYCK *Giovanni Arnolfini and his Wife*

1434
Panel, 82.2 x 60 cm
National Gallery, London

In spite of their naturalism and exceptional detail, Van Eyck's works also contain numerous symbols and clues as to how they should be interpreted on a deeper level. Knowledge of the Bible and key medieval texts may clarify certain things, but readings can still differ sharply. This double portrait is a good example of a painting that continues to pose certain questions. Traditionally it has been interpreted as representing a wedding or engagement ceremony, but this has been questioned recently, and the picture retains a great deal of enigma.

● The **Italian merchant** Giovanni Arnolfini (d. 1472) **and his wife** Giovanna Cenami (d. 1480), both hailing from Lucca, lived in Bruges for years. Their fancy clothes mark them out as people of status. It is no coincidence that he is standing on the side where we glimpse the outside world, while her position associates her with the 'inside world' of the home.

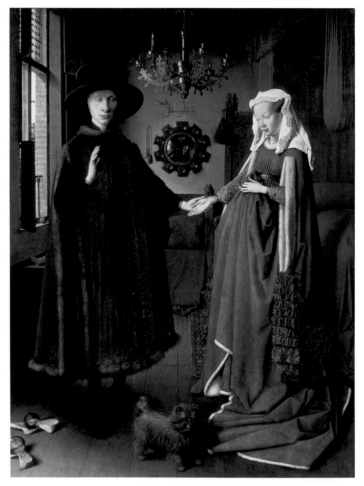

● The **convex mirror** and the **inscription** above it might offer us a key to reading the painting. In it we see the missing part of the room, with two additional figures, creating the illusion that the viewer is in the painted space with the couple. One of the figures may be the painter himself: "Johannes van Eyck was here. 1434", says the conspicuous Latin inscription. Could the two people in the mirror be witnesses to the couple's wedding, which in the 15th century would have been a private affair? If so, they may have asked Van Eyck to capture the moment, like a notary with a paintbrush. Or is he merely indulging in a painter's contrivance?

● The **medallions** around the mirror's frame show scenes from the Passion of Christ. A 'spotless' mirror was itself an established symbol of Mary, referring to the Holy Virgin's immaculate conception and purity. In fact the entire interior is reminiscent of an Annunciation scene.

● The **brush** and the **rosary** (a popular wedding gift) on either side of the mirror allude to the dual Christian injunctions *ora et labora* (pray and work).

● A single candle is lit in the seven-branched **chandelier**, possibly the candle that the bride traditionally gave to the groom. Burning candles frequently allude to the ever-present light of God.

● **Dogs** were a common symbol of fidelity. The man has taken off his clogs, possibly as a gesture of respect for the wedding ceremony.

● **Oranges** frequently symbolize the purity and innocence that reigned in the Garden of Eden before the Fall of Man; they are also a token of prosperity, since these fruits could be afforded only by the wealthy few.

about 1385–1441

JAN VAN EYCK

The Virgin and Child
with Canon George van der Paele and Saints

1436
Panel, 141 x 176.5 cm
(including frame)
Groeningemuseum, Bruges

The Virgin Mary is enthroned in the interior of a church, with the Christ Child on her lap. The donor of the painting is shown kneeling in the same chapel, accompanied by the standing figures of two male saints. The inscription on the frame tells us that Van Eyck painted the panel at the behest of George van der Paele, a canon at the Church of St Donatian in Bruges, to which the work was presented as the clergyman neared the end of his life. Van der Paele is shown praying for admittance to the Kingdom of Heaven, through the intercession of Mary, Christ and the two saints. This interpretation can be read in the painting itself.

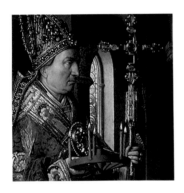

● The Church of St Donatian in Bruges was dedicated to Bishop **Donatian** of Reims (4th century). His relics were kept there, as were his cloak, mitre and staff. According to legend, the young Donatian was thrown into the river Tiber in Rome but was saved by Pope Dionysius, who ordered a wheel with five lighted candles to be floated on the water. This miraculously ceased to move as it passed the spot where Donatian was lying. Hence the wheel with candles that the saint holds in the painting. Van der Paele seems to be looking at the cross on Donatian's staff, which was believed to contain a fragment of the cross upon which Christ died.

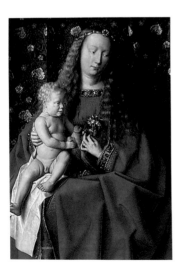

● The **Virgin Mary** was the embodiment in Van Eyck's day of the bond between God and humanity. She was the focus of a rich body of symbolism and imagery: Mary as the 'Church' who carried the Eucharist within her, as the 'Source of Life', as an 'Altar', and much more besides. She is surrounded here by stylized roses in the tapestry behind her; rose-gardens were a traditional setting for mystical experiences like that of the canon in this panel. The **infant Christ** holds a posy of flowers in one hand and a parrot in the other. Medieval people believed that parrots greeted them with the word 'Ave', which is why the birds sometimes feature in paintings of the Archangel Gabriel's announcement to Mary ('Ave, Maria') that she is to give birth to Jesus. In this instance, the parrot emphasizes the central message: the canon's hoped-for entry into the Kingdom of Heaven. It seems to bid him welcome. 'Ave' is, incidentally, also the word 'Eva' – Eve – written backwards; Mary is the new Eve and Jesus the new Adam. Carved figures of Adam and Eve appear in the uprights on either side of the throne.

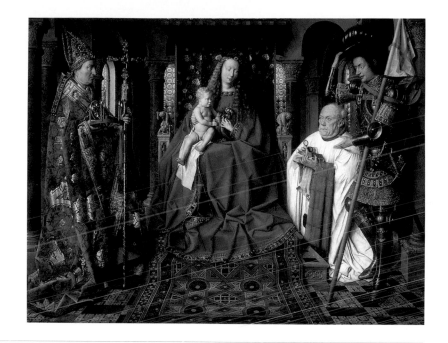

● Church doctrine stated that the Old Testament was a prophetic prefiguration of the Glad Tidings proclaimed in the New Testament. This idea was frequently reflected in art, as we see here on Mary's throne and in the capitals of some of the columns. The woodcarving that surmounts the left arm (from our point of view) of the throne shows **Cain killing his brother Abel** in a prefiguration of Jesus' sacrificial death. The capitals on the left convey a similar message: one motif has the **sacrifice of Isaac** by his father Abraham. The right arm of the throne is topped with the figure of **Samson killing a lion**, which symbolized Christ's liberation of people from Hell. Meanwhile, one of the capitals on the right shows **David's victory over Goliath**. The canon kneels on this 'triumphal' right-hand side of the interior, with its allusions to Christ's death on the Cross and his victory over evil and death, through which humanity gained the possibility of eternal life. This is the central tenet of the Christian faith.

● **St George**, after whom Van der Paele was named, was martyred in the year 305. He was said to have saved a town from a dragon while serving in the Roman army. The Church of St Donatian possessed one of George's arms as a relic. The saint presents his protégé to the Virgin.

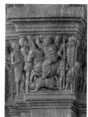
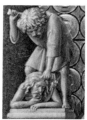

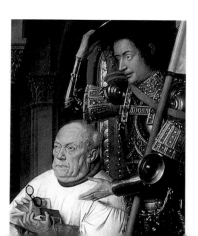

about 1385–1441

JAN VAN EYCK
and assistant?

Diptych: The Crucifixion and The Last Judgement

1430s
Canvas (transferred from panel),
56.5 x 19.7 cm (x 2)
The Metropolitan Museum of Art,
New York. Fletcher Fund, 1933 (33.92a)

Christ sacrificed his life to save humanity. Those who demonstrate their willingness to follow him during their lives will be chosen at the Last Judgement to live eternally in heaven, while the rest will be condemned to hell. These central tenets of Christian doctrine are visualized in this diptych, comprising a Crucifixion on the left and a Last Judgement on the right. In addition to his unmatched technical skill, Van Eyck here displays his considerable learning. The Crucifixion, in particular, with its imaginary Jerusalem rising behind the three crosses, spawned a host of imitators, not least in Italy.

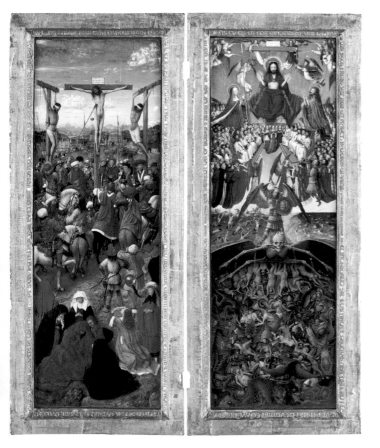

MAN OF LEARNING

Van Eyck has added explanatory texts, mainly in the right-hand panel. Christ's red robe, for instance, twice features the Latin words Venite benedicti patris mei *(Come, you that are blessed by my Father). Mark's Gospel is quoted below Michael's wings: "Depart from me, ye cursed, into everlasting fire, prepared for the devil and his angels." The frame incorporates Biblical quotations that are presented visually in the painting. They include the following fragment from the Book of Revelation, which recounts a vision of the Last Judgement: "And the sea gave up the dead which were in it; and death and hell delivered up the dead which were in them: and they were judged every man according to their works" (Revelation 20:13).*

● Curious onlookers crowd around as the **lance is pushed into Christ's side** to test whether he is dead yet. Some of the crowd have extravagant headdresses or strange faces; they smile or stare at the scene.

● **Jesus' friends and relatives** grieve for him, well away from the cross. Mary wraps herself up in her blue cloak and is consoled by a weeping St John. Mary Magdalene, a fallen woman who had been saved by Jesus, dressed in green, makes a gesture of despair.

● **Angels** sound the trumpets of the Apocalypse as **Christ** appears in judgement, the cross behind him. The Virgin Mary and St John the Baptist kneel close by him, seeking to intercede on humanity's behalf. The twelve white-clad Apostles sit below them, accompanied by standing angels. Other angels receive the souls of the righteous – clergymen on the left and worldly potentates on the right.

● The **Archangel Michael**, clad in full, colourful armour, stands with his sword raised; he generally appears in Last Judgement scenes weighing human souls. The subjugator of demons *par excellence*, he is shown here standing on the wings of Death. The winged skeleton pours forth the unfortunate damned souls that tumble down into hell, where they are condemned to be preyed on for all eternity by voracious monsters. Among them we note the occasional bishop's mitre.

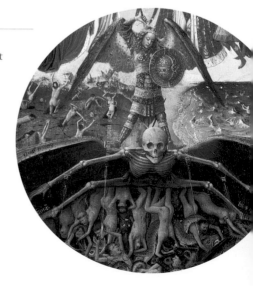

about 1425
Panel, 194 x 194 cm
Museo Nacional del Prado, Madrid

The Florentine artist Fra Angelico, who painted a number of Annunciations, here shows us the fundamental meaning of the episode for worshippers. To the left of the loggia an angel drives Adam and Eve from Eden, while the Angel of the Annunciation delivers his portentous message to the Virgin Mary in the foreground. Himself a Dominican friar, Fra Angelico painted this panel as an altarpiece for the church of the Dominican abbey in Fiesole, near Florence.

● The Advent of Christ that the angel has come to announce means salvation from the sin committed by **Adam and Eve** when they ate the forbidden fruit (shown here at their feet).
Fra Angelico combines the two scenes with didactic intent: the Old Covenant between God and humanity was broken, but will now be replaced by a new one embodied by Jesus Christ.

● **Mary**'s prayerful pose and the holy book on her lap show her to be a model of pious modesty – an image reinforced by the sober room in which she appears. Luke's Gospel tells us that she is expressing her readiness to serve: "Here am I, the servant of the Lord."

● The **loggia** in which Mary sits refers in style to contemporary Florentine architecture.

● Many flowers are associated with Mary and so they appear in abundance in scenes like the Annunciation. They are often shown in an *hortus conclusus* (enclosed garden) – an allusion to Mary's virginity.

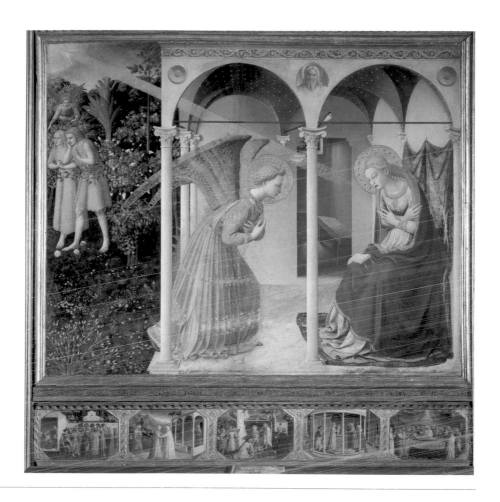

● **God**, the source of the light, sends down a dove; we can just make out his hands. The bird symbolizes the **Holy Spirit** and travels down a light shaft to Mary. At the same moment as Christ's coming is announced, Mary is miraculously made pregnant; Jesus is incarnated as a human being. The image of God the Father himself is worked into the architecture.

● The five scenes in the **predella** illustrate key moments from the Life of the Virgin: her Birth and Wedding; the Visitation, i.e. the meeting between Mary and her cousin Elizabeth, who is pregnant with John the Baptist (both panels are illustrated below); the Adoration of the Magi; the Presentation of Mary in the Temple; the Death of the Virgin. We do not read about Mary's

birth and death in the canonical Gospels, but in apocryphal texts written much later.

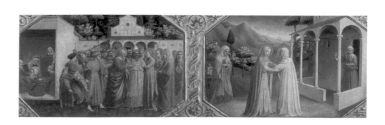

about 1399–1455

FRA ANGELICO *The Descent from the Cross*

about 1436–40
Panel, 176 x 185 cm
Museo di San Marco, Florence

Fra Angelico painted the main scene of this altarpiece which had been begun in a traditional Gothic style by another artist, as can be seen in the side panels, the gablets and the overall shape. Beneath the central arch, five men lower Christ from the cross. The disciple John touches his master's body tenderly. The scene is played out before a brightly lit landscape. Emotion is kept under remarkable control, the colours are clear and bright, and the figures composed and elegant. The altarpiece was painted for the chapel of the Strozzi family in Florence's Santa Trinità.

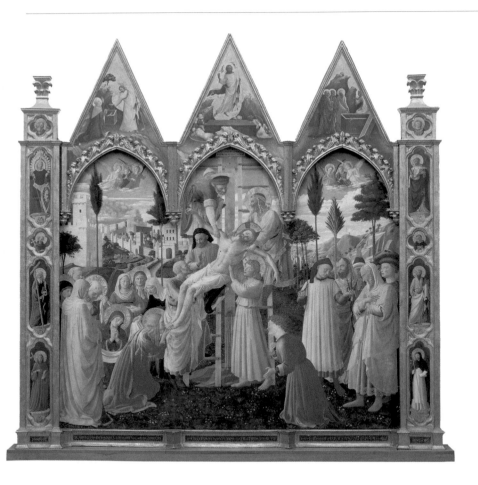

NORTH–SOUTH CONNECTION?

There was intense contact in the 1430s and 1440s between Northern and Southern Europe – particularly Flanders and Florence. It is not especially surprising, therefore, that Fra Angelico's Christ figure is reminiscent of that in Rogier van der Weyden's Descent from the Cross *(see pp. 44–5). Rogier's masterpiece may have circulated in the form of miniatures, which may in turn have featured in the well-appointed library of Fra Angelico's Dominican abbey. Or could the influence have worked in the other direction? Whatever the case, the Italian painter and monk is known to have been interested in Northern European painting.*

● On the left nine **women** stand, bow and kneel. The Virgin Mary – her name inscribed in her halo – is kneeling, while Mary Magdalene kisses Christ's feet.

● Six pious **men**, most likely including contemporaries of the artist, stand on the right; one of them holds Christ's crown of thorns and shows the three nails with which Jesus was pinned to the cross. A pale, golden halo is visible about his head.

● The **kneeling man** is at our level, unlike the scene proper. The sinner and penitent Mary Magdalene also kneels close to the viewer. These two 'ordinary' people invite the viewer to join in their prayers. In addition to the landscape in the background, the carefully executed meadow of flowers in the foreground – a motif known primarily from Flemish painting – is particularly striking.

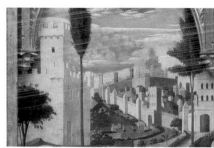

● The realistic way in which this **man** has been painted suggests that this is a portrait. Christ's body clearly shows the marks of the flagellation – beating – it received prior to crucifixion.

● The cloudy sky above the landscape runs across the three arches, linking them together. The walled city of **Jerusalem** is executed in a geometric style.

PAOLO UCCELLO *The Battle of San Romano*

about 1438–40
Panel, 181.6 x 320 cm
National Gallery, London

Paolo Uccello is said to have been obsessed with perspective and movement. How should a painter go about achieving the appearance of volume in two dimensions? And how can the movements of people and animals be depicted convincingly? His fascination is obvious from this colourful panel, which illustrates a skirmish between mounted troops dressed in the manner of medieval knights. Those on the left are armed with remarkably long, heavy lances. Uccello painted this work shortly after the events it depicts. It is one of three panels devoted to the Battle of San Romano. In the 1480s the paintings ended up in the Palazzo Medici – the rich and powerful Florentine family's newly built city palace.

FLORENCE AND SIENA

The Battle of San Romano was fought on 1 June 1432 and was one of a series of encounters between Florence and Siena. At the beginning of the engagement, the Florentine commander Niccolò da Tolentino was surprised by Sienese troops. With barely twenty horsemen, he had to hold off a substantially larger force before the tower of San Romano. He kept the enemy at bay for eight hours, before reinforcements arrived and the Florentines carried the day. The painting shows Niccolò leading the attack.

● The *condottiere* **Niccolò da Tolentino** was a confidant of the Medici; one of the ways we can identify him here is from the 'Solomon's knot' motif on his banner. He is unlikely to have worn such magnificent headgear during the actual battle, but it adds to the ceremonial splendour the panel evokes.

● The **face of the young standard-bearer** is one of the few we can make out; the rest are concealed behind their visors. Only the soldiers

sounding the call to battle are also bare-headed, for obvious reasons. The others' helmets are exuberantly decorated.

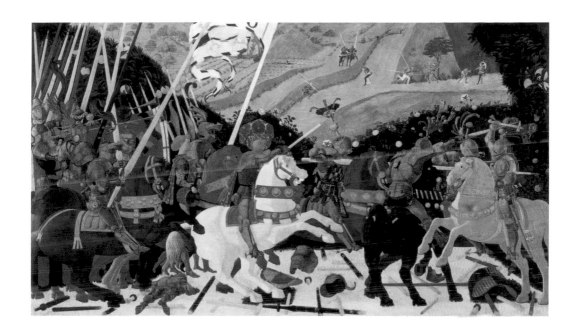

● The **dead man** in the foreground must have caused something of a sensation in Uccello's time, being perhaps the earliest example of foreshortening of a human figure. The broken lances on the ground have also been carefully arranged to lead the viewer's eye to the mounted protagonist.

● Painting people and **horses** was a major challenge. These animals are rather stylized, giving them the character of merry-go-round horses, and this, in turn, serves to heighten the unreal atmosphere of the panel. However, it also must be recognized that the painting has suffered considerable wear and tear over the centuries.

DOMENICO VENEZIANO

The Virgin and Child with Saints ('Santa Lucia Altarpiece')

about 1445?
Panel, 209 x 216 cm
Galleria degli Uffizi, Florence

Small groups of saints shown in the same panel with the enthroned Virgin and Child are a familiar image in European painting; this type of composition was known as a *sacra conversazione* or 'holy conversation'. Which saints are depicted depends on the function the work was intended to fulfil (see opposite page). Veneziano's altarpiece for the church of Santa Lucia dei Magnoli in Florence is one of the earliest examples of the type, although Jan van Eyck should also be mentioned in this context (see pp. 30–31). This main panel shows Mary enthroned in a loggia, accompanied by four saints; the five small panels of the *predella* now belong to different collections.

ONE IMAGE, MANY FUNCTIONS

The choice of saints in a sacra conversazione *depended on the patron and the purpose of the work. They may be the patron saint of the church for which the painting was commissioned or of the city in which the donor lived. Monastic orders liked to see their founder and other associated saints appearing in the company of the Virgin. Individuals also donated paintings to churches and abbeys, in which case their patron saint – and possibly that of their spouse – would appear along with portraits of the donors themselves. The reasons for such donations varied: good fortune, prosperity, victory, the approach of death, the hope for eternal life. The contemporary audience would often have been able to identify the depicted saints from their appearance and attributes.*

● Two male saints stand on the left (the Virgin's right) in their customary positions; they are exceptionally popular figures in Italian painting, St Francis of Assisi and St John the Baptist. **St Francis** wears a friar's habit and reads piously.

● **St John the Baptist** wears his characteristic ragged clothes and carries a crosier. The sunburned and muscular saint, seen in frontal view, is the only figure in the painting who catches the viewer's eye, pointing out to us the enthroned Virgin and Child. The gesture is a visual summation of John's role in the Bible – that of Christ's herald. Mary and Jesus turn towards him. John's face is believed by some to be a self-portrait of the artist.

● **Bishop Zenobius**, making the sign of benediction, and **St Lucy** with her martyr's palm are the patron saints of Florence. He is shown in three-quarter view, while she is represented in profile.

ROGIER VAN DER WEYDEN *St Luke Drawing the Virgin*

1435–40
Panel, 137.5 x 110.8 cm
Museum of Fine Arts, Boston

According to legend, Mary appeared several times to St Luke, who made a portrait of her. The story was popularized by the *Golden Legend* – a 13th-century collection of saints' lives. It explains why Luke, a doctor by profession, became the patron saint of painters as they began to organize themselves in guilds and corporations.

Rogier van der Weyden played an important role in spreading new and innovative themes in Southern Netherlandish art; one of his most successful inventions was this composition of St Luke drawing the physically present Mary. The scene unfolds here in an elevated space (not an artist's studio), looking out onto battlements and a landscape on either side of a river. Paintings depicting the 'Virgin of St Luke' like this one would typically have decorated the altar of a local painters' guild.

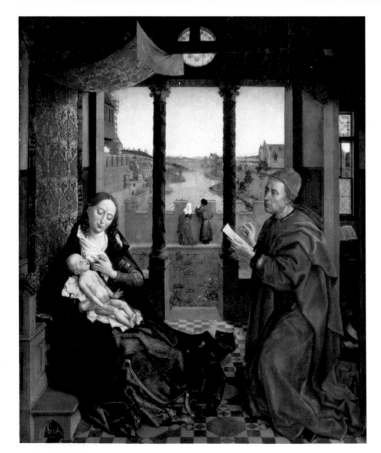

● **Mary** is sitting beneath a brocade canopy, on the footrest of a wooden 'throne'. She is nursing the Christ Child, who seems extremely content. A carving of the Fall decorates the armrest; the motif occurs frequently in images featuring the infant Christ, who came to save humankind from Original Sin.

● Luke is making his preparatory sketch using the 15th century's most common drawing tool: the **silverpoint**. Capable of producing clear and precise drawings, it nevertheless required great discipline on the artist's part: erasing a mark was almost impossible. Earlier examples in panel painting (and some later ones, too; see pp. 170–71) place Luke behind an easel with a brush in his hand, *painting* rather than *drawing* the Virgin's portrait. Luke's headgear may identify him as a physician.

● Luke is separated from Mary by the middleground vista, where two **small figures** are shown gazing out at the river. It has been suggested that they are Mary's parents, Joachim and Anne. Whatever the case, they are strongly reminiscent of the corresponding figures in Jan van Eyck's *Virgin and Child with Chancellor Rolin* (Louvre).

● This glimpse into a separate space confirms the artist's identification as St Luke. The **ox** is the gospel-writer's emblem, like the lion that represents his fellow evangelist Mark; the **open book**, meanwhile, alludes to his reputation as a scholar.

1399/1400–1464

ROGIER VAN DER WEYDEN *The Descent from the Cross*

about 1430–35
Panel, 220 x 262 cm
Museo Nacional del Prado, Madrid

The atmosphere of intense yet controlled emotion in this moving altarpiece is typical of Van der Weyden. Ten life-sized figures share a kind of shallow stage, with Christ's dead body as the central focus. There is virtually no depth to this *tableau vivant* with its golden background; and the nature for which Flemish painters are so renowned is restricted to a few traces on the floor. The fact that the overall effect of this painted surface is that of a polychromed relief may be the particular strength of this frequently imitated composition, in which each figure is intimately bound up with the others.

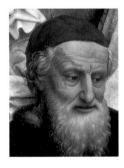
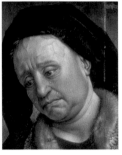
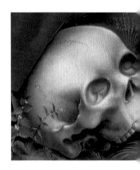

● **Mary** faints with grief and John reaches down to support her. Her body forms a diagonal line that echoes that of her son; this 'imitation' suggests that mother and child are sharing each other's pain. Mary's ordeal arouses the compassion of the worshippers, who empathize with Christ's suffering.

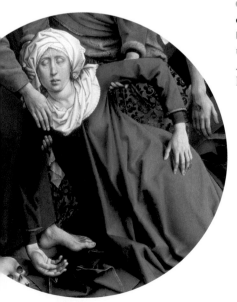

● Jesus' body is held by **Joseph of Arimathea** on the left and **Nicodemus** on the right; the two old men seem quite calm. According to the Gospels, they lowered the dead Christ from the cross and placed him in his cave tomb. The cross is almost symbolically small in this panel and the position of Christ's body would be equally at home in an image of the Entombment; that too adds to the painting's power.

● **Adam's skull** is a constant element in Calvary scenes (see p. 79); Christ's death redeemed humanity from the Original Sin committed by Adam and Eve, making the Crucifixion the beginning of the triumph over death.

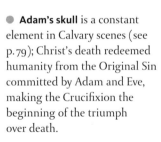

● The scene is 'framed' by a weeping woman at either end. This is **Mary Magdalene**, whose traditional attribute, the ointment pot, is held by the man to the left of her. The repentant sinner used the myrrh it contains to anoint Christ's feet.

● The patrons for this altarpiece – the wings of which have been lost – can be identified from the two little **crossbows** in the Gothic tracery: it was commissioned by the Crossbowmen's Guild in Leuven (Louvain). The tracery has an important function, as it marks the boundary between the sacred realm of these ten figures and our own world. Although the domain of God and his saints lies beyond human existence, the Incarnation of Christ and his sacrifice on the cross enable us to glimpse part of it.

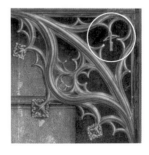

ROGIER VAN DER WEYDEN

Triptych of the Seven Sacraments

about 1440–45
Panel, 220 x 97 cm and 119 x 63 cm (x 2)
Koninklijk Museum voor Schone Kunsten,
Antwerp

This triptych is an excellent example of the famously detailed realism of the 'Flemish Primitives'; yet its setting is unreal and intellectually contrived. What we are presented with is essentially the entire Catholic doctrine captured in a lively and instructive image.

The crucified Christ hangs high up in the nave of a Gothic church. At the foot of the cross, St John supports Jesus' disconsolate mother as the other grief-stricken Maries (Magdalen and Salome) look on. The group's emotional turmoil is typical of Van der Weyden's art. The aisles on either side feature smaller figures who administer and receive two lots of three sacraments. According to the Catholic Church, the sacraments are the visible tokens of the mercy Christ holds out to humankind. Three symbolically coloured angels hover over each aisle, holding banderoles in which a Latin text describes the relevant sacrament.

● Behind the monumental Crucifixion in the nave, the priest at the altar raises the host above his head. The wafer represents the body of Christ, which is physically sacrificed on behalf of a sinful humanity in the foreground of this panel. The **Eucharist** is the seventh sacrament, after the six depicted in the aisles of the church (in the wings of the altarpiece).

● **Escutcheons** are displayed in the upper corners of each panel: on the left that of Jean Chevrot, Bishop of Tournai and the donor of this triptych, and on the right that of the diocese of Tournai. Chevrot himself appears as the bishop in the confirmation scene on the left.

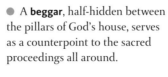

● A **beggar**, half-hidden between the pillars of God's house, serves as a counterpoint to the sacred proceedings all around.

● A **baptism** is taking place in the bottom left corner, where the white of the hovering angel symbolizes purity and innocence. In the next two scenes, youngsters are **confirmed** by a bishop, watched over by a yellow angel signifying the fire of the Holy Spirit, while a priest takes **confession** beneath an angel coloured red for contrition. At the top of the right aisle, another bishop **ordains a priest**. Next comes a **wedding** ceremony, the angel here wearing blue for fidelity, and then a dying man receiving the **final sacrament** – 'extreme unction' or the 'anointing of the sick'. A black angel of mourning hovers above him.

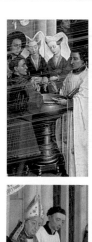

STEFAN LOCHNER *The Virgin of the Rose Bower*

about 1450
Panel, 50 x 40 cm
Wallraf-Richartz Museum, Cologne

There is a tension between tradition and innovation in this little panel by the Cologne painter Stefan Lochner: the golden ground is one of its traditional features, while the sense of space is something new. It seems like a simple panel, yet closer examination reveals that it contains a variety of symbols. The work was most likely intended for personal devotion in either a monastic cell or a private home.

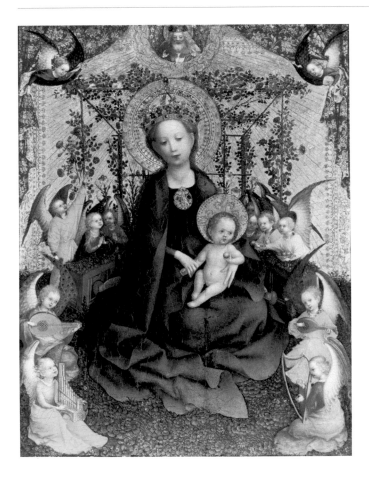

● **Mary** is presented as the Queen of Heaven, although she sits here on a red cushion rather than a throne. Her gaze is cast downwards, as she holds the Christ Child on her lap with both hands, which is closer in feel to another type of painting found in Marian iconography: the 'Madonna of Humility'. Her **brooch** features a unicorn, a mythical creature that, according to pre-Christian legend, could only be caught by a virgin and whose horn was believed to be a panacea or universal remedy. These ideas subsequently fed into Christian allegory, where the unicorn symbolizes Christ's incarnation in Mary's womb.

● **God the Father**, a friendly, grandfatherly figure surrounded by beams of light, is also present, as is the Holy Ghost in its familiar guise of a dove. Together with Jesus, they form the Holy Trinity (see pp. 20–21).

It is their presence, like the crown on her head and the golden background, that makes this 'humble' Mary the Queen of Heaven, an aspect reinforced by the appearance of the angelic musicians.

● Mary sits before a **gold-brocade cloth**, held up by two angels. The white and red roses in the bower behind the Madonna are Marian flowers: red stands for both love and suffering, while white is for purity.

● The little garden is surrounded by a low **stone wall**, within which Mary sits on a paradisaical carpet of flowers. The flowers and fruit are symbolic, while the 'enclosed garden' or *hortus conclusus* itself symbolizes Mary's purity. Angels standing behind the low wall offer the child flowers and fruit; they look like Jesus' playmates.

● The panel owes some of its charm to the **cherubs** who are making music. The angel in the left foreground is playing a portative organ, while the others have a harp and two lutes.

● The forbidden fruit which Adam and Eve ate is traditionally depicted as an **apple**, although it is not described as such in the Book of Genesis. In taking the apple, Christ confirms that he is the 'new Adam' and has assumed his mission to redeem humanity.

KONRAD WITZ *The Miraculous Draught of Fishes*

1444
Panel, 132 x 154 cm
Musée d'Art et d'Histoire, Geneva

This is one of the earliest 'true-to-life' landscapes ever painted. The view to which the Swiss painter Konrad Witz treats us can be seen to this day on Lake Geneva: in the background can be seen (from the left) Mont Salève, Le Môle and the wooded Voirons. For compositional reasons they are grouped together more closely than they are in reality. We stand on the banks of the lake, and in this real setting a story from the Bible has been inserted featuring equally realistic actors. The panel probably formed part of an altarpiece for the Cathedral of St Peter in Geneva.

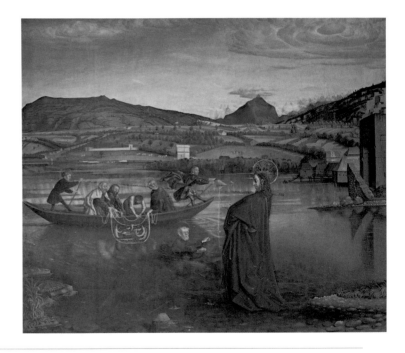

● The **Apostles**, Peter among them, vainly try to draw in the fish-laden net. They have haloes, but otherwise look like ordinary people.

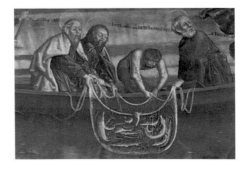

Jesus appeared several times following his Resurrection. The third occasion, according to John's Gospel, was at the Sea of Galilee, where several of his disciples, including Peter, had spent the night fishing, though without success. "But when the morning was now come, Jesus stood on the shore: but the disciples knew not that it was Jesus. Then Jesus saith unto them, 'Children, have ye any meat?' They answered him, 'No'. And he said unto them, 'Cast the net on the right side of the ship, and ye shall find.' They cast therefore, and now they were not able to draw it for the multitude of fishes. Therefore that disciple whom Jesus loved [i.e. John] saith unto Peter, 'It is the Lord.' Now when Simon Peter heard that it was the Lord, he girt his fisher's coat unto him, (for he was naked,) and did cast himself into the sea" (John 21:4–7). The disciples came ashore and ate breakfast with Jesus.

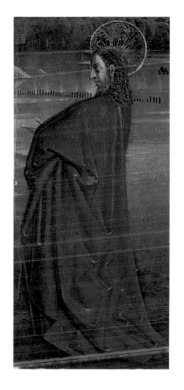

● The **reflections in the water** indicate the precision of Witz's observation and pictorial technique. The illusion of a still lake is virtually perfect.

● The risen **Christ** seems to be walking on the water, which is not stated in the Gospel text; the motif probably alludes to a second Biblical story in which Jesus does, indeed, walk on the water, leaving its surface undisturbed. Our attention is grabbed by Christ's bright red cloak in a scene in which greens and reds contrast with one another. He is a majestic, superhuman figure.

PETRUS CHRISTUS *A Goldsmith in his Shop, Possibly St Eligius*

1449
Panel, 100.1 x 85.8 cm
The Metropolitan Museum of Art,
New York. Robert Lehman Collection,
1975 (1975.1.110)

Saint Eligius (or St Eloy) is the patron saint of goldsmiths. This panel, commissioned by the Bruges guild of goldsmiths, shows him as a craftsman at his workbench, weighing the gold for a wedding ring in a hand-held scale. The ring is probably destined for the aristocratic and fashionably attired couple next to him. His studio is full of skilfully wrought merchandise, including three pewter pitchers, a belt buckle and a bead necklace. The raw materials of the goldsmith's trade are also on display. It is an appropriate setting for the saint and a kind of advertisement for the craftsmen who commissioned the painting. That is probably as far as the symbolism goes in an early genre piece like this.

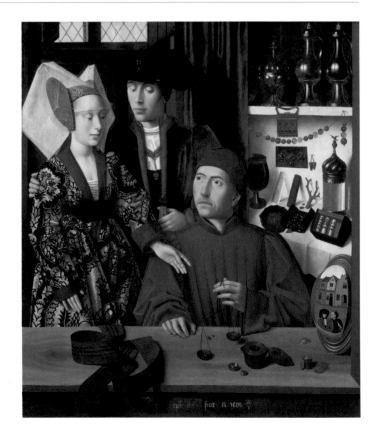

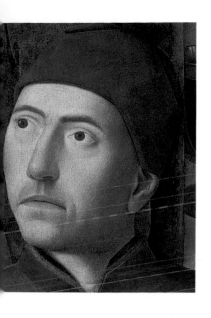

● The main character, traditionally identified as **St Eligius**, is portrayed as a contemporary goldsmith with individualized features; it might even be a portrait. Eligius was a popular saint who lived in 7th-century France in the reign of the Merovingian kings Clothar and Dagobert I, with whom he was friends. He was master of the royal mint before becoming a bishop. According to his hagiographer, Eligius was renowned as an excellent and trustworthy goldsmith.

● A brown **girdle**, used in betrothal ceremonies and clearly part of the young woman's costume, lies on the edge of the workbench, seemingly projecting into the viewer's space. Many painters enjoyed inserting *trompe-l'œil* details of this kind.

● The vessel on the far right was probably intended to hold consecrated **hosts**, as suggested by the fact that it is surmounted with a decorative pelican piercing its own breast to feed its young, a symbol of how Christ saved humanity with his blood. The other objects on the shelves are meant for secular use.

● The **convex mirror** does not reflect the room containing the three main figures, but the marketplace that must lie beyond the goldsmith's workspace. This is another trick to close the distance between the painted space and that of the viewer, and one that Van Eyck had previously used (see pp. 28–9). Two men amble across the square, one of them holding a falcon. Their 'sloth' – one of the seven deadly sins – contrasts with the industry of the goldsmith.

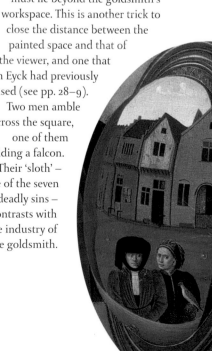

PETRUS CHRISTUS *The Nativity*

about 1450
Panel, 127.6 x 94.9 cm
National Gallery of Art, Washington DC.
Andrew W. Mellon Collection

Although this is a Nativity scene, celebrating the birth of Christ, the illusionistic sculpture in the surrounding arch makes reference to his later sacrifice on the cross. Six figures have gathered around the infant who lies on his mother's robe: Mary, Joseph and four angels. Four shepherds, meanwhile, stand behind the dilapidated stable wall, talking to each other and looking at the baby.

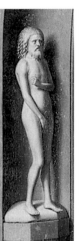

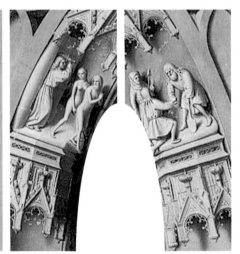

● These two **figurines** hold up the heavy arch like a pair of miniature Atlases. They symbolize humanity, weighed down by Original Sin.

● The stable is seen through a strikingly sculpted arch resembling the portal of a church. Six carved episodes from the Book of Genesis appear above the heads of **Adam** (on the left) and **Eve**, who cover their genitals in shame; the scenes begin with Adam and Eve's expulsion from Eden and end with them bidding farewell to their son Cain after he has murdered his brother Abel. These images add deeper meaning to an otherwise straightforward Nativity. They tell us why Christ came into the world, namely to redeem humanity from the Original Sin committed by the first couple and to enter into a New Covenant with humankind, through his self-sacrifice on the cross.

● Joseph has removed his **shoes** as a token of respect, obeying God's instruction to Moses: "And he said, 'Draw not nigh hither: put off thy shoes from off thy feet, for the place whereon thou standest is holy ground.'" (Exodus 3:5).

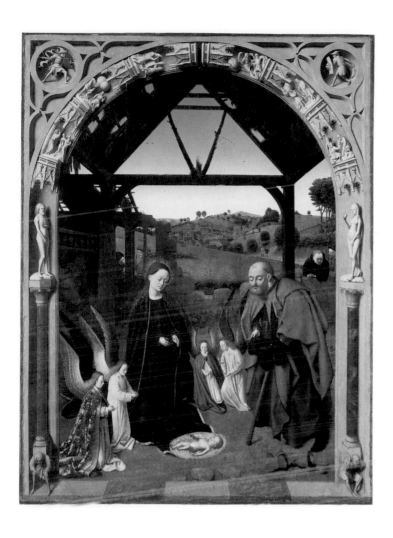

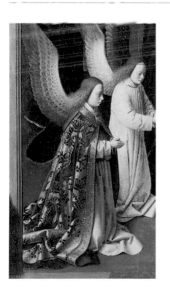

● This **angel** is wearing a brocade cope of the kind worn by priests in Petrus Christus' day, which places him in the role of the celebrant blessing Christ's body during the Eucharist.

● Beneath a blue and white sky a **city** with a prominent domed church is visible in the undulating landscape; this is Jerusalem, where, thirty-three years later, Christ will suffer and die.

JEAN FOUQUET · *Melun Diptych*

about 1452
Panel, 94.5 x 85.5 cm (x 2)
Staatliche Museen zu Berlin –
Preussischer Kulturbesitz,
Gemäldegalerie;
Koninklijk Museum
voor Schone Kunsten, Antwerp

The Virgin appears on the right, the Queen of Heaven seated on an ornate throne, the infant Christ on her lap. The pair are surrounded by six red seraphim, who seem to be holding up the floating throne as three blue cherubim draw near. The child points towards the left wing, which shows the donor, Etienne Chevalier, accompanied by St Stephen ('Etienne' is the French form of 'Stephen'). The prayers of the French royal treasurer are directed through his patron saint to Mary and her divine son, to whom he appeals on behalf of the soul of his late wife, Catherine Budé. The diptych originally hung over Catherine's tomb in the church of Notre Dame in Melun and was intended to ease her admittance to the Kingdom of Heaven. The two wings were sold separately during the French Revolution.

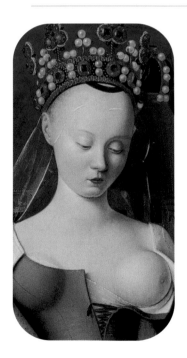

breast is bare. Her throne is decorated with pearls, gems and plates of onyx. Some scholars believe this to be a likeness of Agnès Sorel, the influential mistress of King Charles VII of France. 'La belle Agnès' was said to be 'the most beautiful woman in France'. She died a couple of years before Catherine Budé. Alternatively, this could be a portrait of Catherine herself. Why does Mary bare her breast when the infant is not nursing? This motif is known as *ostentatio* and was linked to the Virgin's role as intermediary and wet-nurse for all humankind.

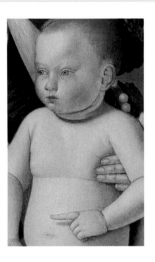

● The **Christ Child** points and looks at Chevalier, the painting's donor; the shadow cast by his finger tells us that the light is coming from above, which is not the case in the left panel. The heavenly and unreal atmosphere of the right wing contrasts strongly with the realistic earthly setting on the left.

● **Mary** is portrayed as a beautiful and fashionable woman; note her costume and her high forehead, perfect, milky skin, hourglass waist and spherical, improbably spaced breasts. She is wearing an ermine cloak, while her bodice is undone and her left

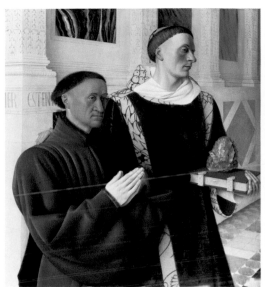

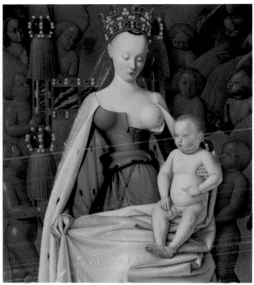

● The group of **red and blue angels** is cleverly arranged – their faces are each viewed from a different angle. The cherubim (blue) were said by the Church Fathers to accompany the souls of the dead to heaven, as they did with the Virgin herself. They are ranked high in the celestial hierarchy – second only to the seraphim – and reside in the ninth heaven, where the Holy Trinity and the Virgin Mary take their place. The angels reinforce the diptych's central theme of the need for divine intercession.

● St Stephen acts as the link between the earthbound Chevalier and the divine realm on the right. The **rock** he carries – like a rough gemstone – symbolizes his martyrdom by stoning.

● The surreal, 'floating' mood of the panel with the enthroned Virgin gives way to realism in the **left wing**. Unlike in the Virgin's wing, there is perspective here and an interior reminiscent of an Italian Renaissance palace – unless it was Chevalier's home. Fouquet, who was an illuminator as well as a panel painter, actually spent some time in Italy.

PIERO DELLA FRANCESCA *The Baptism of Christ*

1450s
Panel, 167 x 116 cm
National Gallery, London

John the Baptist baptizes Christ in a serene, brightly lit setting that is typical of Piero della Francesca. The river that winds back into the landscape is the Jordan in the Holy Land, yet the landscape is Tuscan. For some reason, Jesus does not quite stand in the water; it is unclear whether this is an unintentional slip or the result of restoration. The painting was the central panel of an altarpiece in the chapel of the Baptist in Piero's native town of Borgo Sansepolcro.

BAPTISM

Baptism is Christianity's first sacrament (see pp. 46–7). It represents purification, inclusion in the community of worshippers and spiritual rebirth as a new, Christian person. The New Testament states that Jesus' baptism was attended by the Holy Spirit and by God the Father.

"And it came to pass in those days, that Jesus came from Nazareth of Galilee, and was baptized of John in Jordan. And straightway coming up out of the water, he saw the heavens opened, and the Spirit like a dove descending upon him: And there came a voice from heaven, saying, 'Thou art my beloved Son, in whom I am well pleased.'"

Mark 1 : 9–11

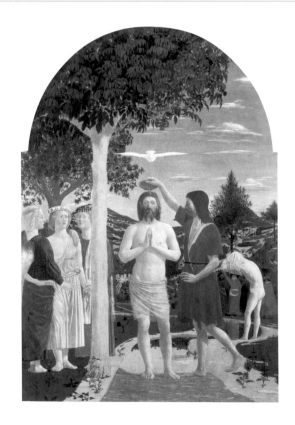

● The **dove**, symbolizing the Holy Spirit, descends from heaven to hover immediately above Jesus' head, its shape echoing that of the white clouds in the blue sky. An image of God the Father may have been located above this panel, unless Piero meant to represent him as the golden light we make out above the dove.

● **John** is the figure who links the Old with the New Testament. He lived a hermit's life in the desert, baptizing people in the Jordan. He is customarily presented as an unkempt man, dressed in shabby animal hides. Several of his usual attributes are absent from this panel, including the lamb and the reed cross.

● The wing on the back of the figure to the left tells us that these are **three angels** attending the baptism. They commonly feature in paintings of this subject and are often shown holding Christ's discarded clothes.

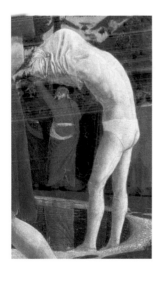

● An unidentified **man removes his clothes**; he is next in line to be baptized and represents the masses of people whom the Bible says flocked to John for that purpose. Piero has opted firmly for simplicity and serenity. The clear reflection of the landscape and the clothes of the priests in oriental attire who depart from the scene testify to the painter's interest in optical effects.

● Piero paints a **hilly landscape** from his native region on the border between Tuscany and Umbria. The town to the left of Christ's hip may be Borgo Sansepolcro itself. It is possible that the painter was acquainted with the landscapes of Flemish painters like Van Eyck, which were already to be seen in Florence. The realism he shares with them allows holy figures to be presented in a setting familiar to contemporary viewers.

PIERO DELLA FRANCESCA

The Dream of St Jerome
(formerly known as 'The Flagellation')

about 1455?
Panel, 58.4 x 81.5 cm
Galleria Nazionale delle Marche, Urbino

For many years this panel was known as 'The Flagellation', and certainly Piero's composition is rather enigmatic: the figure in the background is being flogged (hence the painting's traditional interpretation and title), while three men appear in the right foreground, seemingly indifferent to the nearby torture scene. How can we explain the odd division of the painting, who are the three men and what are they doing? Historians sought avidly for allusions to Piero's contemporary political and religious world. The pieces of the puzzle fall into place, however, when the man being flogged is seen not as Christ but as the Church Father St Jerome. The work is a depiction of *The Dream of St Jerome* – a theme that appears regularly in art.

THE DREAM

*Jerome writes in one of his letters of a dream he once had.
As a young man, he was a great admirer of Cicero, Horace,
Virgil and other pagan Roman authors. He was, he wrote, blind
in those days, until a profound spiritual experience opened his
eyes: "I was brought before the judge's seat, where it was so
light and so bright and radiant that, while I lay on the ground,
I dared not raise my eyes. When I was asked how it was with
me, I replied that I am a Christian. But he that sat there said
to me, 'You are lying. You are not a Christian but a Ciceronian.'
… I held my tongue and between the lashes of the whip – for
he ordered me to be flogged – I was even more tormented by
the flames of my conscience." Jerome swore that he would never
again read a profane text and then awoke from his dream.
Piero places Jerome in a brightly lit, open setting, against
a column surmounted with a gilded Classical statue. The
architecture, too, resembles that of a Classical temple.*

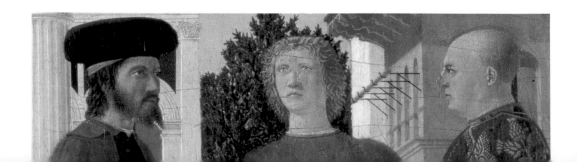

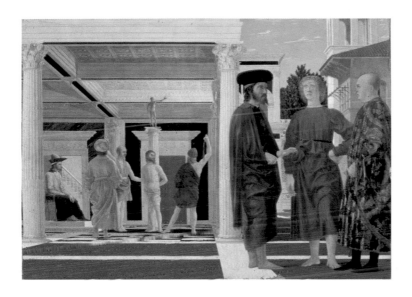

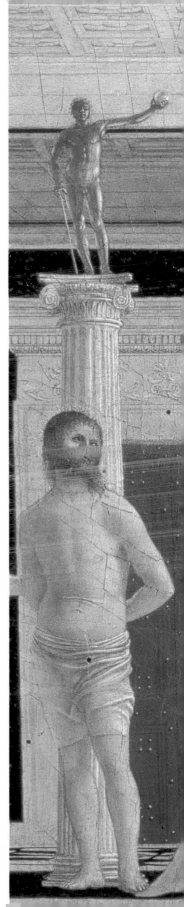

CHRISTIANITY AND PAGANISM

Jerome's dream essentially expresses the conflict between Christian and 'pagan' literature: as a Christian, he was supposed to select his reading accordingly, yet his Classical education continued to influence his work as an author. The issue of the relationship between these two bodies of literature was raised again during the Renaissance, when many Classical texts were rediscovered and Cicero's use of Latin came to be viewed as the model of good writing. The two men in the foreground – the figure between them is a barefoot angel – presumably debate that same point.

● This figure was traditionally interpreted as the Roman governor Pontius Pilate, who ordered Christ's flogging; in fact, he is the **judge** from Jerome's dream.

ANDREA MANTEGNA *San Zeno Altarpiece*

1457–60
Panel, 212 x 125 cm and 213 x 135 cm (x 2)
Basilica di San Zeno, Verona

Andrea Mantegna was fascinated by Classical Antiquity and the visible marks it had left on his country, and this prompted the particular combination of religious motifs and imposing, conspicuously Roman architectural settings which we find in his work. Unusually, this large altarpiece can still be seen in the place for which it was commissioned: the high altar of Verona's Basilica di San Zeno. The three scenes along the bottom (forming the predella) are copies – the originals were taken to France in 1797 and are now in the Louvre.

Despite the triptych format, Mantegna treats the principal scene as a single ensemble, united by the architecture, the sky and the marble floor. The life-sized Madonna is sitting on a marble throne, accompanied by angel-children singing and playing music and by two groups of four male saints. The composition is a late version of a *Maestà* (see pp. 6–9).

● The fruit and vegetables arranged in garlands are painted naturalistically, while the little hooks from which they hang at the top of the painting reinforce the **illusion**: such deceptively realistic details are known as *trompe-l'œil*. The way the festoons are suspended behind the real three-dimensional pillars heightens the impression that they are genuine. The 'real' angels surrounding the Virgin Mary are echoed by the marble putti in the frieze behind her who pour out richly filled cornucopias – a Classical symbol of prosperity and well-being.

● God's presence is signalled by the **light** of the burning candle. Images like this of the Madonna enthroned were frequently accompanied by the Holy Trinity (see p. 48).

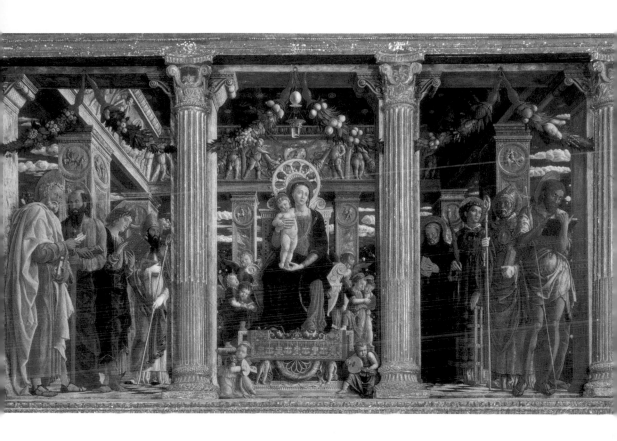

● The composition of the **Crucifixion** in the predella recalls Jan van Eyck (see p.32). To the left of the cross, Christ is mourned by his family and friends, while Roman soldiers throw dice for his clothes on the right. Jerusalem basks in the sunshine in the left background; the right is taken up by a strikingly dark rocky outcrop.

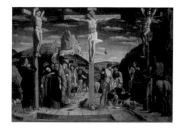

● The eight saints have been chosen in part as an illustration of what the donor – an abbot – valued most highly, the pious reading of sacred texts: seven of them hold or read a book. Viewed here from the left, we see **St Peter**, who seems to beckon us into the scene with the key in his hand, **St Paul**, **St John the Evangelist** and Bishop **Zeno**, the saint to whom the basilica in Verona was dedicated.

● On the right wing, from the left, we see saints **Benedict** (founder of the Benedictine order and author of a highly influential set of monastic rules); **Lawrence** (a Roman martyr); **Gregory** (pope and Church Father); and **John the Baptist**, who faces us.

ANDREA MANTEGNA *St Sebastian*

about 1460
Panel, 68 x 30 cm
Kunsthistorisches Museum, Vienna

Sebastian was a Roman officer of the imperial guard in the 3rd century. When two of his Christian friends were sentenced to death for their religion, he tried to help them, in the process betraying the fact that he too was a Christian. Sebastian was sentenced to be shot with arrows by his fellow soldiers, but his wounds did not kill him. His story was known chiefly through a 13th-century compilation of saints' lives, the famous *Golden Legend*.

The theme was a popular one in the second half of the 15th century, not least because it allowed artists to paint a standing male nude. Approaches varied, depending on whether the painter opted to depict the moment before or after the shooting. In this little panel, Mantegna shows Sebastian's body, riddled with arrows, as an expansive landscape unfolds in the background.

● The story of St Sebastian enabled Mantegna to include **Classical Roman architecture**. Its ruined state, with the crumbling archway, suggests that the Roman Empire was drawing to a close, while the broken statue hints at the triumph of Christianity over paganism.

● It seems incredible that Mantegna's Sebastian has survived his multiple wounds. The saint – his head already graced with a halo – turns his **beseeching gaze** heavenwards. This Sebastian has the air of a Classical marble statue – the

most perfect of all artworks to a painter of Mantegna's time. Sensuality permeates this religious scene, lending it a worldliness that 16th-century Reformers like Luther and Calvin would later condemn.

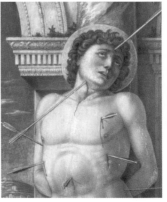

PROTECTION FROM PLAGUE

St Sebastian's protection was invoked against the recurring plagues suffered by medieval Europe. The Ancient Greeks believed that Apollo caused the disease with his arrows, and the arrow was to remain a potent symbol of the plague's sudden onset. Outbreaks of plague certainly prompted many paintings of the Sebastian theme.

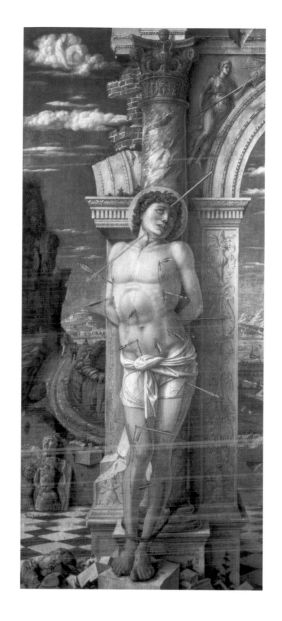

● "The work of Andrea" – it says here in **Greek letters**. Mantegna wanted to present himself as a connoisseur of Greco-Roman Antiquity, since knowledge of Greek was not common in his time.

● Mantegna has painted a sculpted foot near Sebastian's own **feet** in what may have been a demonstration of virtuosity, showing the same thing in different materials.

about 1410–1475

DIRK BOUTS *The Last Supper*

1467
Panel, 180 x 150 cm
Sint-Pieterskerk, Leuven

Although the Last Supper had been depicted many times before, there was something new in Dirk Bouts' altarpiece. It does not present a dramatic detail such as Jesus identifying Judas as a traitor, nor the 'communion' of the Apostles; Bouts focuses instead on the solemn moment when Christ blesses the bread and the wine. His gesture marks the institution of the Eucharist, one of the seven sacraments of the Catholic Church (see pp. 46–7). Bread and wine would henceforth symbolize the body and blood of Christ.

Bouts painted his triptych for a confraternity in Leuven (Louvain) devoted to worship of the Eucharist. Two professors of theology oversaw his work to ensure its accuracy.

● **Christ** sits at the centre, his right hand raised in blessing. The fireplace behind him functions like a cloth of honour. According to Matthew's Gospel, he tells his disciples: "Take, eat; this is my body." **John** sits on Christ's left, his hands clasped, while **Peter** on his right crosses his hands on his chest in a gesture of devotion. The scene that Bouts presents is calm and still, lacking in visible emotion. The traitor Judas – the Apostle in the left foreground – is at this stage merely a quiet, inconspicuous observer.

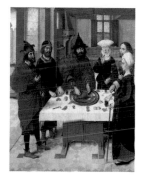

● In addition to Christ and the twelve Apostles, we see four servants or **witnesses** in 15th-century costume; these represent the worshippers of the confraternity who receive the sacrament of the Eucharist during communion. The contract for the painting has survived, and so we know their actual names.

The Gothic interior where this timeless episode takes place is also 15th century; we catch a glimpse of Leuven through the windows on the left, standing in here for Jerusalem. Curiously, the supper appears to be taking place in broad daylight.

● *The Last Supper* is a triptych, its wings containing four scenes from the Old Testament that prefigure the central scene – a long-established theological tradition that found its way into art. This fragment shows a group of Jews preparing the first **Passover** meal as instructed by God; the sacrificial lamb lies on the table. The episode is recounted in Exodus, which goes on to describe the flight of the Jews from their captivity in Egypt; the guests have their walking sticks close at hand, ready to depart. The scene is a prefiguration of Jesus' redemption of humanity through the sacrifice of his body and blood: Christ became the new 'paschal lamb'.

DIRK BOUTS *The Justice of Emperor Otto III: The Beheading*

about 1473–5
Panel, 344 x 201.5 cm
Musées Royaux des Beaux-Arts
de Belgique, Brussels

The chambers in which councillors held their assemblies or in which justice was dispensed were frequently decorated in the 15th century with 'justice scenes' such as this one. They illustrated celebrated cases from history and were supposed to encourage magistrates to issue their verdicts in a just and unbiased way. The theme of this work by Bouts is unique. It tells the medieval story of a man who was wrongly sentenced to death and what happened afterwards. This is one of the two panels that make up the painting, which was commissioned for the new town hall in Leuven (Louvain). Each of the panels weaves several episodes of the story into a fluid narrative.

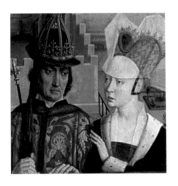

● The **condemned man**, dressed in a penitent's robe, his hands tied and his head and feet bare, is taken to the place of execution, accompanied by a priest. Here he is shown asking his wife to prove his innocence and to show that a miscarriage of justice has taken place by undergoing ordeal by fire.

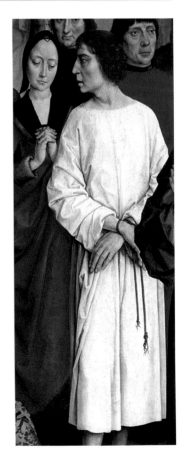

● The wife of **Emperor Otto III** (984–1002) falsely accuses a nobleman belonging to the imperial court of molesting her. In reality, she attempted to seduce him. The emperor takes his wife at her word and orders the nobleman's execution.

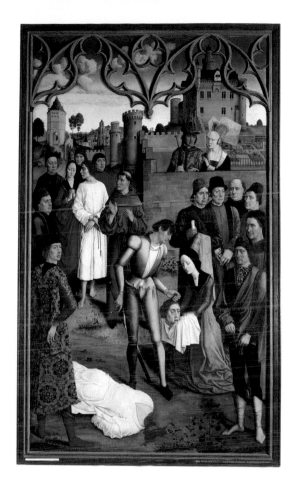

THE TRIUMPH OF JUSTICE

In the second panel, the wife of the executed man undergoes trial by fire to prove to the emperor that her husband was innocent. Her divinely corroborated testimony leaves Otto with no option but to have his own, perjuring wife burned at the stake.

● The executioner presents the wife with her husband's **severed head**; his decapitated body lies on the ground, spurting blood. She maintains her composure, as do the other onlookers at this public execution, who may be the city magistrates. This sense of cool, undramatic dignity is characteristic of Bouts' work. Yellow – the principal colour of the executioner's blood-spattered costume – had negative connotations in the Middle Ages.

● The city shown here represents Bouts' 15th-century **Leuven**, whereas the historical Otto lived around the year 1000. The form of justice and the costumes are also contemporary, which reinforced the impact of the panels for those it was meant for.

ANDREA DEL VERROCCHIO *The Baptism of Christ*

about 1475
Panel, 177 x 151 cm
Galleria degli Uffizi, Florence

Verrocchio was one of the most important sculptors of his time, and his 'sculptural' approach to painting is visible in the two monumental figures that dominate this altarpiece and seize the viewer's attention even from a distance. There are very few paintings that can be ascribed to Verrocchio with certainty, and even this one shows the hand of a second artist – Verrocchio's pupil, Leonardo da Vinci. It is said that the master abandoned his paintbrush on seeing the quality of his apprentice's work.

The *Baptism of Christ* features all the traditional ingredients (see pp. 58–9): Jesus occupies the central position as he stands in the Jordan; John the Baptist pours water over him, while the kneeling angels on the left hold Christ's discarded clothes. In the 16th century the altarpiece hung in the abbey church of San Salvi, in Florence.

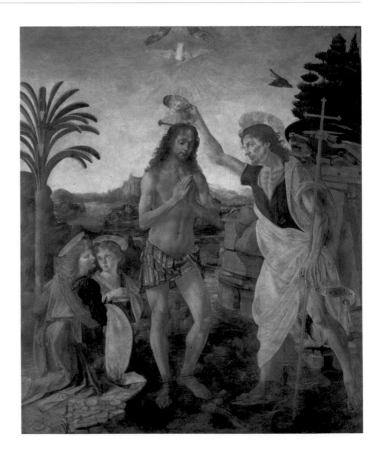

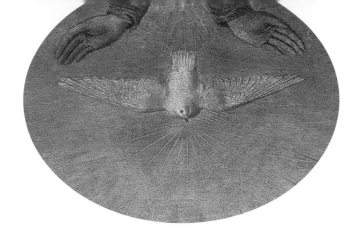

● The hands of **God the Father** and the dove symbolizing the **Holy Spirit** appear amid rays of golden light immediately above Jesus' head. Together with Christ himself, they form the Holy Trinity.

PAINTING FACTORY

Verrocchio had a workshop in Florence, which meant that, like many of his fellow artists, he did not complete all of his paintings himself. It was normal practice for skilled assistants to finish certain elements – in many respects painting was a business like any other.

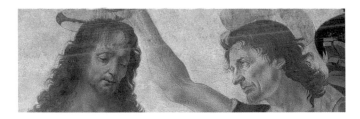

● Leonardo painted the **angel** with the blond curls holding Jesus' clothes, the hands of the second angel and parts of the brownish **landscape**. He altered Verrocchio's design and overpainted finished parts, possibly as late as the 1480s. He also seems to have retouched Christ's face and body.

HANS MEMLING *The Last Judgement*

about 1467–71
Panel, 242 x 180.8 cm
and 242 x 90 cm (x 2)
Muzeum Narodowe, Gdańsk

Memling's *Last Judgement* is a nocturnal scene. Christ appears in the central panel against a golden background (representing heaven), seated on a rainbow and with his feet resting on a golden globe. The 'Judge of Judges' is surrounded by the Twelve Apostles, the Virgin Mary and John the Baptist, while four angels hover above him, holding the 'Instruments of the Passion' (see also pp. 27, 91). Three other angels float beneath him, with a fourth in the right-hand panel, blowing their trumpets to announce the end of the world. In the left-hand wing the souls of the righteous advance naked towards the gates of heaven, where they are presented with the clothes they wore in life. The procession is led by a group of prominent churchmen. The majority of the resurrected souls, by contrast, have been judged and found wanting. They are shown on the right being herded by black, demonic figures into the flames of hell – a kind of volcano. These are the damned.

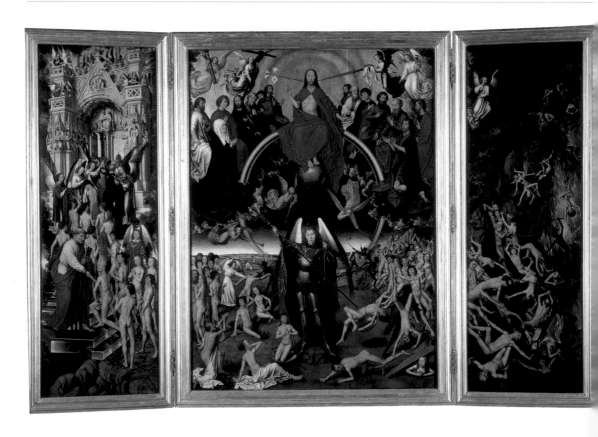

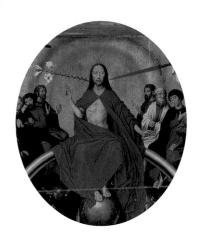

● **Mary and John the Baptist** kneel on either side of the rainbow. They are intermediaries, their prayers interceding on humanity's behalf with Christ and God the Father.

● **Christ** raises his right hand in blessing, while lowering his left – gestures that correspond with the lily of mercy and the red-hot sword of justice above. The rainbow both links and separates the Kingdom of God from the earth.

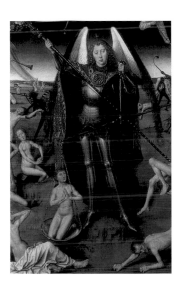

● The huge, armour-clad figure of the **Archangel Michael** stands on a wide plain, separating the good souls from the bad with his scales and crosier. Souls that weigh too little can expect the worst. The weigher of souls also figures in ancient Egyptian and Greek art. All around St Michael, we see the dead rising from their graves to face final judgement. Medieval texts placed these events in the 'Valley of Josaphat'.

● Musician angels greet the righteous with a **concert** from the battlements of the heavenly gate, which is built in the Gothic style. The gateway leads to the Heavenly Jerusalem that has descended to earth.

● **St Peter** – key in hand – receives the souls of the righteous at the crystal stairway leading to the gates of heaven.

● This **Apostle** might be a portrait of Charles the Bold, Duke of Burgundy, who had recently come to power. The righteous soul in the scales is the Florentine banker **Tommaso Portinari**.

HANS MEMLING *Diptych of Maarten van Nieuwenhove*

1487
Panel, 52 x 41.5 cm (x 2)
Sint-Janshospitaal/Memlingmuseum,
Bruges

This intimate diptych places the Virgin and Child in the same contemporary space as the praying donor, although they each occupy their own panel. Mary is shown formally, from the front, while the owner of the painting appears in three-quarter view. The panel testifies to the piety of twenty-three-year-old Maarten van Nieuwenhove, immortalized here fully ten years before he became burgomaster of Bruges. The window behind him on the right offers a glimpse of what might be the city's Minnewater lake.

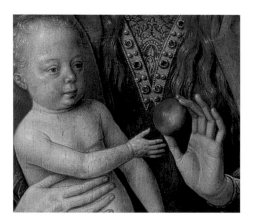

● The **apple** is the symbol of the Fall of Adam and Eve; grasped by the Christ Child, it refers to Jesus' status as Redeemer of humanity from Original Sin. He is shown here reaching for the apple, thus accepting the destiny whereby he will create a new world order.

● The **convex mirror** behind the Virgin shows the two figures viewed from the rear; Memling is following here in the footsteps of Jan van Eyck (see pp. 28–9), using the mirror to reinforce what we, the viewers, see in the panel. The reflection both displays and clarifies the space; we can make out the position of the figures, the windows, the ceiling and a chair with an open book. The mirror takes an entirely artificial premise (that the donor is actually visiting the Virgin Mary) and turns it into reality. More astonishing than that, it suggests that we too are located in the same space and are looking into the double panel as if through an open window. It is a masterpiece of artistic conceit.

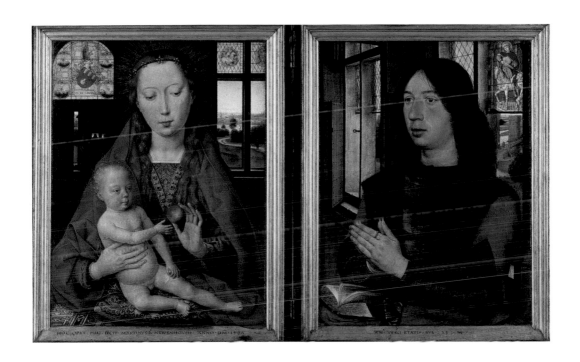

● The colourful **stained-glass window** behind the Virgin on the left features the Van Nieuwenhove arms, the family motto – *'Il y a cause'* (Everything has its reason) – and medallions symbolizing his name: a hand sowing seeds over a garden ('Nieuwenhove' translates as 'new garden'). The **window on the right** contains images of St George and St Christopher. Behind Maarten himself, who was born on St Martin's Day (11 November), we see the young man's patron saint cutting off a piece of his cloak for a crippled beggar – a key episode in the saint's legend.

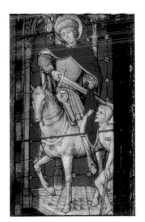

ANTONIO & PIERO
POLLAIUOLO

The Martyrdom of St Sebastian

about 1475
Panel, 291.5 x 202.6 cm
National Gallery, London

From the story of St Sebastian (see p. 64) Pollaiuolo has chosen to paint the moment of the actual shooting of the arrows. The saint undergoes his punishment stoically, as the literary sources dictate. No fewer than six archers stand at the ready. The moment just after the shooting, showing St Sebastian's naked body pierced with arrows, would have been the more traditional choice.

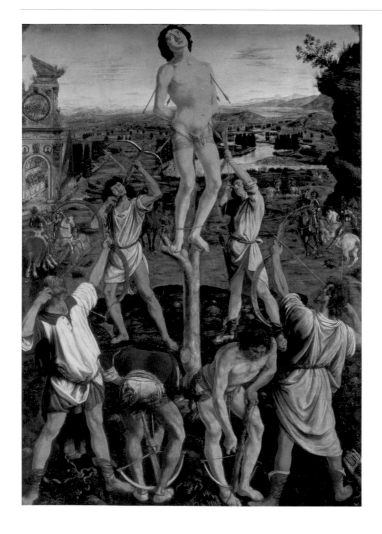

● **Sebastian**, tied to a tree trunk, towers over the landscape. His head seemingly strains to break through the boundary of the frame, an effect emphasized by his eyes, which gaze up towards heaven. The monumental style is characteristic of Pollaiuolo's work. This large panel served as an altarpiece and so had to be effective even when viewed from afar.

● Sebastian and his six executioners form an equilateral triangle, the symmetry enlivened by the **two soldiers** who are loading their crossbows. One is shown clothed, from behind, the other nude in frontal view. The Pollaiuolo brothers – Antonio was a sculptor as well as a painter – offer a true-to-life depiction of the figures and the landscape. The nudes in particular allowed them to show off their mastery of human anatomy and their ability to 'emulate nature'. They show the six executioners from a variety of angles, as if seeking to demonstrate that the art of painting can achieve the same effect as three-dimensional sculpture.

● The martyrdom is set against the backdrop of an extensive and detailed **Tuscan landscape**, through which the river Arno winds its way. The Pollaiuolos, who worked in Florence, knew the region well. The actual story of Sebastian took place in ancient Rome, represented here by the ruined gateway on the left (compare with the ruins in Mantegna's version, p. 65).

● Several **horses** rear up behind Sebastian, as if in protest at the saint's treatment; their armour-clad riders look more contemporary Italian than Roman.

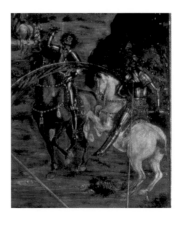

ANTONELLO DA MESSINA *The Crucifixion*

1475
Panel, 52.5 x 42.5 cm
Koninklijk Museum voor Schone Kunsten,
Antwerp

This small panel by the southern Italian artist Antonello da Messina demonstrates how artistic ideas and techniques could reach every corner of 15th-century Europe. The Calvary scene is set beneath a calm sky, the serene, pale Christ at its centre flanked by two contorted bodies: the good thief and bad thief, lashed onto tree trunks. The ever-present figures of Mary and John – Jesus' favourite disciple – are shown grieving in the sandy, rocky foreground, amid the bones and skulls.

● The artist **signed** the panel; the paper nailed to the wood states in Latin: "1475. Antonello da Messina painted me."

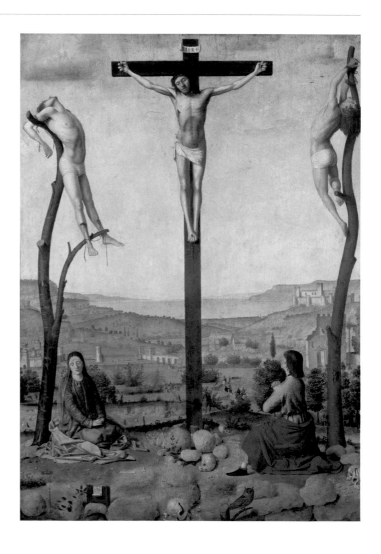

● The **bodies** of the three condemned men are painted in graphic detail, the realism distinguishing this panel as a work of the Italian Renaissance, which considered the study of the human body to be of great importance.

● As a bird of the night, the **owl** has been a symbol of folly and deception since the Middle Ages. In some cases it stands for the Jews who, as the Christians of the time saw it, had turned away from the 'true' religion just as the owl shuns the daylight.

● Crucifixion scenes usually include at least one **skull**. It was believed in the Middle Ages that Adam lay buried in Golgotha (literally 'place of skulls'), where Christ was crucified. Adam's skull symbolizes the Original Sin that he and Eve committed by failing to resist the blandishments of the devil in the guise of a serpent. Their Fall from Grace has been redeemed by Christ's death on the cross.

● A **new branch** sprouts from the tree trunk. This too is a symbol: the dead trunk represents the Old Covenant between God and his people, which is now defunct. However, thanks to Christ's sacrificial death, God has entered into a New Covenant with humankind.

● A procession of mounted men rides away from Golgotha. The verdant **landscape** is especially detailed. Messina was plainly inspired by early Netherlandish painting, yet the clear, southern light and open space are typically Italian.

HUGO VAN DER GOES *Portinari Altarpiece*

about 1475
Panel, 253 x 304 cm and 251 x 142 cm (x 2)
Galleria degli Uffizi, Florence

This altarpiece was commissioned by the Italian banker Tommaso Portinari, who lived in Bruges for more than forty years. He and his wife Maria di Francesco Baroncelli are shown in the wings, kneeling, with three of their seven children: on the left Antonio and Pigello, on the right Margarita. With the exception of Pigello they are all accompanied by their patron saint: Thomas (with a lance), Anthony (bell), Margaret (book and dragon) and Mary Magdalene (jar of ointment). In the central panel the shepherds have come to see the Christ Child, who is being worshipped by Mary, Joseph and small groups of kneeling and hovering angels. The empty palace of King David stands in the background: Christ, born in David's city, is the new King.

MYSTERY PLAYS

*This work has the drama and realism of a mystery play.
These reenactments of Gospel or miracle stories played
a major part in the religious life of ordinary people
in the Middle Ages and the Renaissance, with many
common people owing what Biblical knowledge they
enjoyed to them. Artists borrowed imagery from these
plays so that their paintings would be understood by
a wider audience – here the angels in priests' robes are
a good example.*

● In the central scene the **infant Christ** is not lying in a crib, but on the ground. Mother and child are surrounded by little clusters of kneeling angels, which is how the scene is described in the vision of the influential mystic St Bridget of Sweden (1302–1373).

● As we often see with Van der Goes, these **three shepherds** are ordinary, simple people. Their bodies and their weathered faces show that they work outdoors. The painter may have drawn inspiration from some of his fellow townspeople of Ghent, who performed pastoral dramas and mystery plays.

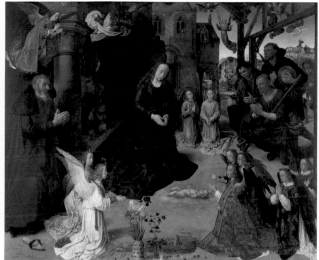

● Each of the objects in this **'still life'** has a special meaning: the sheaf of corn presages the Last Supper, where Christ will break bread (Bethlehem, incidentally, means 'house of bread'). Lilies are a well-known symbol of purity and virginity. It is no coincidence that the highest-ranking angels are wearing priestly robes, since Mass is a celebration of Christ's sacrifice. The seven columbine flowers in the glass symbolize the 'Seven Sorrows of the Virgin': seven harrowing moments in her life, including the Flight into Egypt and the Crucifixion.

● The scenes shown **further back in the landscape** are related to the central panel. On the left, Joseph and Mary are fleeing into Egypt, while on the right the Magi make their way to the stable. The camels show how far they have travelled. On the right of the central panel an angel imparts the good news to the startled shepherds.

HUGO VAN DER GOES *The Death of the Virgin*

between 1477 and 1482
Panel, 147.8 x 122.5 cm
Stedelijke Musea, Groeningemuseum,
Bruges

The Virgin Mary lies, deathly pale, on a bed in a sober interior. She is surrounded by her son's twelve disciples, tired and forlorn, each trying to deal with his emotions in his own way and, it seems, competing for the most theatrical pose. Although the theme of the dying or dead Virgin was popular with painters, it did not originate in the Bible, but became well known through the highly influential collection of saints' lives from the second half of the 13th century, known as the *Golden Legend*. Its author, Jacopo da Voragine, took the story in turn from the Apocryphal Gospels. When, in the latter part of the 16th century, the Church rejected non-Biblical, 'medieval' subjects of this kind, the Death of the Virgin as a theme rapidly disappeared.

● The Apostle with the unkempt hair shielding the candle flame with his hand is Peter's brother, **Andrew**, while the young man in red, leaning forward, is **St John the Evangelist**.

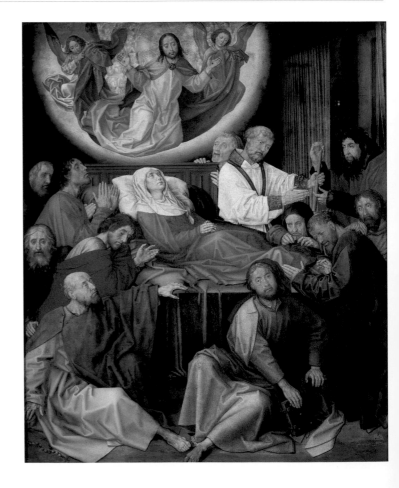

● At the top, **Christ** and a group of angels hover in a heavenly sphere of light, ready to collect the Virgin's soul. He spreads his arms wide as if to receive her, showing his stigmata. There is no contact in the painting between the heavenly beings and the mortals below; Christ is part of Mary's vision.

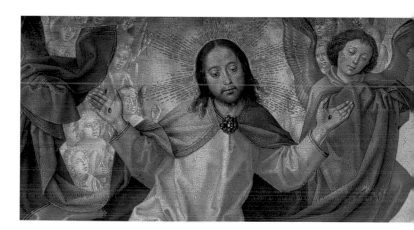

● The **Apostle** in the foreground is one of two figures in the painting who look at us with great intent; it is as if Van der Goes were painting a scene from a play and wishing to draw us in. All our attention is focused on the 'actors' rather than the details. As opposed to the heavenly figures of Mary and Christ, they are simple people, as we see from their weathered faces and rough hands and feet.

● **St Peter**, chief among the Apostles and founder of the Church, is dressed as a 15th-century priest, linking the event to contemporary reality. Visibly old and tired, he takes a freshly lit candle from one of his fellows. It was customary at the time to give lighted candles to people who were dying; the flame was a symbol of their Christian faith.

● The **book** held by the Apostle in the foreground is closed and a **rosary** lies disused in the bottom left corner; it is as if with Mary's passing the life of the Apostles was also coming to an end.

SANDRO BOTTICELLI *Allegory of Spring*

about 1480
Panel, 203 x 314 cm
Galleria degli Uffizi, Florence

We enter the world of Classical mythology through two celeb-rated works painted by Sandro Botticelli in the 1480s (the other is discussed on pp. 86–7). Although not the first of their kind, mythological themes remained unusual in the 15th century. These were painted for the Villa Medici of Castello near Flor-ence. Venus stands in the middle of a paradisaical spring garden, strewn with flowers and bordered with orange trees. Her blind-folded son Cupid hovers above her, ready to fire off his flaming arrow, while behind her stands a myrtle tree, which was tradi-tionally associated with the goddess of love. The Three Graces dance to the left, while the god Mercury uses his magic wand or *caduceus* to drive away the clouds. To the right the god of the west wind, Zephyr, coloured grey, green and blue, seizes the nymph Chloris. To her left is Flora, who is about to scatter roses – the flower most associated with Venus – on the ground.

A HIDDEN MESSAGE?

There has been much debate as to the meaning of this painting; some interpretations have gone into great detail. As far as we can tell, Botticelli is not presenting a specific mythological tale, although he did draw inspiration for this sensual scene from a wide variety of Classical and contemporary literary sources. The mythological figures shown here can all be linked to marriage.

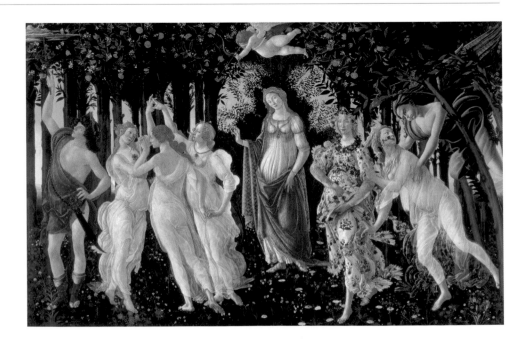

● **Mercury**, too, is closely linked with both Venus and springtime in Classical texts. He is the son of Maia, after whom the month of May is named. Mercury uses his wand to disperse the clouds, which have no place in Venus' golden garden.

● **Venus** is presented as a richly dressed *matrona*, a goddess of honourable – that is to say, marital – love. In her garden it is always spring. She seems to point to the three dancing Graces, who are her companions in Classical mythology. Cupid aims his arrow at them: the one who is hit will be destined to marry…

● **Flora**, goddess of flowers, embodies the ideal of beauty in Botticelli's time. Her gown is embroidered with roses – Venus' flower – and she also wears floral jewellery. She, too, was associated with the month of May.

● Botticelli will have read about **Chloris** in the Classical writer Ovid's *Metamorphoses*. The nymph was raped by Zephyr in the garden (with the golden apples) of the Hesperides; they subsequently married and were able to enjoy eternal spring. Chloris is trying to cry out, but flowers are all that come from her mouth. Although he is shown here as a villainous spirit, Zephyr had

positive connotations in the Classical world, which linked him with spring and with Venus. According to a poem by Botticelli's contemporary Angelo Poliziano, Zephyr is the only wind permitted to enter Venus' garden, as he does here. It is he who provides the dew and the sweet fragrances, and who covers the earth with all manner of flowers.

SANDRO BOTTICELLI — *Birth of Venus*

about 1485
Panel, 172.5 × 278.5 cm
Galleria degli Uffizi, Florence

Blown by the flying Zephyr and Chloris (see *Allegory of Spring*, pp. 84–5), the nude goddess Venus is carried over the water in a giant seashell. Here she makes landfall in a bay with an orange grove, as roses rain down around her. A young woman hurries up to welcome and clothe her. Botticelli drew his inspiration from a variety of sources including a poem by his contemporary Angelo Poliziano, which describes the birth of Venus, and from an Ancient Greek hymn to Aphrodite (the Greek name for Venus).

BONFIRES OF THE VANITIES

Fashionable palazzi in late 15th-century Florence must have featured many more Venuses of this kind, yet few examples have survived. This is in part due to the iconoclastic fury that swept Florence in the 1490s, when the charismatic friar Girolamo Savonarola encouraged the burning of 'immodest' possessions, including paintings, that distracted people from God.

"I will sing of stately Aphrodite (Venus), gold-crowned and beautiful, whose dominion is the walled cities of all sea-set Cyprus. There the moist breath of the western wind wafted her over the waves of the loud-moaning sea in soft foam, and there the gold-filleted Horai welcomed her joyously. They clothed her with heavenly garments …"

Second Homeric Hymn to Aphrodite, trans. H. G. Evelyn-White

● **Venus**, goddess of love, brings beauty to the world; beauty is divine and, therefore, those who love beauty are pursuing values that are lofty and even heavenly. This kind of thinking was current in Botticelli's Florence, where it helped reconcile Classical and Christian ideas.

● **Venus' posture** recalls a Classical sculpture type – the 'Venus pudica' (Modest Venus), in which the goddess conceals her breasts and genital area with her arms and her knee-length, golden hair. She gazes dreamily and shyly into the middle distance.

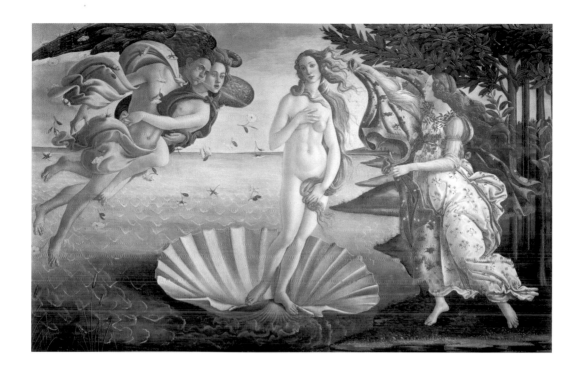

● **Zephyr and his companion Chloris** bring movement to the scene as they fly across it, blowing Venus and her shell onto the beach.

● The figure on the right may be one of the **Horai** – goddesses of the seasons – in which case she would be Spring. Like the Graces, the Horai (or 'Horae' in Latin) were part of Venus' company. Her own dress and the robe she brings for Venus are decorated with spring flowers. The nymph wears a garland of myrtle (Venus' plant) around her neck and below it a girdle of roses (Venus' flower).

● The painting bathes in a **golden glow** that picks out the foliage, the flowers, the shell and the robes; it is a divine light, fitting for this scene.

FILIPPINO LIPPI *The Vision of St Bernard*

about 1485
Panel, 210 x 195 cm
Chiesa della Badia, Fiorentina, Florence

Bernard of Clairvaux, who lived in the 12th century, founded the highly influential Cistercian Order and wrote numerous theological treatises in which the Virgin Mary features prominently. Following his death, he became the subject of a great many legends. Lippi's panel shows a mystical encounter between the Virgin and Bernard set in a rocky landscape near a monastery. Cistercian abbeys were generally located in remote, undeveloped areas, as is the case here.

● **St Bernard** looks up from his work. His books stand or lie behind him on a rocky shelf. The desk at which he is writing is equally 'natural'. The scholar looks tired: according to legend, Mary gave Bernard the strength to finish one of his texts despite his illness. His motto, 'Sustine et abstine' (Bear and forbear) hangs on the rock behind him. Bernard preached simplicity and forbade among other things the decoration of sacred spaces, not least abbey churches.

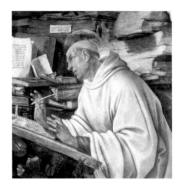

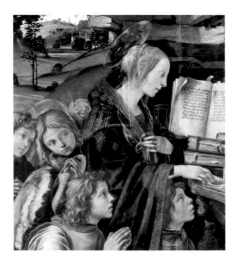

● **Mary**, who has the air of a young mother with four children, is plainly interested in Bernard's writing. The angels accompanying her look at the saint with childlike, curious gazes; their faces are reminiscent of Lippi's master, Botticelli. The landscape that unfolds behind them is more welcoming than the rocky surroundings of the abbey.

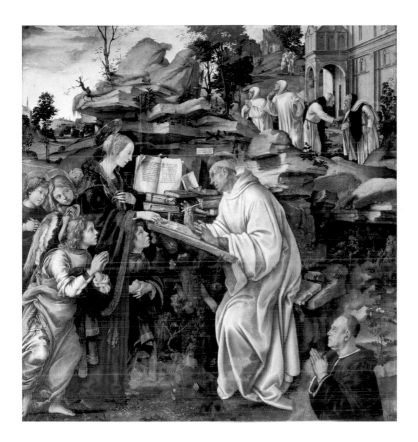

● Two **demons** watch the apparition from the dark cave in which they have been chained. They symbolize the heresy that Bernard suppressed.

● These **monks**, in their white Cistercian habits, watch the golden glow in the sky in prayer and amazement, while in the background some of their fellows carry an old man towards the abbey.

● The **donor** of this work, Piero di Francesco del Pugliese, is also present in the lower right corner. He clasps his hands in prayer and watches the miraculous events unfold. The panel was painted for his family's chapel in a monastery.

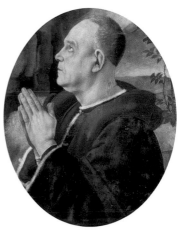

GEERTGEN TOT SINT JANS? *The Apotheosis of the Virgin*

about 1490–95
Panel, 24.5 x 18.1 cm
Museum Boijmans Van Beuningen,
Rotterdam

Mary is seated on a crescent moon with a dragon beneath her, within an oval of sunlight. She holds the infant Christ. Angels swirl around them in three distinct circles. The panel is a hymn of praise to Mary and was intended for private devotion. It was designed to encourage the reciting of the Rosary – a practice that was on the rise in the 15th century. The cult of Mary and the Rosary was particularly strong in Haarlem, the city where the artist worked.

This manifestation of the Virgin Mary refers to a section in the final book of the Bible: the Book of Revelation or Apocalypse of John. The text in question does not mention Mary by name, but she is identified here with the woman in the vision: "And there appeared a great wonder in heaven, a woman clothed with the sun, and the moon under her feet, and upon her head a crown of twelve stars: And she being with child cried, travailing in birth, and pained to be delivered. And there appeared another wonder in heaven; and behold a great red dragon, having seven heads and ten horns, and seven crowns upon his heads. And his tail drew the third part of the stars of heaven, and did cast them to the earth: and the dragon stood before the woman which was ready to be delivered, for to devour her child as soon as it was born. And she brought forth a man child, who was to rule all nations with a rod of iron: and her child was caught up unto God, and to his throne."

Revelation 12 : 1–5

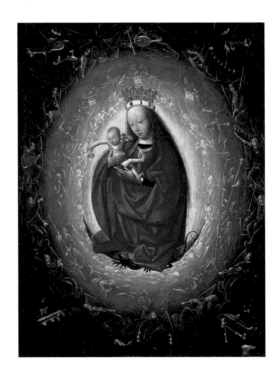

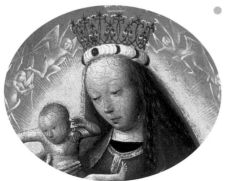

 Mary's **starry crown** is carried by two seraphs and rests on a garland of roses, composed of a repeated sequence of five white roses and one red one. This refers to the beads of a rosary, which generally has ten smaller beads interspersed by a single larger one.

The **first circle of angels**, who almost disappear in the bright light, is filled with six winged seraphs, of the kind described in the Old Testament by Isaiah. They are located close to God's throne (see pp. 56–7).

Four angels carry three small flags with the abbreviated word **'sans'**, short for *Sanctus*: 'Holy, holy, holy' are words that feature regularly during Mass.

Six angels in the **second circle** carry the 'Instruments of the Passion'. These are the implements used to torture and crucify Jesus: the column of the flagellation, the crown of thorns, the hammer and nails of his crucifixion, the cross, the spear used to stab him in his side, and the sponge soaked in vinegar to quench his thirst.

In the **outer circle** an orchestra of angels is making music with percussion, string and wind instruments in honour of Mary. Their faces, hands and instruments are the most strongly lit. Jesus with his two bells seems to be taking part in the concert.

DOMENICO GHIRLANDAIO · *The Birth of the Virgin*

1491
Fresco
Santa Maria Novella, Florence

This fresco presents two episodes from the life of Mary's mother, Anne: the divine conception of the Virgin Mary and a postnatal scene. The setting for this religious theme looks like the home of a fashionable Florentine family. Indeed, we might even call it a 'genre scene' (an episode from everyday life). Five of Anne's female relatives have come to visit her in her confinement; they too look like well-to-do ladies from Ghirlandaio's Florence.

● While Anne, who has just given birth, rests in her bed, the **midwives** prepare to give the baby Mary her first bath.

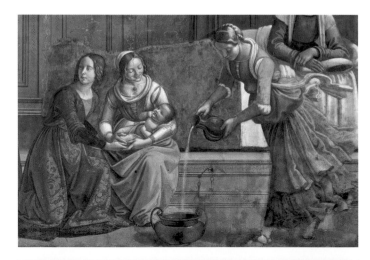

● **Putti** play music and dance – a motif in keeping with the tastes of a time that was hungrily rediscovering the Classical past. The Latin text below the frieze with the joyful putti reads: "Your birth, Virgin Mother, was the cause of joy throughout the world."

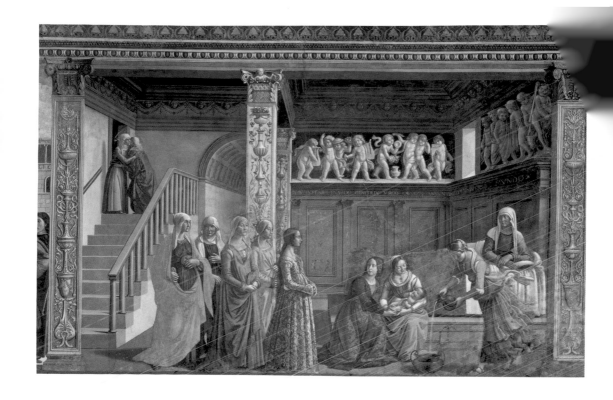

IMMACULATE CONCEPTION

This story revolves around the notion of the 'immaculate conception': the doctrine that no earthly lust was involved when Mary was conceived. It was necessary to establish her as an utterly pure being, capable of becoming the Mother of God. Since Mary was not conceived in lust, she was free of Original Sin. It was a subject that sparked fierce controversy in the medieval Church.

● After twenty years with no children, an angel foretold that Joachim and Anne were to have a baby – the child that would grow up to be Christ's mother. To conceive the infant, the couple was instructed to go and embrace one another at Jerusalem's Golden Gate, which is what we see here at the top of the stairs. That **embrace** was sufficient for Anne to become pregnant with Mary. The story is told in apocryphal texts from late antiquity and is repeated in the 13th-century *Golden Legend*. The scene at the Golden Gate was much loved in art, especially in cycles devoted to the Life of the Virgin.

HIERONYMUS BOSCH

The Garden of Earthly Delights

1480–90
Panel, 220 x 390 cm
Museo Nacional del Prado, Madrid

Hieronymus Bosch's *Garden of Earthly Delights* triptych offers a hallucinatory warning against a life of lustful pleasure rather than one of demure conjugal morality. In true Boschian fashion, he begins by showing the 'true paradise' in the left-hand panel – a kind of zoo world, full of real and imagined animals – before moving on to a perverted 'false paradise' – the consequence of Original Sin – and finally, inevitably, to hell. The core message is that sexual passions threaten humanity's soul. Dozens of figures and creatures illustrate this central theme with their behaviour (or, rather, misbehaviour). For Bosch and many of his contemporaries nature had a menacing quality and there was a perpetual struggle being waged between culture and nature: civilization versus barbarism, self-control versus passion.

● Many scholars have wondered whether the central panel depicts an **image of paradise or of a world of debauchery**. In a wide, open landscape, young people dally naked in the foreground, talking and interacting with each other and with the plants and animals. At the centre of the panel, women bathe in a round pond, circled by men mounted on animals, representing their passions. Bosch might have been inspired here by fertility rites; in addition, literature of his time viewed riding in a circle as a symbol of sinfulness and passion. The background is filled with bizarre structures in the water and on the land – again simultaneously organic and artificial. These are sexually charged metaphors: to Bosch nature is a dangerous 'artist'.

● In the left panel Christ blesses the **union of Adam and Eve**, the emblem of holy matrimony. That union required people to control their sexuality and to view it solely as a means of procreation. The Fountain of Life in the central panel looks like a plant but is also sculptural. The owl in the globe is an image of dark, seductive evil and sexual temptation. Paradise is under threat…

● Temptation, animalism and exhibitionism are ubiquitous in this **'paradise'**, with people literally becoming one with nature rather than using their reason to subdue it. We are looking at a cultureless *false* paradise – a common symbol in medieval courtly literature. It was also the subject of a popular myth that claimed there was an earthly paradise somewhere, where all physical desires were fulfilled. In this instance, however, the happy pleasure garden in the centre panel leads people straight to hell on the right.

● Earthly nature, according to Bosch's worldview, was sexual and hence uncontrollable and dangerous; that is the drama of humankind and the underlying theme of the triptych as a whole. It explains the creatures that are at once human and vegetable (or animal), the voluminous and suggestive fruits – among which the strawberry features prominently – and the **musical instruments** in hell, which are also symbols of love and lust. The message Bosch propagates in his *Garden of Earthly Delights* is a Christian one, yet he does so using the most profane of images.

about 1450–1516

HIERONYMUS BOSCH *The Temptation of St Anthony*

about 1501
Panel, 131 x 238 cm
Museu Nacional de Arte Antiga, Lisbon

Bosch devoted several important works to famous hermits, including this St Anthony triptych. Anthony (251–*c.* 356) lived in the desert, where his legend says he was constantly assailed by demons in every form, from monsters to naked women. In Bosch's vision of the world, hermits like St Anthony show us the true path, which requires us to reject the sinful life around us and follow the example of Christ. The triptych presents a jumble of sinful creatures, both real and imagined. The miniature, teeming figures populate each of the four elements – earth, fire, air and water – and stand for the dangers, fears and temptations that beset us at every step on this earth.

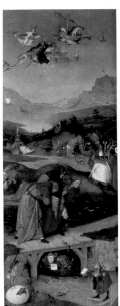
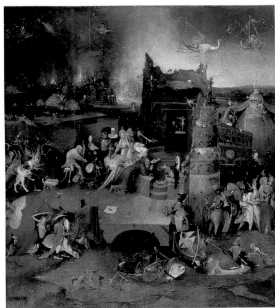

"No man [says Jesus] shall succumb to the devil and his blandishments, who fixes his eyes upon my blessed Passion and invokes my aid. Whenever he feels tempted, let him seek my crucifix, make the sign of the cross, spit at the enemy and say, 'Be gone, foul adversary'. And he shall immediately find my consolation, as did the blessed Anthony."
Machiel van Hoogstraten, *The Booklet of God's Love*, about 1520

Anthony is carried violently through the air by demons, while below we see two monks and a layman helping the half-dead hermit back to his cell after his aerial ordeal.

This is an odd **trio**: the stag (shown here in a red cloak) was an established symbol of lust, while the man with the bishop's mitre is holding a staff surmounted with a half-moon – an allusion to the threat posed by the 'infidel' Turks. The mitre is on fire, recalling the fact that heretics and witches sometimes had a mitre placed on their heads, just before being burned alive. In other words, this figure is some kind of 'demon bishop' – Bosch loved to turn the world on its head.

The **kneeling hermit** makes a sign of blessing while looking directly at us. A little further away, Christ himself observes the scene, standing by an altar with a crucifix. The message of Bosch's art is generally clear; it is the imagery he uses to convey it that has thrown up question after question ever since.

Anthony prays and averts his gaze from a **naked woman** who lurks enticingly within a hollow tree trunk. Anthony's message – and hence Bosch's – emphasizes restraint, stead-fastness in the face of temptation, and forbearance. A hermit's life of contemplation is the ideal in the midst of an evil world.

about 1450–1516

HIERONYMUS BOSCH
and/or workshop

The Haywain

about 1516
Panel, 135 x 200 cm and 135 x 100 cm (x 2)
Museo Nacional del Prado, Madrid

This triptych, like the artist's *Garden of Earthly Delights*, shows where the Fall of Man (left wing) has led humanity: towards a life that will inevitably culminate in the torments of hell (right). Bosch presents us here with a powerful, satirical exhortation against 'evil'; in his uniquely imaginative way, he confronts us with sin in all its guises. Salvation, the pessimistic artist believed, is only possible if we choose to emulate Christ's example. Many of his fellow painters preferred to offer more positive role models.

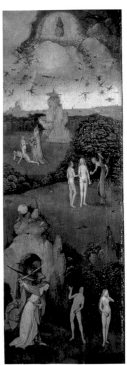
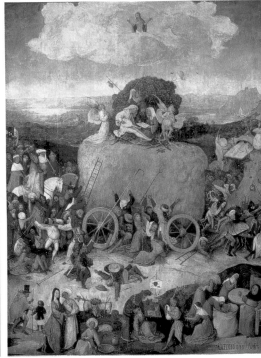

 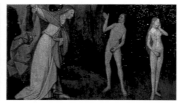 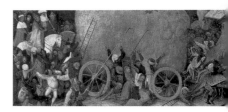

● Three images of **Adam and Eve**: following the Creation and the Fall, the first human couple is banished from the Garden of Eden, just as the rebellious angels with their leader Lucifer are being thrown from heaven at the top.

● What Bosch offers in the **central panel** is his vision of how human beings live their lives: as if on a hay cart or haywain, trundling inexorably in a single direction, occupied all the while with worthless and transient earthly things. The hay symbolizes that worldliness

and ephemeral pleasure, while the cart on which it is stacked so high is drawn by demonic figures and followed by a group of worthies. People battle fiercely to grab a handful of hay. Haywains also featured in religious processions as humorous emblems of stupid and objectionable behaviour.

● An angel poised **on top of the cart** prays for Christ to intercede on humanity's behalf. But there is a demon here, too, coloured blue to signify hypocrisy and deception, who plays enticing music, while an owl lures other birds. Owls frequently appear in Bosch's work in the guise of malicious tempters. A couple embrace and music is played nearby: devilish trickery causes people to lose sight of God and to advance cheerfully towards their doom.

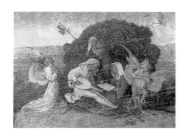

● High up in the clouds, far removed from earthly sin, the **risen Christ** looks on, displaying the wounds he received in order to redeem humanity. He offers the sole prospect of salvation, yet that is plainly not the priority of the people riding the haywain.

● The closed wings depict a **pilgrim**. He is a symbol: just like a pilgrim setting out in search of salvation and healing, humanity has far to travel before its sinfulness can be redeemed. The pilgrim here looks back in a gesture of repentance, pondering the errors he has made along the way.

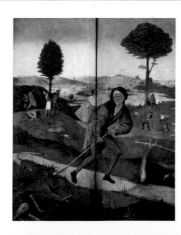

HIERONYMUS BOSCH *Christ Carrying the Cross*

1510 or later
Panel, 74 x 81 cm
Museum voor Schone Kunsten, Ghent

This work by Bosch is on a radically different scale to the others illustrated here. However, the themes remain the same. Christ shows people the way to salvation and away from sin, but does so through immense suffering, endurance and in great solitude, like a hermit. Bosch's radical views were fully aligned with the spiritual movements of his time. Here, as in many of his religious works, he also takes time to analyse humankind. While the story told is quite orthodox – both Veronica and Simon of Cyrene feature – the treatment is typically idiosyncratic. Never before had anyone painted such a compacted jumble of human heads, lacking any real sense of space.

● The **saviour** of humanity is alone in his final moments, amid a world of sinners. The serene Christ is defenceless and deserted by all as he closes his eyes to the hellish sadism and coarseness into which he has been plunged.

● **Identifiable figures** appear elsewhere: in the top left corner is Simon of Cyrene, who helped carry Jesus' cross, while the figure bottom right is the 'bad thief', who was crucified alongside Christ; the deathly pale individual in the upper right is the 'good' (that is to say repentant) thief.

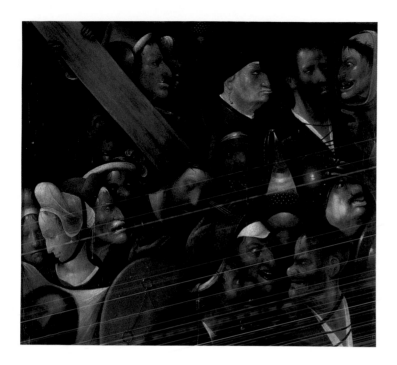

It was popularly held in Classical and medieval times that **evil** rendered people ugly. This painting is an apt illustration of the maxim; some of the figures in this hectic jumble seem to be turning into beasts. They represent a sinful humanity – an insane world that has condemned its saviour to crucifixion. Yet for all their madness, we still make out signs of exuberance, slyness or sadism in the individual faces.

Although her eyes are closed, **Veronica** turns to the cloth bearing the imprint of Christ's face, which appeared there when she wiped the sweat off his brow. Veronica – *vera icon* means 'true image' – is the only woman shown here with Christ; she stands slightly apart from the mêlée. Although the Virgin Mary played a key role in 15th-century art as the Mother of God and a consoling intercessor for mortals seeking salvation, she is remarkably absent in Bosch's work; this panel is no exception.

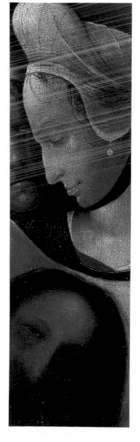

about 1450–1523

LUCA SIGNORELLI *Sermon and Deeds of the Antichrist*

1500–4
Fresco
Chapel of San Brizio, Orvieto Cathedral

A TOPICAL WORK?

The Antichrist was (and still is) often interpreted in terms of the contemporary political and religious situation: he was variously identified as a Muslim, a heretic, a Jew, a religious hypocrite and even, by Protestants, as the Pope. Some viewed him as the personification of all heresy within the Church, while Signorelli may have used the figure as a vehicle for his anger at the strict Florentine preacher and moralist Savonarola, who had been executed in 1498 (see also p. 86).

As the year 1500 approached, there was an upsurge in prophecies that the end of the world was near – something that tends to happen whenever a round number of years is reached. The end of the world and the Last Judgement are the themes of the remarkable frescos that Luca Signorelli began to paint in 1499 for the San Brizio chapel in Orvieto Cathedral, where Fra Angelico had worked half a century previously.

This large scene focuses on the Antichrist, the personification of evil, who was also expected to appear in the last days as an agent of Satan. Antichrist is Christ's opposite, yet appears similar: he preaches, comes to Jerusalem, performs miracles, rebuilds the Temple, ascends to heaven, and so forth. Yet everything he says is lies and deceit. He barely features in the Bible, yet the Antichrist played a key role in medieval perceptions of the Apocalypse. Signorelli's fresco shows about a hundred people spread in groups across a flat and desolate landscape, with a gigantic, temple-like building in the background. Several episodes from the life of Antichrist can be seen, culminating in his destruction.

● The **preaching Antichrist** looks just like Jesus, yet it is the devil who whispers in his ear what he is to say to the people. A crowd has gathered about him, some of their faces far from friendly. There are offerings at the base of the pedestal; he is evidently a hit with at least some of his audience. His expression is a parody of that of the true Christ.

● The **monks** are evidently engaged in some kind of debate; one of them points to the pseudo-Resurrection of the Antichrist in the middle of the fresco, while others leaf through their books.

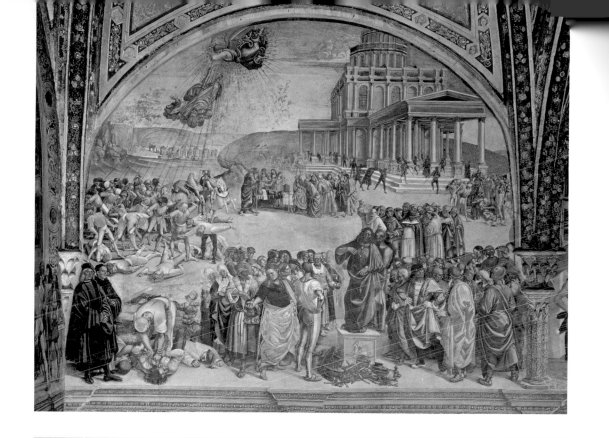

● Two **gentlemen** dressed in black stand to one side, looking on. The figure on the left is Signorelli, while the one on the right may be Fra Angelico.

● A **massacre** is taking place among the anti-Antichristians – those who refuse to listen to him; the 'unbelievers' are murdered, like the Christian martyrs before them.

● The rays of light in this anti-divine scene are not the usual gold, but a **bloody red**. An aggressive angel, armed with a sword, hovers in the air, sending down his beams to earth. This is Michael, who will vanquish the 'last enemy' and his followers.

● This **young woman** sells her body to the old man we see giving her money.

LEONARDO DA VINCI *The Last Supper*

1495–8
Tempera on plaster, 460 x 856 cm
Santa Maria delle Grazie, Milan

Leonardo's famous *Last Supper* shows the reactions to Christ's announcement that one of his Apostles was to betray him. The agitation and confusion of the twelve are obvious; split into three groups, their emotional responses are to question, deny, accuse and debate.

The mural painting is located in the refectory of a Dominican abbey in Milan, where it takes up the entire wall. Through its use of perspective, it seems to create a second room, beyond the real one. The work is badly damaged, which severely complicates our appreciation of it. Its poor condition reflects Leonardo's experimentation with new techniques.

A PSYCHOLOGICAL DRAMA

"And when they had taken their places and were eating, Jesus said, 'Truly I tell you, one of you will betray me, one who is eating with me.' They began to be distressed and to say to him one after another, 'Surely, not I?'"

Mark 14 : 18–19

Leonardo has opted for the most dramatic moment, when Christ says that an as yet unidentified member of the company will betray him. While he was not the first artist to do so, what makes this work so innovative is the combination of compositional skill, precision and imaginative, psychological power. Leonardo took around three years to complete it, to the great annoyance of his patron.

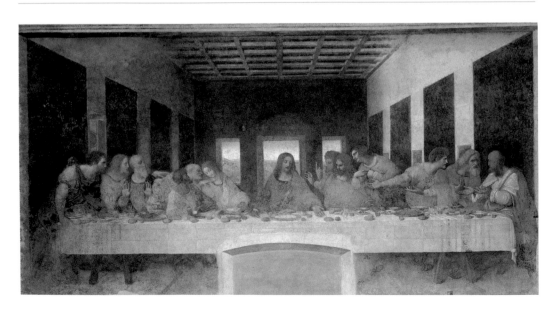

● **Christ**'s fellow diners recoil, leaving him isolated against the central window; neither he nor any of the Apostles has a halo, but in Jesus' case, the sunlight seemingly takes on that function. Christ's serenity contrasts with the intense emotion all around him, moments before the institution of the Holy Eucharist (see p. 66).

● A calm **John** sits at Christ's right hand; the tempestuous **Peter** leans towards him, shoving **Judas** out of the way and reaching for the knife with which he will cut off a Roman's ear a few hours from now. Judas sits with his face in the shadows, seemingly betrayed by the way he recoils in shock. To make matters worse, he clasps the purse containing

the silver coins he received from the authorities and knocks over the salt.

● One of the work's greatest strengths in the eyes of contemporaries was the illusion of reality and naturalism that it radiated. The Apostles' robes were originally reflected in the **tin plates and glasses**, but that effect has been irretrievably lost.

● Selecting this moment from the story enables Leonardo to individualize the Apostles. **Matthew**, for instance, seeks his fellows' reassurance – surely it can't be true?

LEONARDO DA VINCI *Mona Lisa ('La Gioconda')*

about 1503–6?
Panel, 77 x 53 cm
Musée du Louvre, Paris

"A good painter has two chief objects to paint, man and the intention of his soul." So said Leonardo da Vinci, whose *Mona Lisa* has been viewed for centuries as the product of that thesis. There is no more famous smile than this one, the enigmatic character of which has become legendary. "Of the things that render a person beautiful, it is above all the face that makes people pause, rather than precious adornments," said Leonardo, in a typically astute observation.

THE POWER OF ENIGMA

Before Leonardo, faithful portraits display sharp, clear outlines. The power of this one, however, lies in its vagueness, blurring and uncertain contours. It all begins, of course, with the smile: what kind of smile is it? The shadows at the corners of the woman's mouth obscure the answer, as do those around her eyes. This opens the sitter's mood to interpretation, expanding its expressive potential. Leonardo invented the technique known as sfumato, *in which the blurring caused by the play of shadows softens the edges of a person's features. Employing clearer and subtle lighting effects, he unleashed a new pictorial revolution. Interestingly, the smile recurs in other works by Leonardo.*

WHO IS THE SITTER?

The sitter has never been conclusively identified. Is it an actual or an ideal portrait? The fact that the work remained in the artist's possession after completion seems to indicate that it was not a commissioned portrait. Here are some of the contenders:
• Isabella d'Este, Duchess of Mantua, whose portrait Leonardo drew at the time of his stay there;
• a mistress of a member of the Medici family or of the artist himself;
• the wife of the Florentine Francesco del Giocondo, 'Madonna Lisa di Antonio Maria Gherardini', hence 'Mona Lisa' and 'La Gioconda'.

● The strange, **dreamy landscape** adds much to the painting's attraction. There are no people here, simply rocks and rivers – favourite motifs of the artist – roads, and an aqueduct. Oddly, the left- and right-hand parts do not match: the horizons differ, as does the artist's viewpoint in each instance.

● The woman sits on a chair, her forearm and beautifully rendered hands resting on the arm. **Columns** are hinted at on the far left and right, creating the impression that she is sitting in an open loggia.

LEONARDO DA VINCI *The Virgin and Child with St Anne*

about 1510
Panel, 168 x 130 cm
Musée du Louvre, Paris

The Virgin Mary sits on the lap of Anne, her mother, while taking hold of Jesus' waist. The child is playing with a lamb. The three of them sit in a mountainous landscape. Leonardo received the commission for this altarpiece from the Florentine monastery of Santissima Annunziata. He did not, however, finish it: along with the *Mona Lisa* (see pp. 106–7), the painter kept hold of this panel until his death.

THE HOLY FAMILY
Painters have depicted the family to which Mary and Jesus belonged in many ways. Two basic types are especially widespread: the 'nuclear' Holy Family comprising Mary, Jesus and Joseph, and the 'Family of St Anne' or 'Holy Kinship'. The latter is the name given to images of Anne's three husbands (including Joachim), her three children (one of whom is Mary), and their respective families, to which Joseph and Jesus also belong. The theme fell into disuse in art towards the end of the 16th century, when the Council of Trent forbade images of Jesus' uncles, aunts and cousins; after all, these were figures derived not from the four Gospels, but from stories in the Apocryphal 'Proto-Gospel' of James and the 13th-century Golden Legend.

● The **lamb** is a highly charged animal when it appears in Jesus' company, as it was the key symbol of his sacrifice for humanity (see pp. 26–7). His cousin, John the Baptist, referred to Jesus as the 'Lamb of God'. Lambs also symbolize meekness and innocence. All the same, there is little trace of that weight of symbolism here, where the Christ Child's woolly hair echoes the fleece of the lamb.

● The theme of the **three generations** – grandmother, mother and child – appears in both Northern and Southern painting, although it is rare for Mary to sit on her mother's lap: they mostly appear side by side, with Jesus in the middle. Anne looks down with a smile that is similar to the one on the lips of the *Mona Lisa*.

● The **landscape**, with the tree in the middle ground, merges into a mountainous, greyish-blue panorama that is also reminiscent of the mysterious landscape in the *Mona Lisa*.

GERARD DAVID *Triptych with the Baptism of Christ*

about 1502–8
Panel, 127.9 x 96.6 cm
and 132 x 43.1 and 42.2 cm
Stedelijke Musea, Groeningemuseum,
Bruges

In the key scene of this triptych by Gerard David – the 'last of the Flemish Primitives' – St John baptizes Jesus in the river Jordan. The painting belongs to the tradition of Van Eyck and Memling, with its attention to detail and its precise rendering of diverse fabrics and materials. On the left, an angel in a richly decorated gold brocade cope holds Christ's simple clothing; he is a recurring character in depictions of this theme (see pp. 58–9, 70–71).

● The painting's **donors** kneel in the wings, accompanied by their children: in the panel on the left we see Jan de Trompes, councillor and burgomaster of Bruges, with his son and his patron saint, John the Evangelist. The right wing shows his wife, Elisabeth van der Meersch, her patron saint and the couple's four daughters, watching the baptism scene.

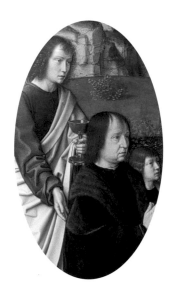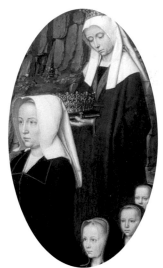

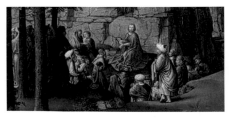

● The **background scenes** show St John preaching in the wilderness (left) and presenting the newly baptized Christ to his followers (right), as described in the Gospels.

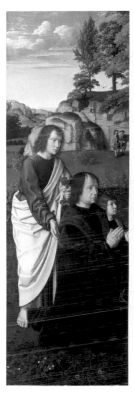
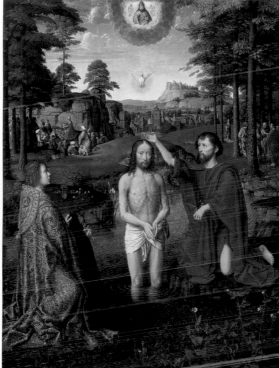

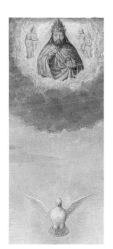

● **God the Father** and the **Holy Spirit** are usually present in scenes showing the Baptism of Christ and this is no exception. The three are positioned precisely in the vertical axis of the central panel and hence the triptych as a whole.

● The figures are all integrated into an expansive and varied **landscape** that runs across the three panels, changing from green to pale blue towards the horizon according to the rules of aerial perspective. David frequently devotes a great deal of attention to the detailed and realistic rendition of nature. The water flows here past a yellow iris – one of an astonishing number of details. David's triptych clearly shows the way landscapes were gradually evolving in the 15th century into the key element of the image. In the course of the 16th century, landscape developed into a genre in its own right.

LUCAS CRANACH *Rest on the Flight into Egypt*

1504
Panel, 70.7 x 53 cm
Staatliche Museen zu Berlin –
Preussischer Kulturbesitz,
Gemäldegalerie

The fleeing Holy Family pauses at a spring on the edge of a pine forest. Cherubs crowd around them as they rest in this lovely, natural landscape. Cranach has placed this idyllic – some would even say 'romantic' – scene in a wooded and mountainous setting, reminiscent of the Alps. This is the earliest signed work known by this artist.

A POPULAR SUBJECT

The Flight into Egypt is a familiar theme in art (see pp. 146–7, 226–7). Once again, a brief mention in the Gospels, of how Mary, Joseph and the infant Christ fled to Egypt to escape the wrath of King Herod, gave rise to all sorts of additions and pictorial details. Smaller-sized paintings showing this 'domestic' scene sold very well to private customers.

● **Signing** an object that forms part of the composition (here we see the initials *LC* and the year *1504*) was a common way for artists to assert their authorship (see p. 147).

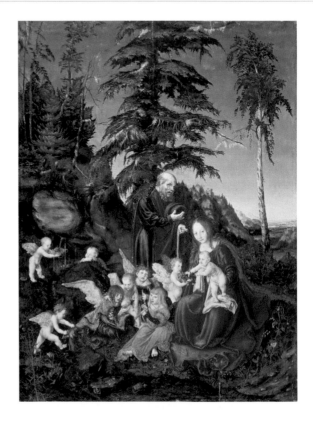

● One of the **cherubs** offers the baby Jesus a piece of fruit. Another fills a shell with clear spring water and a third has even been out 'hunting'. The other little angels – all the perfect age to be Jesus' playmates – play music and sing. What is normally a quiet and domestic scene is here transformed into something altogether more festive.

● The **flowers** depicted in paintings featuring the Virgin Mary are rarely chosen purely for decoration, but instead for their symbolic value.

● Cranach knew the southern German and Austrian **Alps** well from his childhood. The Holy Family has chosen to stop at a quiet spot; to them it is a place to rest, while for the viewer it provides an opportunity for prayer and contemplation.

GIOVANNI BELLINI　　*The Virgin and Child with Saints*

1505
Canvas (transferred from wood),
500 x 235 cm
San Zaccaria, Venice

Venice, being an island city full of reflective canals, is synonymous with colour and light, and these qualities are the hallmarks of the city's painting, which reached an absolute peak in the 16th century. Bellini, an early exponent of that development, painted this altarpiece for the modest church of San Zaccaria. It represents four 'worlds': Byzantium (the mosaic in the half-dome), Classical Antiquity (the decoration of the pillars and capitals), the Renaissance (the individualized human figures and the overall setting) and, of course, the Catholic faith.

● This scene, a *sacra conversazione*, is often seen in the 15th and 16th centuries (see pp. 40–41). Here, the **Christ Child** sits on **Mary**'s lap, making the sign of benediction. Bellini has added another figure (an angel?), which plays a violin-type instrument at the foot of the throne. In the previous century, the saints tended to keep their distance, often appearing in the wings of a triptych; here, by contrast, they all stand close together in a single space, together with the Virgin and Child.

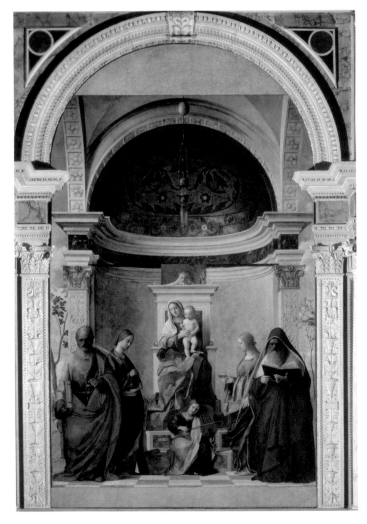

THE PALM OF VICTORY

*Artists generally depicted Christian martyrs holding
a palm branch, enabling us to identify them as saints
who died for their faith. The symbol was borrowed
from the Romans, for whom the palm branch was an
emblem of victory; it was carried, for instance, in
triumphal processions. For the Christian Church,
it became a symbol of the martyr's victory over death.*

● As always, **Peter** is shown with
the keys to the gates of heaven.
He is also holding a book of holy
scripture. Like Jerome on the
right, he is positioned frontally.
It is customary for the figure on
the far left in a *sacra conversazione*
to make eye contact with the
viewer. In this altarpiece, there is
remarkably little interaction
between the different figures.

● **Jerome**, one of the so-called
Fathers of the Church, translated
the Bible into Latin (the Vulgate).
He is shown here reading the
Book of Books, recalling the great
scholar that he was. (To read
more about this much-loved
character in art, see pp. 224–5).

● **St Catherine**, who can be
identified from the broken wheel
on which her hand rests, was
extremely popular. Her attribute
refers to the method of her death
(about AD 300): she was lashed
to spiked wheels, an instrument
of torture designed especially
for her. God intervened and
destroyed the device with
lightning, following which
Catherine was beheaded instead.

● **Lucy**, another popular
saint in southern Europe,
holds a dish containing her
eyes. According to different
versions of her legend, these
were either gouged out
during her martyrdom
(about AD 300) or else
she plucked them out
deliberately to make herself
less attractive to men after
she had been sent to a

brothel by her judge. She is
brightly lit, echoing her name,
which derives from *lux* – Latin
for light.

about 1431–1516

GIOVANNI BELLINI *Feast of the Gods*

1514
Canvas, 170 x 88 cm
National Gallery of Art, Washington DC.
Widener Collection (1942.9.1)

At first sight, this looks like a group of men and women enjoying some food and a fair amount of drink in the open air, with a little flirtation on the side. Bellini produced this painting – one of his few works on a non-religious theme – for the same ducal chamber in Ferrara for which Titian painted his *Bacchus and Ariadne* and two other works (see pp. 176–7). It can only be read by those who know the work of Ovid, as the scene is based on an incident in the Roman poet's *Fasti*, a work devoted to the Roman calendar. In fact, these 'people' are gods. The eighty-year-old Bellini painted a divine banquet, which Titian later reworked (repainting most of the landscape).

THE STORY
One night when the nymph Lotis was sleeping,
she was approached by Priapus, the god with
the legendary phallus, who had fallen in love with
her. Just as he was about to touch her, the donkey
belonging to Silenus, a constant companion of
Bacchus, started braying, waking everyone up.
Lotis managed to escape Priapus' sexual advances,
to the great hilarity of the other gods present.

● This is a **satyr** – half man, half goat, a creature of the wild in Classical mythology. He is bringing another jug of wine, highlighting the general atmosphere of the scene, in which the male merrymakers at least have plainly had plenty to drink.

● This is the principal action: **Priapus**, leaning on a tree, fiddles with the dress of the sleeping Lotis. Any moment now, the donkey on the left will begin to bray. In other words, Bellini has opted for the instant before the story reaches its climax. The main characters are placed on the margin of the group, while the composition centres on the banquet of the gods.

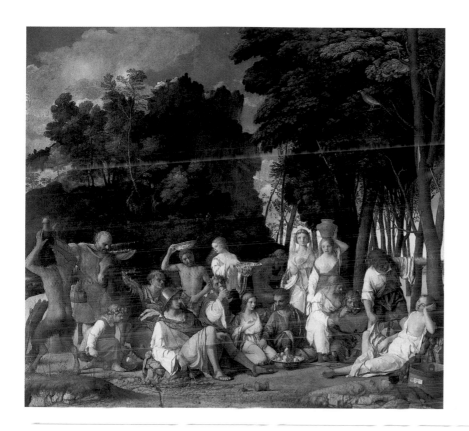

● The infant **Bacchus** is filling a cup from the barrel, behind which sits the bald forest god **Silvanus**. A man with a helmet leans against the barrel; he holds an unusual wand that identifies him as **Mercury**, god of commerce.

● The standing figures are **a satyr and a nymph**, who are acting here as servants. **Jupiter** sits in front of them, drinking out of a silver cup, just behind the goddess **Cybele** on the left and **Neptune**, who is unable to keep his hands to himself, to the right.

● **Apollo** is usually presented as a paragon of male beauty, but here he looks more like a drunken dwarf.

QUENTIN MASSYS *Triptych with the Lamentation of Christ*

1511
Panel, 260 x 263 cm
and 260 x 120 cm (x 2)
Koninklijk Museum voor Schone Kunsten,
Antwerp

The Antwerp Carpenters' Guild commissioned Quentin Massys to paint this altarpiece for its chapel in the city's cathedral, where it would encourage worshippers to reflect and pray. The theme chosen for this purpose was the highly emotional Lamentation over the dead Christ. Jesus' body has just been brought down from the cross, and is being mourned by the familiar figures: his mother Mary (in blue) and his favourite disciple, St John the Evangelist (in red). Others present are the penitent sinner Mary Magdalene (far right, wiping the blood from Christ's feet with her hair) and Joseph of Arimathea (far left). The two other women are the Virgin Mary's half-sisters, while the other male figures are an unknown man and the bearded Nicodemus. Every time Mass was celebrated before this painting, the congregation recalled the fact that Jesus gave his life to redeem humanity. The two wings are devoted to two holy martyrs (see opposite page).

UGLY EQUALS EVIL

For centuries, people were convinced that evil could be read from a person's appearance – above all from an ugly face. Their clothes also serve as signals that we are looking at torturers, sinners, layabouts, unbelievers: yellow, brown and motley mixtures are further indicators of wickedness, while heathenism, lasciviousness and ostentation were all signified by expensive and exotic clothes.

● In the landscape in the **background**, Christ's tomb is being prepared on the right; Golgotha, with its three crosses (the two thieves hang there still), appears in the middle; Jerusalem is shown on the left, behind Joseph of Arimathea.

● **John the Baptist** was one of
the carpenters' patron saints.
In a sumptuous interior, a
dancing Salome presents his head
to her stepfather Herod and her
mother Herodias, during a
banquet to celebrate the king's
birthday. Herodias loathed
St John, who had revealed and
attacked her unlawful marriage
to Herod. After her daughter had
danced for the king so beautifully
that he granted her a wish, the
queen saw her chance and
instructed Salome to ask for
John's head (Mark 6: 14–29).
A royal banquet circa 1500
consisted of a similar combination
of food, song, dance and (less
harmful) spectacle.

● **John the Evangelist** was the
carpenters' second patron saint.
He was boiled in a cauldron of oil
by the Romans – a veritable
multitude of whom are shown
here – for refusing to
acknowledge their gods; John
gazes, seemingly unmoved, at his
own God up in heaven. Mounted
on a white horse, the Emperor
Domitian – a man of legendary
cruelty – looks on. The fortress
of Antwerp, of which nowadays
only the gateway – the 'Steen' –
remains, can be made out in
the background.

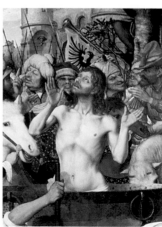

about 1460–1530

QUENTIN MASSYS *The Banker and his Wife*

1514
Panel, 70 x 67 cm
Musée du Louvre, Paris

Banking and moneylending were relatively new professions at the beginning of the 16th century. In a rapidly changing society, commerce and money were becoming increasingly important and the Church was one of the voices that warned against the attendant abuses. The man in this picture is absorbed in his work, weighing coins and calculating their gold content, as his wife looks on avidly.

This is an early 'genre' painting; not a portrait but a scene from everyday life. Such images generally contained a moral lesson or a religious message and were produced for the open market rather than for any specific patron. Quentin Massys was known for giving his characters distinctive features and a certain individuality.

● The woman opens her **Book of Hours** – a book with a prayer for every day – to a page containing a miniature of the Virgin and Child. She seems more interested in her husband than in her pious prayer book; do religious values have to make way for greed and ephemeral earthly goods in the new commercial metropolis that Antwerp, where Massys worked, was fast becoming? Or will the 'higher' values, symbolized here by the Book of Hours, help this couple to stay on the straight and narrow? There is no one 'correct' reading.

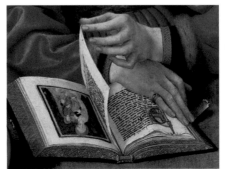

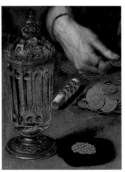

● The **crystal goblet** with its golden base and lid, and the pearls lying on the black velvet cloth, have led some to suggest that this man is a jeweller. This view is supported by the panel's composition, which recalls an earlier work by Petrus Christus, in which St Eligius features as a goldsmith (see p. 52). The link with Christus' work is further reinforced by the 15th-century clothes that Massys' husband and wife are wearing. In this instance, however, the scene is more secular than saintly.

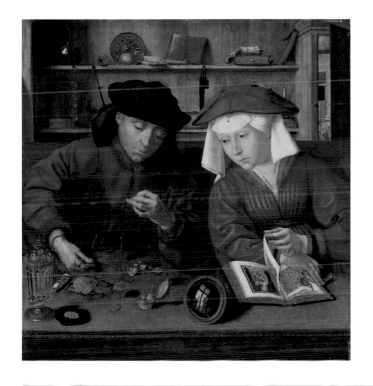

The original frame of this painting incorporated a cautionary verse from Leviticus: "Ye shall do no unrighteousness in judgment, in meteyard, in weight, or in measure. Just balances, just weights, a just ephah, and a just hin, shall ye have: I am the Lord your God."

Leviticus 19:35–37

● We have already encountered **mirrors** in paintings by Van Eyck, Christus and Memling (see pp. 28–9, 52–3, 74–5); painters seized on the motif as an opportunity to show off their virtuosity. The reflection brings another dimension into the painting and sometimes it enables us to see the artist himself. This particular mirror shows a window with an outdoor view and a man who might be reading.

● **Scales** are a traditional symbol for the weighing of good and evil in the dispensation of justice, as seen in many Last Judgement scenes.

MATHIAS GRÜNEWALD *Isenheim Altarpiece: The Crucifixion*

about 1510–15
Panel, 269 x 307 cm
Musée Unterlinden, Colmar

Paintings rarely express their purpose as clearly as this one does; it is part of a larger ensemble that Grünewald painted for the monastery of the Antonites in Isenheim, near Strasbourg. The monks cared for the sick and the idea was that the suffering shown in the painting would lend courage to their patients – including plague victims – helping them to overcome death. Illness and pain, it was thought, could be an expression of grace capable of restoring the soul. In this panel, Christ and his followers are rendered human and fellow-sufferers.

The Crucifixion is observed by Mary, St John the Evangelist and a kneeling Mary Magdalene on the left, and by John the Baptist on the right. The side panel on the left shows St Sebastian, whose protection was invoked against the plague (see p. 65), while the one on the right has the hermit St Anthony, founder of the Order that commissioned the painting. Grünewald himself later died of the plague.

● The **Magdalene** kneels in the loose dirt; she is traditionally associated with the penitent sinner who anointed Christ's feet, hence the ointment pot in front of her. She is an 'ordinary' person and is thus depicted smaller than the other figures, in keeping with medieval tradition.

● The body of the **dead Christ** has been horrifically tormented: the crown of thorns is a bloody instrument of torture, there are open wounds and weals, his skin is full of splinters, his arms seemingly dislocated, his feet twisted and his loincloth a mere rag.

● In the darkness – as described in the Gospels – a grieving **St John** comforts the fainting **Virgin Mary**. She is dressed in pure white. Before his execution, Jesus asked John to take care of her. The two figures are invariably present at Crucifixion scenes.

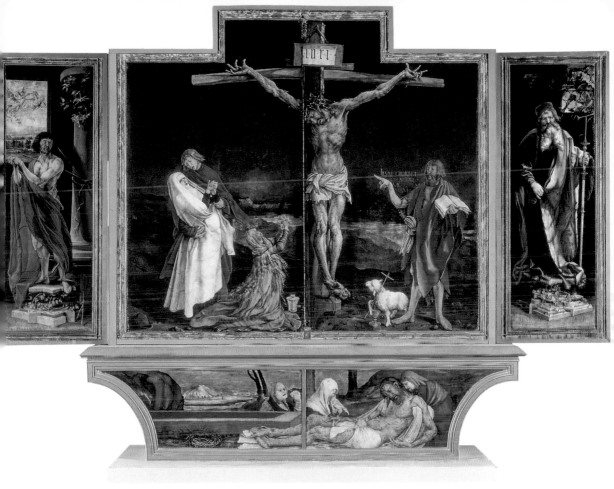

● **St John the Baptist** is an unusual figure to find by the cross, as the Gospels tell us he was beheaded some time earlier. That may explain why he looks unaffected by the scene before him. The text above his pointing arm reads, 'He must grow, I must diminish'.

● A **monster** breaks the window in the top right of the right-hand panel to infect the air with his pestilential breath.

● Christ is the **Mystic Lamb** who shed his blood to save humanity; that is what we witness here.

RAPHAEL *The Marriage of the Virgin*

1504
Panel, 170 x 118 cm
Pinacoteca di Brera, Milan

According to local legend, Mary's wedding ring was kept in the cathedral at Perugia. This sparked considerable interest in the theme of 'Mary's Wedding' – *lo Sposalizio* in Italian – a popular theme in Umbrian art for many years. The subject also crops up elsewhere, especially as part of cycles devoted to the Life of the Virgin. The Gospels are silent about Mary and Joseph's wedding, but the occasion featured in numerous Apocryphal texts dating from late Antiquity and in the 13th-century *Golden Legend*, a highly influential source for many artists. Raphael, a native of the Umbrian town of Urbino, was twenty-one when he painted this work for the principal church of Città di Castello, near Perugia.

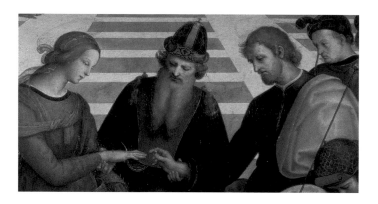

● Joseph gives Mary the **wedding ring**, which is positioned at the exact centre of the painting. In accordance with an old tradition, he is barefoot as he does so. A priest stands between them. Joseph owed Mary's hand to a miracle: all her suitors brought staffs to the Temple, but his suddenly began to bloom. This was taken as a sign from God: just as Joseph's staff had spontaneously flowered, so Mary would become pregnant without losing her virginity.

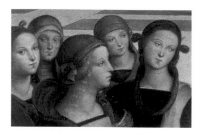

● The seven **virgins** with whom Mary was raised in the Temple also witnessed the miracle of Joseph's staff. Five of them are standing here with Mary at the moment the marriage is solemnized.

● Mary's **other suitors** are still present, holding their non-miraculous staffs in a group behind Joseph. In the foreground one of them snaps his staff in frustration.

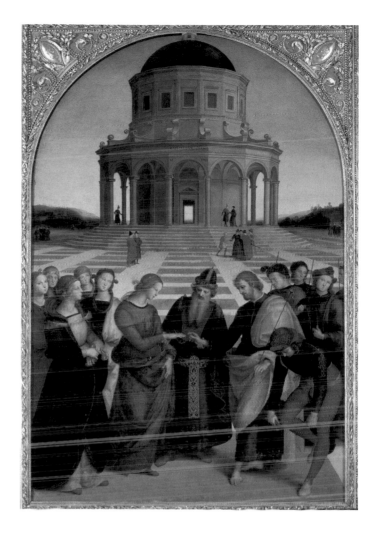

● Mary was traditionally said to have been raised in the **Temple in Jerusalem**; as the future mother of Christ she was, after all, "devoted to the Lord". The construction of domes was a new architectural concept in Raphael's time. This Temple illustrates the architectural interests of the artist, who would later go on to put them into practice. *"Raphaël Urbinas"*, it reads here: Raphael of Urbino.

RAPHAEL *The Triumph of Galatea*

about 1512–14
Fresco, 295 x 225 cm
Palazzo della Farnesina, Rome

Raphael painted this effervescent fresco in the Roman Villa Farnesina of banker Agostino Chigi. The story it illustrates (see below) is related in the *Metamorphoses*, but Raphael based his painting on an adaptation of Ovid's work – a poem by his Florentine contemporary Angelo Poliziano (see also p. 86). The nymph Galatea flits across the sea, in her chariot, surrounded by a crowd of companions. Raphael clearly demonstrates in this whirl of figures his phenomenal talent for balanced and harmonious composition.

THE STORY
The beautiful sea-nymph Galatea lived near to the Cyclops Polyphemus, who fell in love with her. Three different versions of the story have come down from the Classical era. According to the first, Polyphemus won Galatea over by playing her his flute and singing. In the second, Galatea seemingly began to flirt with Polyphemus but then fled back to the sea. In the final version, Galatea preferred the shepherd Acis to the coarse and awkward Cyclops. Catching the couple in flagrante delicto, *Polyphemus killed Acis with a boulder. The theme, a variation on 'Beauty and the Beast', was very popular in the Renaissance.*

● **Galatea** turns her head, which is positioned at the precise centre of the fresco, as she hurtles forwards across the water. Is she hearing Polyphemus' song of love? It has been suggested that her upward gaze is an expression of her desire to live a chaste and proper life, in contrast to some of the creatures that surround her.

● There are three **cupids** here, with a fourth watching from behind a cloud. They are ready to fire off their arrows, which will strike Galatea and cause her to fall in love.

'TRIONFI'

Triumphal chariots with mythological, historical or allegorical figures, accompanied by their retinues, were a very popular theme in Renaissance and baroque painting. The driver could be Cupid, shooting his arrows, Bacchus or Jupiter; or sometimes Death or Time. The chariot is pulled by appropriate animals: eagles for Jupiter, centaurs for Bacchus, fleet-footed stags for Time, and so forth. Real triumphal chariots dated back to Roman triumphal processions and also featured in medieval parades.

● **Dolphins** pull Galatea's seashell chariot. In Antiquity the dolphin was also the attribute of love goddess Venus and her son Cupid.

● **Tritons** are lesser sea-gods, mermen who accompany Neptune, god of the sea, and Galatea, while blowing conch shells. This one is riding a seahorse. Other male figures in this fresco are hybrid creatures who are enjoying their arousing game.

RAPHAEL *The Transfiguration*

1520
Panel, 405 x 278 cm
Pinacoteca Apostolica Vaticana, Rome

Raphael worked on this magnificent panel in the final year of his life. He was just thirty-seven. It is a dramatically composed painting whose upper half is suffused with a supernatural light, while the lower half is dominated by shadow effects. Jesus, flanked by two old men, hovers above the heads of the three startled and dazzled Apostles, his hands raised in a prayerful 'orant' pose. What we are witnessing is not Christ's Ascension, but his Transfiguration on Mount Tabor (see below). Raphael combines this motif with the subsequent episode in the Gospels: the healing of a possessed boy, which is depicted in the lower part of the painting. The work was done for the Cathedral of Narbonne but it was transferred as early as 1523 to the main altar in San Pietro in Montorio in Rome. It may have been the patron, Cardinal Giuliano de' Medici, who asked for the two episodes to be combined.

● The Gospels record that when Jesus came down from the mountain, a father, accompanied by a crowd of people, brought his only son, an epileptic, to him. Epilepsy was associated in the ancient world with **demonic possession**. Jesus drove the 'unclean' spirit from the boy – something his Apostles had been unable to do – thereby healing him.

THE STORY

"And it came to pass about an eight days after these sayings, he took Peter and John and James, and went up into a mountain to pray. And as he prayed, the fashion of his countenance was altered, and his raiment was white and glistering. And, behold, there talked with him two men, which were Moses and Elias: Who appeared in glory, and spake of his decease which he should accomplish at Jerusalem. But Peter and they that were with him were heavy with sleep: and when they were awake, they saw his glory, and the two men that stood with him" (Luke 9:28–32).

A cloud then surrounds Christ, Moses and Elijah, and God's voice is heard instructing the Apostles to listen to his son. After that Moses and Elijah disappear and the three are left alone again with Jesus. What they have seen remains a secret.

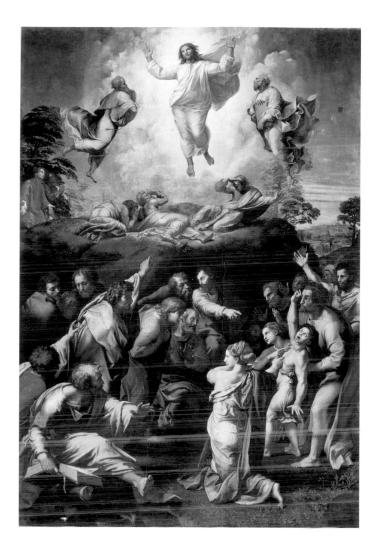

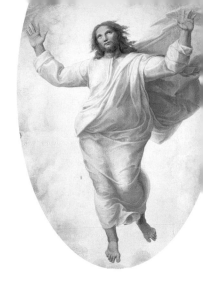

● The **Apostles** look at the possessed boy in surprise. Their efforts to heal him have failed. Two of them gesture with their arms in a way that connects the scene before them with what their fellows are witnessing on the mountain: salvation for the boy – and by extension for all humanity – can only come from above.

● These **two kneeling figures** in the margin have been linked with Narbonne, the city for which the work was commissioned.

MICHELANGELO *Sistine Chapel ceiling:*
The Fall of Man and the Expulsion from Paradise

1508–12
Fresco
Sistine Chapel, Vatican, Rome

The ceiling of the Sistine Chapel is the absolute apogee of monumental painting. This is the sixth of nine episodes and immediately follows the central scene with the creation of Eve. The composition is split into two halves, clearly differentiated by the movement in each: on the left we see the Fall, while on the right an angel with a sword banishes Adam and Eve from the Garden of Eden.

A HISTORY OF THE WORLD

The nine scenes in the ceiling together illustrate the first of the three periods into which the Church divided the history of the world; the other two are dealt with elsewhere in the chapel. The first period is the time before Moses received the Law from God, while the second is the time of the Old (Jewish) Covenant. The third and final period is that of the New Covenant, which began with the death and resurrection of Christ.

● Eve has just been given the **fruit**, while Adam picks one too. Traditional renditions of the scene have Eve picking the fruit herself, as described in the Bible, and giving it to Adam.

● The **serpent** who presents the forbidden fruit is a woman whose colourful (orange, green and pink) coils signify her fatal attraction – a brilliant touch that has only become apparent once again since the ceiling's recent restoration.

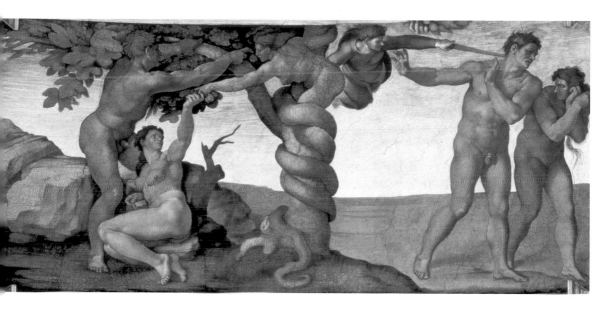

● This bleak plain, with its rocks and tree stump, is not much of an **'earthly paradise'**; Michelangelo was not interested in painting landscapes, his main interest was the human figure.

● One of the consequences of the Fall was a sense of **shame** at human nakedness: Adam and Eve tried to cover themselves up with fig leaves, but Michelangelo chooses to ignore that detail. The term *terribilità* was quickly and widely applied to describe his art, and there is indeed something uncompromising, harsh and, to some, shocking about his non-traditional portrayal of the human body and its emotions.

MICHELANGELO **Sistine Chapel ceiling:**
The Creation of Adam

1508–12
Fresco
Sistine Chapel, Vatican, Rome

The completed frescos of the Sistine Chapel ceiling measure roughly 14 metres across and 40 metres in length. The walls of the chapel were painted by artists of the previous generation, among them Botticelli and Ghirlandaio (see pp. 84–7, 92–3), whose themes helped shape the choice of the nine scenes in the ceiling illustrating the story of the Creation as described in the Book of Genesis. The lives of Moses and Christ had already been set out on the walls. The nine scenes were interspersed with prophets, Sibyls, Christ's forefathers, and figures and episodes from the Old Testament. Michelangelo's version of the story has become an icon of Western art.

DEEPER MEANINGS

Since the 19th century, some observers have wondered whether Michelangelo's frescos contain some deeper meaning. It has been claimed, for instance, that this is an allegory of the soul and the way that, as history has progressed, it has increasingly degenerated into the slave of the body. Others believe that the key to understanding the paintings lies in Augustine's City of God. Although hypotheses of this kind can shed light on theological issues in Michelangelo's time, they also throw open the doors for all sorts of unprovable speculation.

● At the moment of his creation, **Adam** – the Classical ideal of physical beauty – looks into God's eyes as he supports himself with his right arm. The Garden of Eden is suggested by green and blue fields of colour.

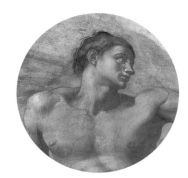
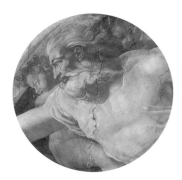

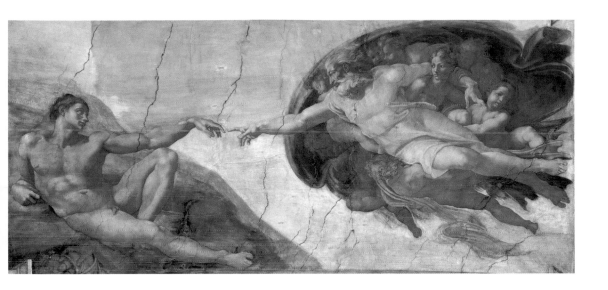

GENESIS

The Book of Genesis describes the creation of the first human being in two ways:

"And God said, 'Let us make man in our image, after our likeness' … So God created man in his own image" (1:26 and 27).

"And the Lord God formed man of the dust of the ground, and breathed into his nostrils the breath of life; and man became a living soul" (2:7).

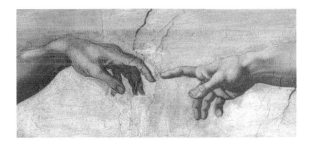

● Michelangelo's influential **image of God** is that of a powerfully built, grey-haired and bearded father-figure, surrounded and carried along by angels. His cloak billows out with the speed of his flight; the space about him is empty.

● God bestows life by reaching out to touch the **hand** of Adam, "created in his image". This is the psychological focus of the fresco. Michelangelo did not invent the motif of a recumbent Adam and God's life-giving hand, but never before had the image been

represented so powerfully; the two hands are located literally between heaven and earth and will make contact in the next instant.

MICHELANGELO *Sistine Chapel: The Last Judgement*

1536–41
Fresco, 13.7 x 12.2 m
Sistine Chapel, Vatican, Rome

In 1536, some twenty-five years after completing the ceiling, the sixty-one-year-old Michelangelo once again took up his paint-brush in the Sistine Chapel. The western wall behind the altar was to be decorated with a fresco of unprecedented size showing the Last Judgement: a theme that certainly lent itself to such an awe-inspiring project. We only have to look at some of the other Last Judgements in this book (see pp. 32, 72, 151, 159) to under-stand the revolution in painting and the sense of shock that Michelangelo's work was to unleash.

The artist breaks with many of the traditional components: there is no heavenly gate or mouth of hell, for instance, no architecture and hardly any landscape – just human beings, angels and saints. Michelangelo nonetheless retains the key elements, even if they take a moment to identify: in the lower left of the fresco we see the Resurrection and ascent of the elect; the central zone shows Christ surrounded by saints and other residents of heaven; while in the lower right the souls of the damned descend towards hell. The elaboration of the figures and the swirling and sustained dynamism of the overall image are utterly unprecedented.

"Then they foregathered, huddled in one throng, weeping aloud along that wretched shore which waits for all who have no fear of God. The demon Charon with his eyes like embers, by signalling to them, has all embark; his oar strikes anyone who stretches out."

Inferno, Canto 3 : 106–111,
trans. A. Mandelbaum

INDIGNATION

The reception of the Last Judgement illustrates just how relative the various stylistic labels can be; it has been variously categorized as 'Renaissance', 'Mannerist' and 'Baroque'. Whatever the case, it is a gigantic study of the human body in all its poses and movements – the essence of Michelangelo's art. The fact that he explored this particular theme in such a way at the epicentre of Church power caused considerable indignation: here, it was said, is a man who places his art and the depiction of the body above his religious duty, and who has introduced pagan images into the heart of the Christian faith. Even before the painter's death, the most conspicuous nudes were given clothing to wear. Michelangelo's work was a 'scandalous' example of an artist who insisted on following his own path.

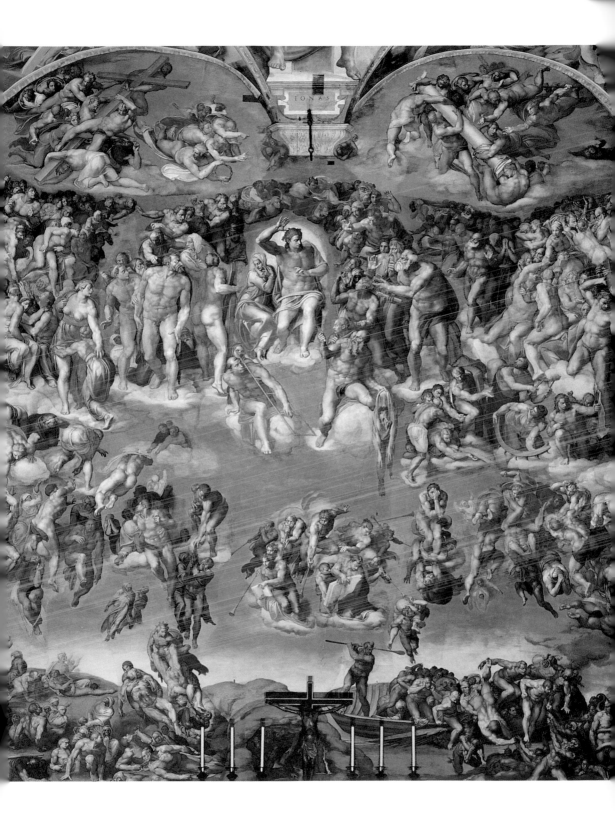

IONAS

● This is one of the **saints** we can identify: the Apostle and martyr Bartholomew shows the knife with which he was flayed alive and holds his skin in his hand. This has long been believed to be a self-portrait of Michelangelo.

● This magnificent **Christ** is enthroned within a golden glow high up on the painting's central axis, his mother **Mary** to his right. He raises his right hand and lowers his left – the traditional gesture that seemingly sets the events around him in motion and also enables him to display his wounds. Mary's downturned, interceding gaze is an equally familiar feature. Yet the powerful athleticism of Jesus' figure, which has been compared with that of Jupiter, is wholly new. What's more, he is nude, apart from a casually draped loincloth, and has no beard (see also p. 221).

● At the top of the fresco, **muscular figures** rather than the usual winged angels hold the cross, the crown of thorns and the whipping post – three of the 'Instruments of the Passion' (see pp. 27, 91).

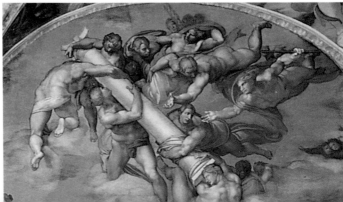

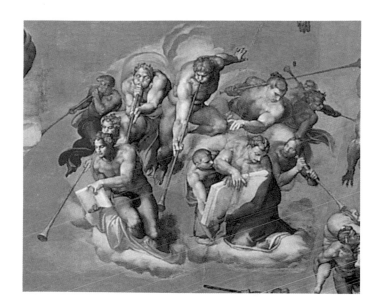

● Below Christ, also on the central axis, the seven **angels** of the Apocalypse blow their trumpets to announce that Judgement is nigh, while others carry the Book of Revelation. This is the moment with which the entire process actually begins.

● A tangle of bodies is delivered to hell in the shadowy lower right. It seems strange to encounter the mythical Greek ferryman **Charon** (see p. 149) in a Biblical scene and this was, indeed, a pictorial invention of Michelangelo's. Charon had, however, already made his appearance in the literary hell of Dante's *Divine Comedy* (c. 1320; see p. 134).

● This figure, like Charon, is from Greek mythology: **Minos** was one of the judges in Hades, the underworld. Michelangelo reputedly gave him the features of the papal master of ceremonies, Biagio da Cesena, who had complained about the scandalous figures with which the artist was adorning the Pope's chapel. The naked 'Minos' is entwined by a snake that bites his penis.

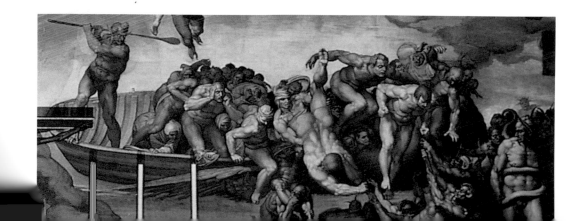

GIORGIONE *The Tempest*

about 1508
Canvas, 82 x 73 cm
Galleria dell'Accademia, Venice

We know very little about Giorgione, who died at the age of thirty-two, and whose firmly attributable output is limited to a handful of works. His painting nonetheless stood at the centre of a revolution, as is visible in this intriguing little canvas. Everything here – figures, landscape, air, light and architecture – is united in a seamless whole. Painting to Giorgione above all was about colour; when combined with the central role given to the landscape, this added up to something entirely new. The uncertainty surrounding the painter has led to much speculation, not least regarding this work. Giorgione is considered a highly intellectual artist, and he was certainly interested in Classical mythology.

● What is the **stork** doing on the roof? Does it have some symbolic meaning? Storks are occasionally used in painting to symbolize the love of children for their parents.

● The **lightning bolt** and sky heavy with thunder must have a particular significance, and one that is unlikely to be favourable. Lightning in both Classical and Christian imagery is interpreted as an instrument of divine wrath.

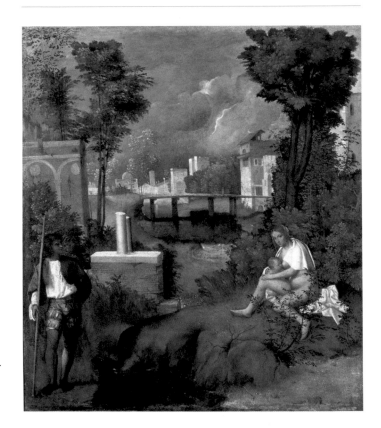

What is going on in this scene? It is a question that began to be asked shortly after Giorgione's death. Here are some of the principal hypotheses:

• It is an episode from a Classical Greek story – a popular source in Giorgione's Venice

• A young mother has just been chased from the city and encounters a friendly young shepherd

• The Trojan prince and shepherd Paris leaves his wife Oenone and child for the Greek Helen, promised to him by Venus. Paris abducts Helen, sparking the Trojan War, in which Oenone and the child die. The approaching storm is supposedly an indication of this

• The Rest on the Flight to Egypt (see also pp. 112–13)

• A pastoral allegory: the storm represents an unpredictable yet inescapable Destiny, while the soldier is Constancy and the woman Charity.

Other commentators have suggested that it was Giorgione's intention to be mystifying and to paint a work of sheer atmosphere, even if such an interpretation seems rather anachronistic.

● A **pillar** is a symbol of firmness and stability. A broken pillar recalls the Old Testament hero Samson, who destroyed the Philistine temple, but its relevance to this scene remains unclear.

● Is this **a soldier, a shepherd or a gypsy?** And what is his relationship with the woman? X-radiography revealed that a female bather was originally sketched in here. Perhaps, then, the scene does not actually refer to a specific story at all.

● The sitting woman is **naked**, except for the white cloth around her shoulders. She looks out of the painting as she nurses a baby. Apart from the nudity, the maternal scene also naturally recalls images of the Virgin and Child.

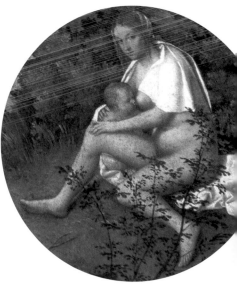

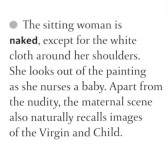

GIORGIONE & TITIAN *Sleeping Venus*

about 1509–10
Canvas, 108 x 175 cm
Gemäldegalerie Alte Meister, Dresden

A young, nude woman is sleeping with her left hand covering her genital area and her right arm behind her head. She is lying on red and white fabrics. An open landscape with buildings and a citadel unfolds behind her on the right. This painting was begun by Giorgione, but left unfinished at the time of his premature death. He probably painted the woman and maybe also the rock behind her. It was Titian, Giorgione's pupil, who finished it: he painted the landscape, added the cloths and he also placed a Cupid at the woman's feet, which later disappeared through wear and successive restorations. A third, anonymous, hand of a later date can be detected in areas.

● The painting at one point featured a **Cupid** at the woman's feet, added by Titian, which is still visible in the infrared reflectogram of the corresponding area (far right). This is the key to our interpretation of it, as the presence of Cupid firmly identifies the woman as none other than Venus (though we cannot be sure that Giorgione intended it to be there). The goddess's son drew the viewer into the scene, bringing it to life. Moreover, Cupid appears to have held an arrow and a bird, endowing the canvas with a plainly erotic meaning.

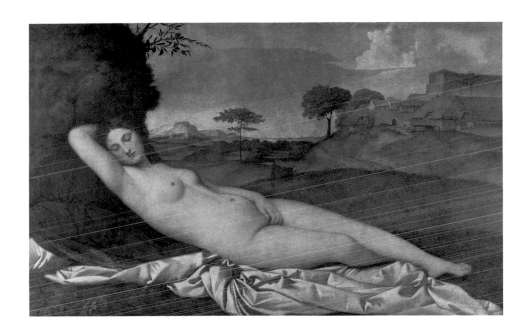

We are looking at a woman who is sleeping and is therefore 'absent'. The motif of the **sleeping Venus** in a garden or landscape 'where it is always spring' is well known from Roman wedding poems, in which the love goddess appears surrounded by putti, while Cupid frequently turns up to wake her and spur her into action. Venus would then attend the wedding to which the poem was devoted, lending her helping hand to the process of love. The same motif is used abundantly in 16th-century Latin poetry. If Giorgione's painting is the visual rendition of such a wedding poem, that might enable us to identify the work's patron as Jeronimo Marcello, who married Morosina Pisani in 1507.

ALBRECHT DÜRER *Martyrdom of the Ten Thousand*

1508
Canvas (transferred from panel),
99 x 87 cm
Kunsthistorisches Museum, Vienna

We know from his letters that this spectacular work was one of Dürer's favourites. It was commissioned by Frederick the Wise, Elector of Saxony and a learned man who had also engaged Dürer's talents on several previous occasions. The subject, provided by the patron, is the martyrdom of the Ten Thousand Christians on Mount Ararat in what is now Armenia. They were massacred by the 4th-century Persian King Sapor, acting on the orders of the Roman Emperor. Frederick had a personal interest in the story, as his collection of relics included what were said to be remains of some of the victims. The panel was intended to hang in the elector's relic room, to illustrate the origin of some of the pieces found there. The theme also had contemporary resonances.

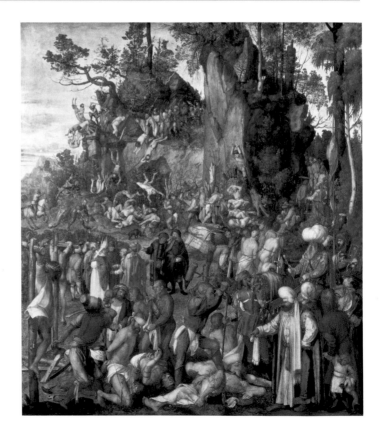

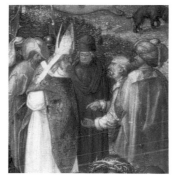

● The bearded man with the enormous turban is probably the **leader of the massacre**, the Persian King Sapor. The Christians' tormentors look remarkably 'oriental', which was no doubt a reference to the 'Turkish threat' in Dürer's own time.

● One of the martyrs was a man called Acacius, whom Dürer portrays here as a **bishop**, and who is said to have been the leader of the Ten Thousand. He is being led in shackles to the two central figures.

● Two black-clad men stand out amidst the bloodbath: the one on the right is **Dürer himself**, dressed in mourning robes, while the portly man on the left is his friend Konrad Celtis, whose black clothes are those of a professor. The painter carries his own signature, which reads (in Latin): "This Albrecht Dürer, German, made this in the year of our Lord 1508." Is the message of the painting that the human spirit lives on, despite the brutality all around? Or is this detail simply included to commemorate Konrad Celtis, who had recently died and with whom Frederick too was well acquainted?

● A total of around 130 figures has been painted, each dying one of a variety of martyrs' deaths. The gruesome subject-matter naturally lends itself to an exercise in painting human nudes. Several **torments** recalling the Passion of Christ are deliberately included in the foreground.

ALBRECHT DÜRER *Four Apostles*

1526
Panel, 215 x 76 cm (x 2)
Alte Pinakothek, Munich

Dürer presented these two panels to his native Nuremberg in 1526, a year after the city fathers had adopted Lutheranism as their official religion. They hung in the town hall rather than a church, as their subject might suggest. The dispute as to whether Dürer's 'artistic testament' was intended as an independent work or as part of a greater whole remains unsettled. However, we now know that the panels were executed as a stand-alone diptych of evidently Protestant inspiration. In addition to depicting four larger-than-life-sized Apostles – the title is actually misleading, since the Gospel-writer Mark, who was not a disciple of Christ, also appears – Dürer shows four temperaments, each of which is made to embody a different approach to religion.

● **John** reads the Word of God as recorded in his own Gospel, which was the one preferred by the reformer Martin Luther. **Peter**, founder of the Church in Rome, is standing in John's shadow, holding his familiar attribute: the key to the gates of heaven. John is sanguine (young, red cloak and reddish hair), while Peter is phlegmatic (old, sunken face and downcast eyes).

● **Paul** (older, reticent and introspective) embodies melancholy, while **Mark** (young and with piercing eyes) stands for the choleric temperament. Protestants claimed Paul, who is shown standing in front of Mark, as their spiritual father. He, too, was not one of the original twelve disciples, but later came to be viewed as an Apostle.

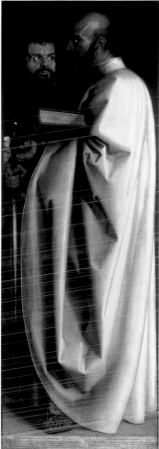

A WARNING TO PROTESTANTS

*The lengthy quotes inserted below the four figures are taken from
Luther's German translation of each of their respective writings.
Dürer appears to have rejected not only the Church of Rome, but
also the more fanatical of his fellow Protestants. As a humanist,
he wanted to encourage people to exercise their common sense.
His introduction to the words of the four Apostles and Evangelists
reads as follows: "In these perilous times, all worldly princes must
beware of taking the temptations of man for the Word of God.
The Lord shall not suffer His Word to be distorted. So warn these
four excellent men: Peter, John, Paul and Mark."*

JOACHIM PATINIR *Landscape with the Flight into Egypt*

about 1515
Panel, 17 x 21 cm
Koninklijk Museum voor Schone Kunsten,
Antwerp

For Joachim Patinir, nature is always the main focus of his paintings, no matter what the precise title might be. His landscapes are invariably composed and imaginary, forming the grandiose backdrop against which the seemingly secondary religious narrative unfolds. This small panel shows *different* episodes from the same narrative, the well-known story of the Flight into Egypt, as briefly described in Matthew. The classic image of Joseph, Mary and the infant Christ fleeing with the donkey appears in the foreground.

"And when they were departed, behold, the angel of the Lord appeareth to Joseph in a dream, saying, 'Arise, and take the young child and his mother, and flee into Egypt, and be thou there until I bring thee word: for Herod will seek the young child to destroy him.' When he arose, he took the young child and his mother by night, and departed into Egypt: And was there until the death of Herod."

Matthew 2 : 13–15

AERIAL PERSPECTIVE

A characteristic feature of Patinir's work is the high vantage point he adopts in order to encompass this modest yet expansive landscape, which happily mixes rocks from the Ardennes with a Brabant village and an Italianate sea. This painting is also an excellent example of the use of colour to suggest depth. The foreground is done in brown-greys, the middle distance in green and the background in blue-grey; the sea and mountains seem to melt into the air and light.

● The **falling statue** does not refer to any Gospel account, but instead to medieval legends which stated that when Jesus passed, heathen idols would miraculously fall from their pedestals.

● The **drama** takes place near this group of houses (right). Herod's soldiers have been ordered to kill all boys under the age of two, in the hope that this will do away with the 'King of the Jews', whose advent had been foretold. This too we find in Matthew (see opposite).

● Another **miracle** takes place in the cornfield by the farms, as the newly sown corn shoots up in order to confound Jesus' pursuers. When the soldiers asked when the fugitives had passed that way, the farmers truthfully replied: "Just after the corn was sown." The story comes from an Apocryphal Gospel on Jesus' childhood.

● The painter has added his **signature** in *trompe l'œil*: it looks as if it has been carved into the rock (bottom left).

JOACHIM PATINIR *Landscape with Charon Crossing the Styx*

about 1520
Panel, 64 x 103 cm
Museo Nacional del Prado, Madrid

A scene from Classical mythology in a Christian religious picture: this remarkable fusion tells us that something new is emerging in Northern painting just after 1500, following earlier developments in Italy. On the left angels are guiding souls to a paradisaical landscape with (in the background) a city with church spires, while Hell awaits on the bank on the right. On the river in the middle, separating the two possible destinations, a boat carries aboatman and a human soul. Neither God the Father nor Christ are anywhere to be seen. As throughout Patinir's oeuvre, the panoramic landscape – a riverscape in this instance – is the actual subject.

● The ferryman carrying dead souls across a river comes from Greek mythology and is not a Christian figure. The waterway is the Styx, the river of oblivion (see also p. 137). The bearded man's name is **Charon** and he is notoriously grumpy and ill kempt. Maybe he, or his passenger, still needs to decide upon his destination: the easy, short road to Hell or the longer road to Paradise?

(SECOND TO) LAST JUDGEMENT?
According to medieval belief, the souls of the dead were judged twice. The first judgement occurred immediately after death and determined whether they were destined for the earthly paradise or for purgatory. The divine Last Judgement at the end of the world would then decide their ultimate destination: Heaven or Hell.

● Until Judgement Day, the **righteous dead** reside in the earthly paradise, which appears here in the background, behind a charming, woody landscape, with the Fountain of Life. Angels are leading groups of souls there. Greco-Roman beliefs concerning the afterlife also foresaw an idyllic place – Elysium – for certain favoured souls.

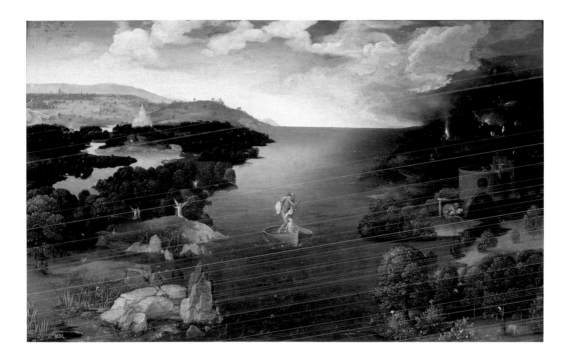

"There Charon stands, who rules the dreary coast –
A sordid god: down from his hoary chin
A length of beard descends, uncomb'd, unclean;
His eyes, like hollow furnaces on fire;
A girdle, foul with grease, binds his obscene attire."

Virgil, *Aeneid* 6:298–301, trans. John Dryden

● The dark, **hellish landscape** is lit here and there by flaming fires. The looming demonic creatures are reminiscent of those of Hieronymus Bosch, who was a near-contemporary of Patinir.

● The three-headed dog guarding the entrance to hell or Hades (the underworld) to ensure that no soul escapes is **Cerberus**, another Greek monster.

BAREND VAN ORLEY *The Last Judgement and the Seven Acts of Mercy*

about 1520
Panel, 248 x 218 cm and 248 x 94 cm (x 2)
Koninklijk Museum voor Schone Kunsten,
Antwerp

By the time Barend van Orley painted this *Last Judgement*, around 1520, the theme had already acquired quite a history in the visual arts, of which the artist was naturally well aware (see p. 72). Christ appears on a rainbow – the token of the Covenant between God and humanity – with his feet on a globe. He is surrounded by angels. Below him, the Archangel Michael helps weigh the souls of the dead. To the left of the central panel, a mass of blessed souls raises their hands towards heaven; the souls of the damned appear on the right, condemned to hell. A band of clouds runs across the painting, with two sets of six Apostles in the wings; on the left they sit with Mary and on the right with John the Baptist. They are here to intercede on humanity's behalf with the Supreme Judge.

SEVEN ACTS OF MERCY

This altarpiece was commissioned by the municipal almoners of Antwerp, who dispensed charity to the city's poor and needy. That explains the work's secondary theme, the Seven Acts of Mercy cited in the New Testament in Matthew's description of the Last Judgement: "For I was an hungred, and ye gave me meat: I was thirsty, and ye gave me drink: I was a stranger, and ye took me in: Naked, and ye clothed me: I was sick, and ye visited me: I was in prison, and ye came unto me ... Verily I say unto you, Inasmuch as ye have done it unto one of the least of these my brethren, ye have done it unto me" (Matthew 25:35–36 and 40). The burying of the dead, which the passage does not mention, became especially important in the Middle Ages, which were afflicted by repeated plague epidemics.

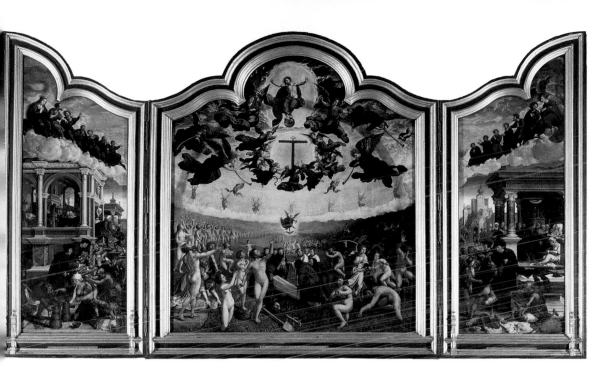

● The themes depicted in the wings are intrinsically entwined with **human conduct on earth** and are closely linked with the Last Judgement. Three 'Acts of Mercy' are shown here: clothing the naked (foreground), visiting prisoners (rear left) and caring for the sick (right).

● In the left-hand panel drinks are given to the thirsty, food to the hungry and shelter to the homeless. The painting expresses Christian doctrine, which states that believers should earn their place in heaven by performing Acts of Mercy, or **charity**.

● The seventh Act of Mercy – **burying the dead** – is shown, appropriately enough, in the central panel.

JAN GOSSAERT

The Metamorphosis
of Hermaphroditus and Salmacis

about 1520
Panel, 32.8 x 21.5 cm
Museum Boijmans Van Beuningen,
Rotterdam

New subjects and forms began to appear in Netherlandish art in Jan Gossaert's time, including themes from Antiquity presented in a 'Classical' mode. Gossaert may even have been the painter responsible for introducing these elements to the Low Countries, following their establishment in Italy several decades previously. Painters were primarily interested in episodes from Greek and Roman history, mythological stories and pastoral themes, and displayed a predilection for such formal features as nudity and an emphasis on anatomy, architectural settings and landscape. The result was at once a revival and a reinterpretation of ancient aesthetics.

THE STORY

Salmacis was the nymph of a spring in Asia Minor who was much concerned with her appearance. Having fallen in love with the sixteen-year-old Hermaphroditus, son of Hermes and Aphrodite, she lured him into the water where she tried to kiss and embrace him. As the youth continued to struggle and the nymph persisted in her advances, the two merged into a single being. Ever after, the Roman poet Ovid tells us, any man bathing in those waters would emerge "half woman, weakened instantly".

● The idea that men were much more likely to fall victim to female **attempts at seduction** than the other way around reflects a male-dominated culture and the widespread belief that women were more lustful than men. It was women, therefore, from whom the 'danger' of erotic misconduct was seen as most likely to emanate. This is how Ovid describes what happened when Salmacis saw Hermaphroditus swimming:

"'I've won, he's mine!' she cried, and flung aside/Her clothes and plunged far out into the pool/And grappled him and, as he struggled, forced/Her kisses, willy-nilly fondled him,/Caressed him; now on one side, now the other/Clung to him as he fought to escape her hold."

Ovid, *Metamorphoses* 4 : 357–362, trans. A. D. Melville

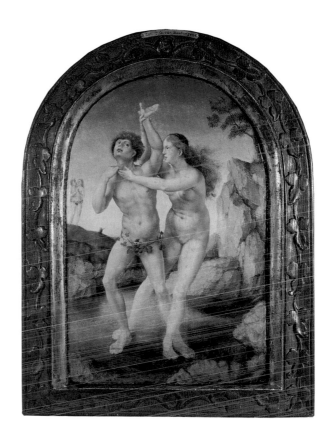

● The story presented Gossaert with a difficult challenge: how to express in a painted image that the two figures already shown in the foreground will subsequently be transformed into a single person? According to Ovid, they even ended up with a single face. This is Gossaert's ghostly solution, seen in the background on the left.

EROTIC MATERIAL

Gossaert worked for Philip of Burgundy (1464–1524), bishop of Utrecht and illegitimate son of Duke Philip the Good, who aspired to a court along Italian lines. As far as court painting was concerned that desire resulted in amorous, mythological nudes, substantially selected for their erotic potential. It was widely believed indeed that the celebrated Greek and Roman artists, whose work was known only from literary accounts, chiefly painted mythological nudes. To make such potentially offensive material acceptable, the images were sometimes accompanied by moral texts, or else symbolic details were added, alluding to the transience of physical beauty. This panel had an external frame which is likely to have featured an aphorism warning against the dangers of effeminacy. Philip presented the painting to his half-niece, Margaret of Austria, the governess of the Low Countries, whose court was located in Mechelen (Malines).

ROSSO FIORENTINO *The Descent from the Cross*

1521
Panel, 333 x 196 cm
Pinacoteca Comunale, Volterra

This *Descent from the Cross* has a strange feel, due primarily to the absence of any sense of space and to the fields of intense colour. The emotions, vividly expressed by the figures at the bottom, seem out of place in what is a rather abstract overall composition. The painting is a reaction to Michelangelo's voluminous figures. Rosso painted this work for the Cappella della Croce di Giorno in the church of San Francesco in Volterra. The emotions experienced by the figures in the painting were meant to invoke similar feelings in the viewers.

● **John the Evangelist**, Christ's favourite disciple, turns away, overcome with grief. The servant holding the ladder watches impassively. He is not directly involved with these people.

● Surprisingly, **Christ's sallow body** shows no traces of blood from his many wounds.

● The upper part of Rosso's painting is given over to the effort needed to remove Christ's body from the cross. The **four men** involved form a kind of circle around him. Joseph of Arimathea is probably the man at the top, while the one at the bottom has to resort to virtual acrobatics as he attempts to support Christ's legs. Rosso has deliberately added to the scene's complexity, as we also see from the third ladder (traditionally there are only two).

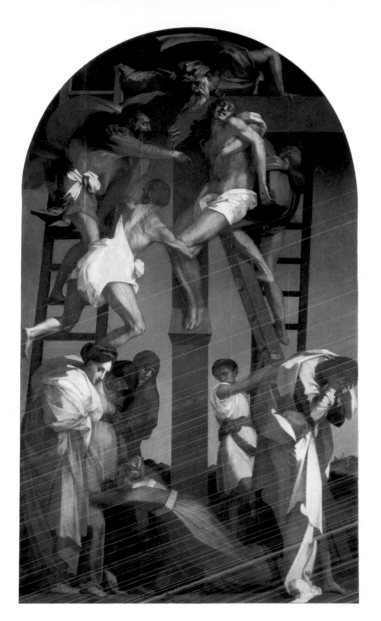

The Gospels state that Jesus' body was lowered from the cross by Joseph of Arimathea – a Jewish judge who was a secret follower of Christ. Nicodemus, another clandestine disciple, is only mentioned in John's Gospel. Artists initially painted the two men with Mary and John at the foot of the cross, but one or two servants later joined them, along with a number of grieving women.

● The **'Holy Women'** – companions of the Virgin Mary – are frequently included in Deposition scenes like this; one of them is Mary Magdalene.

155

1495–1562

JAN VAN SCOREL · *Christ's Entry into Jerusalem*

about 1526
Panel, 79 x 147 cm
Centraal Museum, Utrecht

Van Scorel was commissioned to paint this triptych in 1526 by Herman van Lokhorst, dean of the church of St Salvator in Utrecht, to hang over his parents' tomb. The painter had returned from Italy two years earlier, having also travelled to the Holy Land in 1520–21. The theme of the commission was perfectly in keeping with its purpose: as Christ journeyed to the earthly Jerusalem, so worshippers hoped that the souls of their dead would be allowed to travel to the Heavenly Jerusalem. This is just the central panel of the triptych, showing Jesus riding up the Mount of Olives on a donkey, a palm branch over his shoulder.

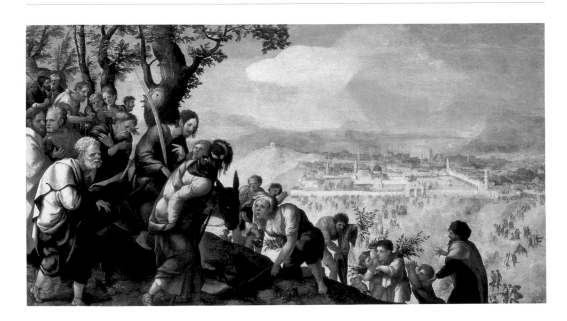

"And the disciples went, and did as Jesus commanded them, And brought the ass, and the colt, and put on them their clothes, and they set him thereon. And a very great multitude spread their garments in the way; others cut down branches from the trees, and strawed them in the way."

Matthew 21:6–8

● Christ's followers are led by **Peter**. **Judas** is here, too – he is the man with the reddish hair who, to judge from his purse, has already received the thirty pieces of silver for betraying Christ. The man in front of him seemingly attempts to warn us about the future traitor. The figures reveal the stylistic influence of Raphael.

● **People prepare the way** by laying cloaks on the road along which Christ will pass and by gathering palm branches. Many Christians still commemorate this episode on Palm Sunday (the Sunday before Easter).

● **Jerusalem** lies on the sunny plain. As Scorel had actually visited the city, he was able – possibly for the first time – to paint a topographically accurate view of it; or at least of how it appeared in 1520: Mount Zion with its monastery complex is on the left; the city walls, with the Golden Gate in the middle, at the front; and beyond that the Temple Mount. Crowds stream out of the city on every side.

LUCAS VAN LEYDEN *The Last Judgement*

1526
Panel, 269.5 x 185 cm
and 265 x 76.5 cm (x 2)
Stedelijk Museum De Lakenhal, Leiden

The Last Judgement, as described in visionary detail in the Book of Revelation, was a theme that lent itself to a number of uses. It featured in memorial paintings, for instance, and in 'justice scenes' painted for magistrates' chambers in town halls to remind those administering the law that they should do so impartially. Van Leyden painted this altarpiece for the children of Claes Dircsz, in memory of their father, a former timber merchant, churchwarden and burgomaster of Leiden. The grandiose work hung in the church of St Peter in Leiden, above the seats of the local magistrates, but was later moved to the town hall. Lucas van Leyden was plainly acquainted with the Italian Renaissance, but his work also betrays the lasting influence of the tradition of Hans Memling and Barend van Orley (see pp. 72–3, 150–51).

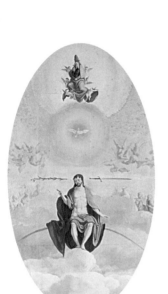

● **Christ** sits in judgement on the central axis of the altarpiece, below God the Father and the Holy Spirit. He raises his right hand and lowers his left. On either side of his head, we see a lily, associated with a verdict of 'innocent', and a sword, signifying 'guilty'. The implications of his judgement are depicted below and in the wings. Christ is surrounded by the Twelve Apostles sitting in the clouds and, higher up, by the hazy figures of saints and angels bathed in a golden celestial light. The Virgin Mary and John the Baptist, who often appear to intercede on humanity's behalf, are not present on this occasion.

● The **dead**, who have been summoned to rise by the sound of the trumpets, are being led away: the elect, to Christ's right, by friendly angels, and the damned, on the other side, by demons. Others, in the middle, fearfully await judgement. Virtually all their faces look in the same direction, making it clear which side they prefer.

● Angels guide the **souls of the righteous** through the clouds towards the celestial light we see in the central panel.

● The depiction of **hell** as a giant, fishlike monster with a gaping maw remains medieval in inspiration.

ALBRECHT ALTDORFER *The Battle of Issus*

1529
Panel, 158.4 x 120.3 cm
Alte Pinakothek, Munich

This astonishing panel was part of a cycle of sixteen works painted by different artists, commissioned by Duke Wilhelm IV of Bavaria. Its theme was the heroic deeds of eight men and eight women, all Biblical personages or historical rulers. The series took over fifteen years to complete.

Altdorfer's contribution shows the historical battle of Issus in Asia Minor (333 BC), one of the three pitched encounters between Alexander the Great and Darius, King of Persia. That East–West conflict resonated clearly in Altdorfer's time, when the Turks were threatening the Balkans.

A FAITHFUL RECONSTRUCTION?
Surviving accounts of the battle – and of Alexander's campaign in general – are vague. Moreover, Altdorfer had no idea how to depict ancient warfare, Persian architecture, women's fashions, and had to rely on familiar landscapes, such as those of the Alps and the Danube. Yet the effect of his choices is to equate past and present, bringing the events closer to the world of the viewer.

● The Persian women in Darius' retine look like ladies from the German court. It is recorded that Alexander captured many of the Persian king's female relatives and courtiers, and that he treated them with respect.

● This is the **crucial moment** as the battle rages: Alexander is about to capture Darius, who attempts to flee in his chariot, looking fearfully over his shoulder. Dead men lie all about.

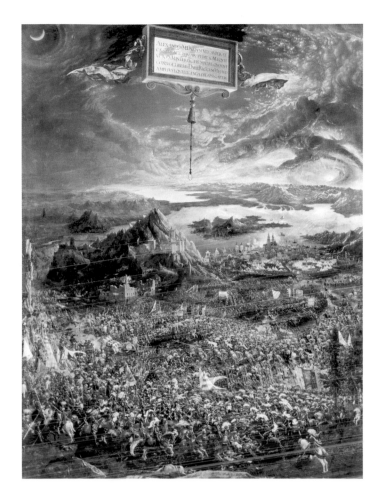

Altdorfer's great interest in the painting of **landscapes** is clear even in a heavily populated work like this. He produced Europe's first autonomous landscapes – that is to say, views free of human figures. In this work he shows us the Mediterranean Sea, beyond which unfolds a so-called 'world landscape' seen in bird's-eye view.

A prominent **notice** is painted above the dramatic scene, suspended at a slight angle between the rising moon and the setting sun. The cord and the ring hang directly over Alexander's head. The Latin text reads: "Alexander the Great defeats the last Darius. Of the Persian army, 100,000 foot soldiers were killed and more than 10,000 horsemen. The fleeing Darius could save no more than 1,000 of his knights. His mother, wife and children were taken prisoner." Several elements in the battle itself are also labelled, including the numbers of troops.

The **city of Issus** looks remarkably European; the Macedonians have pitched camp nearby.

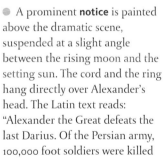

HANS HOLBEIN *Altarpiece of Jakob Meyer or Darmstadt Madonna*

about 1525–6 and 1528–9
Panel, 146.5 x 102 cm
Hessische Hausstiftung, Darmstadt

Jakob Meyer zum Hasen (1482–1530/31), the fabulously wealthy merchant's son and military commander who commissioned this work, was a long-serving burgomaster of Basle. His career came to an abrupt end in 1521, when he was charged with corruption. Eight years later, Protestantism was adopted as Basle's official religion. Meyer, to whom Holbein owed several of the commissions that helped shape his career, is the piously kneeling and praying man on the left. He was a fervent Catholic and his commissioning of this altarpiece was an expression of that intense faith: Mary was, after all, one of the Protestants' chief targets. Here she offers Meyer the tender protection of her cloak – a well-known motif from medieval art ('Virgin of Mercy'). Fortunately, the painting was able to survive the wave of iconoclasm that swept Basle in 1529.

● The scene takes place in the open air, as we see from the stylized **grape vines and fig leaves** against the blue background.

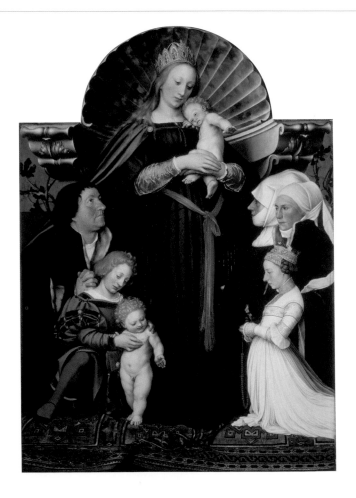

● The woman at the back is **Meyer's first wife**, who died in 1511. **His second wife**, Dorothea Kannengiesser (about 1490–1549?), kneels beside her, while their **daughter Anna** holds a red rosary in the foreground. Her *Jungfrau* hairstyle tells us she is no longer a child. The two women are also holding rosaries.

● The fashionably dressed figure sitting in front of the devout Jakob Meyer is probably **St James the Greater** (Jacobus), after whom the former burgomaster was named. He is identifiable from the pouch on his belt: James was also the patron saint of pilgrims. The naked toddler he is holding is **John the Baptist**, whose presence here is an Italian tradition. The two young saints are painted in an idealized way, unlike the Meyer family. The men are on the left and the women on the right, as was customary.

● With Jesus on her arm, **Mary** strikes an impressive and majestic pose before her throne, with its scallop-shaped canopy.

She is wearing an empress's crown, for in this painting she is *Regina Coeli*, the Queen of Heaven (see pp. 56–7).

● Holbein is indebted in this work to both the Italian Renaissance and early Netherlandish masters like Van Eyck and his followers, who rendered in a highly naturalistic manner.

HANS HOLBEIN *Jean de Dinteville and Georges de Selve*
('The Ambassadors')

1533
Panel, 207 x 209.5 cm
National Gallery, London

Several of Holbein's portraits present a purely tangible, real-seeming world, yet often there is more to them than meets the eye. This example was commissioned by Jean de Dinteville (about 1503–55), whom we see standing on the left. He was sent to England by King Francis I of France as an ambassador to protect the interests of his country. The man on the right is also French; he is Bishop Georges de Selve (about 1508–41), who was in England on a secret mission in the spring of 1533, a time when the English were on the brink of seceding from the Catholic Church. Holbein, meanwhile, had left his native Basle, and was working in London.

● This strange smear is actually a disembodied **skull** that has been highly distorted by extreme foreshortening (anamorphosis). Only if viewed from a sharp angle does its true appearance become apparent (simulated far right). The skull is, of course, the ultimate *memento mori*. All things on earth are transient, including the people and objects in this painting. When we position ourselves so that we can see

the skull as a skull, the other, supposedly realistic objects are in turn distorted. The moral is that death is everywhere and always, but we do not recognize it.

And when we do finally make out its shape, life in turn becomes twisted and blurred.

● The two gentlemen rest their elbows on a piece of furniture known as a 'whatnot', on which **scientific instruments** are laid out. These mark the pair as men of learning, of the kind who were at

that time shaking the foundations of old beliefs. This was, for instance, the age of Copernicus. The objects displayed include a celestial globe and a sundial.

● The presence of the **crucified Christ** behind the curtain (upper left corner) raises this scene to a higher level, as does the skull: despite their status and intellectual activities these remain sinful and mortal human beings, answerable to God.

● The **lute** is a symbol of harmony, but on this instrument a string has broken. This may refer to the increasing discord between Catholics and Protestants in these years. The **hymnbook** is open to texts that do not upset either party and may represent Holbein's plea for a unified Church.

● The **globe** shows Europe in a prominent position, and Africa below it. Even the place in France where Dinteville's castle stood can be made out.

CORREGGIO *Holy Night*

about 1530
Panel, 256 x 188 cm
Gemäldegalerie Alte Meister, Dresden

Correggio was an extraordinarily innovative painter of the early 16th century. His groundbreaking treatment of light and shade was especially influential. In this panel, which has been called the first great nocturnal scene in European painting, the light creates a balance between the busy scene on the left and the quiet joy on the right. Here the birth of Christ becomes a miracle of light (although the motif of Christ as 'Light of the World' was not invented by Correggio). The painting served as an altarpiece in a private chapel in the church of San Prospero in Reggio nell' Emilia.

"That was the true Light, which lighteth every man that cometh into the world."
John 1:9

"I am the light of the world: he that followeth me shall not walk in darkness, but shall have the light of life."
John 8:12

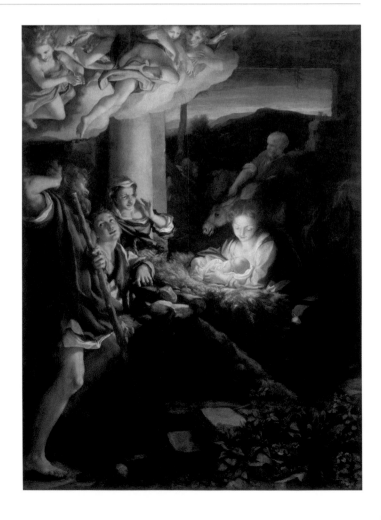

● According to Luke's Gospel, on the night of Christ's birth a band of **angels** appeared to the wakeful shepherds, praising the Lord: "Glory to God in the highest, and on earth peace, good will toward men" (Luke 2:14). The angels are in the clouds; they are bathed in light and form a complex, brilliantly painted tangle.

● This **shepherd**, an imposing figure, is already in the stable, where he beholds the nocturnal miracle with his own eyes. His sheepdog sniffs at the crib.

● One of the two **servant girls** is dazzled by the light. The other seems to share her joy with the shepherd. The light is reflected by the white pillar behind them.

● **Joseph** hardly features in this scene. He is occupied with the ass in the background.

● The newly born **Christ Child** lies in the crib and glows with a bright, seemingly magical, light that also illuminates the face of his happy **young mother**.

about 1490–1534

CORREGGIO *Jupiter and Io*

1532?
Canvas, 163.5 x 74 cm
Kunsthistorisches Museum, Vienna

Members of the social élite in Renaissance Italy eagerly commissioned sensual scenes from Classical mythology (see pp. 176–7, 180–81). Correggio painted a series of four titillating canvases devoted to the erotic escapades of Jupiter, probably for Federico Gonzaga, the Duke of Mantua. In each one, the amorous supreme god takes on a different disguise to seduce his chosen target: he is a swan with Leda, golden rain with Danaë, an eagle with Ganymede and, in this instance, a cloud with Io. Only the latter two stories are recounted in Ovid's *Metamorphoses*. Each of the four paintings is relatively explicit – the act of love is close at hand or already under way, making these some of the most erotic works of the entire Renaissance, even though they never once show a man of flesh and blood. Gonzaga presented this canvas to Emperor Charles V when he visited Mantua.

● The divine cloud embraces the nude Io, who seems enraptured – as instructed, perhaps, by the patron. A flesh-and-blood **hand** can be made out inside the woolly paw around her waist. Unsurprisingly, the painting has put many viewers in mind of the 18th century, when Correggio's ideal of female beauty and the sensual atmosphere of this painting were to inspire many an artist.

● This scene has rarely been depicted in art. For how does one paint a lascivious cloud making love to a woman? Correggio has the disguised Jupiter perform two deeds; here he brings his **mouth**, pursed for a kiss, close to Io's lips. A human face looms in the cloud.

● A **stag** drinks from the water; the meaning of this is uncertain as the animal does not appear in Ovid's version of the story. Perhaps it refers to the fact that Io's father was a river god.

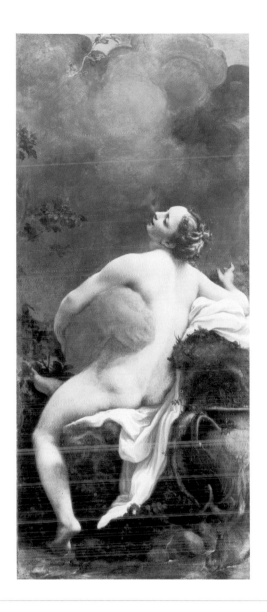

"For now the girl had run;
Through Lerna's meadows and the forest lands
Of high Lyrceus she sped until the god
Drew down a veil of darkness to conceal
The world and stayed her flight and ravished her.
Juno meanwhile observed the land of Argos
And wondered that the floating clouds had wrought
In the bright day the darkness of the night."

Ovid, *Metamorphoses* 1:599–606, trans. A. D. Melville

THE STORY

Jupiter fell in love with Io, daughter of the river god Inachus,
pursued her and raped her in the guise of a cloud (the moment
shown in the painting). To mislead his wife Juno, the god then
changed Io into a heifer, but Juno had the animal guarded by
Argus, who had a hundred eyes. Jupiter ordered Mercury to kill
Argus, upon which Juno unleashed terrifying and maddening
torments on Io, causing her to flee. All ended well, however,
and Io was eventually restored to her original form. She bore
a son, Epaphus, who was thought to be Jupiter's child. Ovid
describes the episode shown here by Correggio in a few brief
verses (see above).

MAARTEN VAN HEEMSKERCK *St Luke Painting the Virgin and Child*

1532
Panel, 168 x 235 cm
Frans Halsmuseum, Haarlem

Paintings on this theme were commissioned in the 15th and 16th centuries by Guilds of St Luke – painters' corporations – to decorate their altars in local churches. The gospel-writer Luke, who was their patron saint, is shown painting the portrait of the Virgin Mary and the Christ Child. According to medieval legend, Mary appeared to him several times for this purpose (see p. 42). Van Heemskerck presented the work to the Haarlem painters' guild, for its altar in the church of St Bavo. The gift marked his departure for Italy, where he was to spend the next five years.

● A Haarlem baker is said to have posed for the Luke figure, which is a little odd for a saint with a reputation as a scholar. He is an older man, wearing a pince-nez and a red cap. The side of his seat is decorated with a **relief**, which Van Heemskerck uses to incorporate St Luke's customary attribute – a bull.

● This curled-up **sheet of paper** contains a poem in which Van Heemskerck's colleagues thank him for his gift.

● The muscular man behind the painter is wearing a **laurel crown**. He gestures with his arm, looks over the artist's shoulder and seemingly wants to lend a hand; Van Heemskerck probably intended him to personify Inspiration.

● An unusual and high-spirited detail in this panel is the front leg of the chair on which Mary sits, which is decorated with a striking face at the top and a large **bird's claw** at the bottom. In this otherwise bare studio interior, the torch is held up by an angel and the top of the easel is surmounted with a male head. Even the pose of the Christ Child is out of the ordinary.

PARMIGIANINO *The Madonna with the Long Neck*

1532–40
Panel, 216 x 132 cm
Galleria degli Uffizi, Florence

Parmigianino is one of those odd painters of the mid-16th century who stray from the conventional, Classical norm and are known under the vague, generic name of 'Mannerists': artists with refined, idiosyncratic mannerisms. This unusual Madonna is the final important (and notorious) painting by an artist who died aged only thirty-seven. The unnaturally elongated bodies and body parts we see here were a conscious choice of the painter, even though they prompted one critic to call the work a 'fairground mirror'. Nor is the composition any more harmonious: a group of angels is crammed into a corner on the left, while the space on the Madonna's opposite side is populated solely by a pillar and a tiny human figure.

● Mary has a remarkably long **'swan neck'**, while her fingers, foot and the whole of her slender figure have been accorded the same treatment. Elegance is synonymous here with artificiality. The sleeping Christ Child has been stretched, too.

● Like the mother and child, this little figure has also been oddly elongated; a tall, slender man – possibly **St Jerome** – he is shown unrolling a scroll of parchment.

● The **egg-shaped vase** has tempted some to interpret the panel symbolically; Parmigianino is known to have been interested in alchemy and this knowledge has prompted speculation that the vase represents the crucible in which alchemists sought to transform base matter into gold. Others see the shapely object as proof of the artist's literary inspiration: in poetry, the shoulders, neck and head of a woman were sometimes compared to a perfect vase.

● The **column** in the background is likewise strange and unusually tall, seemingly emphasizing the fact that elongated shapes are indeed part of the artist's deliberate plan. He is being unconventional on purpose, stepping away from the Classical definitions of beauty and creating something unexpected. There is something very modern about this calculated pursuit of effect and straying from the beaten path.

TITIAN *Assumption and Coronation of the Virgin*

1518
Panel, 690 x 360 cm
Santa Maria Gloriosa dei Frari, Venice

Two days after her death, Mary is said to have risen from the tomb over which the Apostles were holding vigil and to have been carried up to heaven. The story of the Assumption does not come from the New Testament, but from unofficial, so-called 'Apocryphal' Christian texts from the 3rd and 4th centuries. It was a popular theme in art, especially in churches dedicated to the Virgin. The key details of the episode determined the way it was presented: with the Apostles standing at the bottom, Mary being borne aloft by angels and, in some cases, God awaiting her arrival at the top. Titian observes this three-way split between earth, sky and heaven, producing a scene rich in emotion in which the three zones are linked to one another by movement, gazes and above all gorgeous colour.

● **Mary** looks up towards heaven, holding out her arms. She is bathed in a powerful, golden, heavenly light that resembles a gigantic mandorla. The gold that surrounds Mary's figure and expresses the supernatural character of heaven recalls the background of Byzantine icons.

LATE RECOGNITION

The Assumption has been celebrated as a holiday for centuries. It became especially well established in the Catholic calendar during the Counter-Reformation, with its heavy emphasis on the cult of the Virgin. Even so, it did not become an 'article of faith' for Catholics until 1950.

SHOCK

This altarpiece – the largest ever painted in Venice – was intended to catch the eye at a distance of about a hundred metres. Titian's patrons, the monks of Venice's church of Santa Maria Gloriosa, were initially shocked by it, yet this Assunta *was to establish the then twenty-eight-year-old artist's reputation.*

● **God**, floating on high, is a severe, elderly man who inevitably makes us think of Michelangelo. The **cherub** hovering by his head holds Mary's crown, ready for her coronation.

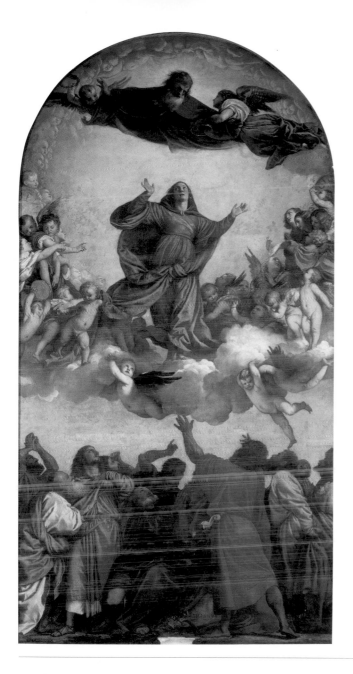

● Christ ascended to heaven by himself, but his mother is said to have been **carried** there **by angels**. The angelic mass in Titian's painting plays music and pays homage to Mary.

● The **Apostles** react intensely to the events they are witnessing, gesticulating and tangling with one another within the space. The two wearing red cloaks in the foreground guide the viewer's eye up towards Mary.

TITIAN *Bacchus and Ariadne*

1520–23
Canvas, 172.2 x 188.3 cm
National Gallery, London

The Duke Alfonso d'Este ordered a set of five paintings to decorate a small private room in his palace in Ferrara, including three by Titian, and Bellini's *Feast of the Gods* (see pp. 116–17). The series is a high point in Italian Renaissance art. The subjects are closely related: all of them are erotically tinged, inspired by Classical mythology and feature Bacchanalian scenes. Titian's mastery of colour, composition, movement and powerful imagery is brilliantly displayed in this unprecedented *tour de force*.

● The **starry crown** over Ariadne's head is a future gift from her soon-to-be-husband Bacchus: after her death he saw to it that her golden crown, a wedding present, was fixed to the heavens as a constellation.

THE STORY
Ariadne, daughter of the King of Crete, abandoned her home to follow the Athenian Theseus, with whom she had fallen in love. Although she helped him escape the labyrinth of the ferocious Minotaur on Crete, Theseus callously abandoned her on the island of Naxos; fortunately, a new and besotted lover then entered her life, in the shape of the god Bacchus.

"She, then, pitifully looking out at the receding boat, / wounded, was spinning convoluted cares in her mind. / Then came swooping from somewhere Bacchus in his prime / with his cult of Satyrs, with his mountain-born Sileni, / seeking you, Ariadne, aflame with love for you. / Then too came raving, … the Bacchantes … Some brandished ivy spears with leafy points. / Some tossed pieces of a ripped-apart bullock. / Some wreathed themselves with coiled snakes. / Some with deep baskets / were celebrating mysterious rites, / … / Others were striking drums, their palms raised high / or were stirring shrill chimes with polished brass cymbals. / …"
Catullus, *The Wedding of Peleus and Thetis*
64:249–264, trans. T. Banks

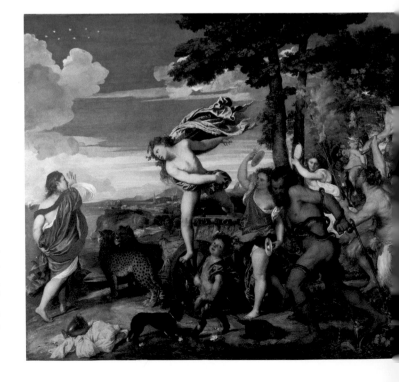

• **Ariadne** reaches out her hand to the now barely visible ship of her beloved Theseus, who left her while she was sleeping. She seems on the verge of walking away as she looks with surprise into the eyes of Bacchus, whom she is seeing for the first time.

• The infatuated **Bacchus**, god of wine and intoxication, leaps from the chariot that has brought him to Naxos in what is an unforgettable freeze-frame pose. He is in the riotous company of satyrs and maenads, who carry the symbolic attributes of his cult. The Roman poet Catullus described the scene as Titian painted it here.

• The **satyr** is wreathed in grapevines, as is his stick. He waves a bull's leg and the bacchante waves a tambourine. The two exchange glances, mirroring Ariadne and Bacchus. The bronzed strongman in front of them who seems to be wrestling with a snake is one of those who "wreathed themselves with coiled snakes" (Catullus).

• This mischievous **baby satyr** – half human, half goat – in the mid-foreground, seems to be leading the procession. The child is the only figure who looks out of the canvas. He wears a garland on his head and drags a calf's head behind him. The black dog at his feet barks at all the commotion.

• The **two cheetahs** have pulled Bacchus' chariot here. They stand and wait serenely, the only ones in this canvas to do so.

• The grotesquely fat **Silenus**, Bacchus' foster-father and leader of the satyrs, is sleeping off his hangover, still on his donkey. His companions have to support him to prevent him falling off.

TITIAN *'Venus of Urbino'*

1538
Canvas, 119 x 165 cm
Galleria degli Uffizi, Florence

A young woman poses nude in an interior, her left hand concealing her genital area, while her other hand gently grips a small bouquet of roses. She looks the viewer in the eye. The space she occupies is partially screened off from a second room. Titian is plainly referring in this canvas to the Giorgione *Venus*, on which he collaborated around 1510 (see pp. 140–41). Titian's 'Venus' may have been intended for the bridal chambers of the young Duke Guidobaldo della Rovere and his wife Giulia da Varano in Urbino's ducal palace.

NUDES

Reclining nudes – male at first, and later also female – date back to Classical Antiquity. The theme of a room with a female nude and another person (in this case the viewer) looking on derives from literary tradition, where examples can once again be traced back to the Greco-Roman era. In the first half of the 16th century, physical beauty, eroticism and sexuality became widespread artistic themes – a new development, culturally as well as socially.

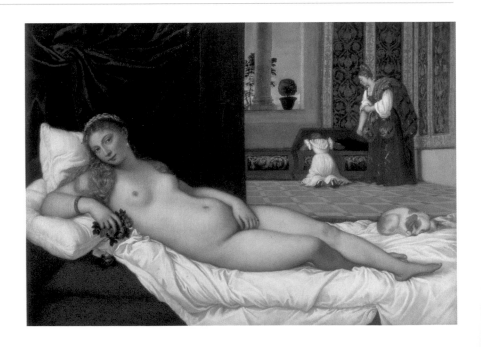

This **woman** is awake, lying on a bed indoors, wearing jewellery and holding a posy of roses. She certainly looks as though she belongs to our world – a courtesan perhaps. Giorgione's sleeping Venus, by contrast, is timeless. Erotic scenes like this in varying degrees of explicitness were common in the 16th century (see pp. 168–9, 176–7). They were intended to create an arousing atmosphere in bedrooms and bridal chambers, and were even believed to increase fertility.

Titian has painted this **dog** in more or less the same spot where Giorgione (or perhaps Titian himself?) had placed Cupid (see p. 140). The animal also makes an appearance in a portrait he made of Eleanora Gonzaga, the mother of patron Guidobaldo, that same year. Dogs are a well-established symbol of fidelity.

Two **maids** are taking clothes out of a couple of chests. Bridal chests (cassoni) like these were painted with narrative scenes and the inside of the lid often depicted a nude man and woman. One might say that the woman reclining in the foreground of Titian's work corresponds with the images that appeared under the lids of the chests.

The special shape of the room's **window**, with the column in the middle, is also to be found in a drawing of the ducal palace in Urbino, possibly confirming the work's destination. The myrtle tree is a symbol of eternal commitment.

TITIAN *Venus and Adonis*

1554
Canvas, 196 x 207 cm
Museo Nacional del Prado, Madrid

We know of several dozen versions of this narrative theme – one of Titian's favourites – painted by the artist himself, his workshop or his followers. This one, which is generally considered the best, was executed for King Philip II of Spain as one of a series of eight *poesie* – visual poems on mythological themes.

The goddess of love, Venus, tries to prevent her mortal lover Adonis from setting off on the hunt. She is afraid – rightly as it turns out – that the trip will prove fatal. (For the full story, see p. 208). Titian's interpretation of the story was entirely new.

ARTISTIC LICENCE
Titian will have known the story of Venus and Adonis from Ovid's Metamorphoses *and its many contemporary translations and adaptations. However, he deviates from Ovid's version in this scene in order to make it more attractive and arresting. The Roman poet states, for instance, that Venus left* before *Adonis set off on the hunt.*

● The nude **Venus** pleads with **Adonis** who, spear in hand, is about to leave; his hunting dogs strain at the leash. There are several precedents for this Venus seen from behind, including Correggio's *Io* (p. 169) and reliefs from Classical Antiquity.

"The Danaë which I already sent Your Majesty was viewed entirely from the front. For that reason, I sought in this new poesia to bring variety and to show the rear of the body. That will make the chamber in which they will hang all the more pleasant."

Titian to Philip II

● Venus has already taken to the air in her **flying chariot**. Titian has turned the traditional swan-drawn version described by Ovid into a chariot drawn by doves – birds associated with love by the Ancients. A ray of light falls on the barely visible Adonis, who has been fatally wounded. Titian has included the two key moments in the story: Adonis' departure and his death.

● **Cupid**, Venus' arrow-firing little son, is the 'third party'. He is not directly involved, however, and has even fallen asleep: his work accomplished, he has hung his bow and arrow in the tree. Alternatively, his pose could suggest that Adonis 'has not been hit by Cupid's arrow' and is therefore not in love with Venus. According to Ovid, Venus fell in love accidentally, having scratched herself on one of Cupid's arrows.

LORENZO LOTTO *The Annunciation*

about 1527
Canvas, 166 x 114 cm
Pinacoteca Civica, Recanati (Marche)

In this altarpiece Lotto offers an original variation on a familiar theme; he does not, however, stray from Luke's Gospel – the only one to describe the Archangel Gabriel's announcement to the Virgin Mary. The angel, Luke explains, was "sent by God" and the Virgin was "much perplexed" at his words and did not understand the meaning of them. Luke's text is Lotto's point of departure for this Annunciation, in which the artist's powers of psychological observation are clearly displayed.

● **God the Father** appears to direct his angel, while Lotto has omitted the dove that usually represents the Holy Ghost in Annunciation scenes.

MOBILE HOME

The painting was done for a church in Recanati, near the Italian city of Loreto. According to legend, the house where Mary received her glad tidings was miraculously transported from Nazareth to Loreto in 1291, just as the Holy Land was being threatened by Muslims. The Basilica of Loreto became a place of pilgrimage.

● A diffident and startled **Mary** turns away from the messenger with his astonishing news. She looks out of the canvas at the viewer, as if appealing for our advice and involving us in the mystery, all of which emphasizes her humility. Apparently Mary had been reading the Bible on a *prie-dieu* – a traditional motif – when she was surprised by the angel.

● A **cat** flees the arrival of the other-worldly intruder. The startled animal has been taken as a metaphor for a terror-struck Satan, but the detail may just as easily have been inserted to give this supernatural scene a familiar and even comic touch.

● The orderly Italian **grounds** outside is an enclosed garden, a *hortus conclusus* – a long-established symbol of Mary's purity.

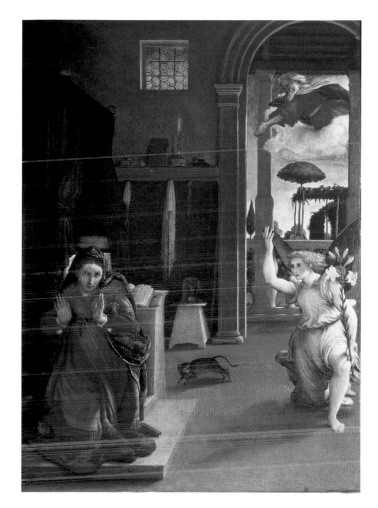

● The interior is sober and calm, unlike the vehement gestures of the two protagonists. The row of neatly ordered **objects** is painted with a detailed realism, reminiscent of the Flemish art of the time; we can almost make out the grains of sand as they fall in the hourglass.

● Gabriel traditionally holds a **lily** as he greets Mary as a symbol of the Virgin's purity.

AGNOLO BRONZINO *An Allegory with Venus and Cupid*

about 1540–50
Panel, 146.5 x 116.8 cm
National Gallery, London

In allegorical paintings the characters each represent a certain quality, perhaps a vice or virtue. Sometimes these characters are easy to interpret, often because of a specific 'attribute' that appears with them; sometimes they are quite deliberately obscure, forming part of an intellectual game. This painting by Bronzino has its share of open questions. We can safely conclude that the theme is erotic, with a dark undercurrent, and that the artist emphasizes the work's dual message with a refined, 'Mannerist' approach. Besides being a painter of note, Bronzino was also a celebrated poet.

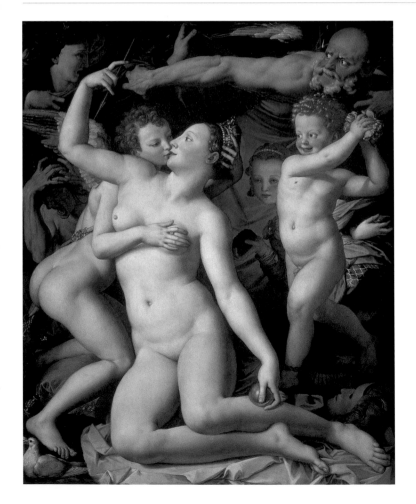

● The **figure with its head in its hands** could be Jealousy or Despair, while the head staring vacantly in the upper left corner represents **Folly**. She tries to draw the curtain, to obscure the idyllic scene from Father Time.

A ROYAL GIFT

Bronzino was court painter and portraitist to the Medici.
This painting was a gift from them to King Francis I of France,
who was known for his love of refinement and eroticism. That may
provide us with certain clues to help us read the image.

● The central female figure
– not to mention the central
theme – is **Venus**, representing
love. Her milky skin reflects
the Renaissance ideal of beauty.
The golden apple she holds
in her left hand is her standard
attribute. According to Classical
mythology, she was presented
with the fruit, inscribed with
the words "To the fairest", by the
Trojan Paris. Venus is embraced
by Cupid, her winged son.
The arrow in her right hand is
Venus' weapon of choice, as well
as Cupid's.

● The winged, bronzed and
muscular man is **Father Time**,
identified by his hourglass. Time
– old and bearded – is the natural
enemy of fresh, young love.

● **Masks** and disguises are
often used as symbols of deceit
and hypocrisy. Has love been
unmasked?

● The blushing, laughing **boy**
with the mop of curls is about
to scatter roses, the flower most
closely connected with the Roman
goddess Venus. Its thorns were
associated in the Renaissance
with the pain that love can cause.
This little boy symbolizes the
foolish and happy side of love.
The hands of the hybrid character
with the falsely angelic face,
standing behind the boy, are the
wrong way around. This is **Deceit**.

● The **dove** has been
an emblem of love since
ancient times, and as such
is an attribute of Venus.

about 1525–1569

PIETER BRUEGEL *Mad Meg*

1562
Panel, 115 x 161 cm
Museum Mayer van den Bergh, Antwerp

With its ruined buildings, monstrous creatures, skirmishes, weird vessels and scorched, glowing horizon, this painting seems like a vision of hell unleashed. In the midst of the chaos, an oversized and manic-looking woman strides purposefully across the foreground; this is 'Dulle Griet' or 'Mad Meg', whose insanity was synonymous in Bruegel's day with evil. This is a didactic painting in the best Flemish tradition: its various incidents and figures illustrate a larger, central theme, but every opportunity to heighten the strange atmosphere is seized with gusto.

● **Mad Meg** was a familiar figure in the comic plays performed in Bruegel's time, in which she represented evil or shrewish women. The character developed from stories about the popular St Margaret, who was said to have outwitted a dragon. The dragon was a demon and in some versions Margaret herself was presented as a malevolent figure. Bruegel may also have been alluding to the expression 'robbery before the gates of hell', which was used to describe someone trying to profit from a situation in a particularly audacious or venal way. That is what Mad Meg is doing here; sword in hand, she carries away her collection of loot.

● Following Meg's example, other, smaller female figures on the **bridge** are successfully beating and restraining the monsters and demons, some of which they tie to cushions, echoing another old proverb.

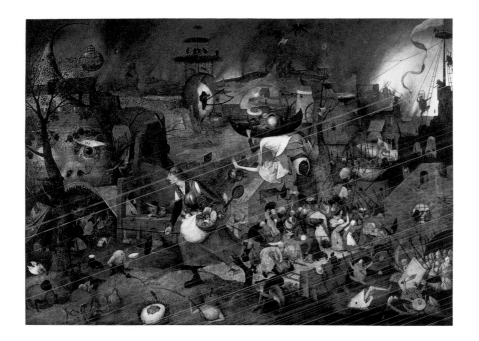

The **mouth of hell** resembles the maw of a whale – a common late-medieval motif. Although a traditional figure, this incarnation is far from the all-devouring orifice we find in other paintings: Mad Meg is the chief personage here, not Satan. In any event, she does not seem to be intimidated by the nearness of the gates of hell.

This **fantastic being** is as disproportionately large as Meg herself; he scoops coins out of his egg-shaped behind and tosses them to the crowd below. 'Dishing it up with a big spoon' was an expression meaning to live a life of luxury. The figure carries a boat containing several smaller figures who squander and fight over their supplies.

Mad Meg's greed and this prodigality are equally sinful forms of behaviour.

PIETER BRUEGEL *Netherlandish Proverbs*

1559
Panel, 117 x 163 cm
Staatliche Museen zu Berlin –
Preussischer Kulturbesitz,
Gemäldegalerie

Proverbs were extremely popular in Bruegel's century: collections of them were published and they were illustrated in a variety of media. People loved their double meanings and the values they conveyed. Bruegel's painting is the first visual representation of what is basically a Land of Proverbs; he crammed about a hundred of them into this composition. Many of the participants here have Bruegel's characteristically vacant or witless faces.

● The **world** here has been turned **upside down** and this rascal defecates on it for good measure (he hates everything).

● The painting's old title, '**The Blue Cloak** or the Folly of the World', tells us that there is more going on here than just a catalogue of disconnected proverbs. By placing a blue, hooded cloak on her husband, the woman in red acts out a proverb that tells us she is cheating on him. Deception, sinfulness and absurd human behaviour are the central themes of Bruegel's work. Several of the depicted proverbs show a world bound up with deceit and being deceived, and with concerns that lack any sense.

In front of the couple with the cloak, a man fills in a pond, even though the calf has already drowned; while behind them, people variously 'carry the daylight in a basket' (waste their time), 'hold a candle to the devil' (flatter everybody indiscriminately) and 'confess to the devil' (reveal secrets to an enemy): all things that only a fool would do.

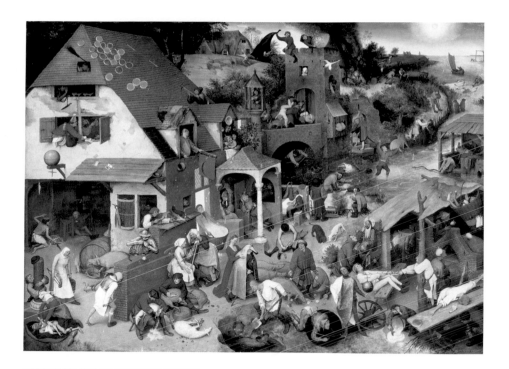

● A **pillar-biter** is a hypocrite, while a woman who carries fire in one hand and water in the other is not to be trusted.

The man **'belling the cat'** is also 'armed to the teeth'.

The **figure standing in the river** can't bear the fact that the sun is shining on the water: in other words, he is jealous of his neighbour's success.

And the **monk** tying a flaxen beard to Christ – also clad in blue, like the cuckolded man beneath the cloak – is another hypocrite.

● Bruegel's paintings tell us a great deal about the everyday lives of ordinary men and women in the 16th century. This **toilet** is typical of the time. It is used by two people at once, who 'defecate through the same hole', signifying that they are bosom buddies. The privy hangs over the water, into which people would relieve themselves directly.

PIETER BRUEGEL *The Census at Bethlehem*

1566
Panel, 115.3 x 164.5 cm
Musées Royaux des Beaux-Arts
de Belgique, Brussels

Some themes, religious or otherwise, lend themselves perfectly to paintings that are first and foremost contemporary landscapes, with only limited space given to the ostensible subject. This panel is a good example. We look down from a high vantage point onto a Brabant village set in a snowy landscape. The scene is populated with dozens of small figures – adults and children at play or engaged in everyday winter occupations. A crowd has gathered outside the inn in the lower left...

● **Joseph**, pointing the way, and a heavily pregnant **Mary** approach the inn with their ox and ass; he carries a basket containing his carpenter's tools.
The theme of the census called by the Roman emperor Augustus and described in Luke's Gospel is an extremely rare one in art. Joseph and Mary were obliged to travel from their home in Nazareth to Bethlehem, the city of Joseph's ancestor David. The events are set in winter because Christ was born in Bethlehem on 25 December. Perhaps the child will be delivered in the somewhat ramshackle little structure right from the centre, as suggested by the cross on its roof.

● This will have been a familiar scene in Bruegel's time: people congregating to pay their **taxes**. One man behind the table collects the money, while his colleague records the payments. We know this is an inn because of the wreath hanging over the window and the jug next to the door, both of which advertised a public house. A pig is slaughtered in the foreground to feed the travellers.

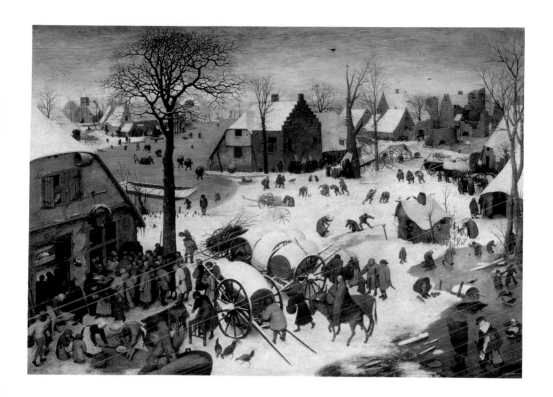

● Bruegel may have been inspired by the exceptionally harsh winter of 1564–5, a year before this panel was painted. People warm themselves by a **fire** in front of a stone house, a **hollow tree** serves as an impromptu tavern, and children play in the snow.

● **A house is being built** in the foreground in front of **derelict buildings** reminiscent of fortifications; details like this have prompted some to interpret the ruins in the panel as a symbol of the old beliefs that must now make way for the new with the birth of Jesus Christ the Saviour.

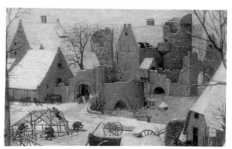

PIETER BRUEGEL *The Wedding Dance*

1566
Panel, 119.4 x 157.5 cm
The Detroit Institute of Arts

There are about 125 guests at this open-air wedding party in the country. People dance in a semicircle in the foreground, while others talk, drink and flirt in small groups in the background. Musicians in the bottom right corner provide the atmosphere. Typically for Bruegel, everybody here is a type – some are even caricatures – rather than an individual. The scene initially appears confused and chaotic, yet on closer inspection the composition turns out to be carefully structured.

● The exuberant atmosphere is having an all too conspicuous effect on the **dancing men**. Waving your arms and legs around like this was considered indecorous in Bruegel's time, as was laughing too heartily. This is more, then, than simply a painted report of the wedding festivities. The depiction of human instincts and inappropriate behaviour – gluttony, heavy drinking and all manner of physicality – is generally intended in a moralizing or satirical way. In this instance, the city-dwelling Bruegel is censuring the excesses of country weddings and fairs. It was Hieronymus Bosch, around 1500, who first established the rural wedding as a popular theme for both painters and poets, reinforcing townspeople's image of themselves as decent and restrained.

● This somewhat **mysterious man** stands back and observes with an enigmatic half-smile on his lips. Writing instruments hang from his belt, which suggests that he may be an intellectual of some kind, casting a wry gaze – similar to Bruegel's – over this dissipated scene.

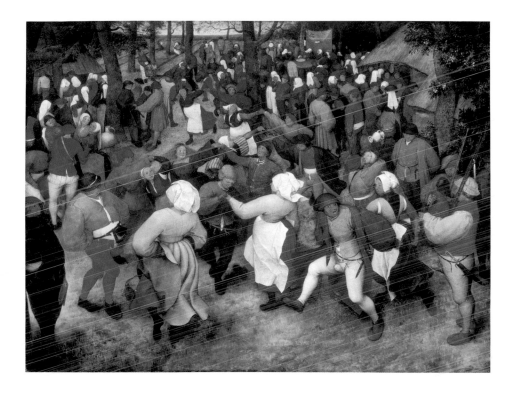

This is the **bride**; her head is uncovered and she is dancing with a man who looks older than her, possibly her father. She seems to be more controlled in her movements than the guests in the foreground.

This is the table where the bride was sitting before getting up to dance. There is a **crown** above her seat and a **cloth of honour** behind it.

JOACHIM BEUCKELAER
and/or workshop

Market Scene

1567
Panel, 149 x 215 cm
Koninklijk Museum voor Schone Kunsten,
Antwerp

Market and kitchen scenes began to appear around 1550 and remained a popular genre in the Low Countries for the following century. Painting many different types of fruit and vegetables, as in a still life, allowed artists to demonstrate their technical virtuosity. Works of this type convey the new sensuality of the Renaissance, as well as a curiosity about all that God's nature has to offer. At first glance, such displays are primarily an expression of prosperity, yet there can be more to them than meets the eye.

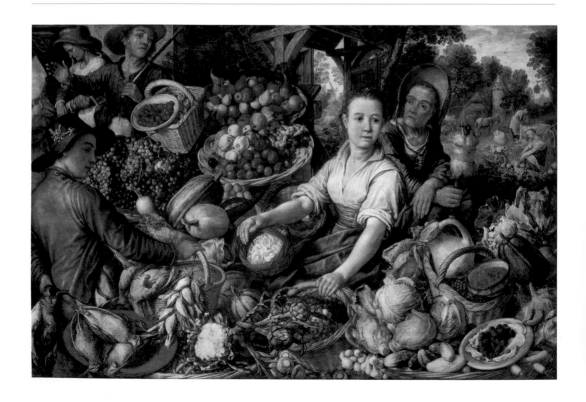

● The apparent realism of this feast of colour and shapes is deceptive. What we see here could never have appeared on a 16th-century market at the same time: **cherries**, for instance, were picked in the early summer, **grapes** in September and **cabbage** was harvested in the winter. What is more, many of the fruits and vegetables shown were considered to be aphrodisiacs, or else their names were used in everyday language as sexual euphemisms. In the literature of the time, 'sweet fruit' was always just a hop and a skip away from 'sweet love'…

● The **old woman** behind the **young fruit seller** may be a procuress; the meaning of her spindle is unclear. The body language of the two young people reveals their attraction, in the way they studiously avoid each other's glances. Although we can never be certain, it is widely held that Beuckelaer's images of sensual abundance were intended as a symbolic warning against immoral behaviour.

● The figure on the left is a **fowler** or bird-catcher, the Dutch word for which – *vogelaar* – also meant 'womanizer'. His hat is decorated with the badge of a militia company featuring crossed arrows, possibly a reference to Cupid. His wares include ducks, snipes, tits and partridges; the latter especially was thought to be a very lewd bird.

PIETER POURBUS *Portrait of François van der Straten*

1567
Panel, 68 × 53.5 cm
Museum Mayer van den Bergh, Antwerp

Pieter Pourbus' sitters expected him – and his colleagues – to paint their portraits in such a way as to highlight their social identity; works like this are not, therefore, intended as psychological studies. They show instead the position held, or aspired to, by the sitters – in Pourbus' case, mostly prominent citizens of Bruges. This explains the emphasis on the way the person is presented – the coat of arms, clothes, jewellery, pose and so forth. Nevertheless, such portraits were based on drawings from life: the people they show did indeed sit for them.

"Rejoice, O young man, in thy youth, and let thy heart cheer thee in the days of thy youth, and walk in the ways of thine heart, and in the sight of thine eyes: but know thou, that for all these things God will bring thee into judgment. Therefore remove sorrow from thy heart, and put away evil from thy flesh: for childhood and youth are vanity."

Ecclesiastes 11:9–10

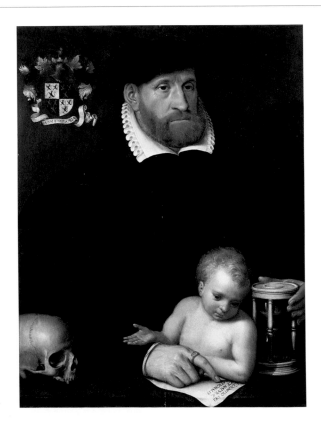

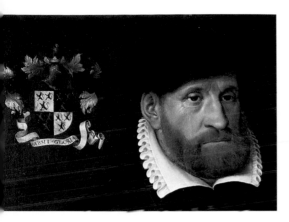

● In his left hand, Van der Straten holds an **hourglass**, another symbol of transience. The *vanitas* portrait – all earthly things are fleeting and vain – had a long tradition. In this instance, Pourbus took his cue from a 1537 print featuring a quotation from Ecclesiastes (see opposite) that perfectly suits Van der Straten's would-be humble motto.

● The lawyer, city councillor and burgomaster **François van der Straten** – the inscription (top right) dates the portrait to 1567 and states the sitter's age as fifty-five – poses against a neutral background. He gazes into the middle distance, which creates an impression of aloofness. His coat of arms is shown to the left – three lions in the four quarters and his motto below – seemingly suspended in the air. '*Absit gloria*' means 'Not for the glory'; the man wishes to be seen as a modest administrator.

● The **skull** is a symbol of ever-present death; the naked child on the man's lap points towards it while focusing on the text, a grown-up expression of melancholy on its face. The different elements form a seamless whole that expresses the Latin idea *Nascendo morimur*: "We are born to die". Van der Straten points to a Latin text: *Cognitio dei et naturae rationalis* (Knowledge of God and of rational nature); it is such knowledge that makes him the modest man he is.

JACOPO TINTORETTO *St George and the Dragon*

about 1555–58
Canvas, 157.5 x 100.3 cm
National Gallery, London

Tintoretto was a Venetian painter of unusual – and in some cases even eccentric – compositions that are full of drama and tension. This work is a prime example of his approach. A heroic act is taking place, but is confined to the middleground, while the foreground is given over to a princess who flees in our direction. Tintoretto is less concerned with a perfect finish than with dramatic impact. His characteristically strange colours heighten the theatrical effect, as do the high horizon and the high vantage point adopted by the painter. The canvas was probably done as a private commission.

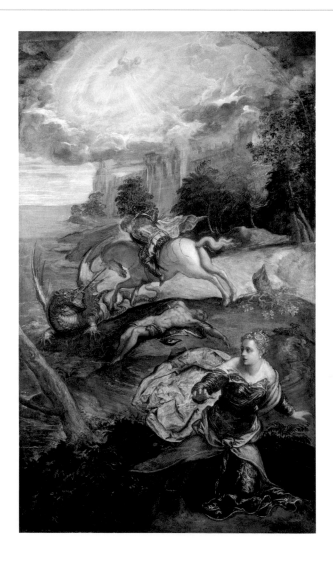

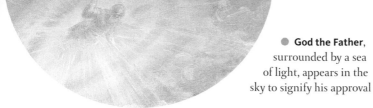

● **God the Father**, surrounded by a sea of light, appears in the sky to signify his approval of George's deed. The silver-grey outlines of a city can be made out below him.

THE STORY

The martyr St George was a soldier saint who lived in the 3rd century. According to a medieval romance, he killed a venomous dragon in his native Cappadocia in Asia Minor (modern-day Turkey), in order to save the princess who was to be sacrificed to the monster – a familiar motif deriving from Greek mythology. The story functions as an allegory of a real historical event – Cappadocia's conversion to Christianity, partly through George's influence. This was visualized as the killing of a dragon, representing Satan and heathenism, with a spear. The woman, meanwhile, stood for the region and its cities that had been 'saved'. As knowledge of this symbolism faded, the story of the princess and the dragon took hold. A hybrid version of the tale also existed, in which George's dragon-slaying persuaded the heathens to convert or else was made a precondition of his heroics. George is the patron saint of Venice (among many other places).

● **George**, mounted on a white charger, is just about to kill the dragon by driving his lance into the beast's maw. The battle takes place on the seashore, while one of the creature's earlier victims lies dead nearby, the position of his corpse recalling the crucified body of Christ. Thanks to George, the princess has narrowly managed to escape death.

● The **princess** is running away from the violent scene in the direction of the raised position of the painter (and the viewer). The colours of her magnificent clothes are echoed in the principal action in the middleground.

199

JACOPO TINTORETTO *Christ at the Sea of Galilee*

about 1575–80
Canvas, 117.1 x 169.2 cm
National Gallery of Art, Washington DC.
Samuel H. Kress Collection, 1952.5.27

Depending on which Gospel we read, Christ appeared one or more times between his Resurrection and Ascension to heaven. John's Gospel states that one such occasion occurred at the Sea of Galilee (see pp. 50–51). Tintoretto's rendering of the scene provides a striking illustration of the painter's considerable originality, and not only in relation to his colleagues in Venice. The closest comparison, stylistically, is with El Greco, who did indeed get to know Tintoretto's work in Venice.

● **Christ** stands in the foreground; he is a gigantic figure compared to the tiny fishermen. His outstretched arm seems to suck Peter from the boat.

● "Now when **Simon Peter** heard that it was the Lord, he girt his fisher's coat unto him, (for he was naked,) and did cast himself into the sea" (John 21:7). Tintoretto opts for the moment in John's account where Peter realizes that the man on the shore is the risen Christ.

● A hard wind is blowing (look at the sail and the mast bending under its pressure), the clouds are low and menacing and powerful waves disturb the lake's surface; like the strange light, these **natural elements** intensify the curious atmosphere in which the miraculous episode takes place, adding to its dramatic power. John's Gospel makes no mention of any such unusual weather conditions.

JACOPO TINTORETTO *The Crucifixion*

1565
Canvas, 536 x 1224 cm
Scuola di San Rocco, Venice

The tension and sense of tragedy that are central to Tintoretto's work reach a peak in this gigantic canvas, measuring more than twelve metres across; the figures in the foreground are larger than life-sized. The devoutly Catholic painter set out to elicit maximum emotion from the viewers of his religious works. He was active at the height of the Counter-Reformation, at a time when the Church was reasserting its authority in the face of Protestant reform. Tintoretto painted this *Crucifixion* for a Venetian confraternity – an association of lay people devoted to charitable works. Organizations like this had their own buildings (known in Italy as *scuole*), which they decorated richly. This spectacular panorama shows the moment at which the three crosses were raised on Golgotha.

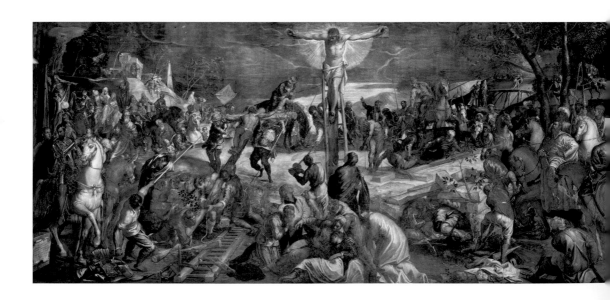

● The three crosses also illustrate different moments in the crucifixion process. The **'bad thief'**, on Christ's left, is still being bound to his cross. He turns his back on Christ, recalling his mocking words in the Gospel: "Are you not the Messiah? Save yourself and us." A man in the foreground digs the pit into which his cross will be set.

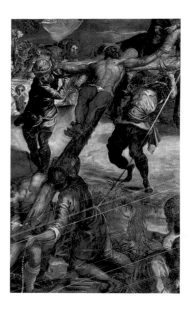

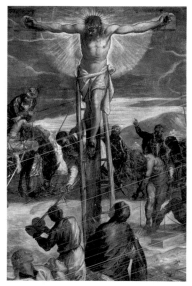

The **crucified Christ** rises high above the mass of people on the ground. He forms the central point of the scene and is surrounded by a heavenly light that illuminates the space in front of him. All the rest is dark, as described in the Gospels. Jesus is about to be offered a sponge soaked in vinegar to quench his thirst. The man on the mule behind him is the centurion who will shortly stab his lance into Christ's side.

A second cross is being raised; on it we see the **'good thief'**, who showed faith and

remorse before he died, symbolized here in the way he gazes at Jesus.

The figures closest to the viewer are, appropriately, the **mourners** around Christ's cross; they show us how we ought best to respond to what we are witnessing. The remainder of the large crowd reacts with indifference to the executions.

Crouching in a corner, as if in shame, **soldiers throw dice** for Christ's clothes (John 19: 23–4).

PAOLO VERONESE *The Marriage at Cana*

1562–3
Canvas, 666 x 990 cm
Musée du Louvre, Paris

This wedding scene resembles a gigantic theatre performance, the scenery made up of imposing Classical architecture and the stage peopled by dozens of actors on several different levels. In the foreground, Christ sits at the centre of a richly laid-out table, his mother at his side. The wedding guests are dressed elegantly in the Venetian style. In this large canvas, Veronese offers his interpretation of the Marriage at Cana where, according to John's Gospel, Christ performed his first miracle. The result is a scene full of grandeur and visual pleasure – especially in the colours. Appropriately, the painting was executed for the refectory of the Benedictine abbey of San Giorgio Maggiore in Venice.

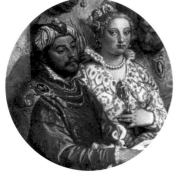

● The actual **bride and bridegroom** are banished, as it were, to the margin of the scene, while the serene figure of **Christ** sits at the centre of the composition, surrounded by the bustle of the other guests. His position and that of his mother suggest that they are actually the focus of the celebration. Their simple clothes contrast markedly with the luxury all around them.

THE STORY
John's Gospel records that Mary, Jesus and his disciples were invited to a wedding in Cana. In the course of the celebration, the wine ran out and Mary advised the servants to do whatever Christ told them:
"Jesus saith unto them, 'Fill the waterpots with water'. And they filled them up to the brim. And he saith unto them, 'Draw out now, and bear unto the governor of the feast'. And they bare it. When the ruler of the feast had tasted the water that was made wine … the governor of the feast called the bridegroom … This beginning of miracles did Jesus in Cana of Galilee, and manifested forth his glory; and his disciples believed on him"
(John 2 : 7–11).

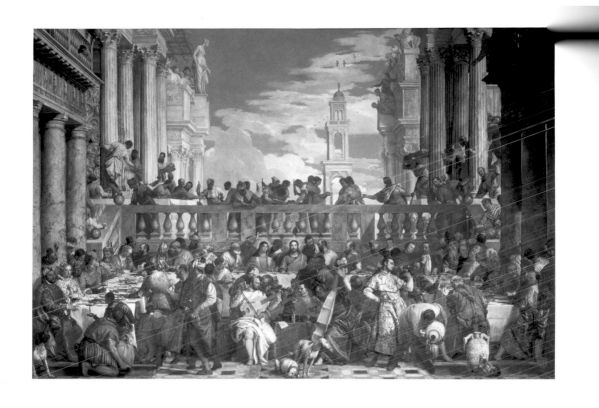

● The wedding **musicians**, who are also located on the central axis, below Christ, are actually four Venetian artists: Veronese himself, Bassano, Tintoretto and Titian.

● An **hourglass** stands on the little table between the musicians, no doubt alluding to an earlier point in the same Gospel account, when Jesus says to his mother: "Mine hour is not yet come" (John 2:4).

● **Meat** for the wedding feast is being prepared just above Jesus' head; this may be a prefiguration of his own sacrifice.

about 1528–1588

PAOLO VERONESE

*Allegory of Virtue and Vice
('The Choice of Hercules')*

about 1580
Canvas, 219 x 169.5 cm
The Frick Collection, New York

Few people would guess from the physique of the man at the centre of this composition that we are, in fact, looking at the Ancient Greek superhero Hercules. Yet Hercules he is, presented here by Veronese as an elegantly attired 16th-century gentleman. We cannot be sure, but the Venetian artist may have painted the work for the Habsburg Emperor Rudolf II, in whose collection it is listed in a 1621 inventory. The moralizing theme of the 'choice of Hercules' or 'Hercules at the crossroads' was much loved in Renaissance and Baroque painting. It is done here in the Venetian style, with extravagant clothes and the characteristic bright lighting and colourful palette.

THE STORY
The story – or rather allegory (see also pp. 184–5) – dates back to Classical Antiquity and was recounted by the Greek author Xenophon. At a certain point in his life, Hercules finds himself at a crossroads, where he meets two women. Each tries to persuade him to follow 'her' particular path, one of which is narrow and difficult, rises steeply but culminates in 'true happiness'. The second path is wide and easy, and leads to sunny meadows where people flirt happily. The women are named Virtue and Vice. The hero of this moralizing scene naturally opts for Virtue.

● **Hercules' head** – possibly a portrait or even self-portrait – is positioned close to that of **Virtue**; it is plain which way the hero is inclined and what he intends to shun. The personification of Virtue wears a laurel wreath.

● Vice holds a deck of **cards** in her left hand, symbolizing a life of play and idleness. Her throne is decorated with a **sphinx** – an emblem of lust in the Renaissance – with a knife leaning against her breast.

● Vice has evidently used force in her attempt to make Hercules choose her path: his left **stocking is ripped** and we see blood. A glance at Vice's talon-like fingernails tells us all we need to know...

● 'Honor et virtus post mortem floret', reads the **inscription** held up by a caryatid: 'honour and virtue flourish after death'. The motto reinforces the moral lesson the painting seeks to convey.

BARTHOLOMEUS SPRANGER *Venus and Adonis*

about 1586
Panel, 135 x 109 cm
Rijksmuseum, Amsterdam

A nude woman – Venus – embraces a man – Adonis – who is about to set off hunting. Cupid sits on the left, while behind this trio a fairytale landscape unfolds, peopled with satyrs, nymphs, humans and animals. A magnificent (though certainly not Classical) fortress stands atop a rocky outcrop.

THE STORY

The irresistibly handsome Adonis was a brilliant hunter; Venus, the goddess of love herself, was smitten by him when she accidentally injured herself on one of the arrows of her son Cupid. She implored Adonis to take care while out hunting, but to no avail: a wild boar attacked him and he died from his wounds before Venus was able to intervene. In her grief, she transformed him into an anemone.

Artists preferred two dramatic scenes from the story: the moment at which Adonis sets off hunting and Venus tries to stop him, and the one where the goddess grieves over her dead lover. Spranger broadened out the departure scene by placing other episodes in the background, a device often used in narrative painting.

● **Adonis**, spear in hand, hunting horn at his side, and dogs leashed, is ready to leave. **Venus** tries to make him stay with her (see opposite page). The Mannerist Spranger liked to paint nude figures in complex poses.

> *"My darling, to my risk; never provoke / Quarry that nature's armed, lest your renown / Should cost me dear. Not youth not beauty, nor / Charms that move Venus' heart can ever move / Lions or bristly boars or eyes or minds / Of savage beasts."*

Ovid, *Metamorphoses* 10 : 549–554, trans. A. D. Melville

● According to Ovid, the **love-sick Venus** forgot her usual pastimes and places, drifting about mountain and forest – the terrain of the hunter. She pursued only harmless quarry and warned Adonis to do likewise. **Nymphs and satyrs** were wood-dwelling mythological beings.

● **All manner of creatures** move about the forest or swim in the water: those in the foreground include a butterfly, a frog and turtledoves, while the background features goats and swans, among others. These are meant as examples, no doubt, of the harmless, small game that the besotted Venus enjoyed hunting.

● In Ovid's account, Venus hears Adonis's dying cries from her **chariot** drawn by swans; she turns around and rushes to him, but is too late.

EL GRECO

The Funeral of Count Orgaz

1586
Canvas, 460 x 360 cm
Santo Tomé, Toledo

Count Orgaz was a devout man and a benefactor of the church of Santo Tomé in Toledo. Legend has it that when his funeral was held in 1323, Saints Stephen and Augustine were in miraculous attendance, supposedly carrying his body to its final resting place in the churchyard of what was then Spain's ecclesiastical capital. It is there that this substantial canvas, painted in 1586, hangs to this day. El Greco received the commission from the parish priest, who is probably the man in the translucent robe, lower right. The painting is characteristic of the artist's *horror vacui* – fear of leaving any blank spaces. The many faces – both in the row of earthly funeral-goers at the bottom and in the divine company upper right – are those of prominent contemporary Spaniards. The enthroned Christ is surrounded by angels (who seem to merge with the clouds) and a number of saints. The Virgin Mary sits at his feet, with a kneeling John the Baptist.

● A fair-haired **angel** bears the count's soul, in the shape of a translucent infant, up to heaven through a gap between two 'clouds'; his visible wing is painted with remarkable realism.

● The **crucifix** serves to link heaven and earth; the events illustrated in this canvas have been made possible by Christ's death on the cross.

A MELTING POT OF STYLES

How may we explain El Greco's distinctive painting style? His Cretan origins are an important factor, as it was in Crete that he was introduced to the non-realistic art of the Byzantine icon. When he subsequently settled in Toledo, he found himself in a bastion of Catholicism still marked by medieval traditions. En route between the two places El Greco had also come into contact with Venetian art, including that of Tintoretto, which had made a substantial impression on him. The Greek artist remained a devout Catholic to the end of his life. Some art historians have detected a strand of mental instability and a lack of technical skill in his work; yet its visionary and mystical aspects are paralleled by the writings of contemporary mystics.

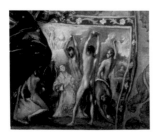

● The two saints who descended to earth in 1323 on the occasion of the pious count's funeral are a youthful **Stephen** on the left and the elderly Church Father **Augustine** (354–430) on the right. Stephen was the first martyr, having been stoned to death in around AD 35; his killing is depicted on the robes he wears.

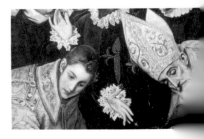

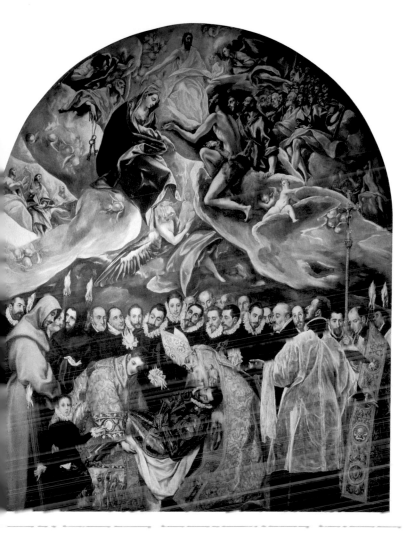

● Two people gaze out of the canvas; they are almost certainly the **artist** himself and his eight-year-old **son Jorge**, whose year of birth is stated on his handkerchief.

● **Mary** looks down, while **John** looks upwards. The Virgin as intercessor – a heavenly intermediary on behalf of sinful human beings – was a much-loved motif in art, especially after the notion had been firmly rejected by Protestant Reformers in the 16th century; this simply highlighted Mary's importance on the Catholic side. The Byzantine tradition, in which El Greco had trained, also placed particular emphasis on the Virgin's role as mediator.

● The figures of the heavenly musicians are elongated – a trademark of the older El Greco.

EL GRECO *The Resurrection*

about 1597–1604
Canvas, 275 x 127 cm
Museo Nacional del Prado, Madrid

According to Matthew's Gospel, Jewish religious leaders visited Pilate the day after Jesus' death to ask for his tomb to be guarded; they feared that his disciples would otherwise remove the body and claim that he had risen again, as Christ himself had foretold. It is these guards whose amazement we see as Jesus is resurrected from the dead in this painting – probably part of an altarpiece. It was displayed in a seminary in Madrid that was financed by a lady-in-waiting of Queen Anne, Philip II's last wife. This was one of El Greco's most important commissions, but the complex has since disappeared and its paintings have been dispersed.

FILLING THE GAP
The moment of Christ's Resurrection from the grave – the key element of Christian faith – is not described in any of the Gospels. Resurrection scenes only began to appear in art at a relatively late stage, after 1300. In these, the soldiers guarding the tomb are shown as Christ stands up in his sarcophagus or steps out of it. Such images were banned in the 16th century by the Council of Trent (see p. 222). The fact that the Resurrection takes on certain features of Christ's Ascension derives from a tradition established in Italy. The tomb itself is featured barely if at all.

● The serenity of the naked **Christ** contrasts with the vehemence of the scene played out beneath him. He is bathed in light and seems to rise effortlessly, the banner of the Resurrection in his hand and a red cloak flapping behind him.

● Christ's **crossed feet** recall his recent death by crucifixion.

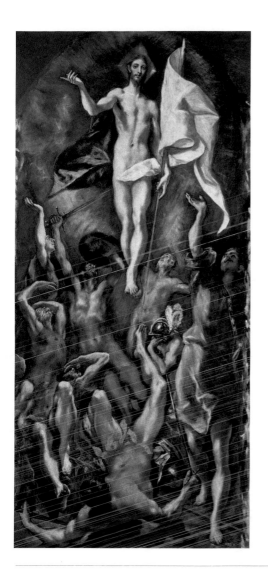

El Greco was a successful painter who ran
a large workshop. Shortly after his death,
the criticism began to be voiced that can s
be heard today now and then: the elongated
forms are unnatural, the colours garish and the
themes one-dimensional. In spite of (or rather
thanks to) this, El Greco was widely adopted in
the 20th century as a forerunner of modern art;
whatever the case, realism gives way in his work
to emotion and symbolism.

● While one **soldier** lashes out
wildly with his weapons and
the man in the foreground falls
backwards with astonishment, the
only one wearing a helmet – and a
conspicuous one at that – is plunged
into reflection or confusion by the
miracle unfolding before his eyes.
The group of panicking soldiers
gives the artist the opportunity
to present a variety of poses.

EL GRECO *The Opening of the Fifth Seal of the Apocalypse*

about 1608–14
Canvas, 224.8 x 199.4 cm
The Metropolitan Museum of Art,
New York. Rogers Fund, 1956 (56.48)

El Greco painted an altarpiece for the church of St John the Baptist in the Spanish city of Toledo, where he had lived since 1576. This canvas, which is just part of that work, illustrates a moment from the Book of Revelation, also known as the Apocalypse of St John. In his vision of the end of the world, the author saw a scroll with seven seals in God's right hand. The Lamb of God broke the seals, one by one, each opening accompanied by a specific event. The Apocalypse culminates with the Last Judgement and the descent to earth of the Heavenly Jerusalem, symbolizing a society free of time, death and sorrow. The book was intended to encourage the persecuted early Christians and to offer them hope. We can be fairly sure that the missing section above this canvas showed the Lamb breaking the fifth seal, which will have rendered the scene comprehensible. The canvas itself is unfinished and in poor condition.

"And when he had opened the fifth seal, I saw under the altar the souls of them that were slain for the word of God, and for the testimony which they held: And they cried with a loud voice, saying, 'How long, O Lord, holy and true, dost thou not judge and avenge our blood on them that dwell on the earth?' And white robes were given unto every one of them; and it was said unto them, that they should rest yet for a little season, until their fellow-servants also and their brethren, that should be killed as they were, should be fulfilled."
Revelation 6 : 9–11

● In the foreground El Greco represents the ecstasy and divine vision of the larger-than-life-sized **John**, his head and hands raised to heaven. The sky is unnaturally dark.

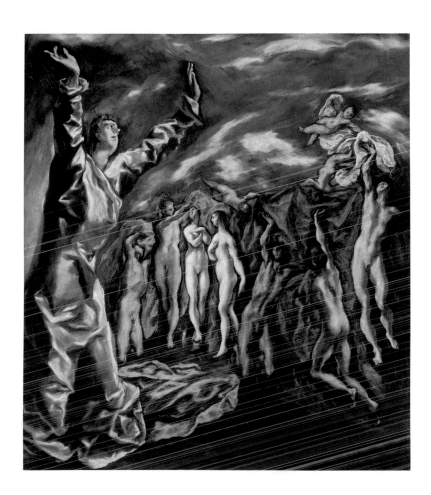

● El Greco has putti-like angels bring the white **robes** that are referred to in the text as well as differently coloured clothes; angels functioned, among other things, as messengers between heaven and earth. The agitated martyrs are naked and, also as described in Revelation, 'nameless'.

JOOS DE MOMPER *River Landscape with a Boar Hunt*

about 1600
Panel, 118 x 174 cm
Rijksmuseum, Amsterdam

The painted landscape gradually developed as a genre in its own right in 16th-century Southern Netherlands, spreading from there to Holland in the 17th century, where it was to reach new and brilliant heights. The successful artist Joos de Momper acted as something of a bridge between the two neighbouring regions; after working in Antwerp during Rubens' time, he went on to exert a huge influence on painters in the North.

This is a so-called 'world landscape' – a compilation of possible views that summarize all that, in the painter's eyes, nature has to offer. In other words, it is a product of the artist's imagination (see also p. 161). Landscapes grew steadily more realistic in the course of the 17th century, whereas this riverscape teems with anecdote.

SPECIALIZATION OF ARTISTS

As the 16th century progressed, many artists began to specialize in a particular genre or theme, such as landscape, portraiture, animals, still lifes or flowers. There was plainly sufficient demand to support this more diversified supply. A side-effect of this development was that, in the Spanish Netherlands especially, artists began to collaborate if the subject-matter went beyond their particular speciality. The finely rendered human figures in this painting, for instance, were done by Sebastiaen Vrancx (see also pp. 230–31).

● **Hunters** and their dogs converge on the scene in the foreground – all eyes are fixed on a wild boar that is about to be captured, although one of the dogs is getting the worst of the encounter. The movement of the pack draws the viewer's eye to the bridge and hence to the river, which then carries us towards the broad, misty horizon in the background. This shift from dark tones (of brown) to light shades (of green and blue) is a long-established technique for suggesting depth.

● The **architecture** is very varied: there is a windmill on a hill in front of the port, and both are overlooked by a castle-like complex built into the mountainside. An Italianate villa stands on the edge of the cliff on the opposite side; the woman on its balcony greets the approaching man.

● Two **ships** bombard one another just off the island in the river, while a land-based cannon also fires off a round. Like the hunt, these human activities disturb the apparent serenity of the natural landscape.

JOACHIM WTEWAEL *Mars and Venus Surprised by Vulcan*

1601
Copper, 21 x 15.5 cm
Mauritshuis, The Hague

The tangle of divine, naked bodies in this scene includes a couple caught *in flagrante delicto*. The illicit love-affair between the gods Mars and Venus has been revealed, and other divinities hurry to the scene to witness the spectacle. The story was told in Homer's *Odyssey*, but artists could also find the account in Ovid's *Metamorphoses* and its many adaptations.

In this diminutive painting on copper, Wtewael manages to represent a whole range of physical poses, doing so in a way that identifies him as a 'Mannerist'. Owners of explicitly erotic works like this may well have reserved them to show to a select circle of acquaintances.

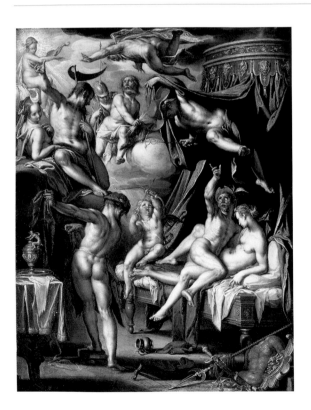

THE STORY

The love goddess Venus was married to Vulcan but had an affair with Mars, the god of war. Their adultery was discovered by the all-seeing sun god, Apollo. Vulcan forged a bronze net in which he subsequently captured the lovers and held them prisoner, calling upon the gods to witness what had been done to him. According to Homer the deities found the whole thing highly entertaining. Stories like this were interpreted in a moralistic way in Wtewael's time; the discovery of the adulterous relationship represents God's all-seeing eye and his punishment of sin, no matter how hidden it might appear. All the same, Wtewael turns this into a rather jolly scene. Comic eroticism also features in the literature of the time.

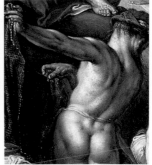

● It is **Mercury** who raises the curtain and reveals the secret. We recognize him from his familiar staff (the *caduceus*) and striking red hat. Jupiter approaches to his left, carried by his eagle and clutching his lightning bolt, while the helmeted goddess Minerva, the incarnation of wisdom, appears behind him.

● With a powerful movement, **Vulcan** removes the net once everyone has witnessed the scene. He still wears his leather blacksmith's apron and red and blue headgear.

● According to Homer, the **female gods** shunned the disgraceful scene; by including two of them here, Wtewael seems to be making his own ironic comment on that claim. In addition to Minerva, we see Diana (the crescent moon on her forehead is a symbol of chastity), who represented virginity. Saturn, god of time, sits alongside her with his scythe.

● Homer tells us that Mercury himself wanted to sleep with Venus, too. **Cupid** here aims his love-arrow at the god, as if to make that desire come true; or is it a last attempt to stop Mercury betraying the lovers to the other gods?

● **Apollo**, god of the sun and of art, is a crucial figure in the story, as it is he who reveals the affair between Venus and Mars. He is shown here playing music in a sunny corner.

CARAVAGGIO *The Supper at Emmaus*

1600–1
Canvas, 141 x 196 cm
National Gallery, London

The elements for which Caravaggio is best known – emotion, drama and the contrasting effects of intense light and deep shadow (*chiaroscuro*) – were fully in evidence in his work by around 1600. The backgrounds of his canvases are all but empty, focusing our attention on the principal actors, who are expressive, flesh-and-blood human beings. Most of the painter's scenes are inspired by the Bible, as is this *Supper at Emmaus*, which illustrates a dramatic moment from the New Testament. The story is told by Luke (24:13–32) and takes place on the day of Christ's Resurrection. Jesus is walking to the village of Emmaus when he meets two of his disciples for the first time since they abandoned him following his arrest. Caravaggio was not the first artist to depict the moment at which the two men recognize Christ as he blesses their food. What is new, however, is the dramatic close-up view of the protagonists.

● The centre of the scene is occupied by the illuminated figure of the **beardless Christ** as he concentrates on the objects laid out on the table in front of him. Scholars in Caravaggio's time interpreted the Supper at Emmaus – like the Last Supper – as a prefiguration of the sacrament of the Eucharist, in which bread and wine (represented here by the grapes) are transformed into the body and blood of Christ, who sacrificed his life for humanity. Christ's gesture here is that of

a priest. The fact that Jesus is shown without a beard might reflect early Christian images found in Caravaggio's time, in which the Messiah appears clean-shaven. Michelangelo, of whom Caravaggio was a great admirer, had already painted a beardless Christ in the Sistine Chapel (see p. 136). All the same, many people were shocked by this down-to-earth image of Jesus.

● This man – most probably the **innkeeper** – is a figure of contrast; while the sitting disciples react with astonishment, he stands quietly, looking on without understanding. In this way,

he represents the world of unbelievers. His shadow forms a dark circle around Jesus' head; even the ignorant and faithless honour Christ, albeit unwittingly.

> *"And it came to pass, as he sat at meat with them, he took bread, and blessed it, and brake, and gave to them. And their eyes were opened, and they knew him; and he vanished out of their sight."*
>
> Luke 24 : 30–31

● Physical movement was held by Caravaggio's contemporaries to be the most appropriate and effective way of conveying a person's emotional state – an idea illustrated by the **theatrical pose** of this disciple. His gesture of amazement throws his hand in our direction, taking it almost beyond the boundaries of the painting. Baroque art frequently contains similar invitations to the viewer to take part, as it were, in the action. The scallop shell suggests that the Apostle might be **James the Great**. James' shrine is located in Santiago de Compostela in northern Spain – the destination of countless pilgrims over the centuries, who wore shells like this to identify themselves.

● The **still life** reinforces the central message. The rotten apples and decaying figs symbolize Original Sin, while the pomegranate was a well-known token of Christ's Resurrection – his victory over that same sin. The fruit already functioned as an emblem of spring and fertility in Classical Antiquity. With this still life, Caravaggio managed to smuggle a more lowly genre into the one considered most prestigious: history painting, with its scenes from the Bible, history or mythology.

CARAVAGGIO *The Entombment of Christ*

1603–4
Canvas, 300 x 203 cm
Pinacoteca Vaticana, Rome

Caravaggio painted this work for a chapel in the church of Santa Maria in Vallicella in Rome, where it served as an altarpiece. Every time the priest stood at the altar during mass and raised the consecrated host with the words "This is my body", worshippers would see the 'mystic' body of Christ immediately below his painted, 'physical' body, which is the most brightly lit element in the painting. This Entombment heightens the message behind the sacrament of the Eucharist.

Caravaggio's painting is gripping, its composition masterful. The viewer's eye is led from the raised hand in the top right corner down along a diagonal running through the sorrowful, bowed heads and Christ's horizontal body to the shroud in the bottom left. The latter hangs over the tomb, seemingly penetrating the viewer's space. The plant symbolizes new life in this barren environment.

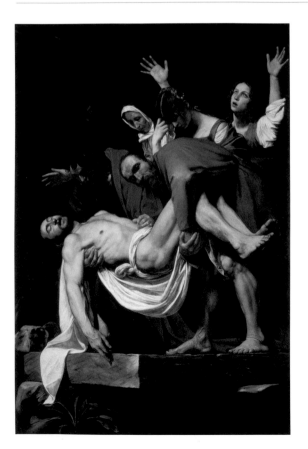

COUNCIL OF TRENT

The Council of Trent, which was convened to reform the Catholic Church, set out new requirements for religious art in the 1560s. It had to be readily understood by ordinary people; lesser details were to be omitted; and religious themes had to be dealt with in an elevated manner. The demands attached to ecclesiastical commissions are likely to have had a strong influence on Caravaggio's choices. The dramatic nature of scenes from Christ's Passion or the martyrdom of saints certainly met the requirement that viewers be moved. Although Caravaggio gets straight to the essence of the Biblical account, his approach was not without problems; he was accused of being excessively down-to-earth, especially in his choice of models.

On the right, Mary Cleophas raises her hands to the skies in **despair**, her gaze pleading for heavenly assistance, in a classic gesture of utmost misery. Next to her Mary Magdalene bows her head. The background is dark and empty, focusing all our attention on the figures.

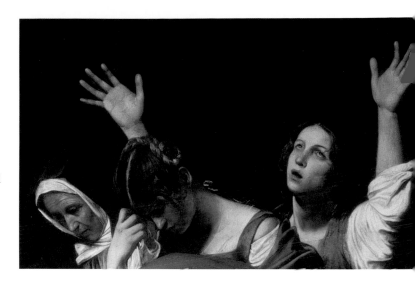

The **Virgin Mary** is an old woman dressed as a nun, which is unusual. Her outstretched arms seemingly wish to embrace the entire scene. In the foreground the bent-over **Nicodemus** laboriously carries Christ's ashen body, helped by St John. As with so many of Caravaggio's figures, including the Apostles, he is a plain man – anything but heroic – with a weathered face and muscular calves and feet. Nicodemus looks out at the viewer, drawing us into the drama with his eyes.

Reliefs from Greco-Roman Antiquity showing heroes killed in battle used a **hanging right arm** to symbolize the loss and grief inherent in the scene. This is where the diagonal beginning with the raised arm, upper right, leads us. As he grasps Christ's heavy corpse, John

unintentionally sticks a finger in the open wound in his side – a gruesome detail of the type we find on other occasions, too, in Caravaggio's work.

CARAVAGGIO *St Jerome in His Study*

about 1605
Canvas, 112 x 157 cm
Galleria Borghese, Rome

St Jerome (about AD 340–420) was one of the four Latin Church Fathers. He was incredibly popular in painting, where he appeared in three different guises: as an ascetic hermit, as a scholar in his study (Jerome made a seminal translation of the Bible into Latin, known as the 'Vulgate') and as a Doctor of the Church in cardinal's robes. Protestants, who were not in favour of saints to start with, ridiculed St Jerome. Among other things, he had propagated the veneration of the Virgin Mary, of which they disapproved. As a result Jerome became a symbol in Catholic circles for the fight against heresy – a role in which Caravaggio painted him several times.

JEROME, ALONE

St Jerome's steadfast companion in many paintings is a lion, but it too is absent in Caravaggio's interpretation. The lion is the product of a popular medieval legend, according to which Jerome relieved the animal of a painful thorn in its paw, following which the lion stayed with him the rest of its life. The Catholic Counter-Reformation was keen to make short shrift of such fables and to return to the essence, which is what Caravaggio does in this picture.

● Caravaggio, like many of his fellow artists, portrays **St Jerome** as an old, bearded man. He is half naked and sitting at a sober study table on which lie three substantial tomes. He reads the Bible attentively and is poised to write: this is the image of Jerome the scholarly Bible translator and Church Father. His solitary depiction in such bare surroundings combines this aspect with that of the ascetic. Jerome's humble nakedness is fitting for a man known as a hermit.

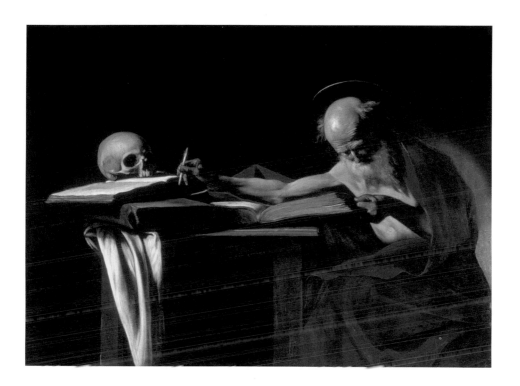

St Jerome was to become a model for scholars, and was thus often pictured in a cosy study. None of that for Caravaggio: except for the table, the space is shrouded in darkness. The interior is extremely sober, which was in keeping with the guidance of the Council of Trent (see p. 222). This required that all that was superfluous should be banished from religious paintings. The emphasis here is placed firmly where it belongs: asceticism, the transience of life on earth, and ever-present death. Jerome's domed head is echoed by the **skull** on the right; this is a *memento mori*: human beings die, but the Word of God lives on. The skull seems to be staring at St Jerome as much as at us.

ADAM ELSHEIMER *The Flight into Egypt*

1609
Oil on copper, 31 x 41 cm
Alte Pinakothek, Munich

Adam Elsheimer painted several small works on copper. He was drawn to shadowy scenes like this, in which the light effects and atmosphere are created by candles, torches and the moon. A man, woman and child walk across the middle foreground with their donkey. The trees they pass are almost black, in spite of the bluish-green moonlight. We are looking at the Flight into Egypt of Joseph, Mary and the baby Jesus. Paintings on this subject are usually set in daylight (see pp. 112–13, 146–7); Elsheimer, by contrast, offers a tranquil, nocturnal landscape unified by three light sources. The rest of this painting on copper is practically monochrome.

● These **shepherds** stand by their night fire with their animals to the left of the painting. Joseph and Mary are about to encounter them. The scene, in monochrome brown, is filled with details like the leaves on the trees and the movement of the animals.
The figures recall the "shepherds abiding in the fields, keeping watch over their flock" (Luke 2:8) on the night Jesus was born.

● The **Holy Family** trudging along seems like a minor detail within the overall scene. Joseph holds a torch that illuminates the luggage piled onto the donkey.

● This is the earliest known **moonlit scene** in European painting. Dutch painters in particular went on to explore the theme at length over the rest of the 17th century.

● Something else that makes this painting special is that it shows the night sky, with the **Milky Way**, the **Great Bear** (top right: incorrectly located) and other constellations. The heavens take up more than half of the work's overall surface, which is unprecedented. As far as we can tell, this is the first time the Milky Way was ever painted in such a naturalistic way. This may reflect the influence of scientists like Kepler and Galileo – two contemporaries of the Rome-based German artist Elsheimer – who were busily toppling established views of the world at this time. What we see here is what you would observe with the naked eye in southern regions. Elsheimer was not concerned, however, with scientific accuracy, as we see from his combination of a full moon and a clearly visible Milky Way.

HENDRICK AVERCAMP *Winter Landscape with Ice Skaters*

about 1609
Panel, 77.5 x 132 cm
Rijksmuseum, Amsterdam

In early 17th-century Holland a trend developed towards more natural and realistic-seeming landscapes, composed in the studio using sketches made 'from life'. This was the method used by Hendrick Avercamp, who specialized in winter scenes. Once relegated to the background of narrative paintings, landscape now developed into the main theme – something that, in the nascent Dutch Republic, might have had more than a little to do with national pride as well as religiously inspired respect for God's creation.

The horizon remains high in this painting, allowing ample room for the profusion of detail on the ground; it was to be lowered by the next generation of painters (see pp. 300–303). This panel is packed with anecdote: people skate, sledge and sail on the ice, carry straw and buckets, play a form of ice hockey, and much more besides. Judging from their clothes, citizens from every level of society have ventured onto the ice.

● This gable end adorned with the Antwerp city arms tells us that this is a **brewery and inn**. A hole has been made in the ice near the building from which buckets of water are drawn for use in beer-making. Avercamp's inclusion of the Antwerp arms might be a nod to Pieter Bruegel and Flemish painting (see pp. 190–91). The bird trap in the left foreground, comprising a door balanced on a stick, is a direct quotation from the Flemish master.

● Among the more mischievous details, we find a pair of lovers, a man urinating and an exposed behind. The artist's 'signature' is another droll element: on the shed we make out 'Haenricus Av' and a scrawled stick-figure.

● Does this winter scene have a **moral**? Although ice occasionally functions in literature as a metaphor for a life that can be all too slippery and hazardous, there is no evidence to suggest that this was Avercamp's intention here.

JAN BRUEGHEL
& PETER PAUL RUBENS

The Garden of Eden with the Fall of Man

about 1617
Panel, 74 x 114 cm
Mauritshuis, The Hague

The Garden of Eden was presented in Netherlandish painting as a lush landscape in which the most diverse animals live together in peace and harmony. Jan Brueghel the Elder, son of Pieter Bruegel (see pp. 186–93), was a celebrated flower painter who specialized in this theme, which he painted dozens of times. The subject was extremely popular in his time, yet was largely to die out afterwards. Brueghel collaborated on this panel with his good friend Rubens, who painted the two nude figures who were to squander the joys of Paradise.

● **Adam and Eve** feature prominently in the foreground, on the edge of a forest. The crafty serpent we see coiled around the tree has just talked Eve into picking a fruit from the 'Tree of Knowledge' and eating it, despite God's instruction not to do so. What is more, she is handing another piece of the same fruit to Adam. This is the still-peaceful moment before the new-found shame at their nakedness and their punishment – expulsion from Paradise and condemnation to a life of hard toil (for Adam) and the pain of childbirth (for Eve).

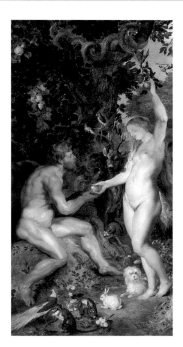

● This is the **Tree of Life**. Anyone who ate from this tree would become immortal. Brueghel has a goat jump up against it.

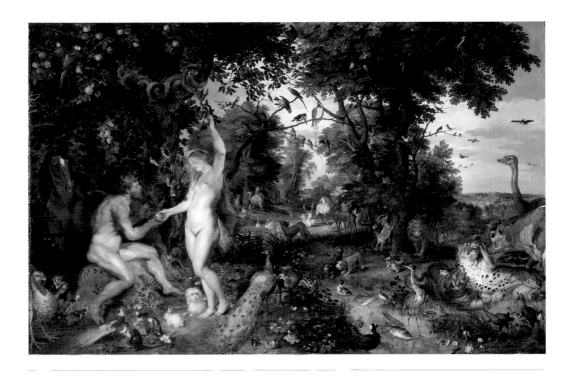

● **Animals** have the run of the Garden. The monkey, an animal associated symbolically with 'folly' or even the devil, apes the behaviour of the first couple in picking the forbidden fruit. A bird of paradise, appropriately enough, stands at Adam's feet. The peacock, meanwhile, is a Christian symbol of eternal life and resurrection.

● The **grapes** that hang above Adam's head allude to the wine that is transformed into Christ's blood during the Eucharist. Christ was to redeem humankind from their sins, including the 'Original Sin' that is being committed here.

● Utopias like the Garden of Eden generally have paradisaical rivers running through them. This little **stream** winds its way between the two crucial trees.

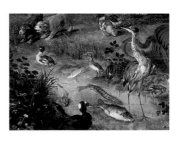

ROELANT SAVERY — *Landscape with Animals*

about 1618
Panel, 60 x 80.5 cm
Musées Royaux des Beaux-Arts
de Belgique, Brussels

Roelant Savery was born in Flanders but was active in Holland. At the age of twenty-eight, he was appointed court painter to Habsburg Emperor Rudolf II in Prague, where he spent a number of years. This painting was probably executed after his time in Prague, since one of Rudolf's celebrated collections comprised a zoo filled with exotic animal species. His collection of thorough-bred horses was equally famous. Savery produced numerous nature studies in the Tyrol and Bohemia, and it is there that he may have seen the rocky formations divided by a fast-flowing river that we find in this panel. All those observations fed into this paradisaical painting, which does not represent a real landscape but a carefully composed ensemble. Savery is known for scenes imbued with an idyllic, unreal atmosphere; here he displays his allegiance to a tradition of *fijnschilders* ('fine painters'), who included among many others Jan Brueghel the Elder and Gabriel Metsu (see pp. 230–31, 316–19).

● An **oak tree** stands on a spit of land at the brightly lit centre of the panel; **ostriches skirmish** with one another as an elephant raises its trunk and a bison and camel also come to blows. Is the Eden-like atmosphere of the scene under threat? Either way, Savery is clearly a talented painter of animals.

● The **galloping horse** seems to be under attack; nor is the scene we glimpse beyond it very peaceable. In a sense, painting horses had become a second kind of 'portraiture' for artists.

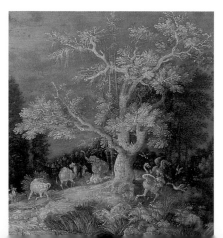

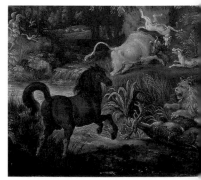

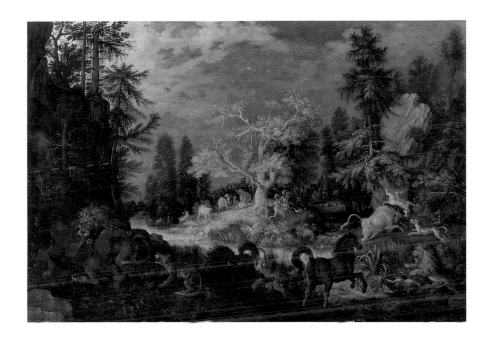

● A **lion** sinks its claws and teeth into the back of a **horse**, which is brought down by the assault. We know that Savery copied the pair from a bronze sculpture in Rudolf's *Kunstkammer* or private gallery, to which he, as court painter, had access. The drawings he made there would later function as a kind of database of themes, motifs and poses. This is clearly no paradise of peacefully co-existing animals of the kind we find elsewhere (see pp. 230–31), but whether Savery was seeking to convey some kind of message here, we simply cannot say.

PETER PAUL RUBENS *Samson and Delilah*

1609
Panel, 185 x 205 cm
National Gallery, London

Rubens was one of the greatest painters of his day of religious, mythological and historical themes. Artists of his time could approach the Old Testament in one of two ways: they could take its personages and stories as a prefiguration of the Christian New Testament, or they could treat them as straightforward historical figures and events, without seeking to emphasize their religious connotations. *Samson and Delilah* is an example of the latter approach. Like many stories from Classical mythology and the Old Testament, the theme has a powerfully sensual and erotic charge; it is a tale of seduction and betrayal.

THE STORY

The Israelite Samson falls in love with Delilah, a member of the hostile Philistine people. Her countrymen are keen to learn the secret of Samson's great strength and offer Delilah a great sum of money if she can persuade him to divulge it. Samson initially resists, but eventually succumbs in the face of her persistent questioning.

"'If I be shaven, then my strength will go from me, and I shall become weak, and be like any other man.' And when Delilah saw that he had told her all his heart, she sent and called for the lords of the Philistines, saying, 'Come up this once, for he hath shewed me all his heart.' Then the lords of the Philistines came up unto her, and brought money in their hand. And she made him sleep upon her knees; and she called for a man, and she caused him to shave off the seven locks of his head; and she began to afflict him, and his strength went from him."

Judges 16 : 17–19

● The **principal scene** comprises this illuminated grouping of four faces: the muscular Samson – a figure worthy of Michelangelo – has fallen asleep in Delilah's lap, possibly after making love to her. She looks on, her breasts exposed, as a 'barber' cuts off Samson's hair – the source of his great strength.

The old woman holding the candle is a procuress and does not appear in the Biblical account. Rubens has evidently set the scene in a brothel, its dark, luxuriant interior bathed in an atmosphere of sultry eroticism. The red of Delilah's robe stands for both passion and the bloody events about to unfold.

● Painters like Rubens and Rembrandt focus our attention on the most important and dramatic moment in the story, with other episodes alluded to in **background scenes**. In this instance, Philistine soldiers lurk out of sight, armed with the tools they need to put out Samson's eyes, their faces lit by torches.

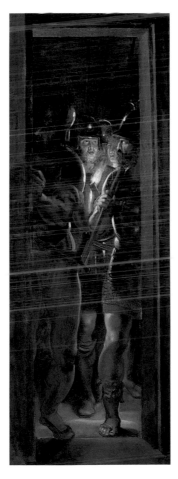

● This is **Venus**, the Roman goddess of love, and her son **Cupid**. The niche containing these figures further heightens the painting's erotic charge. The way Delilah tilts her head echoes Venus' pose.

PETER PAUL RUBENS *The Descent from the Cross*

1611–14
Panel, 420 x 310 cm
and 420 x 150 cm (x 2)
Cathedral, Antwerp

Rubens painted this triptych as an altarpiece for the harque-busiers' chapel in Antwerp Cathedral. The three panels contain different stories, beginning with the ingeniously structured composition in the middle, which shows a group of people lowering Christ's body from the cross at dusk. The left wing depicts the Visitation, where a pregnant Mary meets her cousin Elizabeth, who is also going to have a child, while the right wing focuses on the presentation of the infant Christ to the high priest in the Temple. The two wings therefore feature scenes – both framed by Classical architecture – from the beginning of Christ's life, while the central panel deals with the end.

 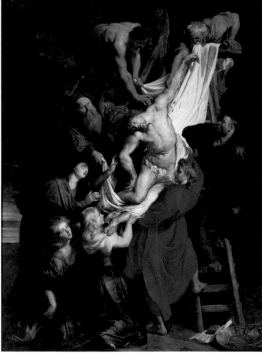

● This is one of the images visitors would see on an 'ordinary' day in the cathedral, when the triptych was closed: **Christopher carrying the Christ Child** across a river, a theme based on a medieval legend. As the patron saint of the harquebusiers, who commissioned the altarpiece, Christopher had to be included somewhere in the painting; yet because of doubts as to Christopher's historical veracity, the Church had attempted to quash his cult. Rubens solved the dilemma by moving him to the less prestigious closed wings, where he endowed the saint with the strength and allure of the Classical hero Hercules.

● Christopher – whose Greek name Christophorus means 'bearer of Christ' – is the link between all the scenes featured in the altarpiece; each tells a different story, but there is a single leitmotif: 'carrying' Christ. In the open left wing of the painting, it is the pregnant Mary who carries him, while on the right it is the **high priest**. And in the central panel, the task falls chiefly to Christ's beloved disciple John (clad in a scarlet cloak, the colour of the Passion).

● **Nicolaas Rockox**, one of the onlookers in the Temple, was burgomaster of Antwerp, master of the harquebusiers' company and a friend of Rubens. The painter owed this important commission, which helped establish his reputation, to him. Rockox's presence as an 'extra' is an expression of Rubens' gratitude.

● **Mary Magdalene** and **Mary Cleophas**, a half-sister of the Virgin, kneel at the foot of the cross. Christ's mother is shown standing, her entire demeanour and her pallid face betraying her misery. The fact that she is not kneeling, as is frequently the case in other paintings on the same theme, is probably a consequence of Church guidelines. During the Counter-Reformation, painters were expected to abide by the text of the Bible and to distance themselves from what their predecessors had done. John's Gospel states (19:25) that the Virgin Mary *stood* by the cross.

● The imposing body of Christ is reminiscent of **Laocoön** in the famous Greco-Roman sculpture, of which Rubens was a great admirer. "One of Rubens' great achievements is that he, like Michelangelo before him, distils a universal truth from the old stories, be they Classical or Biblical. He transcends the strict division between pagan and Christian. In this instance the death of Laocoön becomes the Passion of Christ" (Kristin Lohse Belkin).

PETER PAUL RUBENS

Minerva Protects Pax from Mars ('Peace and War')

1629–30
Canvas, 198 x 297 cm
National Gallery, London

Painters have always enjoyed using mythology to comment on contemporary affairs. Rubens explored this idea, especially in his later mythological paintings – a period in which he grew increasingly concerned about the political situation in Europe. Peace and war is the theme of this effervescent allegory, in which the figures each personify specific qualities, or the lack of them.

The central personage is Peace (Pax), who appears nude, breastfeeding a child, while behind her a helmeted Minerva, goddess of wisdom, shields them from Mars, god of war, the male figure in armour. He is accompanied on the far right by raging Furies. Rubens shows himself in this painting to be an intellectual artist who was actively involved with the affairs of his time.

● Two **girls** in contemporary attire are led from the right towards the centre. One is about to be crowned by the young god of marriage, who holds the wedding torch in his hand; they are offered fruits from the cornucopia held by an old satyr – half human, half goat – while a leopard rolls on its back. These characters heighten the painting's central message: Peace brings prosperity (the cornucopia), stability and harmony (the impending marriage), and happiness (the sweet-tempered leopard). Children and happiness often go hand in hand in Rubens' work.

● The **two dynamic women** on the left also celebrate the blessings of Peace: one holds a bowl full of precious goblets and pearls, while the other shakes a tambourine.

It is unusual for the personification of Peace to be **nude**; in fact, we can only be sure of her identification thanks to the putto flying above her head, holding an olive wreath and *caduceus* or staff of peace. Were it not for that little figure,

we might interpret this beautiful and sensual woman as Venus feeding her son Cupid – a popular motif in the Renaissance. In other words, this Peace is a Venus look-alike. The characters around her are all related to Venus, too, especially the satyr, the leopard and

the woman with the tambourine, all of whom belong to the traditional retinue of wine god Bacchus, who is linked with Venus in the popular proverb 'hunger and thirst [for wine] cool Venus' ardour'. Rubens takes the message of love and turns it into an innovative political allegory The language of love (Venus) has become the language of Peace: Love and Peace, happiness and harmony are united.

1558–1617

HENDRICK GOLTZIUS — *Mercury Giving the Eyes of Argus to Juno*

1615
Canvas, 131 x 181 cm
Museum Boijmans van Beuningen,
Rotterdam

Goltzius has painted a scene from a story told by Ovid in his *Metamorphoses*. Argus' headless corpse lies on the left, while the goddess Juno leaps from her chariot – a peacock-drawn cloud – in the middle. Mercury sits on the right, his bloody sword on the ground before him. He hands Juno Argus' gouged-out eyes, positioned at the centre of the canvas.

GOING BEYOND OVID

The specific incident shown in this painting does not appear in Ovid, nor is it likely given the psychological structure of the story: Mercury and Juno are opponents. Jupiter ordered Mercury to kill Argus, who was working for Juno, which means he has plainly acted against her will. The murderous god offering her the eyes is thus Goltzius' invention. Perhaps his motive in bringing them together was to be able to combine a living female and male nude. All Ovid has to say about the aftermath of Mercury's killing of Argus, is this:

"Argus lay dead; so many eyes, so bright
Quenched, and all hundred shrouded in one night.
Juno retrieved those eyes to set in place
Among the feathers of her bird and filled
His tail with starry jewels."

Ovid, *Metamorphoses* 1:718–722, trans. A. D. Melville

● This is the character at the focus of the episode – **Io**, whom supreme god Jupiter (who had had one of his numerous love affairs with her) turned into a heifer to hide her from his wife, Juno. When the suspicious Juno ordered the all-seeing Argus to guard the newly transformed creature, Mercury killed the watchman at Jupiter's behest (see p. 169).

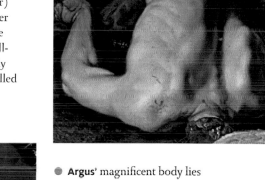

● **Argus'** magnificent body lies twisted. Goltzius' model, which he used on a number of occasions, was the 'Belvedere Torso'; he drew it several times during his period in Rome.

● The goddess Juno is the protectress of marriage and the **peacock** is her emblematic bird. She will place the many eyes of Argus on the peacock's tail, as a tribute. According to Ovid Argus had a hundred eyes, but Goltzius obviously chose to deviate from the story (see above).

● Mercury's characteristic staff with the winding snakes around it (the *caduceus*; see p. 219) lies almost hidden under a cloth. It is the only item by which he can be identified in this painting.

1582/83–1666

FRANS HALS *Banquet of the Officers*
of the Civic Guard of St George

1616
Canvas, 175 x 324 cm
Frans Halsmuseum, Haarlem

Group portraits were a flourishing genre in Dutch painting of the 17th century: municipal councils, boards of trustees and other local worthies all had themselves immortalized together, as did the officers of civic guards. The portraits adorned the halls in which the groups met or held their celebrations. We know of around 250 militia pieces from the 16th and 17th centuries, among them Rembrandt's spectacular *Night Watch* (see pp. 286–7). The challenge facing the painters of such portraits was how to prevent them becoming lifeless and overly formal. How could they convey the group spirit between those depicted, while simultaneously preserving their individuality? Frans Hals – the master of the lively portrait and himself a long-standing member of the St George company shown here – demonstrates how to do it in this painting, the first of his five civic guard portraits. As is frequently the case in this genre, the setting is the farewell banquet for officers who have served for three years.

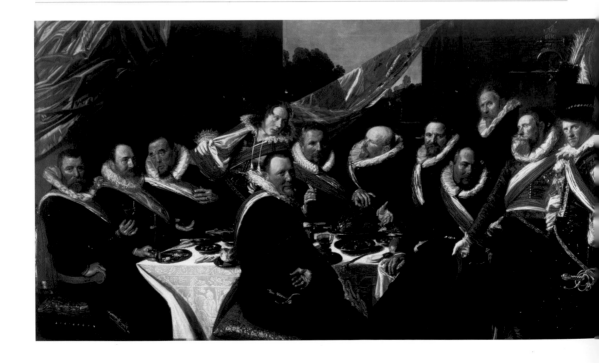

THE ÉLITE

Civic guard members were often wealthy men from the local élite. They had to pay to be included in the painting, which is why we do not usually see all the members in portraits like this, let alone any of their wives or children. For the most part, militia dinners were not particularly jolly or spontaneous affairs: a great many rituals and customs had to be strictly observed. Records suggest, however, that things did occasionally get a little out of hand...

● The **hierarchy** of the company is apparent from the way the table is organized. The colonel sits in the place of honour at its head, raising his glass. He is the only officer wearing an orange sash.

His second-in-command sits to the right of him. Three captains come next, with the three lieutenants on the other side of the table. There are two sets of three because a company consisted of three platoons. There were a total of eleven officers, if we count the three standard-bearers or ensigns.

● The three **ensigns** are not sitting at the table but are standing nearby, holding their flags. This is one of them. They were permitted to retain their rank provided they did not get married.

● The **company's servant** has also been included. It was his job to serve food and drink to the officers.

1582/83–1666

FRANS HALS

Wedding Portrait of Isaac Massa
and Beatrix van der Laen

about 1622
Canvas, 140 x 166.5 cm
Rijksmuseum, Amsterdam

Frans Hals is recognized nowadays as an exceptionally original painter. Many of his portraits of Dutch burghers – shown individually, in groups or, as in this instance, as couples – are remarkably loose and realistic in their execution. This is a wedding portrait. Isaac Massa (1586–1643) was a wealthy and cultivated merchant who enjoyed a prominent position in Haarlem society. He probably knew Hals well. In 1622, Massa married Beatrix van der Laen, the thirty-year-old daughter of the burgomaster. This portrait gives an impression of informality – the expensively dressed newly-weds lean against a tree, smiling and relaxed. Such broad smiles are unusual; Hals' contemporaries tended to view grinning faces as indicative of stupidity and lack of self-control. In spite of the picture's informal appearance, however, the artist has also included several traditional symbols of fidelity and devotion.

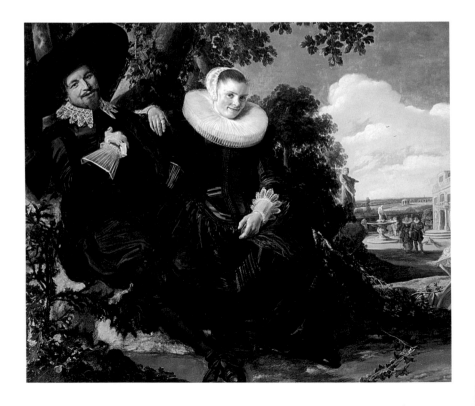

A wedding portrait, by definition, also depicts a relationship. Here, Isaac Massa places his gloved **right hand** on his heart in a familiar gesture of fidelity. Beatrix affectionately rests her **left hand** on his shoulder, echoing the way the vine just above twines itself around the trunk of the tree, symbolizing love and companionship. At the same time, she displays the two rings on her index finger: her engagement ring and her wedding ring, set with a diamond. In the 17th century, the Dutch bourgeois marriage increasingly evolved towards a relationship founded on mutual friendship and affection, a development reflected in paintings like this.

In the distance to the right of the newly-weds, we make out a **'garden of love'** – a motif dating back to medieval literature and art that was especially popular in the Renaissance. In addition to courting couples, gardens like this often feature

peacocks, a long-established symbol of Juno, the Roman goddess of marriage, and fountains representing fertility. Upturned vases and architectural ruins, finally, are a frequent allusion to the transience of earthly possessions and existence.

Some of the **plants** featured in this painting had a symbolic meaning for contemporaries. We know this from a variety of sources, including so-called 'emblem books', which contained prints accompanied by short verses. This spear thistle, for instance, was known in 17th-century Holland as *mannentrouw* ('male fidelity').

The ivy growing near Beatrix' feet can also be interpreted symbolically: it attaches itself to a house or tree in the same way wives were supposed to cling to their husbands.

ARTEMISIA GENTILESCHI *Judith Beheading Holofernes*

about 1620
Canvas, 170 x 136 cm
Galleria degli Uffizi, Florence

Few Old Master paintings have been read as autobiographically as this work by Artemisia Gentileschi, the best-known female artist of her time. Her biography records that she was raped as a young girl by an assistant of her father, Orazio Gentileschi, an artist who moved in the same circles as Caravaggio. This violent scene is thought to be an expression of her rage at that earlier, horrific incident. The subject, which comes from the Apocrypha, had long been popular among male history painters, too. Whatever her motivation in painting it, Artemisia was plainly inspired visually by works on the same theme by Caravaggio and her father. She painted this dramatic scene many times, possibly because it proved very lucrative.

THE STORY

Judith, a Jewish widow, schemed to free her people from their Assyrian occupiers, led by General Holofernes. She beautified herself and infiltrated the enemy camp pretending to be a traitor, accompanied by her maid. A few days later Holofernes, who had fallen for her charms, invited her to a feast. She encouraged him to drink and when he was sufficiently inebriated decapitated him with his own sword. Judith and her maid then walked out of the camp carrying the general's head in a bag. The Assyrians panicked when they heard the news and fled. The story was seen as a symbol of victory over sin, and Judith was sometimes viewed as a prefiguration of the Virgin Mary.

● Caravaggio, the revolutionary who irrevocably changed the art of painting, is cited frequently in this book. His influence is evident here in the lighting, the exclusive emphasis on the protagonists, the emotional intensity and the realistic character of the figures: Gentileschi does not fashion **Judith** after the latest ideals of beauty. She seems to recoil from her deed – or at least from the gush of blood – though without losing her resolve.

● It is unusual for the bloody act of decapitation itself – achieved here, it would seem, by a cutting motion – to be the focus of the scene; artists tended instead to show **Holofernes'** already severed head.

● According to the story in the Apocryphal Book of Judith, the maid was not present in the tent; Judith and the inebriated Holofernes were alone. Gentileschi was not the first to include the maid in the

action, as it allows the artist to expand the composition into a triangle.

GUIDO RENI *Atalanta and Hippomenes*

about 1612
Canvas, 206 x 297 cm
Museo Nacional del Prado, Madrid

This canvas resembles a classical ballet performance, with the elegant movements, physical interaction between the two young bodies, and fluttering fabrics. There is little to suggest that this is actually a race against death, as recounted by the Roman poet Ovid. Reni has chosen a key moment in a rarely painted tale from the *Metamorphoses*, which enables him to depict male and female nudes in very different poses as part of an ingenious composition.

THE STORY

Atalanta is a king's daughter in Boeotia who beats all her male competitors in running contests. An oracle foretells that she will never marry. She herself devises a test: she will marry the man who can beat her in a race. Atalanta is attractive and many men rise to the challenge. While their prize is clear, so is the risk: if they lose, they die. Atalanta is thus literally a femme fatale. *Hippomenes too falls in love with her – as does Atalanta with him. Venus, the goddess of love, gives him three golden apples as a ploy. He drops them one by one during the race. Atalanta picks them up, falls behind and finishes second. The story ends badly: the two make love in a sacred place and Venus punishes them by changing them into lions.*

● Atalanta has already picked up two **apples** and now does the same with the third and final one. Hippomenes, meanwhile, has pulled ahead.

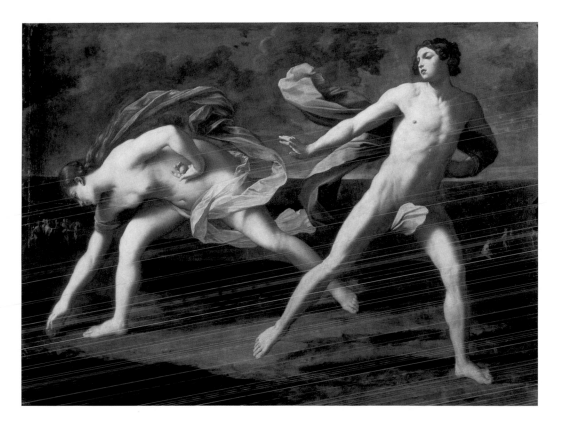

"So then he threw
One of the three gold apples from the tree.
She was amazed and, eager to secure
The gleaming fruit, swerved sideways from the track
And seized the golden apple as it rolled.
He passed her and the benches roared applause."

Ovid, *Metamorphoses* 10 : 664–8, trans. A. D. Melville

● Ovid's story suggests that
Hippomenes' gesture means:
'Stay behind me', yet he also
seems to be warding her off.
A far-reaching autobiographical
interpretation of the gesture has
even been suggested, according to
which Reni had a strong mother-
fixation and no room for other
women in his life…

● Like the running bodies,
the **fluttering draperies** create
the impression of movement.

ANTHONY VAN DYCK *Portrait of Isabella Brant*

1621
Canvas, 153 x 120 cm
National Gallery of Art, Washington DC.
Andrew W. Mellon Collection

The Antwerp-born Anthony van Dyck worked for several years as the gifted assistant to his older fellow townsman Peter Paul Rubens (see pp. 234–41), who described him as his best pupil. Van Dyck is said to have presented this portrait of Rubens' first wife, Isabella Brant, to his master as a gift on his departure for Italy. Isabella (1591–1626) was 30 years old at the time. She sits in front of the prestigious baroque triple-arched gateway that Rubens himself designed, and which connected his house to the studio, while separating the (public) garden from the private courtyard. The effect is Italianate. Rubens' garden is partly visible beyond the gateway. The draped red curtain obscures the void between foreground and background, a motif that Van Dyck adopted from Venetian painters like Titian.

● Van Dyck was a master of portraiture and the rendering of fabrics, and it was here that he was to achieve his greatest success. The broadly smiling **Isabella** is dressed in a black cloak over a richly decorated gown, the bodice of which is embroidered with gold thread. She is wearing gold earrings, strings of pearls and gold chains set with jewels. She is shown in three-quarter view, turned to the right, looking towards the façade of Rubens' studio (invisible to the viewer).

● Van Dyck made a few modifications to the gateway: in reality, this statue of Minerva – Roman goddess of wisdom – stood at the top, along with Mercury, the Roman god of trade, diplomacy and of painters. Together they guarded Rubens' domain and proclaimed the importance of his home: here lives an artist, a worldly man of letters, who is well versed in tradition and not averse to material success. By placing Minerva on the balustrade above Isabella's right shoulder, Van Dyck establishes a direct and flattering connection between the sitter and the goddess of wisdom. Minerva becomes the lady of the house's protectress.

● **Roses** are often used in art to symbolize the purity of the Virgin Mary. In Classical Antiquity, however, the flower was associated with Venus, the goddess of love. That link was re-established in the Renaissance, when the flower's scent and beauty were again likened to Venus. Isabella's rose represents her love for Rubens, who is present here through the gateway he designed.

ANTHONY VAN DYCK *Rinaldo and Armida*

1629
Canvas, 236 x 224 cm
The Baltimore Museum of Art

Everything in this canvas by Van Dyck – the dramatic emotions, movement and colours – is spectacular, yet refined. He has painted a key moment from a literary masterpiece that had appeared half a century earlier: *Gerusalemme Liberata* (*Jerusalem Delivered*, 1581), by the Italian poet Torquato Tasso. This offers a supposedly historical account of the First Crusade, led by Godfrey of Bouillon. Its two main characters are Armida, the beautiful niece of the King of Damascus, and Rinaldo, an important Christian leader.

THE STORY

*Armida is a formidable weapon for the Syrian king.
She is a witch whom he sends to the Christian camp to
lure away the knights and addle their brains. But when
she tries to seduce Rinaldo in order to kill him, she
herself falls in love with him. She whisks him away to the
Isles of the Blessed, and makes love with him in the open
air. Rinaldo will later abandon Armida, but they are
ultimately reconciled.*

TITIAN REVISITED

*This painting by Van Dyck shares the spirit and use of
colour we find in the work of the Venetian artist Titian.
It caught the eye of King Charles I of England – an
admirer of Titian – for whom Van Dyck subsequently
went to work in London in 1632.*

● The **cupids** contribute to the amorous atmosphere. But the mischievous curly-headed one sucking on his thumb – the only one looking out of the painting – seems like a humorous touch on the artist's part.

● While **Rinaldo** is sleeping, **Armida** approaches to kill him, but is instantly smitten. We see it in her eyes, the garland of roses she drapes around him, and the fluttering of her scarlet cloak.

"*Thus sung the spirit false, and stealing sleep, / To which her tunes enticed his heavy eyes, ... / Then from her ambush forth Armida start, / Swearing revenge, and threatening torments smart. // But when she looked on his face awhile, / And saw how sweet he breathed, how still he lay, / How his fair eyes though closed seemed to smile, / At first she stayed, astound with great dismay, / Then sat her down, so love can art beguile, / And as she sat and looked, fled fast away / Her wrath, that on his forehead gazed the maid, / As in his spring Narcissus tooting laid.*"
Torquato Tasso, *Jerusalem Delivered*, Canto 14, verses 65–6, trans. Edward Fairfax

● The **water nymph** or mermaid has sung Rinaldo to sleep, as Armida ordered. She leaps up out of the water with a musical score in her hand – possibly a reference to the lost opera *Armida* by Claudio Monteverdi, which enjoyed its première in Mantua in 1628, a year before Van Dyck painted this work.

ANTHONY VAN DYCK

Queen Henrietta Maria with Sir Jeffrey Hudson and a Monkey

1633
Canvas, 219.1 x 134.8 cm
National Gallery of Art, Washington DC.
Samuel H. Kress Collection

In 1632 King Charles I of England invited Anthony van Dyck to join his court as an artist. This work was painted a year later and is one of Van Dyck's earliest portraits of Charles' wife, the twenty-four-year-old Henrietta Maria, daughter of Henry IV of France and Maria de' Medici. She had already been married to Charles for eight years at the time. Van Dyck is a master at capturing fabrics in paint, as is proven here once again. The play of light, movement and the choice of the other colours make the cool blue of the queen's informal hunting dress spring to life. Her small stature is disguised by Van Dyck's scenography: Henrietta Maria is standing on a stone platform, accompanied by her dwarf, and she is viewed from below. Her long nose and prominent chin have also been 'adjusted'. Van Dyck portrayed her in the company of a few of her favourite, exotic things.

● Van Dyck presents Henrietta Maria in this informal portrait not as a queen – her **crown** is pushed off to the right with studied nonchalance – but as a serious character and a woman of great charm.

● The **orange tree** in the vase in the background is another favourite of the queen, who loved exotic plants. Henrietta Maria is known to have been an avid garden enthusiast and had trees like this one imported

from her native France to decorate her palaces. Orange trees were seen as a curiosity at the time, while oranges are also a traditional symbol of the Garden of Eden and its purity and innocence.

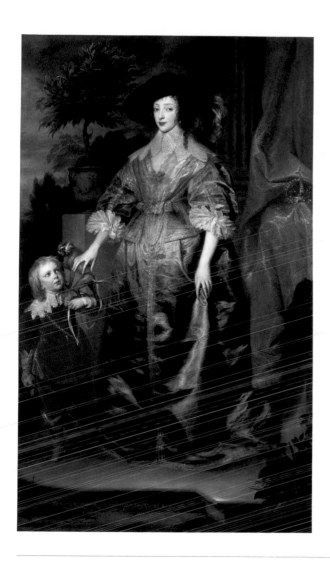

The presence of Jeffrey Hudson reinforces the 'unofficial' character of this double portrait. Jeffrey, a **dwarf**, was fourteen years old in 1633 and was a 'gift' to the queen from the Duke of Buckingham. He became her private secretary but later killed a man in a duel and was banished.

Pug, the **monkey**, was another of the queen's exotic interests – one that was shared by many other royals. The way her hand rests on the monkey and its leash may have a symbolic meaning: this woman is holding back the amorous feelings that are traditionally ascribed in abundance to monkeys.

GERARD VAN HONTHORST *The Procuress*

1625
Panel, 71 x 104 cm
Centraal Museum, Utrecht

We see a laughing young woman, well lit, with a deeply plunging *décolleté*, and a young man wearing an extravagantly plumed hat, just as she does. He reaches out his right hand to her, while placing his left on a money bag. An old woman in a turban looks at her and points at him; she is a procuress and we are in a place where sexual transactions are carried out – the brothel.

THE SHADOW OF CARAVAGGIO
The scale of the artistic revolution wrought by Caravaggio is apparent once again when we study the work of Utrecht painters like Honthorst and Ter Brugghen (see pp. 258–61), both of whom spent time in Rome shortly after the highly distinctive Italian artist's death. Two elements recur constantly in the work of these 'Caravaggists': the spectacular light and shade contrasts known as chiaroscuro, *and the portrayal of ordinary people who fill the entire pictorial surface.*

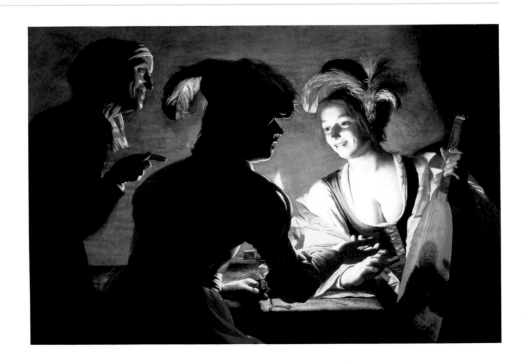

● The woman is holding a **lute**; love and music are often connected in paintings and this instrument was particularly associated with lust and indecency.

● Hats and bonnets decorated with **feathers** stand for loose morals, especially in Dutch art, as do such elements as ample *décolletage*, extravagant clothes and red stockings.

● In Rome, where Honthorst lived for a while, he acquired a nickname: Gerardo della Notte or 'Gerard of the Night'. He owed this sobriquet to the creation of his own genre of shadowy scenes with a single candle as **light source**.

● **Procuresses** in 17th-century Dutch painting are invariably wrinkled old women, their physical ruin supposedly reflecting their moral decadence. Historical research has shown, however, that such women were in reality only slightly older than the prostitutes themselves.

HENDRICK TER BRUGGHEN *St Sebastian*

1625
Canvas, 150.2 x 120 cm
Allen Memorial Art Museum, Oberlin
(Ohio)

According to one version of the story of St Sebastian, the martyr was rescued and nursed after receiving his wounds from the arrows (see pp. 65, 76) by a widow called Irene. He recovered, continued steadfastly to practise his Christian faith, even in the presence of the Roman emperor, and was ultimately beaten to death. His body was hurled into Rome's principal sewer.

Ter Brugghen selected the moment after the 'first execution'. Two women tend to the helpless Sebastian: one carefully pulls the arrows from his body while the other frees his pale hand from the tree to which he has been tied. The three figures have been placed close together in a confined area, forming a single group.

A SECOND CHRIST?
The scene of Sebastian and the two women is strongly reminiscent of depictions of Christ's Descent from the Cross (see pp. 236–7); in both instances, women tend to and help support a practically nude man, dead in one case and half-dead in the other.

● This figure, probably Irene, appears to be an ordinary woman, judging by her clothes. Her head is well lit and in intimate proximity to Sebastian's. Ter Brugghen's focus is firmly on the **personages and the drama** in which they are caught up; there is barely any background or landscape to speak of, merely a few wispy trees. During his ten-year stay in Rome, the painter was heavily influenced by Caravaggio, the master of dramatic light effects and the literal foregrounding of common people.

● Whereas the scene of Sebastian being shot by arrows had always been a popular subject in painting, that of the **'caring Irene'** grew in popularity in the 17th century. The Catholic Church liked to present itself as a caring social institution, and images like this conveyed that message very well.

about 1606–1638

ADRIAEN BROUWER *Brawling Peasants*

about 1625–7
Panel, 25.5 x 34 cm
Mauritshuis, The Hague

Adriaen Brouwer's legacy of approximately sixty paintings mostly feature comically painted anti-heroes of the working class, such as drunk, smoking farmers, peasants and bar-flies, brawlers, knife-fighters and lechers. This panel is no exception.

Brouwer gained great popularity with his Bruegel-influenced genre paintings alive with anecdotes and keen observation. Buyers could goggle at the startling lifestyles he depicted, laughing at things that, as good burghers, they otherwise preferred to keep at a safe distance. The message – "do not live this way" – also gave the artist the excuse he needed to paint this rowdy, sinful bunch. Brouwer's earthy colours and rough brushwork were perfectly suited for the 'uncivilized' themes he liked to portray.

A fight has broken out at the table, with two obvious motives: a **card game** that has got out of hand and an excess of liquor, which can be seen pouring freely from an overturned jug. The argument escalates into physical violence as hair is pulled and scary-looking knives are drawn. The brawl is on the verge of escalating, but a woman tries to calm the man in the mid-foreground.

A **dog** mounting a **pig** provides instant comedy; the natural order of things seems to have been disturbed in these surroundings, where base instincts win out over order and reason.

Nothing in its appearance identifies the house on the left as an inn, other than the fact that it is crowded with **people** curious about the disturbance going on outside. They thrust their caricature faces through the windows and doors to watch.

SIMON VOUET *Cupid and Psyche*

1626
Canvas, 112 x 165 cm
Musée des Beaux-Arts, Lyons

A sensual atmosphere pervades this canvas by Simon Vouet, a Parisian artist who became celebrated in Rome and elsewhere, and around whom a school was to form. A nude, winged boy sleeps below a scarlet canopy as a young woman looks at him, apparently affected by the sight. The story of Cupid and Psyche lent itself to numerous different treatments in art.

● **Psyche** does what she has been forbidden to do: her sister has lied to her, telling her that she was sharing her bed with a monster (see opposite). Her curiosity gets the better of her and she lights an oil lamp while Cupid sleeps. Any moment now a drop of hot oil will fall on the young god of love, waking him and putting an end – albeit temporarily – to Psyche's happiness. This scene from the story of Cupid and Psyche was popular in Vouet's time: Rubens and Van Dyck also painted it.

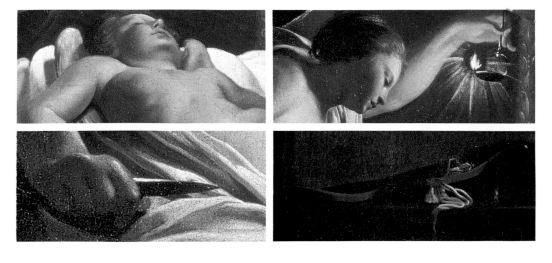

● Fearing that her lover may be a monster, Psyche has armed herself with a **dagger**.

● Cupid normally uses his **bow and arrows** to make others fall in love. Now the young god's weapons are laid aside as he himself is besotted.

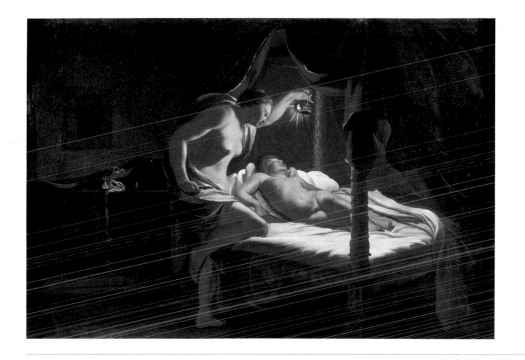

THE STORY

Psyche was a princess who was so beautiful that people even began to neglect their worship of the goddess of love herself. Venus ordered her son Cupid (Eros in Greek) to cause Psyche to fall in love with a monster, yet Cupid himself was smitten. Because of his intervention Psyche suddenly had no more suitors, causing her parents to consult Apollo. Through his oracle he told them that Psyche would be carried off by a monster; however, Cupid took her instead to his magnificent palace. Psyche was very happy with her new partner, but there was one condition: she was never to see him in the light. She disobeyed her instruction and discovered that her lover was, in fact, the beautiful Cupid. Realizing what she had done, the angry Cupid immediately disappeared and the couple were only reunited after Psyche had completed a long and humiliating quest. They were married and Psyche became immortal.

PIETER CLAESZ *Vanitas Still Life with the 'Spinario'*

1628
Panel, 80.5 x 70.5 cm
Rijksmuseum, Amsterdam

The notion of *vanitas*, which comments on the transience and futility of earthly possessions, the swift passage of time, the death that awaits us all, developed into a fully-fledged genre in the 17th century. It is symbolized by meaningful objects inserted among sumptuous fruits and other foods, fashionable serving plates, bountiful flowers and other, similarly luxurious items. Still lifes of this kind represented in miniature the great moral dilemma that faced Holland's young Protestant Republic: how to reconcile abundant wealth with strict, Calvinist morals? These paintings convey a dual message: appreciate the beauty around you, but always remember that it is short-lived.

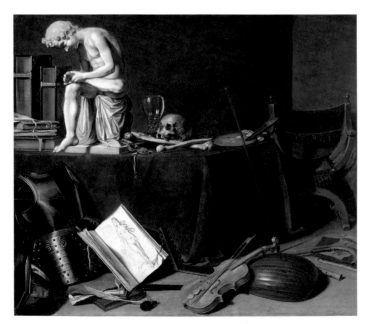

● This still life also tells us something about the **artist's trade** – specifically its various stages of training. Apprentices first learned to mix pigments, before going on to sketch copies and to make drawings of three-dimensional sculptures. These stages are shown here.

● This could almost be a catalogue of *vanitas* symbols: the **skull and bones** remind us that we will all die some day; the **clock** and **smoking oil lamp** are tokens of fleeting time, in much the same way as the empty glass indicates that life will be over before we know it.

● **Musical instruments** – here a violin, lute and flute – are also linked with ideas of transience, for what is more fleeting than music?

● This is a plaster cast of a famous Roman statue: the **Spinario**, which shows a boy removing a thorn from his foot. Copies like this were often found in painters' workshops. They served as examples of Classical art, which many still considered the absolute ideal. Rubens' famous art collection, for instance, included a number of antique statues.

● The metal **armour** in the corner illustrates the kind of challenge still life painters liked to set themselves. Rendering such items tangible and life-like on the canvas was the great test inherent in the genre.

WILLEM VAN HAECHT *Alexander the Great Visiting the Studio of Apelles*

about 1629
Panel, 105 x 149.5 cm
Mauritshuis, The Hague

Images like this of private art galleries as they existed in the 17th century are a feast for the eye. Aside from paintings, such collections included sculptures, globes and other precious objects that the owner wished to display to honoured guests. As we see here, paintings were hung in several tiers up the wall. Willem van Haecht, who specialized in works of this type, was also the curator of the celebrated collection belonging to Cornelis van der Geest of Antwerp – a friend and patron of Rubens. Several of the paintings incorporated in this delightful panel belonged to Van der Geest's collection.

THE POWER OF THE BRUSH

This scene cannot, of course, have taken place in a 17th-century private art gallery, and so the panel has been interpreted as an allegory of the art of painting and of the sense of sight. According to this reading, the story of Alexander and Apelles expresses the power and nobility of painting.

● This scene from Greek Antiquity is a deliberate anachronism. The legendary Greek court artist **Apelles** is painting the portrait of **Alexander the Great**'s favourite concubine **Campaspe**, while surrounded by a group of exotically attired men and women, including his patron, Alexander, himself. The Latin author Pliny describes how Apelles fell in love with Campaspe and that Alexander responded by 'giving' her to him, in gratitude for the portrait. To 17th-century painters, Apelles was the great exemplar of a successful artist capable of extraordinary realism. So, when Rubens was referred to as 'the Apelles of Antwerp', it was a major compliment.

• The **hallway** leads to a gallery and a circular room with niches containing Classical sculptures. Rubens, among others, had a 'temple' like this – modelled after the Roman Pantheon – in his house, which Van Haecht drew on for this fragment. A plaster cast of a famous Classical sculpture, the *Apollo Belvedere*, stands above the doorway on the left. Copies of ancient Roman and Greek statues like this were very popular and we know for certain that the bust of Hercules and the garlands in the middle formed part of the decoration of Rubens' house in Antwerp (now the 'Rubenshuis' museum).

• Several of the paintings can be identified; **Rubens' *Battle of the Amazons*** appears on the left, while **Massys' *Banker and his Wife*** (see pp. 120–21) can be seen on the right.

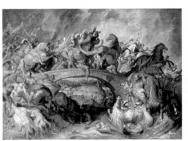

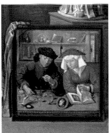

JACOB JORDAENS *Meleager and Atalanta*

about 1617–18
Canvas, 152 x 120 cm
Koninklijk Museum voor Schone Kunsten,
Antwerp

Even when painting stories from Greek mythology, the Antwerp artist Jordaens seems not to have looked very far when it came to choosing his models. Nor did he fail to include his beloved dogs. Jordaens drew on a composition by Rubens to depict a dramatic moment in the story of Meleager and Atalanta (see also pp. 250–51), as told by Ovid in his *Metamorphoses*.

THE STORY

The Calydon region was plagued by a huge wild boar. Prince Meleager set off to hunt it, accompanied by a select company of men and a single woman, Atalanta, with whom he fell in love. The huntress drew first blood from the animal, which Meleager then killed. He offered her the head and part of the back as a trophy, sparking the jealousy of his uncles, who were also on the hunt. When they attempted to take the trophy from her, Meleager drew his sword and killed them. His mother cursed him for his deed and Meleager died a horrible death. The painting focuses on the critical moment just before the double murder is perpetrated.

● Atalanta looks at the youthful Meleager at this moment of high drama. United at the shoulder, the couple is brightly lit and Jordaens' vantage point is low, which adds to the scene's already powerful charge. The Greek hero and heroine look very real, which will have brought the episode closer to contemporary viewers. Considering how the story was to end, the image may have been intended as a warning to viewers to curb their temper.

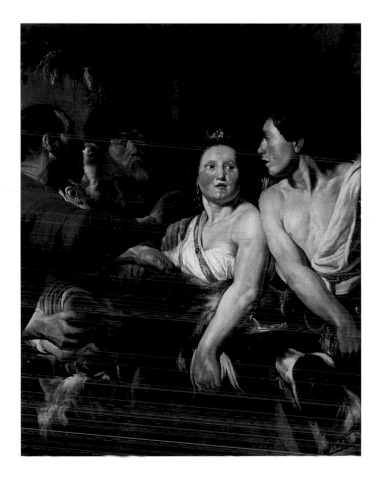

"A plain brooch pinned the collar of her dress, / Her hair was simple, gathered in a knot; / From her left shoulder a quiver of ivory / Hung rattling and her left hand held a bow. / So she was dressed; her features in a boy / You'd think a girl's and in a girl a boy's."

Ovid, *Metamorphoses* 8 : 321–6, trans. A. D. Melville

● In the shadows, the uncles' **hands** reach greedily for the trophy. The *chiaroscuro* effects add to the oppressive atmosphere.

● Meleager's two greedy **uncles** have here become three. Their faces are shown from three different angles as they crowd together in this limited space. They too look like ordinary Antwerpers. As passions run increasingly high, no one in the painting pays any attention to the body of the boar that sparked the drama in the first place.

JACOB JORDAENS *The King Drinks*

1640
Canvas, 156 x 210 cm
Musées Royaux des Beaux-Arts
de Belgique, Brussels

The Feast of the Epiphany or 'Twelfth Night' (6 January) was extremely popular in the Spanish Netherlands in the 16th and 17th centuries. As time passed, the celebrations moved from the streets and into the home. It was traditional for a bean to be hidden in a cake, and for whoever found it to be crowned 'king' for the duration of the festivities. They got to direct proceedings and to appoint their own 'court', with a queen, cupbearer, musician, physician and so forth. Friends and family all joined in the happy play-acting. Jordaens painted several versions of this exuberant scene, which features pleasures that were normally the target of moral censure, such as excessive eating, drinking and smoking.

LEGENDARY ORIGIN

According to one 17th-century legend, the cry
'The king drinks!' (see opposite) originated in the
stable in Bethlehem. During the visit of the Magi,
the baby Jesus was nursing at his mother's
'hallowed breasts', supposedly prompting one
of the Three Kings to exclaim, 'The king drinks!'

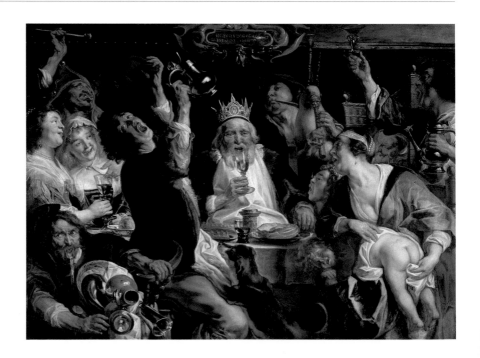

● The **king for a day** was given a crown to wear. Here he lifts his glass in a toast. The king, who is said to resemble Jordaens' father-in-law, the painter Adam van Noort, is seated at a festively decked-out table.

● Part of the fun involved everyone **shouting** "The king drinks!" every time their temporary sovereign took a draught. That is what these men appear to be doing. If people failed to shout, the acting jester would smear black marks on their faces.

● Moralists urged people to behave themselves on Twelfth Night, yet the proceedings frequently degenerated into a **binge**. This man, who has been appointed 'royal physician', has plainly had a few too many; not that the others are letting it spoil their fun. Readings of Jordaens' painting vary widely: is he condemning the behaviour shown here, or celebrating the warmth of the family circle?

● The cartouche above the king's head reads: 'In een vry gelach/ Ist goet gast syn', which means, freely translated, 'It's good to stop at a free inn.' Perhaps Jordaens is taking an ironic swipe at freeloaders.

JUDITH LEYSTER *Man Offering Money to a Young Woman*

1631
Panel, 30.9 x 24.2 cm
Mauritshuis, The Hague

Painted scenes taken from everyday life – so-called 'genre paint-ings' – can be full of hidden meaning: a warning, rebuke, a lesson in morality, and so on. Yet it is not always clear if that is indeed the intention. Painters can be deliberately ambiguous, displaying objects that may or may not be seductive; context becomes very important.

FEMALE PERSPECTIVE?
Is the indifference of this young woman – she has been called a 'bashful victim' – intended as a deliberate contrast with similar scenes, painted by men, in which women respond eagerly to the proffered wages of love? Leyster may have intended to give us a woman's perspective on the theme.

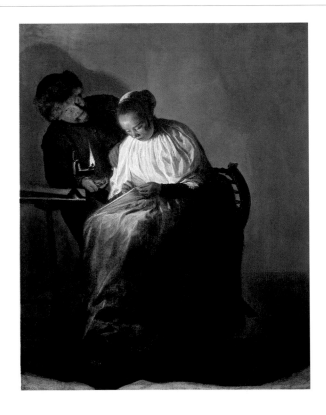

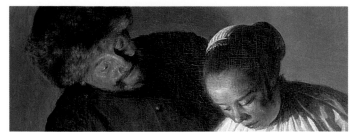

● Most girls in Holland's 17th-century Golden Age were raised to do useful **handiwork**, which naturally included the household chore of sewing. The woman here, therefore, embodies a domestic virtue. Yet the Dutch verb *naaien* had – and still has – the double meaning 'to sew' and 'to have sex', although at first sight there seems no ostensible reason to apply the lewd sense of the word here.

● The hand on her arm, the money and the seductive smile all fail to distract the young woman from her work. This is perfectly in keeping with 17th-century ethics, which viewed sloth, sinfulness and surrender to base instincts

as closely related. The **glow of the oil lamp** highlights the essentials in this unadorned, dusky interior: the handiwork, the woman's simple clothes and the hands and faces with their very different focuses.

● Why is the man offering the lady a **handful of coins**? Love for sale was a popular theme in Dutch painting (see pp. 358–9, 304–5). But nothing indicates that this is a brothel scene of the kind we find elsewhere – there are no alcoholic drinks, tobacco, exuberant gestures or revealing clothing, for instance. Perhaps the man is showing this plainly virtuous woman that he would make her a good husband.

● Judith Leyster is one of the few female artists whose reputation as an artist has survived the Dutch Golden Age. She was also the only woman to be a member of the painters' guild in Haarlem, where she worked. Even more exceptional is the fact that Leyster did not belong to an artistic family, where it was traditional to pass on a craft like painting from father to son or – more rarely – daughter. Leyster's father had a brewery that he named 'Leystar'; Judith often **signed** her work **with a star**.

1594–1665

NICOLAS POUSSIN *The Rape of the Sabine Women*

about 1633–34
Canvas, 154.6 x 209.9 cm
The Metropolitan Museum of Art,
New York. Harris Brisbane Dick Fund,
1946 (46.160)

We know that the French artist Poussin was well versed in Latin literature; indeed, he has been accused of being overly intellectual and of having 'painted with his head'. Interpreting this canvas, too, requires us to know its literary source. It recounts the legendary abduction or rape of the Sabine women by Romulus and the first Romans – a scene that has been depicted frequently in art. Poussin probably painted this version for the French ambassador in Rome.

THE STORY

Rome's legendary founder, Romulus, ordered the kidnapping of the daughters of a neighbouring people, the Sabines, because of the shortage of women in his newly established city. Subterfuge was required, and so a feast was organized supposedly in honour of Neptune, to which the neighbours were invited. According to the Latin historian Livy, the Sabine women were quickly reconciled with their 'Latin lovers'. Romulus himself married Hersilia, one of the abductees. The Romans and Sabines later made peace, allowing Romulus to rule alongside the Sabine king.

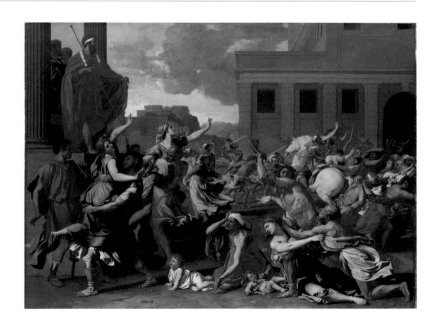

● **Romulus**, accompanied by a couple of servants, observes the implementation of his plans. Their calm poses contrast sharply with the violence unfolding before them. The Capitoline Hill – centre of later Roman power – can be seen in the distance; its inclusion is plainly anachronistic, as for that matter is the entire setting.

● The **young woman** on the left resists in vain as she is carried away by a **soldier**. A young child watches from the ground: this particular Sabine woman is a mother. According to Roman historians, the only married woman to be abducted was Hersilia, who subsequently became the wife of Romulus himself. The **old woman** looks up imploringly as Hersilia is carried off.

● Something odd is happening here, right in the middle of the canvas: this **Roman man and Sabine woman** seem to have paired off happily with one another. This apparently brutal tragedy will, as the Roman historians wrote, have a 'happy ending'. All this suffering, we are led to believe, is only temporary and relative.

● A **father** attempts to rescue his **daughter** from the clutches of a muscular Roman. The girl clings fearfully to his robes while her attacker raises his dagger, ready to strike.

NICOLAS POUSSIN *Et in Arcadia Ego ('The Shepherds of Arcadia')*

1638–39
Canvas, 85 x 121 cm
Musée du Louvre, Paris

Nicolas Poussin was one of many painters to adopt an earlier era as his artistic ideal: in his case, Classical Rome. The artist felt a nostalgic longing for the beauty of those days, which he sought to recapture in his own paintings. This canvas shows three men and a woman at a tomb set in an Italian landscape. The Latin words *'Et in Arcadia ego'* are carved into the stone. The inscription literally means, 'I too (was) in Arcadia'. Two of the men point at the words, while the others look on in silence. The text is the central focus of the canvas and the viewer's interest alike and has – understandably – sparked countless reflections as to the picture's precise meaning.

ARCADIA
Arcadia features in Classical, Renaissance and Baroque poetry – all of which was familiar to Poussin – as the setting for erotic escapades; it represented innocent pleasure and a dream world set amid a gentle and abundant nature. This utopian vision offered an escape route and a counter-reality, which is why pastoral literature included frequent allusions to contemporary affairs.

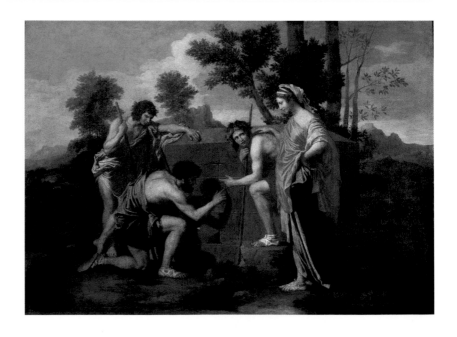

● The three young men are **shepherds**, as we see from their clothes and staffs. They wear laurel wreaths on their heads, as in pastoral poetry in which shepherds compete to find the best singer or poet. The theme of shepherds in an idyllic landscape was exceptionally popular among artists and their patrons.

● The **woman** looks on meditatively. It is unclear whether she is a shepherdess or whether her costume and pose are meant to indicate a different status. Some have identified her as Death or Fate and the inscription as the words she speaks. Others believe that the painting embodies some other secret and mysterious message.

● **Arcadia** is a region in the Peloponnese in Greece that serves in literature as a symbol of bucolic paradise. Life there is blissful, peace reigns and shepherds watch over their flock. The meaning of the **inscription** on the tomb now becomes clear: death *is* present, even in the delightful Arcadia of these shepherds. No Classical source is known for the tag, suggesting that it was coined in Poussin's time. The message could be one

of melancholy at all the good things that must inevitably pass – the familiar *vanitas* motif (see also pp. 197, 267). Alternatively, '*ego*' could refer to the person in the tomb: 'I too *was* in Arcadia when I still lived'. That would make it a posthumous message recalling a happy life.

NICOLAS POUSSIN *The Holy Family on the Steps*

1648
Canvas, 72.4 x 111.7 cm
The Cleveland Museum of Art,
Cleveland, Ohio

The Holy Family sits on the steps of an austere, strictly Classical setting with an ancient Roman flavour. The canvas has drawn praise for the arrangement of its figures, while the unusual – not to say mysterious – surroundings have sparked widespread discussion as to what Poussin intended them to signify. In this period the French artist frequently returned to the theme of the Holy Family. He moved to Rome in 1624, but remained highly esteemed in his own country; Poussin's influence on subsequent French painting was immense. He worked almost exclusively for collectors capable of sharing his intellectual interests. He painted this work for his compatriot Hennequin du Fresne.

THE STORY

There is nothing in the Gospels to prompt this scene; as is so frequently the case, it may have been based instead on a medieval legend. It was said that, on returning from Egypt, the Holy Family paused at the home of Elizabeth and her son. On that occasion, the later Baptist supposedly gave an early display of his reverence for Christ.

● An extended Holy Family sits on the steps; on the left we see Mary's cousin **Elizabeth** and her young son, **John the Baptist**. They look up at **Mary** – the only adult whose face is fully illuminated – and **Jesus**. Joseph sits on the right.

We always have to look out for symbols in Poussin's work. The message here, perhaps, is that Mary is the 'stairway to heaven'. The Virgin and Child, the 'highest-ranking' of these holy figures, also mark the apex

of a pyramid. It has been argued that Mary's absent gaze serves to separate the Mother of God from ordinary mortals.

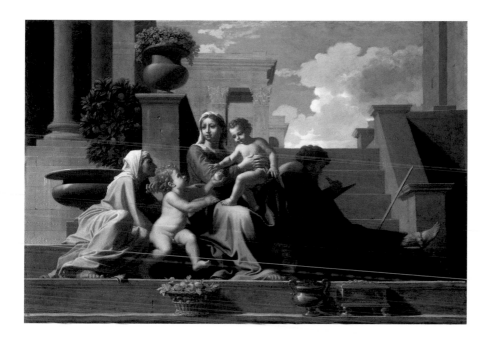

● **Joseph** is the only one of the figures who is wholly unilluminated as he sits apart from the rest of the company, at once present and absent. He looks more like an architect here than a carpenter.

● There are no purely decorative details in this canvas: this **basket of apples** is probably a reference to Adam and Eve's Original Sin, from which Christ has come to redeem humankind. The fact that he is shown reaching for the apple that John holds out to him seems to imply symbolically that he accepts his mission.

1606–1669

REMBRANDT *The Rape of Europa*

1632
Panel, 62.2 x 77 cm
The J. Paul Getty Museum, Los Angeles

Stories from the Bible or Classical history and mythology remained the most prestigious subjects for painters, even for so sought-after a portraitist as Rembrandt. History painting, as it was known, made the greatest demands of artists, who were expected not only to know the ancient literary sources (though possibly only in translation or through the example of their predecessors) but also to incorporate a moral message in the work. Here Rembrandt retells the popular story of the lovesick supreme god Jupiter, who disguises himself as a white bull in order to abduct the Phoenician princess Europa to the continent that now bears her name. Mythological themes like this are fairly rare in his oeuvre.

● Painters in the 17th century increasingly focused on a **key emotional moment** in the stories they sought to illustrate – an approach at which Rembrandt was especially adept, as we see in this example. Europa is terrified as Jupiter swims away with her on his back; she grips the bull tightly and looks behind her as her companions gaze in panic. Emotions run high and are emphasized by the dramatic lighting.

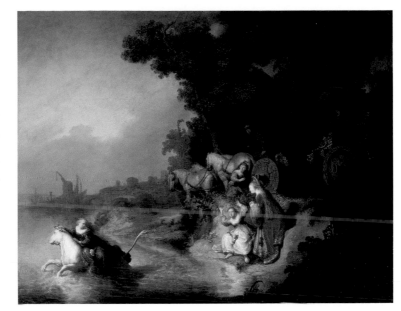

● This detail – **flowers** woven together – also comes from Ovid's story, in which the young women initially offer flowers to the bull to decorate its horns.

● Europa came from Phoenicia, which more or less coincided with modern-day Lebanon; the Phoenicians were celebrated in ancient times as outstanding seamen. According to Ovid, Europa was abducted from the beach. This gave Rembrandt the opportunity to allude in his painting to her people's **maritime activities**, by including a contemporary crane and sailing ships in the misty background below a menacing sky. It was a scene Rembrandt knew well, having lived in Amsterdam – port city *par excellence* – since 1631.

REMBRANDT *The Sacrifice of Abraham*

1635
Canvas, 195 x 132.3 cm
Alte Pinakothek, Munich

In addition to his many serene and still works, Rembrandt painted theatrical compositions like this striking example that are full of physical movement. The Old Testament story in which Abraham receives the divine command to sacrifice his son was considered a prefiguration of the later sacrifice of God's own son, Christ. In Rembrandt's customary way, and following in the footsteps of his great examples, Caravaggio and Rubens, 'sacred history' here becomes a very human story. Calvinism in particular demanded an unconditional faith in God's plans, no matter how difficult to fathom.

● The father places his **hand** over the face of his naked, frightened son to shield the boy's eyes. The brightly illuminated Isaac lies helplessly on the firewood, his hands tied behind his back.

● The **angel**'s gentle right hand grips Abraham's sturdier wrist. The oriental-looking knife is still pointed at Isaac's throat, but falls to the earth. The Bible states only that the angel spoke to Abraham

rather than physically staying his hand (see opposite), but Rembrandt was not the first to present the scene in this way.

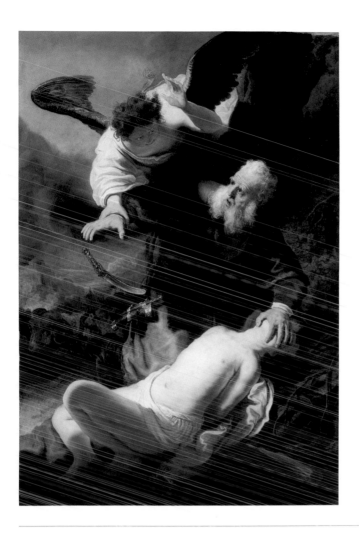

THE STORY

God decided to test Abraham's faith by commanding him to sacrifice his son on the mountainside: "And they came to the place which God had told him of; and Abraham built an altar there, and laid the wood in order, and bound Isaac his son, and laid him on the altar upon the wood. And Abraham stretched forth his hand, and took the knife to slay his son. And the angel of the Lord called unto him out of heaven, and said, 'Abraham, Abraham': and he said, 'Here am I.' And he said, 'Lay not thine hand upon the lad, neither do thou any thing unto him: for now I know that thou fearest God, seeing thou hast not withheld thy son, thine only son from me'" (Genesis 22 : 9–12).

● This is the real **sacrificial animal** supplied by God: "And Abraham lifted up his eyes, and looked, and behold behind him a ram caught in a thicket by his horns" (Genesis 22 : 13).

REMBRANDT

The Company of Frans Banning Cocq and Willem van Ruytenburch ('The Night Watch')

1642
Canvas, 363 x 437 cm
Rijksmuseum, Amsterdam

Militia companies were clubs for powerful and wealthy male burghers in Rembrandt's Holland. Originally founded to keep order in the city, as time passed they also began to fulfil an increasingly ceremonial function. Group portraits immortalizing their more prominent members were commissioned to decorate their meeting halls. These paintings conventionally posed the militiamen around a table or stood them in a group. Rembrandt, however, took a radically different approach in the gigantic work we know as *The Night Watch*, transforming the traditional group portrait into a composition of lively and interacting personages. He painted it for the Amsterdam Company of Harquebusiers (see also p. 236), whose weapon, the harquebus, was a 16th-century firearm. The guardsmen are captured just as they move into action, marching out of a large gate.

The painting has only been known as *The Night Watch* since the 19th century, when it was much darker because of the browning of its varnish. Although that layer – and with it the darkness – was removed in 1975, the work has retained its appealing nickname.

● **Captain Frans Banning Cocq** raises his left arm, a gesture that identifies him as the leader, while also seemingly ordering his men to advance. His arm casts a shadow on **Lieutenant Willem van Ruytenburch**, the man in the bright yellow suit on whom the light falls. He is carrying a 'partisan', a weapon surmounted with a broad spearhead.
The shadow cast on his tunic by Cocq's thumb and index finger draws the viewer's eye to a lion with the Amsterdam arms (three crosses). The man behind the lieutenant concentrates on loading his firearm.

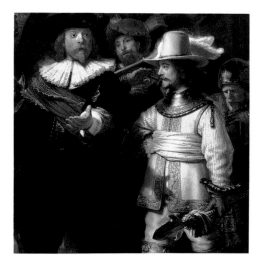

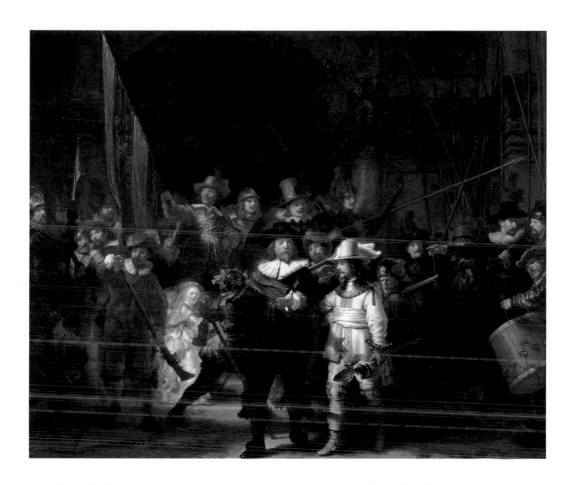

● The **escutcheon** above the gate
contains the names of eighteen
militiamen; only those who paid
were included in the painting,
with the exception of the hired
drummer on the far right.
(A strip containing three people
was removed from the left in the
18th century.)

● The play of light provides
a sense of tension in this huge
picture. A **girl**, also dressed in
yellow, shares the spotlight with
the lieutenant. She walks towards
the right, perpendicular to the
direction of the militiamen,
a dead chicken with strikingly
large claws hanging from
her belt. This is a punning
reference to the Dutch word for
'harquebusier' (*klovenier* sounds
like *klauwenier*, where *klauw* is
'claw'). She is what we would
today call a mascot.

REMBRANDT *The Return of the Prodigal Son*

about 1662
Canvas, 262 x 206 cm
Hermitage, St Petersburg

Rembrandt's exceptional talent as a painter is firmly rooted in the empathy and insight we find in his portraits, self-portraits and paintings of Biblical scenes. In much of his work he shuns theatrical poses and gestures, no matter how emotional the scene, thereby imbuing it with a paradoxical grandeur and directness, free of compromise.

The story of the Prodigal Son, one of Christ's parables, is a frequent theme in art. Its message concerns the reward that God bestows upon the true penitent. This powerful work is one of Rembrandt's late Biblical canvases; some, indeed, believe it to be one of his very last, unfinished paintings.

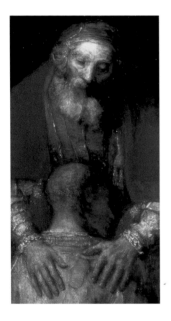

THE STORY
The younger of two sons demands his share of the inheritance and leaves home, leads a dissolute life and squanders his fortune. Penniless and full of remorse, he returns home: "And he arose, and came to his father. But when he was yet a great way off, his father saw him, and had compassion, and ran, and fell on his neck, and kissed him. And the son said unto him, 'Father, I have sinned against heaven, and in thy sight, and am no more worthy to be called thy son'" (Luke 15:20–21). Nevertheless, the younger son is given the best clothing in the house and new sandals. At the party that follows his father has to placate the jealousy and anger of his elder brother.

● The forgiving **father** – is he blind? – gently presses his hands onto the back of his kneeling son. The latter folds his arms across his chest, closes his eyes and has shaved his head: all signs of penitence.

● In addition to the rags the young man is dressed in, Rembrandt highlights the extent of his misery with his equally **ragged feet**.

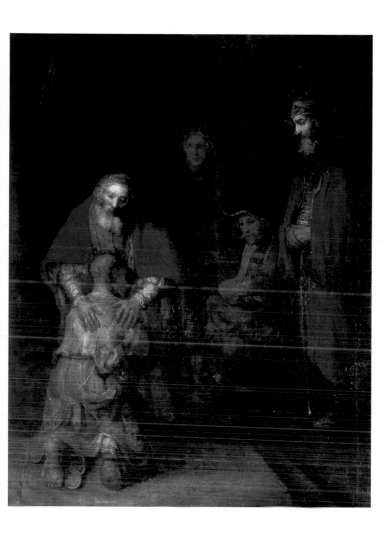

● The unreal, mask-like faces of the **servants** in the shadows have prompted speculation that another artist may have finished this canvas.

● The face of the **older brother** is also well lit. He stands upright, wearing red clothes like his father's, and looks on, apparently unmoved.

BARTHOLOMEUS BREENBERGH *The Preaching of St John the Baptist*

1634
Panel, 54.6 x 75.2 cm
The Metropolitan Museum of Art,
New York. Purchase, The Annenberg
Foundation Gift, 1991 (1991.305)

Dutch landscape painting of the 17th century is known for its characteristic cloudy skies and flat horizons. Yet this was not the only approach to the genre: many Dutch painters visited Italy and drew a life-long inspiration from its landscapes and the golden, southern light – elements that would crop up once they were back in their own flat country. Their landscapes began to sprout Classical ruins and tiny figures acting out stories from the Bible or mythology. Like their fellow painters of home-grown landscapes, these artists composed their work in the studio.

"In those days came John the Baptist, preaching in the wilderness of Judaea, And saying, 'Repent ye: for the kingdom of heaven is at hand' ... And the same John had his raiment of camel's hair, and a leathern girdle about his loins; and his meat was locusts and wild honey. Then went out to him Jerusalem, and all Judaea, and all the region round about Jordan, And were baptized of him in Jordan, confessing their sins."
Matthew 3:1–2 and 4–6

● Breenbergh had already been back in Amsterdam for some time when he painted this panel, in 1634, using drawings he had made on his Italian tour. This **ruin** looks like the Roman Colosseum, which was more dilapidated in Breenbergh's time than it is today.

● This scene, with **John the Baptist** preaching, comes from the New Testament. St John was a symbolic figure in 17th-century Dutch art: he had proclaimed the true Christian faith, just as pioneering Protestants had done under the Spanish Catholic regime a century earlier.

● As the Gospels state, the **multitude** we see here listening to the "voice crying in the wilderness" was large in number and highly varied in its composition. The panel does not show whether or not they are going to be baptized, but a river flows through the landscape, ready to do service.

PIETER SAENREDAM *Interior of the Church of St Bavo in Haarlem*

1636
Panel, 95.5 x 57 cm
Rijksmuseum, Amsterdam

Painting church interiors became a specialism in its own right in Holland's Golden Age. Pieter Saenredam was one of the genre's founders. The works in question were dubbed *perspectieven* (perspectives), as it took both precise observation and the sophisticated rendering of perspective to capture architecture in this way. The method to render three-dimensional objects in a true-to-life manner within the two dimensions of a canvas or a wooden panel had been part of artists' training since the Italian Renaissance. In this example, Pieter Saenredam shows the interior of the church of St Bavo, which still stands in his native city of Haarlem. He often spent weeks sketching on location to prepare his highly detailed paintings.

● The 15th-century **organ** is rendered in exquisite detail, including its gilt inscriptions. The colours of the instrument contrast with the otherwise clear, cool and above all sober interior. The painter and his patron – a local organ enthusiast, perhaps? – might have been dabbling in propaganda, as the Calvinist ministers who held their services in the building wanted as little Catholic-style splendour as possible, which also meant no fancy organs. The one shown here predates the Reformation. In 1636, the year this work was painted, Haarlem's music lovers were on the counter-attack; they wanted to hear more organ music in the church. The organ's painted shutter is open, revealing the Resurrection of Christ.

● A man and a woman stage a secret rendezvous in the **gallery**; Saenredam was fond of light-hearted anecdotal detail like this.

● Churches in the 17th century also served as **public meeting places**. For Saenredam, however, human figures were less important than the interior space, serving primarily to give the viewer a sense of the interior's size. In this panel they also guide our eye; the little boy looks at the man with the sword, who in turn looks at the organ. The interplay of these three levels leads us towards what the artist considers to be the most important element of the painting. The figures in the background blend into the architecture: the further in we go, the higher the key.

DIEGO VELÁZQUEZ *The Surrender of Breda ('The Lances')*

about 1635
Canvas, 307 x 376 cm
Museo Nacional del Prado, Madrid

Velázquez painted this canvas in around 1635 – some ten years after the events it purportedly depicts. The work, which took its popular name from the thicket of proud Spanish lances in the upper right of the canvas, was destined for the throne room in the palace of King Philip IV of Spain. It shows Justin of Nassau handing over the keys of the defeated Dutch city of Breda to the Spanish general Ambrogio Spinola. Breda was a key fortified town which, having been besieged for months, was eventually starved and exhausted into submission. The incident occurred during the Eighty Years' War between Spain and its rebellious possessions in the Low Countries. Although the events shown here never took place in this manner, the artist may have seen them enacted like this in a stage play by Calderón. According to contemporary accounts, the victorious Spinola was very magnanimous upon the city's surrender, and it is this upon which Velázquez chooses to focus.

Velázquez places the dramatic moment of surrender in the foreground. **Justin** (on the left) bows down before **Spinola**, who places his hand on the defeated general's shoulder; or is he stopping him from actually kneeling? They are posed as if on a stage, against a backdrop featuring the brightly uniformed, vanquished Dutch troops and the object of the conflict – the city of Breda itself. Velázquez knew Spinola but never met Justin of Nassau.

SPANISH SELF-IMAGE

Velázquez painted this canvas at a time when Spain was keen to restore its tarnished reputation; although still a great power, the country was going through a period of great difficulty, not least because of the Revolt of the Netherlands. The message the painting seeks to convey is that Spaniards are brave, noble and magnanimous in victory.

The canvas is both symmetrical and unsymmetrical: defeated but stoical **Dutch soldiers** stand on the left, armed only with a few halberds decorated with orange pennants, while a large plume of smoke rises behind them. The young man in the white shirt is being consoled. The two horses play an important part in the overall composition.

The victorious **Spanish officers** lift their hats to mark this ceremonial moment, while the troops behind them proudly raise their lances *en masse* in a display of power and discipline. The men gather around their flag. It was not until the final stage of the design, incidentally, that Velázquez inserted the lances.

The fact that the attractive **landscape** is shown in bird's-eye view suggests that Velázquez based it on maps or engravings.

DIEGO VELÁZQUEZ *Las Meninas*

1656
Canvas, 318 x 276 cm
Museo Nacional del Prado, Madrid

To understand Velázquez's most famous work, we have to begin with the mirror at the back, in which we see the Spanish king and queen posing for their portrait. The painter and courtier Velázquez himself stands to the left, working on a huge canvas. The girl in the foreground in the crinoline skirt is the five-year-old Infanta Margarita, daughter of Philip IV. While she has ostensibly come to watch her parents having their likenesses painted, she too is being immortalized. Margarita is accompanied by two young ladies-in-waiting – the eponymous *meninas*. The seemingly informal character of this court portrait was something new in art, certainly for a canvas of this size. It is more than just a portrait; it is a commentary on portraiture in general – a painting about painting. Velázquez was the favourite court painter of Philip IV of Spain (1621–1665).

● The **Infanta**, whose childlike nature is perfectly expressed, figures centrally in this portrait; the painter is shown standing behind her.

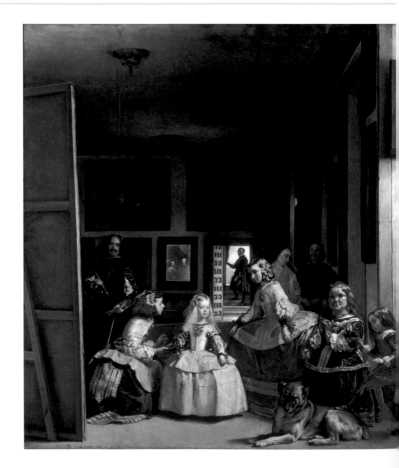

● Nicolasito, the **court jester**, slyly places his foot on the sleepy dog, while Mari-Barbola the dwarf, with her characteristically stocky figure, serves to highlight the Infanta's fragility. Jesters were popular figures at royal courts (see also pp. 256–7).

● In the shadows **a man talks to a woman**, possibly a priest and a nun; the Spanish court was a bastion of the Church. Or perhaps they are a lord and lady-in-waiting.

● The **painter** is every inch the courtier – he even served at one stage as Philip's chamberlain. His gaze is directed at both the royal couple and the viewer. We are positioned where the king and queen would have posed, drawing us into the action; all that is lacking is the ceremonial curtain we see in the mirror. Velázquez plays this intellectual game with the different levels of reality to show that painting is more than a mere craft, something that was fiercely debated at the time. His chest is adorned with the cross of the prestigious order of St James, which he did not receive until two or three years later.

● Velázquez was a younger contemporary of **Rubens**, whom he actually met in Madrid. The Spaniard admired the Fleming and both were huge aficionados of Titian. Velázquez was able to study the other two artists' work in the royal collection in Madrid. This is a subdued view of Rubens' *Pallas and Arachne*.

WILLEM CLAESZ HEDA *Still Life with Oysters, Lemon and Silver Tazza*

1634
Panel, 43 x 57 cm
Museum Boijmans Van Beuningen,
Rotterdam

Haarlem artist Willem Heda was one of the most talented still-life painters of Holland's 17th-century Golden Age – the period that saw the genre's greatest popularity. He was a master of reflected light and specialized in working with a single dominant colour in a variety of shades. Heda painted from life: in his studio he arranged and rearranged objects – both everyday and precious – and foodstuffs until he achieved the delicate composition he was after, the items lying or standing, full or empty, cut or whole, or dangling perhaps over the edge. The most valuable object in this panel is the silver *tazza*, decorated with reliefs, lying on its side.

IN RUBENS' KITCHEN

Peter Paul Rubens owned two of Heda's still lifes. They are likely to have hung in his kitchen, which also served as his dining room. There we can imagine him discussing the works with his fellow diners: not only the brilliance of the painter's technique, but also the importance of healthy food – a theme in which the humanist Rubens was particularly interested. (See p. 334 for the way lemons were viewed at this time.)

● A **broken glass** lies on the table behind the pewter dish of oysters; it is not a motif that Heda used frequently. The shards may be an allusion to the transience of life, or simply an opportunity for Heda to show off his outstanding ability to capture light effects. Opened oysters, meanwhile, offer three textures at once: the rough shell, the smooth mother-of-pearl inside and the soft mollusc itself. The same goes for the half-peeled lemon.

● **Pepper** contained in a rolled-up bit of paper like this often features in Dutch still lifes; it was an expensive spice imported from the East.

● The **half-full wine glass** and the equally half-full beer glass in the right background may allude to the importance of moderation. But perhaps it is too far-fetched to seek a didactic or allegorical message in still lifes like this: where that was the artist's intention, such things tended to be expressed more explicitly. It is more likely that Heda simply opted for this approach to enable him to paint even more different types of reflection: in the wine glass, for instance, we see the daylight falling through a studio window.

299

JAN VAN GOYEN *View of Rhenen*

1646
Canvas, 101.5 x 136 cm
Corcoran Gallery of Art, Washington DC

As the 17th century progressed, Dutch landscape painting gradu-ally became more specialized, driven by the high level of demand from private buyers. Paintings were now largely produced for sale on the open market, rather than being commissioned in advance, and reports even exist of artists – Jan van Goyen among them – who were able to complete a painting in a single day. Van Goyen, to whom around 1,200 paintings are attributed, became the leading exponent of river and polder landscapes, in which sky and water play the starring roles. He was one of a number of Dutch landscape painters who preferred a sober, even mono-chrome palette.

THE PANORAMA

The flatness of the Dutch countryside gave rise to
a specific type of painting: the panorama. Views like
this present an 'empty', flat landscape, with a few eye-
catching buildings (a church, mill or tower, say) or trees
on the horizon, which is so low that the evocative
cloudscape can occupy up to two-thirds of the picture
surface. The vantage point frequently suggests that the
painter was standing on a hill. Rembrandt launched
a new subgenre in the early 1640s, featuring the
distinctive skyline of an entire city on the horizon.

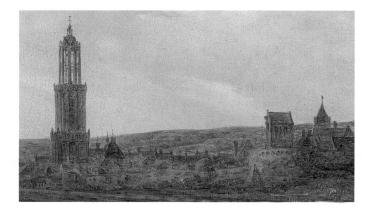

● The church of St Cunera towers over the town of **Rhenen**, which lies in a strategic location to the south-east of Utrecht and was popular with landscape painters.

● **Cloudy skies** dominate Van Goyen's work because of the low horizon. The clouds in this painting are gloomy and ominous, while the Rhine below describes large arcs through the landscape

● Earlier landscapes, from the first part of the 17th century, tend to include a narrative element: there are **people** to be seen. Jan van Goyen's work illustrates the subsequent evolution towards pure landscape, without any human presence. This one has yet to reach that stage: a coach-and-four makes its way along the sunny little road, with two figures walking in front of it. A small rowing boat with three passengers can also be made out on a branch of the river.

ALBERT CUYP *The Maas at Dordrecht*

about 1650
Canvas, 114.9 x 170.2 cm
National Gallery of Art, Washington DC.
Andrew W. Mellon Collection

July 1646 saw large-scale celebrations in the Dutch city of Dordrecht, at the mouth of the river Maas. The end of the drawn-out conflict that won Holland its independence was approaching, and would be officially sealed in 1648. The festivities – to honour some 30,000 soldiers – were to last a fortnight. On 12 July, a fleet of merchant vessels and warships left the port to take the guests home. Local artist Albert Cuyp was on hand to record the occasion.

GOD, NATION AND LANDSCAPE

The narrative element in Dutch landscapes and seascapes is frequently rather thin, the scenery having seemingly been chosen for its sheer decorative quality and beauty. The significance can, however, go beyond straightforward aesthetics: Calvinist belief held that God's hand was visible everywhere in nature. In addition, the 17th century saw a burgeoning pride in the newly created Dutch nation and its unique characteristics – water, impressive skies and the flat, wide-open countryside. Paintings by the likes of Van Goyen, Cuyp and Ruisdael are not topographical studies: their fidelity to nature can vary widely. They took reality as their starting point, but were happy to make changes whenever it suited them.

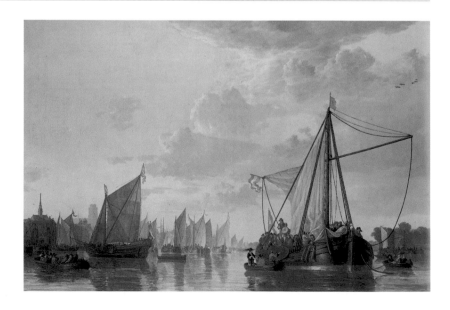

Although Dordrecht painter Albert Cuyp never visited Italy, many of his works are bathed in the golden Italian **light** he will have seen in the work of his contemporaries (see pp. 290–91). Along with Jacob van Ruisdael (see pp. 320–23), Cuyp was instrumental in the subsequent development of the celebrated Dutch landscape, with its powerful contrasts of light and shade, imposing compositions and poetic atmosphere. Towards the end of the 18th century, England was gripped by Cuyp-mania, which is why much of his work can now be seen in British and American collections.

● The **docks** teem with people who have come to wave the ships off to the sound of music. Cannons no doubt fired a salute, too.

● A **man dressed in black** stands in the rowing boat near the large ship. He is wearing a sash with the red and white colours of Dordrecht, suggesting that he is the master of ceremonies. Perhaps it was he who commissioned Cuyp to paint the event.

GERARD TER BORCH *Gallant Conversation*
(formerly known as 'The Paternal Admonition')

1654
Canvas, 71 x 73 cm
Rijksmuseum, Amsterdam

Until well into the 20th century this painting was viewed as a scene of domesticity: the paterfamilias admonishing his crest-fallen daughter with raised finger. However, when another version of the same composition in Berlin was cleaned, it clearly showed the man holding a coin in his raised hand. This utterly changed the interpretation of the work, hence its new title. The many copies and imitations that have survived are testimony to the popularity of the subject.

BROTHELS: TO BE BANNED OR TOLERATED?
To strict Calvinists the brothel embodied the very opposite of decent values – domesticity, faithfulness and family. The only thing you could learn in a brothel was sin. Nevertheless, brothels were tolerated in certain neighbourhoods of Amsterdam and other cities as institutions that helped ensure 'municipal hygiene', not least because they prevented rowdy seamen from bothering respectable women elsewhere in the city.

● The **man** is sitting on a scarlet chair with a sword slung on his belt: he is a soldier, a profession particularly associated with brothel-going. Which is precisely what he is doing right now. The hat with colourful feathers, a well-established symbol of loose morality, confirms the nature of the setting (see also p. 259). The old woman is the procuress, mediating between the customer and the prostitute who works for her; she is a constant figure in brothel scenes. She is drinking – another sign of lax morals – though she seems to be keeping out of the negotiation here

● With hindsight, it ought to have been obvious what this scene is and where it is set; Ter Borch's contemporaries must have been able to read the painting without difficulty. First and foremost, there is a strikingly large bed in this dark, sober room. A less-than-elegant **dog** wanders around, and there is a **candle** on the table to the left – a combination suggestive of lust that is also found in other paintings.

● Because of her striking and fashionable silver-grey dress, all the viewer's attention is focused on the pivotal figure in this scene, the **young woman** selling her charms. We are denied a view of her face.

NICOLAES MAES *Old Woman Dozing*

about 1655
Canvas, 135 x 105 cm
Musées Royaux des Beaux-Arts de
Belgique, Brussels

An elderly woman has dozed off while reading. Her lace bobbins, ordinarily a symbol of domestic industry, lie idle on the cushion, the Bible on the table is open to the Book of Amos, and on her lap there is a second book. In Dutch 17th-century painting, scenes of sleeping people are generally meant to convey a moralizing message: a warning against idleness, against lack of moderation (when the sleep is caused by excess of alcohol) or about the dangers that threaten us when we sleep. A person sleeping is surely forsaking their daily duties.

REMBRANDT AND MAES

*Nicolaes Maes was a pupil of Rembrandt
for a while. This left a permanent imprint
on his work, in the use of dark colours and
chiaroscuro effects. However, there is also
a significant contrast: while Maes painted many
domestic scenes, we do not know of a single one
by Rembrandt, though he did make many such
drawings. This is highly unusual for an artist
of Holland's Golden Age.*

● **Amos** was a 'prophet of doom'
whom God sent to warn people
who fell prey to moral depravity.

● A lonely **old woman**, praying
devoutly in a simple interior,
is a frequent subject of genre
paintings. She has distanced
herself from riches and the
material world and is ready for
the spiritual life after death. Her
opposite is the wicked procuress
(see pp. 195, 235, 258–9). But this
old woman is sleeping, which is
considered sinful for people of
any age. Her attitude is typical of
a lazy person. The prevailing view
was: the older you are, the less
time you have to waste.

● The objects in the interior
reinforce the admonitory tone of
this painting. The message could
not be any clearer than the one
conveyed by the **hourglass**: time
is running out. As life on earth
is short, you had better not waste
the little time you have, as this
woman is doing. The hourglass
also underpins the meaning of
the open Bible.

GERARD DOU *Young Mother*

1658
Panel, 73.5 x 55.5 cm
Mauritshuis, The Hague

Gerard Dou, Rembrandt's first pupil, shared a single great ambition with his painting contemporaries of the Dutch town of Leiden: to paint so delicately that the illusion of reality would realize its full potential. The painstaking technique of the Leiden *fijnschilders* ('fine painters'), the smoothing out of brushstrokes and the pursuit of detail and maximum variety in fabrics and materials were all geared towards this end. Dou, like so many of his compatriots, chiefly practised genre painting. There was much demand for these intimate scenes from everyday life. This particular work was purchased by the Dutch government to present to the newly crowned King Charles II of England in 1660, illustrating the success of Dou's painting at international level, too.

● One of the functions of **curtains** on a painting is to reinforce the illusion that what we see is three-dimensional. 'Photographic realists' like Dou particularly liked to use this motif. The same goes for the glimpses they offer through an open door, window or stairway into another space or outdoors. Dou uses both devices in this painting.

● Dou included **two still lifes** in this composed space; on the left a group of miscellaneous objects bathes in the light from the open window: a basket, a skinned rabbit, a piece of cloth, an upturned tin jug. Tangibility also reigns on the right, where we find a similarly varied collection of materials, including carrots, an overturned lantern, a shiny ceramic pot, a broom, a fish on a ceramic plate and a dead bird.

● The young **mother** looks up from her sewing while the nurse or maid fusses over the happy baby in its wicker rocking-cradle. Cupid is watching in the relief behind them.

● These three objects often have a symbolic meaning: a discarded **slipper** is a reference to love and sex (see also p. 317), an **overturned lantern** is a token of neglect and an **extinguished candle flame** is a sign of time slipping away. Birds can also be loaded with sexual metaphor. It is impossible to know, however, whether that is the intention here.

JAN STEEN *Young Woman Eating Oysters*

about 1658–60
Panel, 20.5 x 14.5 cm
Mauritshuis, The Hague

This tiny painting is an invitation; the young woman looks us straight in the eye, with a distinctly flirtatious edge, all the while sprinkling salt onto an oyster, as if preparing it especially for us. She is alone – unusual in a painting by Jan Steen – and is wearing a fashionable, fur-lined jacket.

"Of all the shellfish, oysters have in every age been considered the most refined; for they whet the appetite and desire for food and for sleep, which well suits the lusty and the delicate alike."

Johan van Beverwyck, a Dordrecht physician, in his popular medical handbook of 1651

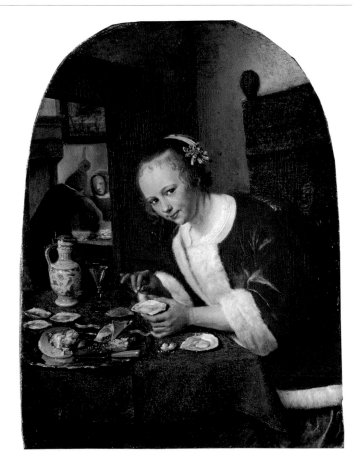

According to conventional wisdom in 17th-century Holland, **oysters** were a powerful aphrodisiac. The look in the young woman's eyes and her gesture leave nothing to the imagination; behind her the bed is waiting.

A sketchily painted **man and woman** are in the room behind the open door; they too are occupied with aphrodisiac oysters. Have these two already moved on to the next stage? Or are they in the kitchen preparing more oysters, for us?

Jan Steen often tucks little **still lifes** into his genre paintings, thus demonstrating his technical expertise. Any such display requires a variety of textures, and we are treated here to a smooth Delft jug; raw, open oysters; a soft bread roll sliced open; a roll of paper containing pepper; a flat, reflecting dish; and salt. The glass of white wine heightens the atmosphere and the message.

JAN STEEN *The Feast of St Nicholas*

about 1665–8
Canvas, 82 x 70.5 cm
Rijksmuseum, Amsterdam

Paintings of seemingly familiar scenes from everyday life were tremendously popular in the Dutch Golden Age. Genre painting, with its stock characters and situations, became a branch of art in its own right. Many, though by no means all, of these anecdotal works had a more or less 'hidden' moralizing and symbolic message; a classic example being a painting showing lots of different pleasures, but which is actually intended as a subtle warning of how one ought *not* to live. Jan Steen was a remarkably productive narrative painter, whose seemingly comical little dramas frequently conveyed a moral of this kind.

● This festively dressed **toddler** is one of the lucky ones: she clutches the John the Baptist doll she has just been given. St John, according to popular wisdom, protects against children's maladies. She also holds a pail containing sweets and toys that she clearly has no intention of relinquishing.

● The Feast of St Nicholas is still an important family celebration in the Netherlands, the only reformed country of Europe where his legend persisted. In Steen's time, this 'Catholic' feast was disapproved of by Protestants, who rejected the worship of saints. Many towns forbade the baking of cakes or biscuits in the shape of the saint. Steen himself was a Catholic. In the 17th century Dutch colonists imported the tradition in 'New Amsterdam' – now New

York City – where the image of *Sinterklaas* later merged with that of a kindly, old, gift-giving man from Nordic folktales into Santa Claus/Father Christmas. On the evening of 5 December, the **saint brings gifts and sweets** to children who have been good

in the past year, traditionally delivering his goodies via the chimney. Hopeful children place a shoe by the fireplace and sing a song asking St Nicholas to leave something in it for them.

● **Big brother** is crying; and, behind him, the maid shows why: St Nicholas has left him a bundle of birch twigs, symbolic of a good spanking, which is what bad children got in their shoes. His younger brother points at him mockingly. He has been lucky; he got a stick for playing *kolf*, a hockey-like game popular at the time (see also p. 314). Maybe Grandma, who is gesturing in the background, will comfort the older boy, as she points at something obscured by the bed curtain. Jan Steen uses the attitudes, expressions and gestures of the characters to tell the story and to illustrate the different emotions accompanying the festivities.

● Steen, the master painter, also reveals his talent for **still lifes** in the left- and right-hand corners of this busy composition. The large diamond-shaped loaf, for instance, was traditionally baked and eaten on festive occasions like this. The apple has a coin wedged in it as a surprise and was traditionally given to friends as a joke.

313

PIETER DE HOOCH *The Linen Cupboard*

1663
Canvas, 70 x 75.5 cm
Rijksmuseum, Amsterdam

Domestic tidiness and order were important, even obsessively pursued, values in 17th-century Dutch society: an orderly household meant keeping out the dirt in both the literal and the moral sense, and hence living a virtuous life. What is more, tidiness came to be seen as a manifestation of the Dutch national personality and one that entailed ceaseless industry; another device for eradicating sinful idleness. Consequently, for all its prosaic theme, this meticulously executed genre painting contains a moral message. We are offered a glimpse into a wealthy interior, as we see from the oak and ebony display cabinet, the pilasters by the windows and door, the paintings and the Greek statue. This is obviously the interior of a house with several rooms and at least two floors.

LIGHT EFFECTS
De Hooch lived in Delft and was a fellow townsman and colleague of Johannes Vermeer. He too was a master in perspective construction and in capturing the play of light. In this case the canvas contains three sources of light, each with its own precisely rendered effects.

● **The maid and the lady of the house** are putting away a stack of clean laundry in the cupboard, their skirts turned up to protect them from any dirt. Guarding the purity of the family was a mother's task. Her most important duty was to turn her house into a beacon of Christian virtue. A man would be entirely out of place in a scene like this.

● The child is playing *kolf* – a type of hockey that was a typical boy's game in the 17th century. He is a boy, then, despite the 'dress' he is wearing. The square-pointed collar is further proof of his masculinity.

"You travel, industrious man,
and care for your earnings,
You stay home, young woman,
and care for your family."

Jacob Cats, 17th-century Dutch poet
and moralist

● Above the door stands a statue of the Greek mythological hero Perseus, displaying his prize: the head of Medusa. Copies of Greek sculptures were very popular in the 17th century. Many still saw Classical art as an ideal to be emulated.

● Behind the door opening we can see the entrance hall and through the outer door a view of an **Amsterdam canal** with a typical canal house of the time. This too is rendered in minute detail.

GABRIEL METSU | *Man Writing a Letter* | *Woman Reading a Letter*

about 1662–5
Panel, 52.5 x 40.2 cm (x 2)
National Gallery of Ireland, Dublin

Love letters were a popular theme in 17th-century Dutch painting – a period in which letter writing gradually spread to all layers of the population (see also pp. 328–9). They were written and read by members of both sexes.

These two panels were intended as a pair, as we see from their identical dimensions. They tell one and the same quiet, simple story: a handsome and clearly wealthy young man writes a letter, which is subsequently read by the female recipient, also in elegant attire. Both protagonists concentrate intensely on their respective tasks, while the two works are bathed in the same clear, silvery daylight.

BEHIND THE CURTAIN
Paintings were often protected by curtains, both to shield them from the detrimental effect of the light, and to lend the work of art a more exclusive air: it was not displayed at all times or to all visitors.

● The young man is sitting in a richly appointed, cosmopolitan interior, with an open window, **oriental table rug, globe** and Italianate landscape painting in a baroque frame. The woman, by contrast, is shown in a far more sober room. This may be an allusion to a certain duality in Dutch society at the time, which prized a focus both on the outside world and on more contemplative, inner values.

● The maid opens the curtain to reveal a seascape, in which a ship makes its way through **turbulent waters** – a familiar metaphor for the hazards of incautious love. Does that mean that the message is a love letter? Perhaps the woman's husband spent a lot of time overseas; not unusual in a seafaring, trading nation like 17th-century Holland.

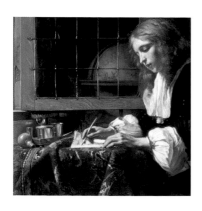

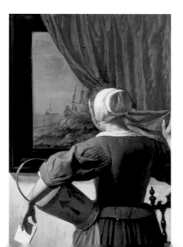

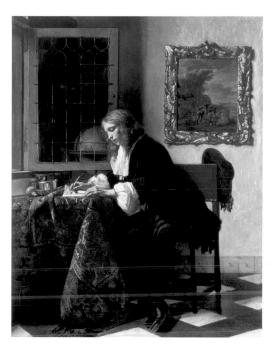

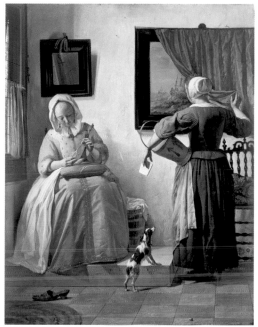

THE DELFT SCHOOL

*Gabriel Metsu, born in Leiden and active in
Amsterdam, has evidently studied the work of two of
his contemporaries – the grand masters of the Delft
School, Johannes Vermeer and Pieter de Hooch.
In this pair of pendants he skilfully demonstrates the
three great accomplishments of the Delft painters
the rendering of natural light in an interior,
balanced composition and the arrangement
of colours. Vermeer, too, developed the theme
of the love letter (see pp. 328–9).*

● The **slipper** on the ground may
be an erotic metaphor, while dogs
were the classic symbol of marital
fidelity – especially when in the
company of recent widows. Is the
dog also looking at the seascape,
or is he trying to get the maid's
attention?

● The **thimble** the woman was
using for her needlework is
lying on the floor, cast
aside as she devotes all
her attention to the
letter. Details like this in
genre paintings tell us
more about the psychology of the
figures, expressing emotion
through understatement.

GABRIEL METSU *The Sick Child*

about 1660
Canvas, 32.2 x 27.2 cm
Rijksmuseum, Amsterdam

A pale, listless child sits on what is presumably her mother's lap. She stares vacantly into space as the woman bends over her in concern. The earthenware bowl of porridge remains untouched on the low table or chest to the left. This is a quiet and touching scene from everyday life, as we find in the work of artists like Vermeer (see pp. 324–5). Paintings of this kind typically feature one or two figures in an ordinary interior. If we imagine a diagonal running from bottom left to top right, we notice that the colours to the left are subdued, while those to the right are bright; the result is a perfectly balanced composition.

IMAGES OF PARENTAL LOVE

Some historians have argued that parental love is a modern phenomenon. High levels of child mortality supposedly left pre-modern parents with a strong sense of fatality, which prevented them from truly loving their children. A painting like this helps to refute that view: it is a modest but powerful example of an adult's solicitude for a suffering child. Sick children are very rare in art; prosperous citizens preferred to commission children's portraits or scenes of healthy youngsters dressed in their Sunday best. Portraits of the entire family, by contrast, sometimes included children who had died.

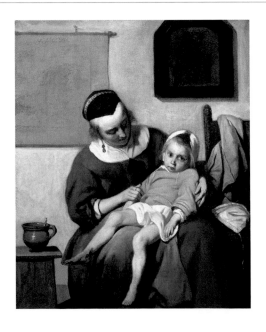

● The child's **bonnet** has been set aside. It is intended to protect the head if the child should fall, but this youngster will not be walking around for a while yet.

● A **map** hangs against the light-coloured wall to the rear. If paintings are anything to go by, maps seem to have hung in many an interior. Metsu signed the painting on the map. (Spelling remained largely a matter of choice in his day, and in this instance he preferred *Metsue*.)

● This **framed image** *inside* the painting shows the crucified Christ, with his mother Mary and his disciple John at the foot of the cross. It raises the domestic scene to a higher plane, the allusion transforming this mother and child into a kind of *pietà*. Perhaps the picture is meant to symbolize Christian charity or *Caritas*?

JACOB VAN RUISDAEL *The Jewish Cemetery*

about 1660–70
Canvas, 142.2 x 189.2 cm
The Detroit Institute of Arts

The Beth Haim Cemetery of Amsterdam's Portuguese-Jewish community has been located at nearby Ouderkerk-aan-de-Amstel since 1616. The tombs shown in this canvas can still be seen today, but the rest of the composition – the undulating landscape, mountain stream and ruins – is invented, serving to enhance the dramatic atmosphere and heighten the symbolism. As so often in Ruisdael's work, an ominous cloudscape hangs overhead.

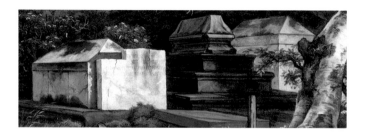

● Sunlight falls on the large **white marble tomb** on the left, the grave of one Doctor Eliahu Montalto, who died in the year that Beth Haim was instituted (1616). Alongside it stands the red marble tomb of Issak Uziel (d. 1622), while the sepulchre below the trees to the right belongs to Israel Abraham Mendez (d. 1627). We know that Ruisdael made drawings of these tombs only *in situ*.

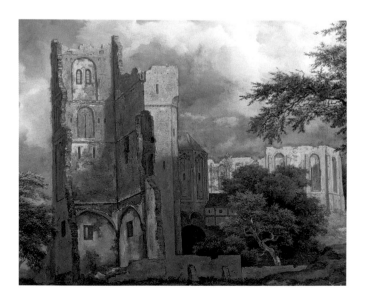

● The tall **ruin** picked out against the stormy clouds is the composition's key element, yet it never stood on the site. Ruisdael might have 'borrowed' an existing, derelict Romanesque abbey which actually stood twenty-five miles away.

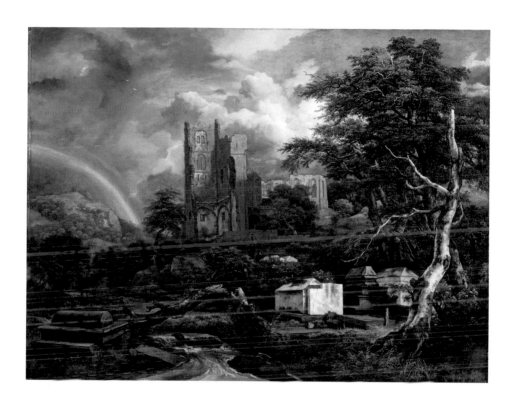

● That there are other references here to the transience of life, in addition to the graves, is plain in the way that Ruisdael added the ruins and the dramatic hillside himself. Like the broken, dead tree and the sunlight breaking through the clouds, everything contributes to the atmosphere of the scene, including the uplifting **rainbow** on the left. We can no longer judge the importance of the painting's symbolism to Ruisdael himself or to the person who commissioned it. Perhaps it is an allegory, each element conveying a second, deeper meaning. The rainbow might allude to God's Covenant with humankind after the great Flood described in the Book of Genesis. Whatever the case, Ruisdael once again includes a few tiny human figures in the painting, this time under the castle.

JACOB VAN RUISDAEL *The Windmill at Wijk bij Duurstede*

about 1670
Canvas, 83 x 101 cm
Rijksmuseum, Amsterdam

Landscape painting became a flourishing genre in its own right in Holland's Golden Age; Jacob van Ruisdael was one of its most versatile and innovative practitioners. His landscapes are dramatic, thanks chiefly to the lighting, the low vantage point, the colour contrasts, the diminutive human figures and the cloud-laden skies that set the tone for many of his paintings. There could hardly be a more Dutch landscape than this work, with its distinctive clouds, windmill, water (in this instance the Rhine estuary) and flat countryside. Ruisdael uses the sunlight to pick out selected details.

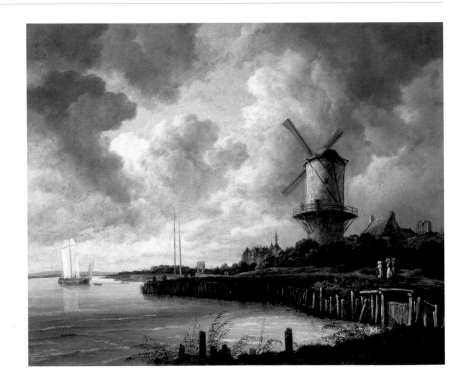

● The **windmill** is already positioned high up to catch the wind, but the artist's low vantage point means that it towers above the rest of the scene. The sunlight gives it a light side and a dark side; the vanes are covered with sails and seem not to be turning. We know that in Ruisdael's 17th century, two mills stood close together in Wijk.

● Above the low horizon we see **dark clouds** with the sun breaking through and bands of light and shadow moving across the still water. The drooping sails of the ship are another clue that there is no wind. Is this the calm before the storm? Can menace and calm really co-exist as they seem to do in this picture? What we do know is that Ruisdael completed this painting in his studio, working from the chalk drawings he produced *in situ*.

● The blunt **tower** of the church of St Martin enables us to both locate and roughly date the painting, since we know from the archives that the clock face on the tower dates from 1668. The medieval castle standing to the left of the mill no longer exists.

● The **three women** in traditional Dutch attire walk in the sunlight at the point where the Vrouwen-poort (Women's Gate) was located in Ruisdael's day. The gate would have obscured the artist's view of the mill, so he left it out, adding the three women as a playful reference to its name.

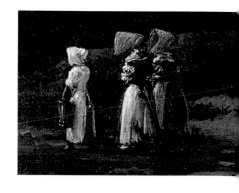

JOHANNES VERMEER *The Kitchen Maid*

about 1658–60
Canvas, 45.5 x 41 cm
Rijksmuseum, Amsterdam

The rather limited oeuvre of Johannes Vermeer of Delft (only some thirty-five paintings have survived) is mostly made up of paintings such as this, showing simple folk in simple interiors. What makes these apparently straightforward genre paintings so brilliant is the artist's masterly sense of natural light, which typically comes from just one side, and their unforced, naturalistic feel. These qualities are perfectly illustrated by *The Kitchen Maid*. As is frequently the case in 17th-century Dutch painting, the ostensible theme is not the overriding concern for Vermeer; these are still lifes with people – exercises in the representation of tangible surfaces and in optical illusion. Vermeer perfected the naturalism introduced by artists like Caravaggio; thanks to him, we look at everyday scenes like this with fresh eyes.

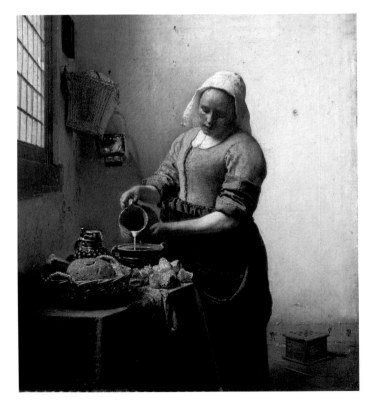

● A **young woman** dressed in white, yellow, blue and red, stands in a bare room, concentrating as she pours milk into a bowl. The low viewpoint adopted by the painter adds to the sense of her robustness. Light enters the space through a window on the left.

● Details like this create the illusion that this is a 'real' space: the **brightly lit hand** against a dark section of wall, the milk, the broken pane of glass and the **shadow of the nail** on the wall. Light has the effect in Vermeer's paintings of blurring the outlines of figures and objects, causing surfaces to blend into one another.

● A basket of bread, a Cologne jug and a basin stand on the table, forming a simple **breakfast still life** together with several loose bread rolls and a blue cloth. Vermeer uses a special technique consisting of tiny dabs of paint to create his light and shade effects and the sense of tangibility.

● The **blue tiles** that form the skirting are decorated with Cupids, and a **footwarmer** stands on the wooden floorboards. If painting is the art of turning three dimensions into two, preserving the illusion of real space, Vermeer is arguably the greatest painter of them all.

JOHANNES VERMEER

The Artist's Studio ('The Art of Painting')

about 1666–7
Canvas, 120 x 100 cm
Kunsthistorisches Museum, Vienna

It is not easy to reconstruct Vermeer's views on painting as an art, but we may assume that his religious belief and the work of many of his contemporaries and compatriots would have encouraged him to detect all manner of symbolism in the natural and human world around him. It is an issue raised on several occasions in this book: how much is intended symbolically, and how much ought we to take at face value, rather than as metaphor? One thing we may be sure of is that Vermeer's work also expressed his view of life. This picture – nothing short of a manifesto – tells us that he also reflected on the theory behind painting, just as Velázquez, for instance, had done before him (see pp. 296–7). It remained in the artist's possession until his death, and was treasured by his family. In it Vermeer offers a brilliant demonstration of his command of perspective. Convincing viewers that what they are looking at is real, was one of the ideals of the Old Masters.

● The way the artist is dressed conjures up a 15th- or 16th-century Burgundian atmosphere, yet the painting on which he works is in the style of none other than Vermeer himself. The **effect** is to suggest a direct link between Vermeer and a 15th-century 'Burgundian' **painter** like Van Eyck. There is little here in the way of equipment – just an easel, the mahlstick on which he rests his hand, and a paintbrush.

He is working on the model's laurel crown.
We know from a number of paintings that a map of the 'Seventeen Provinces' (just behind the easel) was frequently displayed in the Dutch interiors.

● This is no ordinary model, as we see from her attributes: the laurel crown, a book and a trumpet. She is, in fact, **Clio** – Muse of history – who is present

in order to inspire the painter. The message is that painting is one of the 'liberal arts' rather than a mere craft. The trumpet is a symbol of fame.

Artists' studios in the 17th century often had **plaster casts** of Classical sculptures like this male head. It resembles a death mask, but its precise symbolic meaning here is unclear.

An **empty chair** stands ready; perhaps it is set out for us, as we view the painting. Vermeer places chairs in the foreground of other paintings, too. In this instance, it stands just behind the rich, thick curtain that has been pushed aside so that we can witness the scene beyond.

The **chandelier** is surmounted with a double-headed eagle – emblem of the Habsburgs, from whom the Dutch Republic had recently liberated itself.

JOHANNES VERMEER *The Love Letter*

about 1669–70
Canvas, 44 x 38.5 cm
Rijksmuseum, Amsterdam

Vermeer painted his *Love Letter* several years after Gabriel Metsu completed his (see pp. 316–17). Vermeer's images are very distinctive: one or two people in an interior, almost always close to a window. Some of his everyday scenes also have a deeper, hidden meaning. In this instance, the tied-up curtain affords us a glimpse of the woman's spacious, private quarters. The solidly built maid has just handed a letter to her mistress.

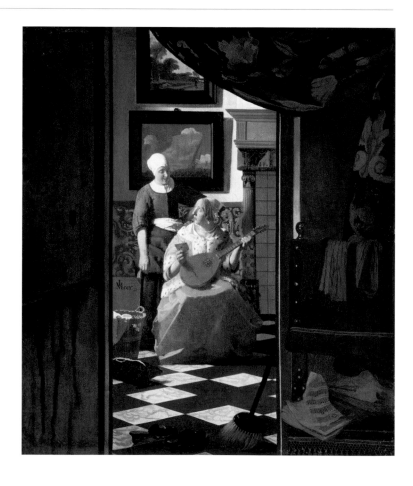

● **Paintings-within-paintings** frequently have a message to convey: in this work, a ship makes its way across the sea in a strong wind and beneath a cloudy sky. The metaphor was already a cliché by the 17th century – love can be every bit as tempestuous and perilous as the ocean. The threatened storm at sea may be an indication that this woman has heartache in store.

● The **topmost painting** shows a man making his way along a sandy path; as in the seascape, somebody has embarked on a journey.

● Allusions to **music** and painted instruments can have very different meanings, depending on the context. In some instances they represent marital joy and harmony; yet in others they are symbolic of hedonism, sensuality and frivolity. They often feature, for instance, in brothel scenes. This instrument belongs to the lute family – a standard lovers' attribute. Its shape was also taken as a reference to a woman's genitals – an analogy also found in the literature of the time.

● **Slippers** can also symbolize the vagina; the motif of cast-off slippers is a popular and perhaps suggestive one. A **brush** leans against the door, again possibly alluding to a less respectable form of love; alternatively, it may be telling us that care for the household has been pushed to one side. Unless, of course, we are simply to take the implement at face value.

CLAUDE LORRAIN *Landscape with the Father of Psyche*
Sacrificing to Apollo

1662–3
Canvas, 175 x 223 cm
National Trust, Anglesey Abbey,
Cambridgeshire, England

How might one take a contemporary landscape – the extensive Roman Campagna with its plains and hills – and turn it into something eternal? Claude Gellée or Claude Lorrain (after his native Lorraine region), usually called simply Claude in English, knew exactly what to do: his combination of unique 'Claude lighting', the realistically rendered Roman countryside, and the ancient ruins and buildings he inserted there, resulted in canvases that truly are timeless dream landscapes. Claude then used these as the setting for mythological or Biblical stories. Highly successful and much imitated, he worked primarily for Europe's aristocracy. So powerful was Claude's influence that he arguably determined our collective picture of the Classical Greco-Roman landscape.

FRANCE AND HOLLAND

There is a marked difference between the landscapes of
Claude and Poussin and the French artists who followed
them on the one hand, and those of Van Goyen and the Dutch
on the other. Claude's Roman temples give way in Van Goyen
to Dutch windmills, while the Frenchman's sunny groves and
hills are replaced by a flat countryside beneath cloudy skies.
The canvases of the Classicist French seem to express
nostalgia for a lost beauty; people even modelled real
landscapes on those they found in Claude. Dutch skies
and landscapes, by contrast, express a religiously inspired
admiration for what could be seen in the artist's own
surroundings.

● Together with the buildings, which include a round, colonnaded temple, the Classical element is provided by this **sacrifice to Apollo**. The offerings are to be cattle. (It was said of Claude, incidentally, that he was barely able to paint people or animals.) The story of Psyche is recounted on p. 265.

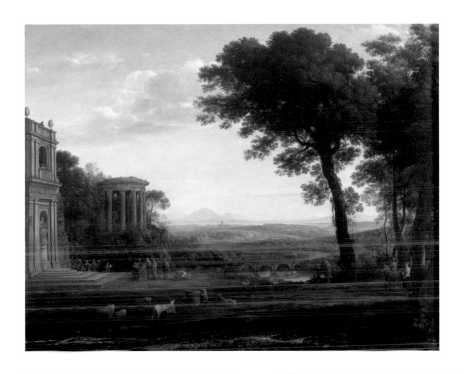

● The central part of this work offers a view of the **distant horizon**, beginning in the foreground with a darkly flowing river and the space in front of the temple. The harbour landscape beyond the bridge is lit by the sun; it merges into a bright horizon, on which we make out the silhouette of a mountain. Claude's work is characterized by an almost infinite recession of planes.

● The **light** seems to penetrate the foliage of the trees, which are located in the right foreground. Together with the Classical buildings on the left they serve as *repoussoir*, a compositional technique aimed at increasing the illusion of depth. The trees testify to Claude's ability to paint from life, although his landscapes as a whole were composed in his studio.

CLAUDE LORRAIN *Sermon on the Mount*

1656
Canvas, 171.4 x 259.7 cm
The Frick Collection, New York

This canvas – a very large one by Claude's standards – is a fine example of his mastery of light effects, which here emanate from the horizon. It was commissioned by the French bishop François Bosquet. The theme is one of the cornerstones of Christian faith: the 'Sermon on the Mount', in which, according to the Gospels of Matthew and Luke, Jesus set out his ethics for a Christian life. Like Moses before him, he offered his people a new Law.

THE STORY
"And there followed him great multitudes of people from Galilee, and from Decapolis, and from Jerusalem, and from Judaea, and from beyond Jordan. And seeing the multitudes, he went up into a mountain: and when he was set, his disciples came unto him: And he opened his mouth, and thaught them, saying, … 'Blessed are the poor in spirit: for theirs is the kingdom of heaven' … And it came to pass, when Jesus had ended these sayings, the people were astonished at his doctrine"

Matthew 4:25, 5:1–3 and 7:28

● **Christ**, dressed in blue robes, sits on the wooded mountain, just as Matthew describes. His twelve Apostles are with him.

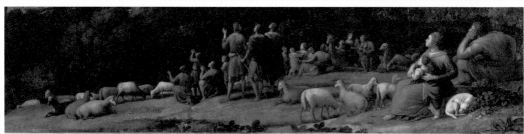

● The people in the audience listen attentively, react, gesticulate or discuss what they have heard; the Gospel-writer talks of their astonishment. In the foreground, a family – mother, child, father and dog – listens to Christ's words. This being the Holy Land, there are sheep nearby, while camels provide a touch of local colour.

The **river Jordan** and the **Dead Sea** lie on this side of the mountain, beneath a sky that gradually shifts from blue to cream. They are positioned lower than the sea on the right.

BOOK OF TRUTH

Claude was a successful painter who sought to prevent plagiarism by keeping what he called a Liber Veritatis – an album of drawings showing which paintings he had 'invented'. It is thanks to this 'Book of Truth' that we are so well informed as to the dating of his work and the patrons who commissioned it.

The painter has 'compressed' the Holy Land so that famous elements of its geography could be included in a single image: this is **Mount Lebanon** with the Sea of Galilee before it; Nazareth lies on the opposite bank. In reality, the Dead Sea (shown to the left of the mountain) is over sixty miles away from the Sea of Galilee. Other geographical details have been similarly modified.

ABRAHAM VAN BEYEREN *Banquet Still Life with a Mouse*

1667
Canvas, 141.5 x 122 cm
Los Angeles County Museum of Art,
Los Angeles. Gift of the Ahmanson
Foundation

Still lifes continued to enjoy great popularity in Holland through-out the 17th century: indeed, demand grew steadily. New varia-tions appeared, including richly laid-out tables of exotic and precious objects, known as *pronk* still lifes. This was the niche in which Abraham van Beyeren excelled. The essence of this type of still life was always the same: an arrangement of objects with varying textures, which allowed artists to display their mastery of the art of composition, the rendering of light and the painting of fabrics. The wealthy burghers who bought paintings like this typified 17th-century Holland: rich, heavily involved in foreign trade (especially with the Orient) and partial to works of art in the home.

LEMONS AS ANTIDOTE?
Lemons are a seemingly ubiquitous feature of still lifes. The fruit was ascribed medicinal qualities in the 17th century: lemons were said to be an antidote to the poisons lurking in a variety of places, not least the gold and silver of expensive serving dishes. Wine, meanwhile, was considered healthy and good for the digestion when eating melons, peaches and other fruits.

● This supreme example of the still-life genre features a sliced-open **melon** on a gilt *tazza* (a saucer-shaped drinking bowl); **oysters** with lemon on a silver plate and others on the marble tabletop (with a piece of lemon peel dangling over the edge); a bright red lobster; and a draped, woven table covering. Van Beyeren brilliantly conveys the hard and soft, rough and smooth, creamy and wrinkled texture of the objects.

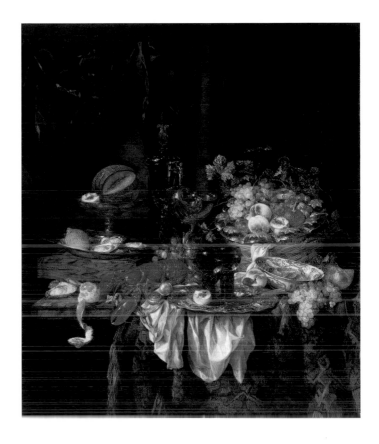

The gilt, curlicued cup and crystal goblet with a fish-shaped base are **treasures** worthy of royalty. Silver, gold, china and the finest glassware: everything is offered up for our admiration. One wonders how the artist's far-from-princely existence allowed him to assemble these precious objects for his painting; or did he simply imagine them all?

A **mouse** walks over the edge of a silver plate; it may be intended as a symbolic warning against a life of gluttony amid such abundance, the consequences of which could be fatal. Perhaps the mouse and the **pocket watch** are a subtle call for moderation in the midst of this highly conspicuous luxury?

JEAN-ANTOINE WATTEAU *The Embarkation for Cythera*

1717
Canvas, 129 x 194 cm
Musée du Louvre, Paris

Watteau's work is characterized by the systematic blending of theatre and reality. We frequently see aristocratic companies communing in parkland (his famous *fêtes galantes*), and there is almost invariably an awareness of the transience of all worldly things. The latter becomes almost premonitory when we recall that the painter himself died aged only thirty-seven. Impressed by Watteau's talent, the Académie Royale in Paris admitted him as a member in 1712. However, it was not until 1717, after repeated requests, that he finally delivered the required *morceau de réception* – this canvas. It too may have been inspired by contemporary theatre.

TWO INTERPRETATIONS
Cythera is one of the settings for the Greek myth that tells how Aphrodite (Venus) was born from the foam of the sea; it thus came to be viewed as an island of love. Watteau's work has been interpreted in two ways. The first, traditional reading – and the one that reflects the painting's title – states that these are couples setting off to the love island of Cythera, which lies within the mist. That makes it a painting full of anticipation, in which the young people, especially the women, seem to hesitate before launching themselves down the path of love. A more recent interpretation, by contrast, argues that the young lovers are actually preparing to depart from Cythera and to return to the 'real' world, emphasizing the painting's melancholy feel.

● This **couple** has risen and is walking towards the ship to the left of the painting. The woman looks back, as if she has qualms about leaving. The pair to the right of them are in the process of standing up, while the final couple are still seated, happily chatting to one another. The rhythm here recalls a sequence of film shots.

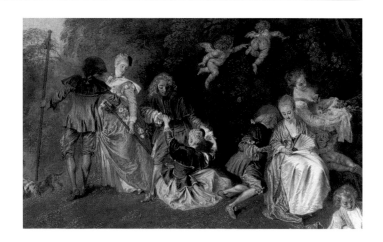

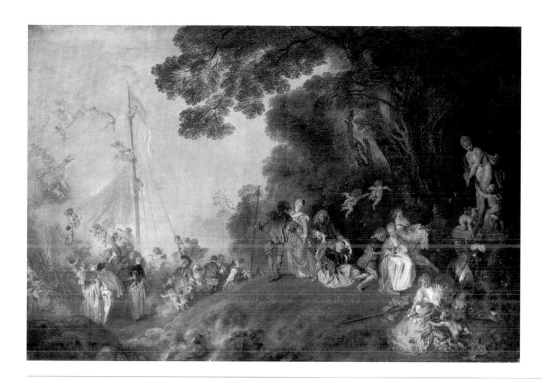

● The **statue of Venus** watches over the scene; the goddess is like a nude version of the elegantly dressed young noblewomen in the canvas. A putto is about to hang a laurel wreath around her, while beneath the statue we make out weapons, a lyre and a book: Venus (or love), they tell us, is greater than war, art or knowledge.

● **Courting couples** climb aboard a lovely ship that will carry them towards the misty horizon. Little cupid figures, or putti, swarm around, acting like the vessel's crew.

JEAN-ANTOINE WATTEAU

Les Fêtes vénitiennes
(formerly 'The Dance')

about 1717–18
Canvas, 54.6 x 45 cm
National Gallery of Scotland, Edinburgh

Many of Watteau's canvases conjure up a world of dreams. However, the idyllic images they present are firmly rooted in the reality of contemporary aristocratic life: open-air festivities in a man-made 'nature', stylishly dressed ladies and gentlemen, and theatrical role-playing to regulate their social intercourse. Venice was very much a place to be for *fêtes galantes* of this type, and it was there that Rococo painter Watteau drew inspiration for a number of his canvases, including this one, which was formerly called 'The Dance'.

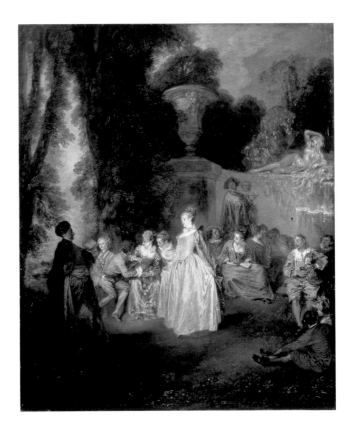

● Only one of the **secondary couples** is shown standing: the man points towards the nude sculpture, while she watches the start of the dance.

● There are clear traces of human activity in these apparently 'natural' surroundings. Take this seductive, **recumbent nude**, who looks down on the goings-on below her. The parkland in this painting shows little sign of the classic, strictly geometrical French gardens of the 17th century.

● While the couples arranged in a semicircle around them continue to chat and flirt, this **lady and gentleman** prepare to dance. The man, who could be the artist Nicolas Vleughels, is dressed in oriental costume, while the woman may have been a popular actress; she is brightly lit, highlighting her fabulous silk dress.

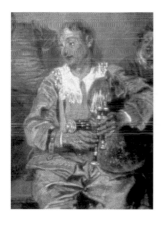

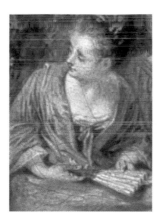

● This woman's attention is focused on somebody other than her partner. She has a **fan** in her hand; we know that these were sometimes used by lovers to signal to one another surreptitiously.

● Some commentators believe that the **bagpipe-player** is a self-portrait of Watteau, appearing here in an imaginative setting with self-deprecating irony.

CANALETTO *The Arrival of the French Ambassador*

about 1735
Canvas, 180 x 259 cm
Hermitage, St Petersburg

The idea that painting is all about working with light is a recurrent theme in this book. Venice's combination of light and water has always made it a unique location or setting, and Canaletto made it his life's work to paint the city in a grandiose style with almost photographic detail. Yet the pomp and splendour are misleading: Venice was past its glory days and its power as a city-state was waning.

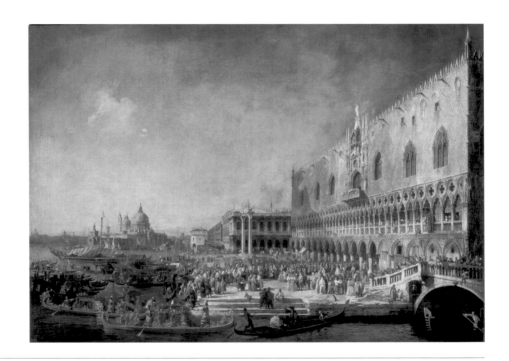

● Here is the reason for this large canvas: the visit of **French ambassador** Jacques-Vincent Languet to Venice in 1726.

He arrives in a state gondola at the San Marco Canal, in front of the imposing Doge's Palace, the centre of Venetian power.

VENICE IN ENGLAND

For many years, Italy, and Venice, were places that affluent Northern Europeans felt they absolutely had to visit. That made Canaletto's vedute (views) of his city extremely popular, especially in England. The 'Grand Tour' that wealthy young men undertook to round off their education and which focused particularly on Italy became a British institution. It is no coincidence, therefore, that much of Canaletto's work can be found today in the United Kingdom. The artist himself spent a good ten years in England.

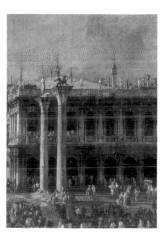

● Canaletto carefully studied the locations that he painted at various times throughout the day, to observe the different types of light. The **Dogana** (customs building) is shown on the left and the baroque church of **Santa Maria della Salute** (completed in 1687) on the right.

● Canaletto loved to paint **anecdotal details** in his precise canvases. Here are a few examples.

● The Doge's Palace – set here against a darkened sky – is crowned with a statue representing **Justice**, the classic symbol for buildings in which power was wielded and justice dispensed. Saints' figures and another winged lion decorate the balcony.

● Two impressive **columns** stand on the Piazzetta. The first is surmounted by a winged lion – symbol of Gospel-writer Mark, who is Venice's patron saint. The second is topped with a statue of St Theodore, whose relics are kept in this city. The 16th-century **library** designed by the great architect Sansovino can be seen behind the columns. Together with St Mark's Basilica (not visible here) and the Doges' Palace, it completed Venice's administrative, religious and ceremonial centre.

GIOVANNI BATTISTA TIEPOLO

Alexander the Great and Campaspe in the Studio of Apelles

about 1740
Canvas, 42 x 54 cm
The J. Paul Getty Museum, Los Angeles

When an artist paints another artist at work, the result inevitably has something to say about the profession of painting as such. It is a motif that occurs several times in this book (see pp. 42, 171, 268, 296). The Venetian artist Tiepolo is best known as a painter of enormous frescos; Italian artists were much sought after in the 18th century to decorate palaces and other interiors all over Europe. In this instance, however, he presents a well-established theme on canvas: the celebrated Ancient Greek artist Apelles, painting the portrait of Campaspe, Alexander the Great's favourite concubine. The story is told by the Roman author Pliny the Elder. The real subject, however, is that of painting itself.

THE STORY

"Apelles of Kos, who attained the height of his powers around 330, outshone all painters who lived before him and also those who were not yet born ... Alexander (the Great) conferred honour on him in a most conspicuous instance; he had such an admiration for the beauty of his favourite mistress, named Campaspe, that he gave orders that she should be painted in the nude by Apelles, and then discovering that the artist while executing the commission had fallen in love with the woman, he presented her to him."

Pliny the Elder, *Natural History*, Book 35, trans. H. Rackham

● The figures in the studio are placed in a setting of **Classical architecture**, both inside and outside. Alexander gazes at an imposing archway, no longer paying any attention to the interaction between artist and sitter.

THE PAINTER'S STATUS

The story of Apelles, Alexander and Campaspe
was frequently used in Renaissance and Baroque
art to express the power of painting, to stress the
profession's high status and, last but not least,
to demonstrate – and elicit – the generosity of
royal patrons,

WILLIAM HOGARTH *Marriage à la Mode II*

about 1743
Canvas, 69.9 x 90.8 cm
National Gallery, London

Marital ethics were the topic of much debate in 18th-century Britain. Frequent marriages of convenience and their attendant unhappiness came in for particular criticism, with a variety of authors taking the view that love was a much sounder basis for marriage. William Hogarth here painted a satire – a genre that by definition has a moral point to convey – of a conventional marriage within the English upper class. This is the second canvas in the series of six known as *Marriage à la Mode*. All the paintings were engraved and the series achieved wide circulation in print form. The actors in this Classical interior are the son of an impoverished earl, a rich merchant's daughter and their butler.

● The **husband** is hardly a picture of health. He has returned exhausted from a night on the town – possibly including a trip to a brothel. The dog has sniffed out what appears to be a lady's cap in his master's jacket pocket.

● The **butler** has reached the end of his tether: the household is in chaos. He leaves the room despairingly, a clutch of bills and a receipt in his hand, and a ledger under his arm.

● Although it is only breakfast time, the **young woman** is already tired out. There seems to have been a session of cards at this fashionable house the night before.

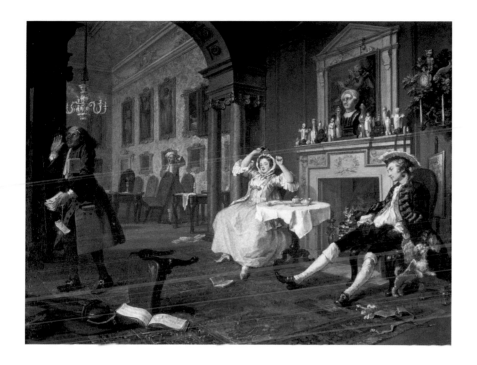

● Both the characters and the **interior** testify to this deteriorating marriage: the painting above the mantelpiece shows Cupid surrounded by ruins, while the nose has been snapped off the bust, symbolizing impotence.

● Although this is a Classical interior, complete with columns and Italian paintings, the **clock** could hardly be more Rococo – a style that, to a painter like Hogarth, stood for all that was abominable, affected and false.

THOMAS GAINSBOROUGH *Mr and Mrs Andrews*

about 1749
Canvas, 69.8 x 119.4 cm
National Gallery, London

Gainsborough was in his early twenties when he painted this canvas, which combines the two genres in which he specialized – portraiture and landscape. By his own account, he preferred the latter. The twenty-two-year-old Robert Andrews married sixteen-year-old Frances Carter in November 1748 and Gainsborough made this portrait of them shortly after the wedding. The couple is shown in front of a stout oak tree – the husband standing and the wife sitting. A real, sprawling landscape stretches out behind them: everything here is unmistakably English.

● **Robert Andrews** cradles his shotgun under his arm as his dog looks up at him. He stands proudly in the midst of his huge estate, which had just become even more extensive, thanks to his marriage. His attitude is aloof yet businesslike.

● **Frances Carter** is sitting on a wrought-iron Rococo bench. Her satin dress shows Gainsborough at his best, while it also reveals – the Rococo elements aside – the extent of Van Dyck's continued influence on English portraiture (see pp. 256–7). Her pose might have been lifted straight from a book of etiquette.

● An area in the woman's lap has been left **unfinished** for an unknown reason. Maybe it was reserved for a child's portrait, or for a book, or even a dead game-bird?

● Our eyes are drawn from a fertile field with recently harvested golden sheaves of corn to **meadows** of grazing sheep, a stand of trees and the hills in the distance. The enclosure of the sheep was a recent development – livestock had previously wandered about freely. The clouds touch the land at the horizon. Andrews' estate was in Gainsborough's native county of Suffolk. The minuscule **tower** in the left background of the canvas helps us to identify the location.

JOSEPH WRIGHT OF DERBY *An Experiment on a Bird in the Air Pump*

1768
Canvas, 183 x 244 cm
National Gallery, London

It is hard to imagine better evidence than this of burgeoning artistic interest in contemporary themes: Wright has chosen to depict a demonstration by a travelling scientist of how a vacuum is created. And this with *chiaroscuro* effects worthy of Caravaggio. Bringing the Italian master's influence together in the same canvas with a scientific experiment, 'candlelight' atmosphere and a study of people's reactions was something new in art.

● A white cockatoo flutters around inside a **glass flask**, from which the oxygen can be removed with an air pump if the valve at the top remains closed. Wright leaves us to guess whether or not it will. Experiments like this and the evidence they furnished that a lack of oxygen can result in death were new at this time. They tended, however, to use less up-market birds – sparrows or starlings, for instance; the fact that this is a cockatoo adds to the drama. With his flowing hair and long red robe, the scientist, or 'natural philosopher' as he would have been described then, looks more like a wizard.

● **Reactions** to the experiment vary sharply as we look around the table. The young couple pay it no heed; the boy leans forward to get a better view; while the man to his right watches attentively, measuring the elapsed time.

● The father comforts his daughter, who can no longer bear to watch the bird's fate; he tries to explain to her what is happening. Her sister, though also distressed, continues to watch. The man on the right meditates on what he is witnessing. The **responses** of those present are more important in this painting than the action itself.

● This is a **pair of Magdeburg spheres**, which were used to a similar end as the main experiment with the bird: when the spheres were placed together and the air between them pumped out, they became inseparable.

● The entire scene is lit by a candle positioned behind this **glass**, which contains a human skull, possibly symbolizing ever-present death.

ALESSANDRO MAGNASCO *Praying Monks*

about 1720–30?
Canvas, 53.6 x 43.9 cm
Museum voor Schone Kunsten, Ghent

This sketchily painted canvas is remarkable for the passion we feel in the scene itself as well as in the rapid brushwork. The three monks appear against an ominous background, at a make-shift altar with a crucifix set in a harsh, inhospitable environment. They are White Benedictines, or Camaldolese.

BACK TO THE DESERT

The order to which these three monks belonged was founded in the 11th century by St Romuald of Ravenna. The Camaldolese or White Benedictines were named after their principal monastery in Camaldoli, near Arezzo. Certain monks came to the conclusion in those days that large abbeys no longer offered them the refuge from the world that they were seeking. 'Back to the desert' expressed their longing for the life of a hermit, a concept with which they were familiar through famous early Christian examples like St Anthony and St Jerome. They founded new communities in impenetrable forests and in the mountains, where they lived together as hermits (see also pp. 96–7).

● The varying poses of the three **monks** form the central message of this work: they display three typically human responses to the suffering they are witnessing.

First, the rebellion of the gesticulating and yelling man, and second, the acceptance and resignation of the monk in the middle – both of them kneeling.

Third, there is the 'escape' of
the monk lying down, who has
turned in upon himself. This kind
of drama and direct narrative is a
familiar feature of the Rococo
movement in art, of which
Magnasco's work is an extreme
example. The monomania of
the subject is affirmed by the
dominant grey-brown colour
scheme.

● Alone with Christ: that
basically sums up the lives of
these monks. That same essence
is apparent in Magnasco's canvas;
there are no attributes here,
merely the monks surrounded
by arid nature with Christ on the
cross. The setting is evocative of
the desolate **loneliness** of Jesus
himself in the final hours before
his arrest on the Mount of Olives.

JEAN-HONORÉ FRAGONARD

The Meeting
(from 'The Progress of Love')

1771–3
Canvas, 317.5 x 243.8 cm
The Frick Collection, New York

Madame du Barry, mistress of Louis XV, commissioned court painter Fragonard in 1771 to provide her with four large canvases for a new pavilion in the garden of her château at Louveciennes, overlooking the Seine west of Paris. The theme was to be that of love and the ruses and stratagems that would-be lovers adopt. It all ended badly: the patron rejected the four Fragonards and took her custom to another artist. Perhaps his work was too direct, focusing too much on unadulterated instinct. Moreover, its full-blown Rococo style was by now considered *passé*. To make matters worse, the figures in the paintings, it was whispered, bore a more than passing resemblance to the king and his mistress. This is the second of the four canvases: a secret rendezvous is taking place, in a corner behind a balustrade, amidst a profusion of foliage. It has been suggested that Fragonard looked to the stage for inspiration.

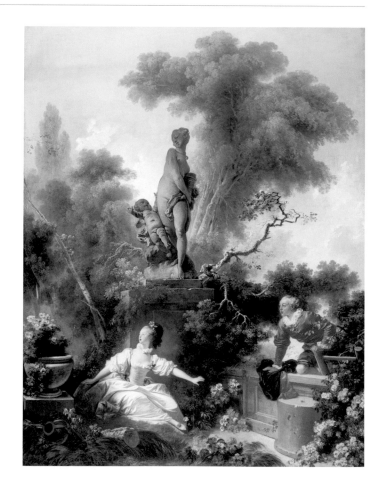

● The **man** in his gorgeous cerise jacket has used a ladder to climb over the balustrade. Like the woman, he is looking at something in the distance that we cannot see. When Madame du Barry ordered paintings to replace the Fragonards, she specified that the figures should wear Ancient Roman costumes rather than contemporary apparel, possibly to create a safer distance.

● The **woman** is dressed in white and yellow, and her hair is decorated with roses – a traditional emblem of love and a flower that is much in evidence in this canvas. She holds a sealed letter in her right hand and strikes a theatrical pose.

● Some critics have made much of the powerful, upwardly thrusting lines of the **trees**, linking them to the lust and passion expressed by the painting. Nature itself, it is claimed, has been aroused.

● In this **statue** of Venus and Cupid, the goddess refuses to give her son his arrows. Fragonard was familiar with the use of garden sculpture as a motif from paintings by Watteau, among others.

FRANCESCO GUARDI *Venice: San Giorgio Maggiore*

about 1780–82
Canvas, 68.5 x 91.5 cm
The Wallace Collection, London

Napoleon captured Francesco Guardi's Venice four years after the artist's death, bringing an end to a glorious period in which Venetian painting had reached astonishing heights. Guardi's cityscapes (*vedute*), with their delicate lighting effects, can thus be said to have rounded off that era. The canvases he painted tend to be similar, which makes them difficult to date; nor is it easy to determine for whom he actually painted them. Probably they were bought by the travellers who came to Venice from all over Europe, who may have wanted to take its unique light home with them as a souvenir.

• Although the *campanile* (bell-tower) of San Giorgio Maggiore was destroyed in 1774, its presence here does not necessarily mean that this painting predates that event – Guardi continued to include it in later canvases for aesthetic reasons.

• The **sky** takes up more than half of the picture surface; whereas Guardi's older colleague Canaletto (see pp. 340–41) devoted a great deal of attention to topographical and architectural detail, Guardi was more interested in light effects.

• The **church** and monastery complex of San Giorgio was a much-loved subject for painters, and not just Guardi. It stands directly opposite the Doges' Palace, which cannot be seen here. The abbey's position 'between sky and sea' causes it to display shifting nuances of colour and shade. Guardi places the buildings in the background, behind a wide stretch of water plied by numerous gondolas and other vessels. The canvas is dominated by the water and the sky that merge at the horizon.

ANGELICA KAUFFMAN *The Art of Painting: Colour*

about 1780
Canvas, 132 x 151 cm
Royal Academy of Arts, London

In 1781, the Royal Academy of Arts in London opened Somerset House, the first building constructed specially for its use. The new lecture hall was decorated by, among others, Angelica Kauffman – a Swiss painter with an outstanding European reputation – who contributed four large allegorical canvases for the ceiling. The themes were 'Invention', 'Composition', 'Design' and 'Colour': the four elements that together were deemed to comprise the art of painting. Kauffman, who was best known for subjects from Classical Antiquity, had been in England since 1766; she was a close friend of the painter Joshua Reynolds and a founder-member of the Royal Academy. Her four canvases can now be seen at Burlington House – the RA's current headquarters.

COLOUR OR DRAWING?

Which is the most important: the drawing and design of a painting or its colour? It is a question that sparked fierce debate in the 18th century, especially in France. Two sides were ranged against each other. The 'Poussinists', who took their name from the French artist (see pp. 276–81), argued that drawing was more important, since it required the painter's greatest gift – his or her intellect. It was a skill that had to be earned through intense study. Colour relied 'merely' on the eye. The 'Rubenists', meanwhile, contended that emulating nature was the greatest goal of painting, in which colour played an essential part. That colour appealed to the senses they considered a further element in its favour. In other words, this was also a philosophical dispute concerning the place and role of the mind and the senses, and how the artist ought (or ought not) to appeal to the emotions. Kauffman, like many others in England, preferred not to take sides.

● The four allegorical figures, including this one representing 'Colour', are all self-portraits of Kauffman. **Colour** is a young woman; she is shown in the open air, with one breast exposed. The message is that colour is 'natural', 'frivolous' and 'pleasurable'. (Her counterpart, 'Design' (drawing), by contrast, is demurely dressed and surrounded by serious Classical architecture.)

● Is the artist **painting a rainbow** in the sky? Or is she taking colours from it to add to her **palette**? Either way, this is another painting about painting.

JACQUES-LOUIS DAVID *The Death of Socrates*

1787
Canvas, 129.5 x 196.2 cm
The Metropolitan Museum of Art,
New York. Catharine Lorillard Wolfe
Collection, Wolfe Fund, 1931 (31.45)

Greek and Roman themes were much loved in revolutionary France, which saw its own heroic ideals mirrored in certain episodes and characters from Classical Antiquity. The 'revolutionary' philosopher Socrates (469–399 BC) was one such favourite. Unjustly condemned, he preferred to die for his ideals and principles rather than renounce his beliefs, flee, or live in exile. That, as the 18th-century revolutionaries saw it, expressed his heroic opposition to an unjust regime.

This canvas was commissioned by the Trudaine brothers, who knew David well and who supported the political reforms that would lead to the French Revolution two years later. The painter, who was very keen on Classical Antiquity, drew here from the book *Phaedo* by the philosopher Plato, a student of Socrates, as well as from texts of his own time.

● A grieving or possibly sleeping **Plato** sits at the end of the bed. We know it is meant to be him because of the writing materials lying beneath his chair. Plato actually recorded that he was not present, due to illness.

● **Socrates**' vital pose as he takes the cup of poison from a mortified prison guard demonstrates his indifference to his approaching death. According to Plato, he has just delivered a long discourse on the immortality of the soul.

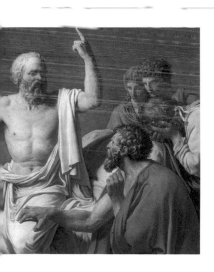

The man grasping Socrates' thigh, as if even now to stop his master going through with his decision, is his pupil **Crito**. In contrast to the latter, the other figures in the painting are allowing their emotions free rein – something that Socrates would, according to Plato, have found distasteful. In a painting, of course, this heightens the dramatic appeal while also serving as a contrast with the resolute hero of the scene.

Plato records that Socrates sent his **relatives** away; some of them are shown here leaving in the background.

JACQUES-LOUIS DAVID *The Death of Marat*

1793
Canvas, 165 x 128 cm
Musées Royaux des Beaux-Arts de Belgique,
Brussels

David was both the official painter and an active member of the revolutionary republican movement in France. One of the revolutions that were permanently to change the face of painting in this period was the expansion of its repertoire of subjects. Contemporary heroism, it was felt, had just as valid a *raison-d'être* as Biblical or Classical themes.

Jean-Paul Marat, a leader of the Revolution and a friend of David's, was stabbed to death in his bathtub by Charlotte Corday on 13 July 1793. He suffered from a skin disease and frequently worked in the bath to ease his discomfort. The murderess claimed to have important information to impart and so gained access to him. David, who had visited Marat in his home just the day before, organized the funeral. He wanted to paint a true-to-life record of the death scene, but there is also an idealizing serenity here. The painting transforms Marat into a symbol – a secular martyr.

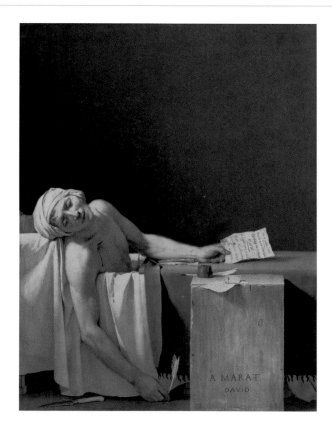

● David was schooled in Classical sculpture and the representation of human **anatomy** – in this dramatic case that of a dying young man. This new, yet ancient, hero with his lifeless, dangling arm inevitably calls to mind images of Christ and the Descent from the Cross. To David, Marat was a hero of the Revolution, murdered in cowardly fashion.

● Marat published the newspaper *L'Ami du peuple*; his **pen** – the journalist's weapon – lies alongside the bloody **murder weapon**.

● The bloody **note** in Marat's hands was the supposed petition brought by the murderess: "My great unhappiness gives me a right to your benevolence."

● The words '*A Marat/David/l'an deux*' are more than a signature: on the side of the makeshift worktable, the painter dedicates his canvas to the dead man it depicts, dating it to 'year two' of the recently introduced revolutionary calendar (i.e. 1793).

FRANCISCO DE GOYA *The Third of May, 1808*

1814
Canvas, 266 x 345 cm
Museo Nacional del Prado, Madrid

The Europe-wide turmoil of the Napoleonic wars is plainly visible in the work of Goya, who depicted the stupidity, cruelty, repression and inhumanity of his era in a way that was both personal and visionary. The painters who came after him would henceforth feel free to set down their own, highly individual perception of contemporary themes on canvas. Like David's *Death of Marat* (see pp. 360–61), the painting illustrated here is based on a historical event: at the beginning of May 1808 the people of Madrid rose in rebellion against Napoleon's army of occupation. French reprisals were unleashed the next day, when hundreds of people were summarily executed. Goya recorded the event following the restoration of King Ferdinand VII of Spain in 1814. The painting, which was intended for public display, had a clear message to convey: the innocent victims did not die in vain.

● It is not the large lantern but the **white shirt** of the next victim that seems to radiate light: the man's pose and the wound in his hand both recall the figure of the crucified Christ. The sense of drama is heightened by the fact that the soldiers stand improbably close to him.

● The members of the French **firing squad** are faceless and have all adopted the same stance – a mechanical touch that enables Goya to turn this seemingly anecdotal scene into a universal image of cruelty and defence-lessness.

● Unlike their executioners, each of the **victims** is an individual, responding to the horror in his own way. The man in the foreground is a Franciscan who clasps his hands in prayer, while others clench their fists or cover their eyes. They are secular martyrs.

● One of those waiting in line to be shot clearly displays his **terror**: the whites of his eyes shine as he bites his fingers.

● The **black sky** – the executions were indeed carried out at night – takes up about a third of this large canvas, heightening its macabre atmosphere.

Select Bibliography

Only monographs used in compiling this book are listed.

Altdorfer
- Kurt Martin, *Die Alexanderschlacht von Albrecht Altdorfer*. Munich 1969.

Fra Angelico
- John Pope-Hennessy, *Fra Angelico*. London 1952.

Avercamp
- Clara J. Welcker, *Hendrick Avercamp 1585–1634, bijgenaamd 'de Stomme van Campen', en Barent Avercamp, 1612–1679, 'schilders tot Campen'*. Repr. Doornspijk 1979.

Bellini
- Rona Goffen, *Giovanni Bellini*. New Haven and London 1989.

Bosch
- Jos Koldeweij, Paul Vandenbroeck and Bernard Vermet, *Hieronymus Bosch. Alle schilderijen en tekeningen*, exh. cat. Museum Boijmans Van Beuningen, Rotterdam. Ghent, Amsterdam and Rotterdam 2001.
- Roger H. Marijnissen and Peter Ruyffelaere, *Jérôme Bosch. L'œuvre complet*. Antwerp 1987.

Botticelli
- Ronald Lightbown, *Sandro Botticelli. Life and Work*. New York 1989.

Bouts
- *Dirk Bouts (ca. 1410–1475), een Vlaams primitief te Leuven*, exh. cat. Leuven 1998.

Brouwer
- Konrad Renger, *Adriaen Brouwer und das niederländische Bauerngenre, 1600–1660*. Munich 1986.

Bruegel
- Roger H. Marijnissen and Max Seidel, *Bruegel*. Brussels 1969.
- Wolfgang Stechow, *Pieter Bruegel the Elder*. New York 1968.
- Peter van den Brink (ed.), *Brueghel Enterprises*, exh. cat. Bonnefantenmuseum, Maastricht; Musées Royaux des Beaux-Arts de Belgique, Brussels. Ghent and Amsterdam 2001.

Caravaggio
- Howard Hibbard, *Caravaggio*. London 1983.

Claude Lorrain

- *Claude Gellée dit le Lorrain, 1600–1682*, exh. cat. Paris 1983.

Correggio

- Cecil Gould, *The Paintings of Correggio*. London 1976.

Dürer

- Fedja Anzelewsky, *Albrecht Dürer. Das malerische Werk*. Berlin 1971.
- Peter Strieder et al., *Dürer*. Antwerp 1982.

Van Dyck

- Christopher Brown, Hans Vlieghe et al., *Van Dyck 1599–1641*, exh. cat. Royal Academy of Arts, London; Koninklijk Museum voor Schone Kunsten, Antwerp. Ghent 1999.

Elsheimer

- Keith Andrews, *Adam Elsheimer: Paintings, Drawings, Prints*. Oxford 1977.
- Gottfried Sello, *Adam Elsheimer*. Dresden 1988.

Van Eyck

- Carol J. Purtle, *The Marian Paintings of Jan van Eyck*. Princeton 1982.
- Hans Belting and Dagmar Eichberger, *Jan van Eyck als Erzähler. Frühe Tafelbilder im Umkreis der New Yorker Doppeltafel*. Worms 1983.
- Till-Holger Borchert, *The Age of Van Eyck. The Mediterranean World and Early Netherlandish Painting 1430–1530*. London 2002.

Fouquet

- Claude Schaefer, *Jean Fouquet. An der Schwelle zur Renaissance*. Dresden and Basel 1994.

Fragonard

- Mary D. Sheriff, *Fragonard. Art and Eroticism*. Chicago and London 1990.

Gentileschi

- Mary D. Garrard, *Artemisia Gentileschi. The Image of the Female Hero in Italian Baroque Art*. Princeton 1989.

Giorgione

- Mauro Lucco, *Giorgione*. Milan 1996.
- Salvatore Settis, *'La Tempesta' interpretata. Giorgione, i committenti, il soggetto*. Turin 1978.
- See also under Titian, *Venus Unveiled*.

Gossaert

- Ariane Mensger, *Jan Gossaert. Die niederländische Kunst zu Beginn der Neuzeit*. Berlin 2002.

Goya

- José Gudiol, *Goya 1746–1828. Biographie, analyse critique et catalogue de peintures*. Paris 1970.

Van Goyen

- Hans-Ulrich Beck, *Jan van Goyen 1596–1656. Ein Oeuvreverzeichnis*. Amsterdam and Noordspijk 1972–87.

El Greco

- Annie Cloulas, *Greco*. Paris 1993.
- David Davies, John H. Elliott et al., *El Greco*, exh. cat. National Gallery, London, 2003.
- Francisco Calvo Serraller, *El Greco. The Burial of the Count of Orgaz*. London 1995.

Grünewald

- Georg Scheja, *The Isenheim Altarpiece*. New York 1969.

Guardi

- Dario Succi, *Francesco Guardi. Itinéraire d'une aventure artistique*. Paris 1995.

Hals

- Seymour Slive, *Frans Hals*. 3 vols. London 1970–74.

Hogarth

- R. L. S Cowley, *Marriage a-la-Mode: a Re-view of Hogarth's Narrative Art*. Manchester 1983.
- F. Ogee (ed.), *Dumb Show: Image and Society in the Works of William Hogarth*. Oxford 1997.

Holbein

- John Rowlands, *Holbein. The Paintings of Hans Holbein the Younger. Complete edition*. Oxford 1985.
- Stephanie Buck, Jochen Sander et al., *Hans Holbein the Younger, 1497/98–1543: Portraitist of the Renaissance*, exh. cat. Koninklijk Kabinet van Schilderijen 'Mauritshuis', The Hague. Zwolle 2003.

Honthorst

- J. Richard Judson and Rudolf E. O. Ekkart, *Gerrit van Honthorst, 1592–1656*. Doornspijk 1999.

De Hooch

- Peter C. Sutton, *Pieter de Hooch*. Oxford 1980.

Jordaens

- Roger A. d'Hulst, *Jacob Jordaens*. Ithaca 1982.

Leonardo da Vinci

- Marco Rosci, *Leonardo da Vinci*. Milan 1979.

Van Leyden

- Max J. Friedländer, *Lucas van Leyden*. Berlin 1963.

Leyster

- Frima Fox Hofrichter, *Judith Leyster. A Woman Painter in Holland's Golden Age*. Doornspijk 1989.

Lochner

- Julien Chapuis, *Stefan Lochner. Image Making in Fiftheenth-Century Cologne*. Turnhout 2004.
- Frank Günter Zehnder, *Stefan Lochner, Meister zu Köln. Herkunft – Werke – Wirkung*. Cologne 1993.

Lotto

- *Lorenzo Lotto, 1480–1557*, exh. cat. National Gallery of Art, Washington, 1997.

Mantegna

- Ronald Lightbown, *Mantegna: with a complete catalogue of the paintings, drawings, and prints*. Berkeley and Oxford 1986.

Martini

- Andrew Martindale, *Simone Martini. Complete Edition*. Oxford 1988.

Masaccio

- Edgar Hertlein, *Masaccios Trinität. Kunst, Geschichte und Politik der Frührenaissance in Florenz*. Florence 1979.
- Wolfgang Kemp, 'Masaccios "Trinität" im Kontext', *Marburger Jahrbuch für Kunstwissenschaft* (1986).

Memling

- Dirk De Vos, *Hans Memling. The Complete Works*. London and New York 1994.

Metsu

- Franklin W. Robinson, *Gabriel Metsu (1629–1667). A Study of His Place in Dutch Genre Painting of the Golden Age*. New York 1974.

Michelangelo

- Anthony Hughes, *Michelangelo*. London 1997.

Patinir

- Reindert Leonard Falkenburg, *Joachim Patinir: het landschap als beeld van de levenspelgrimage*, Ph.D. diss. Nijmegen 1985.

Piero della Francesca

- Kenneth Clark, *Piero della Francesca*. London 1969.
- John Pope-Hennessy, *The Piero della Francesca Trail*. London 1991.
- Ronald Lightbown, *Piero della Francesca*. New York 1992.

Pollaiuolo

- Leopold D. Ettlinger, *Antonio and Piero Pollaiuolo. Complete edition with a critical catalogue*. Oxford and New York 1978.

Pourbus

- Paul Huvenne, *Pieter Pourbus, meester-schilder, 1524–1584*, exh. cat. Bruges 1984.

Poussin

- Anthony Blunt, *Nicolas Poussin*. 2 vols.
 London and New York 1968.
- Pierre Rosenberg and Louis-Antoine Prat,
 Nicolas Poussin 1594–1665,
 exh. cat. Paris 1994.

Rembrandt

- Christopher Brown, Jan Kelch and Pieter van Thiel,
 Rembrandt: the master & his workshop.
 New Haven and London 1991.
- Simon Schama, *Rembrandt's Eyes*.
 New York 1999.
- Gary Schwartz, *Rembrandt: his life, his paintings*.
 London and New York 1985.

Rubens

- Kristin Lohse Belkin, *Rubens*.
 London 1998.
- Kristin Lohse Belkin and Fiona Healy (eds.),
 A House of Art. Rubens an Collector,
 exh. cat. Rubenshuis and Rubenianum, Antwerp.
 Antwerp 2004.

Ruisdael

- Seymour Slive and H. R. Hoetink, *Jacob van Ruisdael*.
 New York 1982.
- Seymour Slive, *Jacob van Ruisdael: a complete catalogue
 of his paintings, drawings, and etchings*.
 New Haven 2001.

Saenredam

- Liesbeth M. Helmus (ed.), *Pieter Saenredam,
 the Utrecht work: paintings and drawings by
 the 17th-century master of perspective*.
 Los Angeles 2002.

Savery

- Kurt J. Müllenmeister, *Roelant Savery*.
 Freren 1988.

Signorelli

- Jonathan B. Riess, *The Renaissance Antichrist:
 Luca Signorelli's Orvieto Frescoes*.
 Princeton 1995.
- Creighton E. Gilbert, *How Fra Angelico and Signorelli
 saw the End of the World*.
 University Park, Pa., 2002.

Tintoretto

- David Rosand, *Painting in Cinquecento Venice:
 Titian, Veronese, Tintoretto*.
 New Haven 1982.

Titian

- Harold E. Wethey, *The Paintings of Titian*, 3 vols.
 London 1969–75.
- *Venus Unveiled*,
 exh. cat. Bozar, Brussels, 2003.

Uccello

- John Pope-Hennessy,
 The Complete Work of Paolo Uccello.
 London 1950.
- Franco and Stefano Borsi, *Paolo Uccello*.
 London 1994.

Velázquez

- Jonathan Brown, *Velázquez. Painter and Courtier*.
 New Haven and London 1986.
- Antonio Dominguez Ortiz, Alfonso E. Perez Sanchez
 and Julian Gallego, *Velázquez*.
 New York 1989.

Vermeer

- Albert Blankert, *Vermeer of Delft:
 Complete Edition of the Paintings*
 Oxford 1978.
- *Johannes Vermeer*, exh. cat. Koninklijk Kabinet
 van Schilderijen 'Mauritshuis', The Hague;
 National Gallery of Art, Washington.
 Zwolle 1995.

Veronese

- David Rosand, *Painting in Cinquecento Venice:
 Titian, Veronese, Tintoretto*.
 New Haven 1982.

Verrocchio

- Günter Passavant, *Andrea del Verrocchio.
 Sculptures – Paintings and Drawings*.
 London 1969.

Van der Weyden

- Dirk De Vos, *Rogier van der Weyden. The Complete Works*.
 London and New York 1999.

Witz

- Marianne Barrucand, *Le retable du salut
 dans l'œuvre de Konrad Witz*.
 Geneva 1972.

Wtewael

- Anne W. Lowenthal, *Joachim Wtewael
 and Dutch Mannerism*.
 Doornspijk 1986.

Index

371

Acknowledgements for Photographs

Every effort has been made to contact copyright holders of photographs. Any copyright holders we have been unable to reach or to whom inaccurate acknowledgement has been made are invited to contact the publisher: Ludion, Muinkkaai 42, B-9000 Ghent; Herengracht 370–372, NL-1016 CH Amsterdam.

Allen Memorial Art Museum, Oberlin (OH) 260–61
Artothek, Weilheim 210–11, 226–7, 278–9, 284–5, 336–7
The Baltimore Museum of Art, Baltimore 254–5
Bridgeman Art Library, London 6–9, 14–15, 34–9, 44–5, 48–51, 58–65, 70–71, 76–7, 84–5, 92–3, 102–3, 112–15, 124–7, 130–31, 134–45, 154–5, 160–65, 168–9, 172–5, 178–9, 182–5, 192–3, 204–5, 220–21, 224–5, 238 lower left, 240–41, 248–51, 256–7, 264–5, 288–9, 296–7, 324–7, 338–41, 344–9, 360–63
Centraal Museum, Utrecht 156–7, 258–9
The Cleveland Museum of Art, Cleveland (OH) 280–81
The Corcoran Gallery of Art, Washington DC 300–301
The Detroit Institute of Arts, Detroit 320–21
Frans Halsmuseum, Haarlem 170–71, 244–5
The Frick Collection, New York 206–7, 332–3, 352–3
Galleria degli Uffizi, Florence 40–41, 80–81
Gemäldegalerie Alte Meister, Dresden 166–7
The J. Paul Getty Museum, Los Angeles 282–3, 342–3
Koninklijk Museum voor Schone Kunsten, Antwerp 46–7, 78–9, 146–7, 150–51, 194–5
Los Angeles County Museum of Art 334–5
Hugo Maertens, Bruges 30–31, 118–19, 122–3, 236–9, 270–71
Mauritshuis, The Hague 120–21, 218–19, 230–31, 262–3, 268–9, 274–5, 308–11
The Metropolitan Museum of Art, New York 10–11, 24–5, 32–3, 52–3, 214–15, 276–7, 290–91, 358–9
Musées Royaux des Beaux-Arts de Belgique, Brussels 68–9, 190–91, 232–3, 272–3, 306–7
Museo Nacional del Prado, Madrid 94–5, 98–9, 148–9, 180–91, 212–13, 294–5
Museu Nacional de Arte Antiga, Lisbon 96–7
Museum Boijmans Van Beuningen, Rotterdam 90–91, 152–3, 242–3, 298–9
Museum Mayer van den Bergh, Antwerp 186–7, 196–7
Museum of Fine Arts, Boston 42–3
Museum voor Schone Kunsten, Ghent 100–101, 350–51
Muzeum Narodowe, Gdańsk 72–3
National Gallery of Ireland, Dublin 316–17
National Gallery, London 16–17, 28–9, 176–7, 198–9, 234–5
National Trust, Anglesey Abbey, Cambridgeshire 330–31
The Picture Desk, London 12–13
Rijksmuseum, Amsterdam 208–9, 216–17, 228–9, 246–7, 266–7, 286–7, 292–3, 304–5, 312–15, 318–19, 322–3, 328–9
Royal Academy of Arts, London 356–7
Scala Archives, Florence 18–23, 86–9, 104–9, 128–9, 132–3, 202–3, 222–3
Sint-Janshospitaal/Memlingmuseum, Bruges 74–5
Staatliche Museen zu Berlin, Preussischer Kulturbesitz, Gemäldegalerie, Berlin 56–7, 188–9
Stedelijk Museum De Lakenhal, Leiden 158–9
Stedelijke Musea, Groeningemuseum, Bruges 82–3, 110–11
The Wallace Collection, London 354–5

First published in the United Kingdom in 2004 by
Thames & Hudson Ltd, 181A High Holborn, London WC1V 7QX

www.thamesandhudson.com

Reprinted 2005

© 2004 Ludion; Patrick de Rynck

Translation from Dutch by Ted Alkins, with Elise Reynolds
Design and typesetting by Anagram, Ghent

British Library Cataloguing-in-Publication Data
A catalogue record for this book is available from the British Library

ISBN-13: 978-0-500-51200-5
ISBN-10: 0-500-51200-0

Printed and bound in China